the shaman's mirror

· · ·

the shaman's mirror

visionary art of the huichol

hope maclean

Foreword by
Peter T. Furst

UNIVERSITY OF TEXAS PRESS
AUSTIN

Portions of Chapters 6 and 7 appeared as "The Origins of
Huichol Art" and "The Origins of Huichol Art, Part II: Styles,
Themes and Artists," *American Indian Art Magazine* 26, no. 3 (2001):
42–53 and no. 4 (2001): 68–77, 98–99. Portions of Chapter 10
appeared as "Sacred Colors and Shamanic Vision among the
Huichol Indians of Mexico," *Journal of Anthropological Research* 57
(2001): 305–323. Portions of Chapters 11 and 12 appeared as "The
'Deified' Heart: Huichol Indian Soul Concepts and Shamanic
Art," *Anthropologica* 42 (2000): 75–90. Portions of Chapters 14 and
15 appeared as "Huichol Yarn Paintings, Shamanic Vision and
the Global Marketplace," *Studies in Religion/Sciences Religieuses* 32,
no. 3 (2003): 311–335.

Library of Congress Cataloging-in-Publication Data
MacLean, Hope, 1949–
 The shaman's mirror : visionary art of the Huichol / Hope
MacLean ; foreword by Peter T. Furst.
 p. cm.
 Includes bibliographical references and index.
 ISBN 978-0-292-72876-9 (cloth : alk. paper) — ISBN 978-0-292-
73543-9 (e-book)
 1. Huichol art. 2. Huichol textile fabrics. 3. Huichol
mythology. 4. Art, Shamanistic. 5. Hallucinogenic drugs and
religious experience. 6. Symbolism in art. I. Title.
 F1221.H9M22 2012
 299'.7845—dc23 2011035818

Cover image: Eligio Carrillo Vicente, *Haa Naki*, 2007. 24" x 24"
(60 x 60 cm). This yarn painting shows a sacred site guarded by
little people called "Haa Naki." Photo credit: Adrienne Herron.

contents

foreword

peter t. furst

Hope MacLean's book, the first to treat in real depth the uniquely Huichol art of "painting" with colored yarns—and from the "inside out," that is, from the artist's viewpoint, rather than only from the "outside in"—brings to mind the transformation from the mundane to the sacred of a yarn painting that looked no different from those made for sale, to which I was witness in December 1968 on the second of the two peyote pilgrimages in which I was a semiparticipant-observer.

There were seventeen Huichol *peyoteros* in our party, thirteen adults and three children, the youngest barely a week old when we started out from an overnight stay on the left bank of the Río Lerma. Across from our temporary encampment was a rural settlement of Huichol peasant farmers and their families. They had left their homes in the mountains and canyons of the Sierra Madre Occidental for lack of arable land, but had never lost touch with their old homes and the relatives they had left behind. Nor had Ramón Medina Silva, a multitalented artist but also a lifelong peasant farmer, who led this pilgrimage, as he had in December 1966, when the late Barbara G. Myerhoff and I had the great good fortune of being the first anthropologists to witness the peyote hunt, of which the Western world had first learned at the turn from the nineteenth to the twentieth century from Carl Lumholtz, the pioneering Norwegian ethnographer of Huichol art and symbolism.

For Ramón, this was the high point of his life. Long ago he had pledged five peyote pilgrimages to his tutelaries, Tatewari, Our Grandfather, the ritual kin term for the old fire god and tutelary of earthly shamans, and Tayaupá, the Sun Father, and this would be his fifth, when he would have the right to call himself a *mara'akame*, Huichol for the shaman who not only cures but sings the many nightlong sacred chants.

Our goal, three hundred miles to the east, was the sacred peyote desert in the north-central Mexican state of San Luís Potosí. The Huichol call the desert "Wirikuta," and they are convinced it was the homeland of their ancestors.[1] One of the Huichols in our party was an exceptionally handsome young

woman named Veradera. As soon as we camped on the first night out, I saw her pull a small rectangular piece of quarter-inch plywood from her woven shoulder bag and cover it with a thin layer of brown wax from the indigenous stingless bee. It certainly looked as though she was preparing the board for one of the yarn paintings that the Huichol have been making for sale since the 1950s and early 1960s, only smaller than usual. By the time we arrived in Wirikuta, she was putting the finishing touches on a wool yarn design that now covered the entire board; after returning it to her bag, she rejoined her companions for the "hunt," literally with bow and arrow, for the little visionary succulent that, for the Huichol, is the transformation of the sacred deer.

Except for the painting's size, perhaps five inches across, in technique and appearance it was no different from those the Huichol make for the tourist trade. True, even in the Sierra you rarely see Huichols, even young children, without something in their hands—a weaving, an embroidery, a string of beads for weaving into rings, necklaces, or ear ornaments—when not otherwise engaged in agricultural or household chores. But why would someone apparently every bit as charged as any of her fellow pilgrims with anticipation of her first encounter with the ancestors and the visionary peyote distract herself—or so I thought—with thoughts of future income?

I could not have been more mistaken. This young artist—who, like her companions, had taken on the name and identity of one of the divine participants in the primordial peyote hunt and, also like them, was addressed as one of the Tateima, Our Mothers, for the duration—turned out to be as deeply immersed as her fellow pilgrims in this, the most sacred, longest-lasting, and physically and mentally most demanding ritual in the crowded ceremonial round.

The first day in Wirikuta was spent "stalking" and harvesting peyote, which, because it is only a few inches across and a dusty grey-green in color, and grows low to the ground under the protection of thorny vegetation, is not easy to spot. The roots are long and come to a point, and no Huichol would fail to leave the bottom portion in the ground to assure cloning and future growth. That night, everyone assembled in a circle around the fire that was the manifestation of Tatewari, Our Grandfather, the old fire god and tutelary of human shamans,

1. Recently published DNA studies have shown this to be "real history" framed in the language of myth, a reminder to anthropologists to give more credence to the people whose culture they are studying than to their own biases. See C. Jill Grady and Peter T. Furst, "Ethnoscience, Genetics, and Huichol Origins: New Evidence Provides congruence," *Ethnohistory* 58, no. 2 (Spring 2011): 283–291.

continuing what they had done in the afternoon: sharing their bounty with their companions and slowly masticating slice after slice. Some also watched for the reaction to the very bitter taste of a young boy peyotero, who was probably ten or eleven years of age.

Ramón was feeding him slices of peyote, urging, as he had everyone, to "chew it well, chew it well, so that you will find your life." Whether the boy liked it was important: if he did, the Huichol say, he was likely to become a shaman; if not, it was cause only for laughter, not shame. As we could see, our young companion, his mouth full of chewed peyote, was grinning from ear to ear and nodding his approval. So the omen was favorable.

But it was the young yarn painter who would soon catch everyone's attention. Sitting perfectly upright, she was taking her time before returning to everyday consciousness, so much so that lighted candles were placed around her, each a miniature manifestation of Tatewari, to shield her from hostile witches who might try to steal her soul while it was traveling out-of-body to Otherworlds. It was not the only time that she kept her companions waiting, eyes closed and with an expression of wonderment, for the return of her soul, and on each occasion her companions saw to it that she was protected by a ring of "little Tatewaris."

But it was on the following day that no one, not I nor her fellow Huichols, could have missed the power of her spirituality, a power that with a simple gesture would send her yarn painting full circle from commercial art back to its origin as visual prayer and means of communication with the ancestor gods.

The Huichols were again assembled around the fire, into whose flames Ramón and his chief assistants were placing various kinds of offerings, including the small wart gourds in which the Huichol keep the nicotine-rich "tobacco of the shaman," *Nicotiana rustica*, which they smoke in maize husk cigarettes to put themselves into a state of mind receptive to the peyote experience.

Veradera, seated with legs slung under, took her little yarn painting from her shoulder bag and, with its muslin cover removed, placed it on the fire, watching intently as, in its reincarnation of art as prayer, it was consumed by the flames: to give pleasure to the deities in exchange for hoped-for benefits, a baby, perhaps, or a calf, or rain and enough of the sacred maize to feed the family. To make sure that not only Tatewari, in his guise as the flickering flames, but also the Sun Father received her gift, Ramón gestured the smoke in the direction of the summit of an extinct volcano towering over Wirikuta, from which, in the time of the ancestors, the sun was born in a fiery eruption.

. . . .

 The yarn paintings made for sale are not in and of themselves sacred. But they do tell sacred stories. And though it may not always be available, for the wax into which the yarn is pressed, Huichols much prefer that of the indigenous stingless bee. Of that little insect, which does not sting but can inflict a little nip, there is a treasure house of sacred stories. And as Veradera's sacrificial yarn design attests, what matters most in the end is the artist's motivation and the depth of his or her relationship to the past.

acknowledgments

Doing fieldwork in anthropology is like directing a Broadway musical. A cast of hundreds makes the research happen, and sometimes it seems that all the researcher can do is orchestrate the voices. While I thank the key players who appear in these pages, I also acknowledge the kindness and concern of the many people who pointed me in the right direction and helped keep me going.

The University of Alberta provided a PhD recruitment scholarship and grant for writing. I thank my supervisor, David E. Young, and committee members, Ruth Gruhn and Gregory Forth. Since then, my colleagues Peter T. Furst and Marie-Francoise Guédon have been a constant source of advice and encouragement. Parts of this work have been published previously, and I am grateful to the publishers for permission to reprint.

The Mexican government, through the Secretaría de Relaciones Exteriores, assisted me with a scholarship for fieldwork. I thank Guillermo Espinosa Velasco, then director general of the Instituto Nacional Indigenista (INI), and Marina Anguiano Fernández, a Mexican anthropologist, who supervised my research under this grant; Luis Berruecos Villalobos, Alfonso Soto Soria, Trini Lahirigoyen, and Jesús Jáuregui of the Museo Nacional de Antropología in Mexico City; and Jorge Alvarez Fuentes and Fernando Delmar of the Embassy of Mexico in Canada. Denise Jacques, Michael Small, and Pierre Sved of the Canadian Embassy in Mexico City gave invaluable backup support.

I also thank the Huichol officials of the Unión de Comunidades Indígenas Huicholes-Jalisco (UCIH-J): Guadalupe de la Cruz Carrillo, Rafael López de la Torre, and Antonio Carrillo. I owe a special debt to those families that invited me into their homes: Tomás Montoya and his wife, Catalina; Alejandro López de la Torre and his wives, Rosa and Alicia; Eligio Carrillo Vicente and his wife, Jacinta Ríos; Guadalupe de la Cruz Ríos and her family, who first introduced me to Huichol culture; Tachillo Pérez, who opened my eyes to what shamanic vision might be. Susana and Mariano Valadez welcomed me into the Huichol Center for Cultural Survival and Traditional Arts in Santiago Ixcuintla.

A number of dealers in Huichol art allowed me to photograph their collections and shared their experience with Huichol artists. Among these, I would

especially like to thank Isabel Jordan, Maria von Bolschwing, Martha Elliott, Donato Schimizzi, Magua and Mahomedalid, Ignacio Jacobo, Kevin Sullivan, Maggy Flocco and Luc Vleeracker, Rolf Schumann, Pilar Fosado, Wayland Coombs and Aruna Piroshki, Jessie Hendry, and Judith Anderson. I am also grateful to those anthropologists who shared their experiences, such as Ingrid Geist, Paul Liffman, Olivia Kindl, and Denis Lemaistre.

I offer special thanks to the Huichol artists who shared their knowledge and the stories of their lives. I hope this research will be a suitable record of the wonderful art that they originated and continue to take in ever more fascinating directions. Fabian González Ríos, David González Sánchez, Modesto Rivera Lemus, Santos Daniel Carrillo Jiménez, Miguel Carrillo Montoya, José Isabel (Chavelo) González de la Cruz, Gonzálo Hernández, Mariano Valadez, and Alejandro López de la Torre all gave lengthy interviews. Eligio Carrillo Vicente has been my mentor and guide over many years. José Flores Bautista Ramos and the Bautista Cervantes family supplied the Tepehuane point of view.

I owe a special debt of gratitude to Adrienne Herron for her superb photographs, which capture the exquisite colors and details of Huichol art.

Finally, I would like to thank my parents, Dr. John MacLean and my mother, Dr. Margaret MacLean, one of Canada's first dealers in Inuit art, who passed on to me her love of indigenous art.

1

the path to the
sierra madre

It was December 1988, and I had traveled four days and thousands of miles, from Ottawa, Canada, to Tepic, Mexico, and from there to Tucson, Arizona, to meet a Huichol Indian woman I barely knew. When I finally found Guadalupe de la Cruz Ríos (Lupe) in a house on the outskirts of Tucson, I realized that the tourist Spanish I had been learning from tapes was wholly inadequate. I could hardly understand anything she and her family were saying. I felt lost and discouraged.

"Why did I come so far to see someone I can't even speak to?" I asked myself. I was ready to turn around and go home again.

The next morning, Lupe and I were sitting in the living room. Everyone else had gone out. On the table next to us was a copy of *Art of the Huichol Indians*, a beautifully illustrated book with many reproductions of yarn paintings—an art made by pressing colored yarn into beeswax spread on a plywood board.[1] Lupe picked up the book and opened it to one of her own yarn paintings.

"*Esto es Tamatsi Kauyumari*" (Sp.: This is Tamatsi Kauyumari, the Deer God), she said, pointing to a picture of a deer-person holding a bow. I wrote down "Tamatsi Calumari."

"*Es el poderoso del venado*" (Sp.: It is the power of the deer). She spoke slowly, sounding out each syllable. I wrote down the words she used. She waited while I looked up *poderoso* and *venado* in my dictionary.

Slowly, we worked our way through all the images in the yarn painting: the altar in the foreground; the Deer God, Tamatsi Kauyumari, a shamanic figure who wields a bow; the evil *brujo* (Sp.: sorcerer) called Kieri (Lat.: *Datura*),[2] who is being shot by Tamatsi Kauyumari; the deception practiced by those who follow the evil plant, *Datura*, instead of the good spirit of the peyote cactus (Lat.: *Lophophora williamsii*); the deer, as the source of spiritual power; and the deer's way of helping the shaman sing.

In a few hours, even though I was almost incapable of carrying on a conversation in Spanish, Lupe used her yarn painting to give me a lesson in some of the basic concepts of Huichol shamanism. One yarn painting became a teaching tool, a vehicle for establishing a relationship between two people from very different cultures and a window into Huichol mysticism.

From that day, I realized that yarn paintings were more than just pretty ethnic designs made for sale to tourists. A study of Huichol yarn paintings might provide a deeper insight into Huichol culture and the shamanism it is based on. This book is the result.

I first met Guadalupe de la Cruz Ríos (Lupe) in the summer of 1988. She and her family were traveling around North America, visiting Native reservations and performing basic ceremonies. The man who had arranged their tour was a Canadian named Edmond Faubert. His family lived near the village of Wakefield in the Gatineau Hills of Quebec, Canada, where I also lived.

During their tour, they stopped in Wakefield. One day, they held an exhibition in our local art gallery, and that is where I met Lupe. We formed a bond, and she invited me to visit her in Mexico. I made several trips over the next few years, and Lupe stayed with me when she and her family made more tours of Canada.

For the first few years, my interest was purely personal. I lived with Lupe and her family for weeks or months at a time, sleeping on the floor of a one-room concrete-block house in the slums of Tepic or on the ground around a campfire in the countryside. Lupe took me with her on pilgrimages to sacred sites. We traveled on rickety old *polleros*—buses with people and chickens riding on top—back into the hills behind Tepic. We rode crowded, second-class buses down the coastal mountains to the beach town of San Blas, home of aging American hippies and of a white rock jutting out of the Pacific Ocean that is sacred to Tatei Haramara, Our Mother the Pacific Ocean. In 1990, we went on the pilgrimage to Wirikuta, in the desert of San Luís Potosí, where we gathered peyote, a hallucinogenic cactus, and encountered the spirit of a tiny deer. Each visit took me deeper into Huichol mysticism, and I began to learn some shamanic practices.

At the same time, I was becoming overwhelmed by the mystical events I was experiencing. When I started, I knew little about the Huichol or about shamanism as a whole. There were few people I knew who could comment on these experiences, and none who could provide guidance. Perhaps optimistically, I decided to go back to university and work on a doctorate on shamanism as a way of structuring what I was learning. (I say "optimistically" because, in ret-

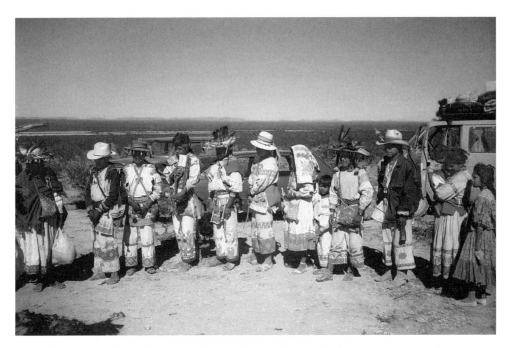

Fig. 1.1. The family of Guadalupe de la Cruz Ríos circling the fire during a ceremony in the desert of Wirikuta. Photo credit: Hope MacLean.

rospect, I feel that many in the academic world still retain a deep suspicion of the more mystical and paranormal aspects of shamanism.) I chose the University of Alberta, where David E. Young was doing innovative research with a Cree healer named Russell Willier (Young et al. 1989). Willier was trying to describe how he healed, and his explanations included accounts of his visionary experiences with spiritual beings. The story that these coinvestigators told was most like what I had experienced among the Huichol. Therefore, I felt that here was a supervisor who might understand my experience. To his credit, David Young has always lived up to that expectation.

When I flew into Puerto Vallarta on my way to visit Lupe, I often visited the galleries that sold Huichol art. They were full of Huichol yarn paintings—gorgeous paintings with glowing colors and obscure symbolism. The paintings seemed saturated with a shamanic worldview that both invited understanding and yet remained curiously beyond reach. I thought that by studying yarn paintings, I could learn what they had to say about Huichol shamanism and its worldview, so I chose the paintings as a focus of my research.

At first, I could hardly understand what the yarn paintings meant. The vivid colors exploded off the boards, and the paintings seemed to be confusing combinations of symbols and figures, jumbled together in ways I could not understand. It was hard to know what to focus on or how to see stories and styles. What the paintings "meant" was the first question I wanted to ask.

As I asked around, I discovered that comparatively little had been recorded about either the history of the yarn paintings or the artists themselves. Only three authors had written about yarn paintings at any length, and those accounts dealt mainly with only three artists. The American anthropologists Peter T. Furst and Barbara Myerhoff had written about my friend Lupe's late husband, the artist Ramón Medina Silva. The Mexican author Juan Negrín had collaborated with a Huichol artist, José Benítez Sánchez, on a series of exhibitions and catalogues. Susana Eger Valadez, an American, had written about her then husband, the Huichol artist Mariano Valadez.[3] Most other references to commercial yarn painting were passing remarks in articles concerned with other matters. Little had been written about the paintings' origins or about the many unsung artists who had produced thousands of paintings over the years.

These unanswered questions piqued my curiosity about the history of the art and the artists who made it. Where did this art come from? Who had transformed it from a sacred art to a commercial one? Who are the mysterious artists who produce it, many barely known even to the dealers?

Research Strategies

My friend Lupe and her late husband, Ramón Medina Silva, were two of the first Huichol to become well-known yarn artists. Lupe could talk with authority about the early years of commercial Huichol art. Although she no longer made yarn paintings, Lupe was a tireless artisan who supported herself by making embroidered clothes and shoulder bags, beadwork jewelry, and backstrap loom weavings. She taught several men in her family to make yarn paintings in Ramón's style. Lupe and her family became my first guides into the meaning of yarn paintings. They explained the legends and stories and helped me understand the basic vocabulary of symbols.

In 1992, I went to Mexico to discuss my research strategy with Lupe's family. I was thinking of using a research technique called photo-elicitation, gathering all the pictures of yarn paintings I could find and then asking Lupe and her family to explain what the paintings meant. The family quickly told me why my plan would not work. Lupe's brother-in-law, Domingo González Robles, told me

that I should not ask them to interpret another artist's work. Only the original artist could say what a painting meant. Chavelo González de la Cruz, a younger artist, was willing to try to identify what individual figures might mean, but he too insisted that only the original artist could say what the combination of figures signified.

The family's reaction gave me clear guidance. It meant I had to locate more painters and get them to interpret their work. In 1993–1994, I expanded my research to other artists. The Mexican government gave me a scholarship that funded six months of field research, as well as—and equally valuable—a letter of introduction from Guillermo Espinosa Velasco, then head of the Instituto Nacional Indigenista (INI). This official support was particularly helpful in gaining access to the Sierra Madre *comunidades*. Nonetheless, most of my contacts were made without government help, and grew out of my initial relationship with one Huichol family. Usually, Huichol introduced me to other Huichol; some private dealers also shared their contacts. I spent six months traveling around the Sierra Madre, tracking down Huichol artists and interviewing them about their lives and art. Finding artists was not easy. They were scattered among urban slums, tiny villages, and isolated mountain *ranchos* (Sp.: homestead), and did not have telephones.[4] Often, I would travel for days to reach an artist, only to find that he had just left to go to a fiesta at another *rancho* or that he had just returned from the city, where he had sold all his paintings. I began to realize it was no easy matter to put an artist together with a good selection of his or her own paintings, as Lupe's family advised.

Moreover, I wanted to interview a wide and representative sample of Huichol yarn painters rather than just a few well-known artists, those popularly regarded as the "best" artists. Artists such as José Benítez Sánchez and Mariano Valadez were already famous, but I did not know whether their art or interpretations were typical of the majority of Huichol artists. So I was just as interested in little-known artists, such as beginner, "souvenir," or folk art painters, as I was in the older, experienced "fine" artists. I wanted to see whether there were differences between artists from different communities, or between artists who lived in cities and those in the Sierra. I wanted to test whether the artists might be considered highly acculturated people, with little background in Huichol culture, or whether they had grown up within the culture, practicing its ceremonies, speaking the language, and learning the mythology. Most of all, I wanted to find out whether the artists themselves were shamans or on a shamanic path.

I wasn't fussy about whom I talked to. I spoke to anyone who would speak

to me. I visited the Sierra communities of San Andrés and Santa Catarina; I met artists in Tepic and the surrounding countryside, and in towns and cities such as Santiago Ixcuintla, Puerto Vallarta, Guadalajara, and Mexico City. I talked to yarn painters and to artists who specialized in other crafts, such as beadwork. These artists represented a range of experience along different dimensions, including their ages; the number of years they had spent doing yarn painting; whether they had ever attended school and, if so, for how long; whether they grew up in an urban, a rural, or an indigenous community; whether they had learned about Huichol religion and shamanic practices as children; and whether they personally considered themselves shamans. I have transcribed a cross section of their viewpoints in order to portray what the Huichol artists have to say about their shamanic and visionary experiences.

I conducted all the interviews myself, in Spanish. I did not use an interpreter. All the artists I located spoke Spanish, but they often spoke a Huichol version of a rural Mexican dialect. They used phrases and ideas based in Huichol concepts, or imposed Huichol grammar on Spanish constructions. Their Spanish can be quite difficult to understand, even for Spanish speakers, unless one has a background knowledge of Huichol culture. In this book, I have translated our conversations from Spanish into colloquial English and added clarifying notes in square brackets to make the interviews easier to understand.

Some artists allowed themselves to be tape-recorded. These artists tended to be older, mature men who were comfortable dealing with foreigners. Their accounts are verbatim transcripts of our interviews. Some other Huichol believe that being photographed or tape-recorded is dangerous. This seems to be particularly a concern of people from San Andrés. Some who refused at first changed their minds once they got to know me. When artists did not wish to be taped, I took notes, and I have paraphrased their answers.

I use the artists' real names rather than pseudonyms.[5] This reflects the fact that the artists are professional artists, making art for the public, rather than anonymous folk artists. Most participated in interviews because they wanted to become better known and were quite aware that publicity is good for business. A number expressed pleasure that someone was asking them about their art and making their views known. I have used the artists' real names when I had clear permission to do so, such as when I conducted formal interviews after explaining that the material would be used for research. I have not used artists' names regarding material given in casual conversation, observed during daily life in a community, or given in confidence.

Between trips to the Sierra, I visited the tourist centers and cities where most yarn paintings are sold—Puerto Vallarta, Guadalajara, Tepic, and Mexico City. I talked to gallery owners, to dealers who bought paintings for resale in North America and Europe, and to Mexican government officials, museum personnel, and other anthropologists. Most allowed me to photograph the yarn paintings they had on hand. This gave me a representative sample of the paintings moving through the markets in 1993–1994. With photographs in hand, I could then discuss the paintings with the artists when I found them. I have since returned to Mexico for five more winters and have spent several months investigating the market for Huichol art in the American Southwest.

I have now followed the development of yarn painting since 1988. There has been a gradual evolution in styles and subjects as innovative artists have introduced new themes and developed new products. I have seen the lives of artists change as they respond to commercial success or to setbacks such as the devaluation of the peso. I have seen children grow up and decide whether to try to live by emulating their parents' artistic practices or by working for wages at the bottom of the Mexican economy.

Research Themes

Several major themes have emerged from my research. One theme is how a sacred art changes when it becomes commercialized, and how this relates to the commodification of culture in the global marketplace. This process affects both the deep structure of Huichol aesthetic values and its manifestation in yarn painting.

What happens when a sacred art enters the commercial marketplace? A number of case studies exploring this process have shown that cultures use a variety of strategies to manage the transition. For example, Navajo singers resisted the commercialization of their sand paintings for many years, fearing supernatural danger from the nonceremonial use of the images. The final compromise was to change the figures somewhat so that they no longer duplicated the sacred art (Parezo 1991). The Haida refused to allow the use of sacred themes in their argillite carvings until the religion was no longer widely practiced (Kaufmann 1976, 65–67). To the Pueblo tribes, weaving has kept its ceremonial significance, and so has never become a commercial product. In contrast, weaving has little religious significance to the Navajo, although Western buyers often think it does, and so the images can easily be changed, or weaving can be abandoned for better ways of making money (Kent 1976, 97–101).

These studies suggest the range of solutions that cultures may adopt in response to pressures to commercialize their sacred arts: from completely refusing to sell, to modifying the figures, to allowing unrestricted freedom once the religion becomes attenuated. One question is how the Huichol have coped with the commercialization of their sacred yarn paintings.

One may also ask, who are the people responsible for this transformation, and what processes led them to modify their art? Did the Huichol decide to do commercial yarn painting on their own, or were non-Huichol involved in the transition? How are yarn paintings regarded by the Huichol, and is there any restriction on the reproduction or sale of sacred images? To what extent have yarn paintings been modified to suit a Western market? Do the dealers or buyers influence the art, and in what ways?

The commercialization of a sacred art is related to broader themes—the growth of tourism to indigenous communities around the world and the commodification of culture in the global marketplace. Tourism has become the largest service industry in the world (Smith and Brent 2001, xvi, 8–9). The sale of local products to tourists is a major component of this industry. There is growing concern about the effect of tourism on indigenous peoples, and about whether it is beneficial, harmful, or somewhere in between.

Clearly, yarn paintings are a part of the global tourism industry, since most are sold in tourist centers in Mexico, and they are marketed as the mystical product of one of Mexico's most exotic pre-Columbian cultures. From both sides, complex negotiations about identity are being played out in this process. Foreign buyers have images about the Huichol, which drive the products offered in the marketplace, and the Huichol have their own set of images about buyers, which may affect what they produce. How this dance of identity plays out is another theme that I explore.

A related theme is whether yarn paintings manifest a deep aesthetic structure that is distinctively Huichol or whether they have become lovely, but culturally sterile, merchandise. Richard Anderson (1990, 235–236) suggests that a consistent pattern in colonial situations is for the colonized culture to "eventually discard the sophisticated systems of aesthetic thought they once possessed and adopt more commercially pragmatic, materially utilitarian and aesthetically superficial values." Technical skill tends to become more important than the religious thought or philosophy underlying the work. Market value becomes the dominant standard. Tyler Cowen (2005, 5) suggests that there may be a cycle in which indigenous artists enter the market and generate excitement because

of their unique worldviews, and then, as they prosper, the artists may move into the cultural mainstream and end by losing the traditional culture that made them unique.

Shamanic Vision and Extraordinary Experience

When I first began to study yarn paintings, I was intrigued by statements that they were spiritually inspired. The dealers in Puerto Vallarta insisted in their sales patter that all Huichol artists were shamans and that all their art was the product of dreams and visions. It made a good story for selling art, since Western tourists are often fascinated by the mystical products of another culture. But was it really true? Were all the artists shamans? Were the paintings the products of dreams and visions? Even if not all the paintings were the product of shamanic inspiration, some might be. If so, how fascinating! What could we learn about the process of envisioning shamanically from a culture that painted pictures of their visions?

My curiosity was driven by my own experiences. Shortly after our first meeting, Lupe gave me peyote, and I had a vision of multicolored deer heads falling like confetti out of the sky. They were preparing the way for a deer spirit who was on his way. In the distance, I heard the sound of deer-hoof rattles announcing his coming. Somehow I knew they were deer-hoof rattles, although I had never seen deer-hoof rattles before, nor even heard of them. In the morning, I sketched the shape of the deer head in my notebook. At the time, I had seen few yarn paintings, but none that reproduced this image. Months later, I saw the same deer head in a yarn painting in a store. The coincidence seemed amazing.

Many years later, I told Eligio Carillo about my vision, and he confirmed that it was a Huichol experience and said he had seen it too. He told me that the deer is a spirit called Tüki, who gives off something like pollen (Sp.: *suelte polvo*), which takes the form of tiny multicolored deer.

> ELIGIO: Yes, that means that it is a deer that brings a powder. It is called Tüki. He brings . . . it is one who brings this. He brings little deer, but it is a powder that he goes along giving off, that is showering down.

Years after my dream of the deer, I discovered a similar description of multicolored spirits of the deer family in a book on Dene shamanism by Robin Ridington (1988, 103). A dreamer was describing the moose spirits that live under the ground around springs where moose like to congregate.

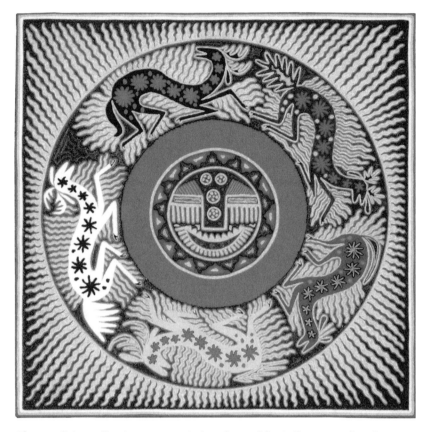

Fig. 1.2. Eligio Carrillo Vicente, yarn painting of a mandala nierika, 2002. 24" x 24" (60 x 60 cm). The painting shows multicolored deer spirits, like those in the author's dream. Photo credit: Hope MacLean.

> Even in cold time, those moose under the ground are lonesome.
> They don't like it there and get tired of it.
> Even if it is frozen over with ice, they just break through. . . .
> They are white with red eyes or some of them are just blue when they come out. Just like blue horses.
> Some of them just really blue, some of them white, and some of them pure yellow.

The similarity was striking. Was it possible that my own vision was a common experience, shared not only by the Huichol but by shamans of other cultures as well?

There are accounts of anthropologists sharing visionary experiences with their consultants. Bruce Grindal (1983, 68) records a vision of the corpse dancing and drumming in an African funeral ceremony.

> From both the corpse and the goka [shamans] came flashes of light so fleeting that I cannot say exactly where they originated. The hand of the goka would beat down on the iron hoe, the spit would fly from his mouth, and suddenly the flashes of light flew like sparks from a fire.
>
> Then I felt my body become rigid. . . . Stretching from the amazingly delicate fingers and mouths of the goka, strands of fibrous light played upon the head, fingers, and toes of the dead man. The corpse, shaken by spasms, then rose to its feet, spinning and dancing in a frenzy. . . . The talking drums on the roof of the dead man's house began to glow with a light so strong that it drew the dancers to the rooftop. The corpse picked up the drumsticks and began to play.

The participants later told Grindal that "seeing the ancestors dance" and hearing the dead man drum was an experience shared by some, but not all, of the participants. He concluded that the fundamental problem raised by his vision was epistemological. Since a vision is not subject to consensual validation by rational observers, one must depart from the ordinary canons of research and assume that reality is relative to one's consciousness of it.

Sharing visions, and the dilemma of what to do about them, has become a theoretical springboard for some anthropologists. Victor Turner (cited in E. Turner 1996, xxii–xxiii) labeled his insight the anthropology of experience and challenged his colleagues to learn about ritual processes "'on their pulses,' in co-activity with their enactors." An increasing number of anthropologists now write about their own extraordinary experiences. Lupe's husband, Ramón, gave peyote to Barbara Myerhoff (1974, 40–42), and she had a vision of herself "impaled on an enormous tree with its roots buried far below the earth and its branches rising beyond sight, toward the sky." She interpreted it as the world tree and said that she saw exactly the same image in a Mayan glyph several years later.

Edith Turner (1996, xxii) saw an African healer extract a grey mass, like smoke, from a patient, then later learned to feel illness through her own hands in an Inupiat village. Her experience inspired her to admonish fellow anthropologists: "It is time that we recognize the ability to experience different levels of reality as one of the normal human abilities and place it where it belongs, central to the study of ritual" (Turner 1994, 94).

While attending a lecture by a Métis healer, Jean-Guy Goulet (1998, 178–179) had a vision of a Dene girl who had died; after he described his vision to Dene

consultants, he found that they were much more forthcoming in sharing their own visionary experiences. David Young and Jean-Guy Goulet (1994, 328–329) call on anthropologists to develop theoretical models that encompass such experiences. Visionary experience is an important part of Native American culture. As Goulet (1998, xxv–xxxiii) points out, information gained through vision is considered as valid and important as information gained through other senses such as sight, sound, or touch.

We do our consultants a disservice if we reject this information. Moreover, we risk failing to understand the complex metaphysical explanations of Huichol religion if we automatically reject the subjective visionary experiences that may underlie it. I would venture to say that sharing our consultants' experiences may give a whole new perspective to fieldwork. For example, once while participating in a ceremony, I suddenly saw a deer standing in the middle of the circle, facing the shaman.[6] I asked one of the other Huichol whether I had really seen what I thought I saw. She replied, "Of course, the shaman has been standing there talking to that deer for a while."

If we, as anthropologists, do not realize that this is what is going on, we may simply see a shaman standing and singing or waving his plumes in the air. We may miss the whole point of what the ceremony is about and what is really happening from the participants' points of view.

As I attended ceremonies and asked the artists about the meaning of their paintings, the Huichol stressed repeatedly the importance of visionary experience. Visions may include hearing sounds and voices, seeing images, or otherwise knowing or apprehending information through empathy or "gut feeling." Visionary experience may include dreams while asleep or visions experienced while awake or in some form of trance. They may include phenomena induced by hallucinogens such as peyote, or experiences undergone while a person is cold sober. Shamans envision when they sing. Ordinary Huichol may envision when they attend ceremonies. Visions are also a recurring part of everyday life that anyone, including young children, are able to experience. Discussion of dreams and visions is a regular part of conversation in some Huichol families.

I deal at length with visionary experience in this book. Here, I will address some methodological issues. Some readers may subscribe to the Western, scientific view that humans have five senses only and that what might be called psychic phenomena have little place in anthropological research (Krakauer 2003, 338; Bateson 1984, 209). Such readers may feel that reports of psychic and shamanic experience cannot be verified and may be falsified by consultants try-

ing to gain some sort of advantage. However, I feel that if we are to understand how the Huichol feel and think about their religion and their art, we must at the very least suspend disbelief and listen closely to what they say. David Young suggests proceeding as if the information were true, and then following the conversations and ideas where they might lead. For example, if a person reports seeing a deer spirit, the researcher may ask what kind of deer, what it said or did, what it meant to the person, and so on. A skeptical reader may at some point choose to believe that reports of visionary experience are false or are the product of cultural fantasy. However, at the very least, we should understand that many Huichol take these phenomena absolutely seriously. If we are to understand what the Huichol are talking about, then we need to listen to them with attention.

An anonymous reviewer of one of my articles once suggested that Huichol artists make up stories of visionary experience in order to entice buyers, and that therefore this information cannot be trusted. I suggest that this concern be dealt with by the usual anthropological methods of verification, such as getting to know consultants well, finding out how they are regarded by others in the community, and using multiple consultants. I occasionally met artists who made up stories to impress me; for example, one young man showed me a photograph of a Mariano Valadez painting and claimed he had painted it. He quickly backed down when I recognized the painting and challenged him. Another artist claimed to be an important shaman, and at the time I was skeptical. I found out several years later that he had completed the required number of pilgrimages and was regarded by others in the community as having some shamanic powers, although he was not as influential as he claimed.

Not all Huichol claim shamanic or visionary experience. Many Huichol told me quite clearly that they were not shamans or did not have these abilities. Their disclaimers indicate that these consultants were not trying to gain any advantage by claiming to be shamans.

It is also valuable to check the consistency of shamanic claims—in particular, whether verbal claims are consistent with observed behavior. Is the person recognized by others in the community as having visionary ability? (In Huichol culture, a person may have visionary ability without being a shaman.) Has the person completed the steps required to become a shaman? Do other people come to the person for shamanic services such as singing or curing? Is the person practicing what he or she preaches? Does the person live according to shamanic principles? Does he or she practice the ceremonies and leave offerings?

Does he or she consistently offer the same kinds of explanations for phenom-
ena? For example, does he or she have a clear and consistent explanation of the
activities of deities? Is visionary experience a regular part of family discourse?
Do people dream and then talk about it with their families in the morning?

The same anonymous reviewer asked whether Huichol are not normally se-
cretive and reluctant to explain their shamanic thought to outsiders. I agree this
can be so, and like most anthropologists, I have certainly met people who did
not want to talk to me. Several artists told me that some shamans did not wish
to share information with anyone, even within their own families. Nonethe-
less, I consistently found that the artists were willing to explain their yarn paint-
ings in considerable detail, and without hesitation. More than that, the artists
were usually pleased and proud to have a chance to explain their work. They
were also willing to tell me about visionary or dream experiences. The key fac-
tor was that I asked for an explanation and was willing to listen to the response.
This means that I spoke Spanish well enough to understand, and respected
indigenous etiquette by allowing the speaker ample time to explore his or her
thought without interrupting. Also, after spending a considerable amount of
time among the Huichol, I developed personal relationships with people who
were known to the artists. Sometimes I asked artists why they were telling me
certain things, and their answer was simple: "Because you asked." I have con-
cluded that a sincere and interested questioner will be taken at face value and
will be given an intelligent and comprehensive response.

It is also possible that some shamans see things in me that make them will-
ing to share information; one shaman told me that I had "many beautiful col-
ors painted on me" and that this attracted him. This means of gaining entrée is
not the usual one recommended in manuals on fieldwork methods, but it may
be the reality of what happens in an indigenous culture.

Indigenous consultants have sometimes confided dreams and visionary ex-
periences to anthropologists. Extraordinary images and symbols are scattered
like fragments throughout the anthropological literature. Whether those imag-
es and symbols are recognized as visionary is another matter. In addition, such
visionary statements have not been collected systematically. (Ethnographers
may set out with a list of categories for data collection, such as house building
or agricultural techniques, but few have set out to collect data on visions.) As a
result, accounts of visionary experience occur randomly, such as when an eth-
nographer wrote down what a shaman or other visionary said. Sometimes they

are just presented as myths. Nonetheless, despite being unsystematic, these accounts are vital information on shamanic perception.

I have pulled together some of these references and compared them to my own Huichol information; they deepen our understanding of how vision forms a constant source of information in indigenous thought. I have mainly compared the Huichol to other Uto-Aztecans, such as the Aztec, Paiute, Yaqui, Papago, and Hopi, who share similarities of thought and worldview. The information is spotty in the anthropological record. It often depends on whether an anthropologist was sensitive about recording it and on how open his or her consultants were to talking about it. For example, Ruth Underhill (1938, 1939, 1979), an early Boasian ethnographer, recorded remarkable material about Papago dreams and visions. The Yaqui seem to have been very open in describing their views of a spiritual flower world to ethnographers such as Muriel Painter (1986) and Edward Spicer (1980).

Occasionally, I have extended the comparison to other Native peoples, especially to the Navajo, who are Dene (Athapaskan), but who intermarried extensively with the Uto-Aztecan Hopi. I suspect that some Navajo thought is strongly influenced by Uto-Aztecan ideas of visionary experience. When I have drawn on other cultures, such as the Cree or Winnebago, it is usually because I found a specific description of visionary experience that sheds light on my own Huichol data.

Eligio Carrillo Vicente,
Artist and Shaman

Eligio Carrillo Vicente is one of my most important consultants on yarn painting and visionary experience. I first met Eligio in 1994. Lupe's family had recommended that I talk to Eligio if I wanted to learn more about yarn painting from a very good artist. Eligio was the uncle of Presiliano Carrillo Ríos, a young man who was married to Lupe's niece, María Feliz. After about a week of false starts and cancelled trips, I prevailed upon Presiliano to take me to Eligio and introduce me.

We took a Volkswagen combi (minivan) along the newly built highway leading into the Santiago River region. The combi dropped us at the side of the highway, and we walked down a cobblestone road to a small rancho. As we approached a concrete-block house, I saw a stocky, heavily muscled man sitting at a wooden table. Eligio waved hello and immediately offered me a chair. I pre-

Fig. 1.3. Eligio Carrillo completing a yarn painting, 2005. The Huichol say that the colors in their clothes replicate the colors of the clothes the gods wear. The gods are pleased when they see humans wearing the same kinds of clothes that they do. Photo credit: Hope MacLean.

sented my credentials, including my letter of introduction from the Instituto Nacional Indigenista. Eligio read the letter carefully, and I felt that it made him more willing to talk to me. He asked me a few questions, then agreed to a tape-recorded interview. I talked to him for several hours that day. He gave me some of my most important clues to the inner meaning of yarn paintings, although I did not realize it at the time. After our talk, I continued to travel around the Sierra, looking for and interviewing other artists. It was only much later, when I had finished transcribing my tapes and was writing my thesis, that I realized how significant were some of the things he said.

At the end of our interview, he described a dream he had had several times over the past week. He saw a woman in white walking up the path to visit him.

When he saw me coming—by coincidence, I was dressed all in white—he turned to his wife and said, "Watch what will happen. That is the one I was dreaming about." His dream was the reason he decided to answer my questions.

I returned to Mexico in the winter of 1999–2000 and decided to look up Eligio again. I wanted to clarify some points raised by our previous interview. I expected to do perhaps one or two interviews. Instead, I spent the whole winter interviewing him. I would tape a long interview of several hours, return home to transcribe it, then go back to ask more questions raised by our conversation. Often, it was only while making a word-by-word transcription that I realized the underlying significance of something Eligio said as a passing comment. For example, his phrase "the colors speak" led me into a discussion of color as a language used by the shamans and gods to communicate. Since then, Eligio has given me an enormous amount of information on Huichol philosophy and on shamanic meaning in yarn painting. We have discussed the nature of the soul, shamanic healing, and the inner structure of energy in the Huichol shamanic universe.

Eligio is one of the most experienced and skillful Huichol artists. (For his biography, see Chapter 7.) He has participated in many pilgrimages to Wirikuta over the past thirty years. As a result, he says that the gods have given him some shamanic abilities, including visionary ability. Nevertheless, he says that he did not ask to become a shaman and that his healing abilities are limited to curing children's diseases. Thus, he might be classed as an "intermediate" or "minor" shaman rather than a senior shaman who leads ceremonies, is an important singer, and is in demand as a healer.

I have confirmed part of what Eligio says with other Huichol and from the literature, but there is also much that is new and so far unpublished elsewhere. Eligio's family left the Huichol community of San Andrés and moved down to the Santiago River during the Mexican Revolution. Thus, his cultural roots and his knowledge go back to San Andrés. There can be variation between communities and between individuals. His knowledge forms a coherent body of philosophy, but it is quite possible that other shamans and other artists might have different explanations for the same concepts.

I have used many of our conversations verbatim in this book, presenting the actual words, translated into English, because I feel that the language and the phrasing are significant. Perhaps others will see meanings that I may have missed or that were lost in paraphrasing. He is not always easy to understand,

and so I have provided explanatory notes in square brackets in the texts. Often, these notes relate to another of our conversations that can help clarify his meaning.

Eligio wanted to discuss this information because of his concerns about transparency and cultural survival. He feels that Huichol young people are often not interested in the kinds of knowledge he has, and he wants to make sure that it is recorded. He takes pride in sharing information: "I don't want to take this with me when I die." I explained at the outset that I was writing for publication, and he allowed me to tape-record all our interviews. He is a strong, intelligent man with a powerful character, and I have trusted his ability to judge what he is prepared to say and have published. I only hope that I can do credit to the information he has entrusted to me.

The Huichol live in the rugged Sierra Madre of western Mexico. "Huichol" is a name given to them by the Spanish, and even the origins of the name are unclear. Early Spanish documents record different versions of this name, such as Xurutes, Uzares, Vizuritas (Rojas 1992, 23), Guisol, Usulique (P. Furst 1996, 40), and Tecual or Teçol (Anguiano 1992, 170–172).

The Huichol name for themselves is Wixárika. It is pronounced "Wee-*sha'*-ree-kah" in the eastern dialect or "Wee-*ra'*-ree-kah," in the western dialect. Carl Lumholtz (1900, 6), an early anthropologist, translated their name as "prophets" or "healers"; more recently, Liffman (2002, 40) translates it as "diviners."

The Huichol speak a language in the Uto-Aztecan language family (Grimes and Grimes 1962, 104), also known as Uto-Nahuan. The Huichol are part of a wide band of Uto-Aztecan language speakers that extends from southern Idaho through the southwestern United States along the western Sierra Madre and the Pacific Coast to the Valley of Mexico, with isolated groups as far south as Costa Rica and Panama (Hill 2001, 913). The Huichol's closest linguistic relatives are the neighboring Cora, followed by the Nahua (and formerly the Aztecs) of central Mexico (Grimes and Hinton 1969, 795; Hill 2001, 930).

The geographic origins of the Huichol are bound up in the larger question of the origin of Uto-Aztecans generally. There is a long-standing scholarly debate whether the Uto-Aztecans originated in the north or the south, that is, in the American West or in Mesoamerica (Hill 2001). One theory proposes that Proto-Uto-Aztecans originated in the north as food foragers. After maize was domesticated in the Valley of Mexico about 3600 BC, the knowledge of maize cultivation diffused northward, reaching New Mexico by 1740 BC. Maize cultivation was adopted by some Uto-Aztecans, but not all, since the northernmost groups still foraged. According to the northern-origin theory, the Huichol may have been a fringe group, far from the northern heartland of Uto-Aztecan culture.

Fig. 2.1. The pine-clad mountains of the Sierra Madre descending into deep canyons.
Photo credit: Hope MacLean.

The other theory proposes a southern origin for Uto-Aztecans. While the debate has gone on for years, the linguist Jane Hill synthesized recent research on Uto-Aztecans and concluded that a southern origin seems most probable. She relates the domestication of maize to a population expansion that occurred first in the Valley of Mexico and then in daughter groups. The resulting population pressures may then have led to unusually rapid expansion northward. Between 2500 and 1000 BC, the maize cultivators leap-frogged over desert regions along the Pacific Coast, seeking arable river systems suitable for maize planting. An unusually rapid expansion would account for the similarities in Uto-Aztecan culture and languages over a wide area. According to this theory, the Huichol were not a fringe group but were close to the center of Proto-Uto-Aztecan culture.

Huichol oral history states that they "originated in the south; as they wandered northward, they got lost under the earth, but reappeared in the country of the *hikuli*; that is, the central mesa of Mexico, to the east of their present home (Lumholtz 1902, 2:23)." This oral history, which links the Huichol with a southern Uto-Aztecan origin, is similar to stories of emergence from underground told by other Uto-Aztecans, such as the Hopi.

The Huichol's present homeland lies astride the Sierra Madre Occidental, which runs down the Pacific coast of Mexico. At their highest, the mountains soar to 10,000 feet (3,280 meters). To the east lies the high central Mexican plateau. In the west, the mountains gradually descend toward the Pacific Ocean and the tourist beach resorts of Puerto Vallarta and San Blas.

The Río Grande de Santiago (also known as the Río Lerma) flows north out of Lake Chapala and cuts through the heart of the mountains. Just north of Tepic, the river makes a sharp turn to the west, flows through the fertile coastal plains around Santiago Ixcuintla, and empties into the Pacific Ocean. According to the Huichol artist Eligio Carrillo, the Huichol call the Santiago River the Río Wirrarika, indicating its role as the center of their homeland.

The 2000 census counted more than 43,000 Huichol. Contrary to rumors on the Internet, the Huichol are not a dying people.[1] In fact, with a high birthrate and an improved infant mortality rate due partly to better access to food and health care, the number of Huichol can be expected to grow quickly over the coming years.

Most Huichol live in the Mexican states of Jalisco and Nayarit. A few have settled in neighboring states such as Zacatecas, Durango, and Aguascalientes. One group, mainly from Santa Catarina, live in far-off Mexico City. A few Huichol have even immigrated to the United States.

A large part of the Huichol nation lives in northern Jalisco, west of the towns of Mezquitic and Huejuquilla el Alto. There are three communities, named Tateikie, or San Andrés; Tuapurie, or Santa Catarina; and Wautüa, or San Sebastián. These are on protected lands called "comunidades" in Spanish, a legal category somewhat like reservations in the United States. The original comunidades had land titles granted by the Spanish crown (Grimes and Hinton 1969, 795). The deeds subsequently disappeared from the archives in Mexico City and have been in dispute since then. The Huichol comunidades are surrounded by land owned by mestizo cattle ranchers, who contest the boundaries in order to gain access to more pastureland. Nonetheless, the status of comunidad provides a degree of protection and security as well as formal recognition of the tribe as an indigenous community.

The three comunidades are subdivided into five governing districts: San Andrés and Guadalupe Ocotán (Xatsitsarie), San Sebastián and Tuxpan (Tutsipa), and Santa Catarina. Phil Weigand (1981, 20) estimates that these five districts are further subdivided into about twenty temple districts. The temples (Hui.: *tuki*) are centers of ceremonial activity. Weigand (1972, 7–8) refers to the three Sierra

communities as the Chapalagana Huichol after the Chapalagana River, which divides the western plateau of San Andrés from the eastern plateaus of Santa Catarina and San Sebastián. The Chapalagana River (also known as the Atenco River) flows into the Huaynamota River, then to the Santiago River.

There are also a number of Huichol communities in Nayarit along the western edge of the Sierra and in the foothills leading down to the city of Tepic, particularly along the Santiago River. In addition, there are old Huichol settlements to the south, such as Amatlán de Jora, which at one time had temples and large Huichol populations. Remnant populations of Huichol live in the hills east of the Pan-American Highway, near such towns as Ixtlán del Río and Magdalena.

Huichol may have always lived in the foothill regions, since archival sources show that these communities were probably populated with Huichol during the Spanish colonial era (Rojas 1992, 12–15, 22). In the early 1900s, many Huichol fled the Sierra and traveled down the Santiago River to escape violent fighting during the Mexican Revolution. These refugee families settled in the foothills, and many never returned to the Sierra communities. By the 1950s, Fabila (1959, 74–75) had found that about one-quarter of the Huichol population was living outside the official Sierra comunidades. I refer to the foothill communities as the Santiago Huichol, to distinguish them from the Chapalagana Huichol. The Santiago Huichol speak Huichol and practice their own ceremonies, and their histories differ somewhat from those of the Chapalagana Huichol.

The Santiago Huichol do not have the legal recognition or protected lands of a comunidad. Some foothill communities, such as Caracól, Salvador Allende, and Colorín, are *ejidos*, which are another legal category of protected communal land. Others are simply groups of families or villages living together wherever they can, on land that is privately owned or not officially occupied.

Increasing numbers of Huichol now live in cities such as Guadalajara and Tepic. In the 1990s, Celso Delgado, the governor of Nayarit, set aside a section of land on the outskirts of Tepic to form a Huichol *colonia* (Sp.: settlement, urban neighborhood) called Zitacua (pronounced "Si-tá-kwa").[2] This colony has a Huichol governor and a temple for ceremonies. However, many Huichol pre-

Facing page

Map 2.1. Map of Huichol territory and some sacred sites.
Credit: Original map from Carl Lumholtz, *Symbolism of the Huichol Indians* (New York: American Museum of Natural History, 1900), 4; additional text added by Designmatters.

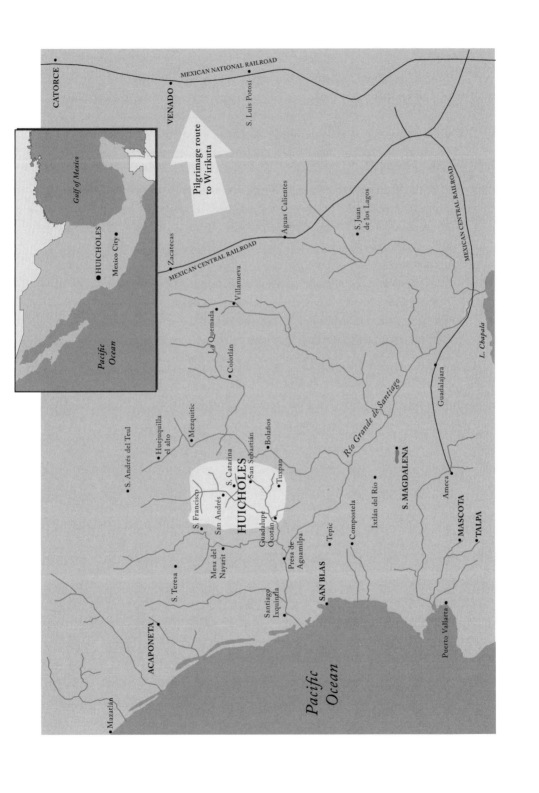

CATORCE

MEXICAN NATIONAL RAILROAD

VENADO

S. Luis Potosí

Pilgrimage route
to Wirikuta

Gulf of Mexico

HUICHOLES
Mexico City

Pacific
Ocean

Aguas Calientes

S. Juan
de los Lagos

Zacatecas

MEXICAN CENTRAL RAILROAD

MEXICAN CENTRAL RAILROAD

Villanueva

La Quemada

Colotlán

L. Chapala

Mezquitic

Guadalajara

Huejuquilla
el alto

Bolaños

Río Grande de Santiago

S. Andrés del Teul

S. Catarina

San Sebastián

Tuxpan

Ameca

S. MAGDALENA

S. Francisco

San Andrés

HUICHOLES

Guadalupe
Ocotán

Ixtlán del Rio

MASCOTA

TALPA

Mesa del
Nayarit

Presa de
Aguamilpa

Tepic

Compostela

S. Teresa

Santiago
Ixquintla

SAN BLAS

ACAPONETA

Pacific
Ocean

Puerto Vallarta

Mazatlán

fer to live elsewhere; for example, a number of Huichol from San Andrés live around the former municipal airport at the opposite end of town.

The rural Huichol prefer to live well separated in extended family compounds called ranchos. Rural Huichol still farm corn, beans, and squash by using traditional slash-and-burn horticulture, but agricultural chemicals are becoming increasingly common. They also keep cattle, goats, and sheep as well as donkeys, mules, and horses.

As the Huichol population grows, there is increasing pressure on the limited arable land available in the Sierra. According to Liffman (2002, 63), their population of about 4,000 families would require about 118,613 acres (48,000 hectares) of cultivable land, which is more than is now available. Clearly, a subsistence economy cannot support everyone. Moreover, the Huichol want cash so that they can buy popular consumer goods, such as portable radio–tape decks (boom boxes), plastic dishes, cotton fabric, glass beads, and yarn. Some affluent families now have propane stoves and buy bottled gas. To earn cash, many Huichol commute to the Pacific coast to plant tobacco and pick fruit. Selling arts and crafts is an increasingly important source of cash income.

3

kakauyari

the gods and the land are alive

Lupe dipped the tips of her shaman's plumes into a jar of water taken from a sacred spring. Then she lifted her *muwieri* in the air and offered a drop of water in each of the four directions.

"Wirikuta, Haramara, Otata, Ta Selieta." She pronounced the names with reverence.

"*Hi xrapa*," she called out, raising her plumes above her head. (She pronounced it "hee shrapa.")

Then she sprinkled a final drop of water into the fire burning beside her.

With her words and her offering, Lupe woke up the beings that live in each direction and called them in to hear her words. The ceremony had begun, and the doors were now open to the spirit world.

Lupe's invocation tied her ceremony into the heart of the sacred map that the Huichol call home. Each direction has a divine guardian living in a specific place. Wirikuta, the sacred desert in the east where the peyote cactus grows; Haramara, the goddess of the Pacific Ocean; Otata, the North, located on a mountain called Auromanaka, or Cerro Gordo, in Durango; Ta Selieta, the South, located in Rapawiyeme, or Lake Chapala, in Jalisco; *Hi xrapa*—the Center.[1]

Years later, Eligio and I were driving through the green fields of sugarcane outside Tepic. Ahead of us loomed the extinct volcano called Sanganguey, or Cerro de Abeja—the Hill of the Bee. The lava core jutted out of the surrounding green slopes like the stinger of a giant bee. I asked Eligio whether the Huichol knew any stories about the mountain.

"The earth is alive," he began. "It is a living person. We call that person Nakawe. The volcanoes are her breath. Every time she breathes, steam comes out of the mountain."

. . . .

Let us look for a moment at how the world works from a Huichol point of view.

The Huichol world is made up of living, breathing beings that are other than human. We live on the skin of one of those beings, whom the Huichol call Ta-kutsi Nakawe. Our food grows because of other beings. Rain mothers, in the form of serpents, live in the springs, lakes, and oceans. When properly fed and encouraged with prayers and offerings, the rain mothers rise up in the form of clouds and bring life-giving rains to the crops.

The earth is flat and square, and surrounded by oceans. It is supported at the four corners—by candles, says Eligio. Others say by trees. If the candles burn down and are not renewed, the earth will die. The earth is like a person; it needs to eat to be strong. If it is not fed and well nourished with the right kind of food, it will become weak. It is our job, the job of the Huichol, to renew the candles and strengthen the world.

We feed the gods with our prayers and offerings. We hunt the deer, we catch a fish, or we sacrifice our cattle, and then feed the gods with their blood. We smear the blood on our arrows and our candles, and then take the offerings to the sacred places where the gods live. We sacrifice ourselves as well. We fast. We fast from salt so that our food will have no flavor. We give up sleep. We refrain from sexual relations so that we will be *limpiecita* (Sp.: totally clean and pure).

The gods are our ancestors—the *kakauyari*. The earth and the waters are our mothers, our elder sisters. The fire is our grandfather. We call him Tatewari. The sun is our father. We call him Tayau. They are all our relatives.

The deer are our relatives as well. The deer is our elder brother; we call him Tamatsi Kauyumari. He is the interpreter, the translator for the gods. It is very hard to hear and understand the gods. Tamatsi Kauyumari tells us their messages.

Tatei Niwetsika is the mother of corn. Her daughters are the spirits of the different colors of corn. She was once our mother-in-law. One of her daughters married a Huichol man and freely gave him endless quantities of corn, without his having to do any planting. Unfortunately, the man's mother did not appreciate the gift, so she demanded that the corn girl start to work hard, grinding corn to make tortillas. Blood poured from the girl's hands because she was grinding her own flesh—made of corn—on the *metate* (Sp.: stone grinding table). A great wind sprang up, all the corn vanished from the granaries, and now the marriage between humans and corn requires unremitting toil.

. . . .

The Huichol view of the world is a magnificent dance between humans and other-than-human beings. There is nothing small about it. The gods and goddesses are the very stuff of the earth and sky, the powers and forces of nature. Humans are essential to their survival. Without the ongoing sacrifice and commitment of humans, the world as we know it would cease to exist.

Lupe once said to me, in some indignation, "The mestizos here don't know what we do for them. It is our prayers, our fasting, our pilgrimages that make the rains come. If the Huichol were not doing that for them, they would not be able to grow their crops. They don't appreciate everything we Huichol are doing for them."

Lupe was not speaking metaphorically. She meant every word quite literally. It is very difficult for Westerners, even as trained anthropologists, to encompass what it means to see the world from this perspective. Westerners use the term "Mother Nature" or talk romantically about Native American conceptions of nature as sacred. But it is difficult for a Westerner to shift fully and see the world as the Huichol do. It is a big leap to feel oneself personally responsible for the ongoing survival and strength of the world.

Huichol Religion

Despite the Spanish conquest, the Huichol managed to retain their religion, including a shamanic curing complex. While the Chapalagana Huichol adopted some Christian practices, such as Semana Santa (Easter Week) celebrations and the worship of wooden *santos* (Sp.: saints), in general their ceremonies remained aboriginal. The Santiago Huichol may have not even adopted the outward forms of Christianity found in the Sierra comunidades; for example, my Huichol consultants have no tradition of practicing Semana Santa ceremonies or worshipping the wooden saints.[2]

Huichol deities represent the spirits of animals, plants, and natural phenomena such as the sun, the earth, mountains, lakes, springs, and rain. Deities may be male or female, and they are considered relatives or members of the Huichol family. For example, important male deities are Tatewari, Our Grandfather Fire; Tau (or Tayau), Our Father the Sun; and Tamatsi Kauyumari, Our Elder Brother the Deer, a messenger of the gods. Female deities include Takutsi Nakawe, Grandmother Growth (literally "Our Elder Sister" Nakawe),[3] goddess of the earth and creation, as well as Our Mothers (Hui.: *Tatei teima*), who include Tatei Werika Uimari, Our Young Mother Eagle Girl, who holds the world in her claws; Tatei Yurianaka, goddess of fertility and crops (sometimes called Tatei

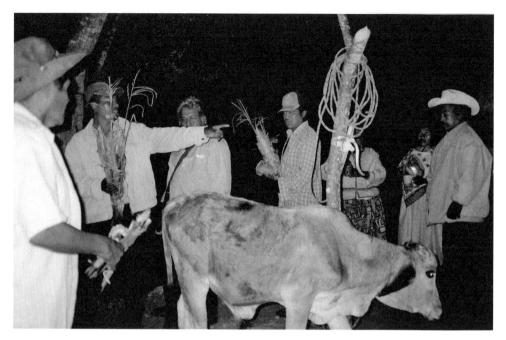

Fig. 3.1. Eligio Carrillo's family preparing to sacrifice a bull calf during a nighttime ceremony. The presiding mara'akame, *left*, is holding his shaman's plumes (muwieri). Two men have been dancing with corn bundles sacred to the corn goddess. Photo credit: Hope MacLean.

Utuanaka); Tatei Niwetsika, the Mother of Maize; Tatei Nüaariwama, goddess of lightning and storms; and a host of goddesses of rain and water. Many goddesses are associated with particular springs or bodies of water, such as Tatei Matinieri, a spring in the desert north of San Luis Potosí; Tatei Rapawiyeme, located in Lake Chapala, south of Guadalajara;[4] and Tatei Haramara, the Pacific Ocean at the town of San Blas, Nayarit.

Indeed, most deities have shrines at particular sacred sites. Many ceremonies include making a pilgrimage to a sacred site in order to leave offerings. If there is a spring or water at the site, the pilgrims bathe in it, drink it, and bring the water home to use in ceremonies.

Perhaps the best-known Huichol ceremony is the pilgrimage to Wirikuta, also known as the "peyote hunt." The pilgrims leave their homeland in the Sierra and travel 400 miles (650 kilometers) northeast to the desert north of San Luis Potosí. In the past, when the pilgrims walked, the journey took about

forty-three days (Lumholtz 1902, 2:126). Now, most pilgrims travel by bus or truck, and the journey takes just a few days.

Part of the pilgrimage ceremony includes collecting and eating *hikuri*— peyote—a hallucinogenic cactus that grows in the desert of Wirikuta. Peyote has the power to transform into deer and corn. The pilgrims may leave offerings at Reunar, the volcano that is the birthplace of the sun, and bring peyote and sacred water back with them for use in ceremonies that bring life to the people in their communities. Peyote is eaten by participants in ceremonies and even given to young children if they want to try it. It is not addictive or harmful when consumed occasionally in ceremonies, as the Huichol use it.

The pilgrimage to Wirikuta is undertaken to re-create the world. It ensures that the sun continues to rise, and the rain to fall, and guarantees that people, animals, and crops enjoy good health. According to Eligio, the original pilgrimage was made by the kakauyari, who are the ancestor-gods of the Huichol. The gods started at the Pacific Ocean and travelled east on their way to a fiesta in Wirikuta. Some gods were lazy (Sp.: *vagón*) and stopped along the way; they transformed into mountains or other sacred sites. For example, a mountain in Nayarit now known as Picachos was originally a group of gods who became tired on the journey and sat down to rest. Other gods reached Wirikuta, and still live there. The modern pilgrims re-create the original journey made by the kakauyari and visit the sacred sites where the gods stopped.

The Huichol also carry out a regular cycle of ceremonies in family ranchos and in the main ceremonial centers. In Spanish, the ceremonies are called "fiestas," but the purpose is much more serious than a party. A series of fiestas throughout the year are concerned with the planting and harvesting of the corn, bean, and squash crops and with maintaining the health and fertility of fields, animals, and people. Ceremonies are held when the fields are cleared, when the corn crop is sown, when the young corn is still green, when the corn is harvested, and when the corn is toasted, and prayers are said for the next year's fertility.

The main ceremonial centers in the Sierra practice an additional round of ceremonies derived from the Spanish. These include Easter ceremonies such as Fiesta de Pachitas (Ash Wednesday), Lent, and Semana Santa as well as ceremonies such as Cambio de las Varas (Changing of the Rods of Power), which occurs during the changing of civil governors.

Huichol Shamanism

On my second visit to Lupe's family, I met a Huichol shaman. Two men arrived in the middle of the night and bedded down with the ten other people sleeping in María's one-room concrete-block house on the outskirts of Tepic. At first light, everyone got up and cleared a space around one of the two beds. Domingo, María's father, was the first patient. He had coughed all night with a serious chest complaint.

The shaman was a short man, dressed like a rural mestizo, wearing a western shirt and pants and leather huaraches. Only his beautifully decorated Huichol bag marked him as Huichol rather than mestizo. He pulled a narrow, oblong, woven *takwatsi* (Hui.: shaman's basket) out of his bag and took out a handful of shaman's plumes, three or four wands decorated with feathers and mirrors hanging from them. He passed his feathers over the patient, shaking them lightly, and then peered into his mirror. He paused, went to the window, and stood there for a few minutes. He looked to the east and seemed to be listening for something. Then he went back to the bed and brushed his feathers around the patient as though gathering dust up in the body. Then he shook his feathers off out the window. He repeated this process a number of times. Finally, he pounced on the patient and, with loud hawking noises, sucked something out of his body, then went to the window and spat it out.

The shaman treated four people that way, including two babies. Afterward, he pulled up a chair and drew a hardbound notebook out of his bag. It had blank pages and a picture of a scuba diver on the front. It was his account book, and he noted down the names of the people he treated, the price of the healing, and whether they had paid. I looked over his shoulder and noticed many names, but few that had paid. The family said they would pay him later. He agreed, and left shortly after, with no small talk exchanged. The family said he came from far up in the mountains and that he would return in a few days to conduct another healing.

It was my first experience of healing by sucking, and I was amazed to discover that this ancient practice was still very much alive among the Huichol. I was struck by the incongruity between the pre-Colombian shamanism and the modern account book. Since then, I have attended many healing sessions and been a patient several times myself. My notes became much longer and fuller as I learned what to watch for and how to interpret what the shamans are doing. Yet I am still mystified by the process, in which the shamans seem to be carrying out operations on the body that only they understand.

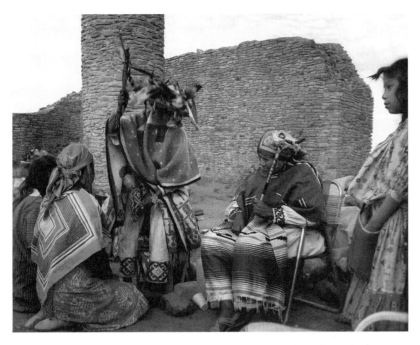

Fig. 3.2. The shaman Tacho Pérez Robles brushing a patient with his shaman's plumes (muwieri) while Guadalupe de la Cruz Ríos watches, 1990. Photo credit: Hope MacLean.

The word for shaman is *mara'akame* (plural: *mara'akate*). In Spanish, the Huichol often call the shaman a *cantador* (Sp.: singer) rather than *chamán*. This translation reflects the mara'akame's central role of chanting in ceremonies as well as of healing groups and individuals. Most mara'akate are men, although women may be mara'akate as well. In the past, this skill was widespread among the Huichol, and Lumholtz (1900, 6) commented that "every third person" was a mara'akame. One still encounters many Huichol mara'akate, both in the Sierra and in the cities.

Kawitero (plural: *kawiterutsixi*) is a second term used to refer to elders who supervise and guide ceremonies, but according to my consultants, *kawiterutsixi* are not necessarily shamans. The term is more comparable to "wise elder" and may be more commonly used in the Sierra comunidades. My Santiago consultants did not recognize the term at all; perhaps it is a term recently adopted into Huichol from Spanish or Mexicanero (Nahua) settlers.[5]

The term "shaman" originated in Siberia, and some scholars argue that it should be restricted to Siberian practitioners. However, I feel that it is widely

recognized as a general anthropological term for practitioners who communicate with spirits, perform healings, and conduct ceremonies in their communities. As I will show, Huichol mara'akate also perform these functions, and so I use the terms "shaman" and "mara'akame" interchangeably.

People become mara'akate in Huichol culture by making vows to certain deities and fulfilling their obligations to the deities for a prescribed number of years. The words used in Spanish reflect the concept of payment. They refer to making a contract (Sp.: *hacer un compromiso*), making payment (Sp.: *pagar la manda*), and completing it (Sp.: *cumplir*). The idea of payment underlies the process of becoming a shaman, through arduous pilgrimages, fasting, offerings, and self-sacrifice. Until the vow is paid, the person is bound. Failing to complete the required sacrifices may bring illness or death, or the person may be diverted to the dark world of sorcery. A shaman is someone who has "completed," or fulfilled, the vows, while a failed shaman has not been able to complete them. It is the spirits who finally decide whether a person will be granted shamanic power. An aspiring shaman can carry out all the prescribed rituals but still fail.

One way to become a mara'akame is by making a prescribed number of pilgrimages to Wirikuta. It has been reported in the literature that five pilgrimages to Wirikuta are required to become a shaman (P. Furst 1972, 144; Myerhoff 1968, 17). Lupe's family requires six pilgrimages over a period of five to six years (with one pilgrimage at the beginning and one at the end of the fifth year). Later, they told me that six years is just a beginning and that it takes six years to "go up the staircase" (or climb to knowledge) and another six years to come down again. Some Huichol consultants have told me that up to ten or twelve years are required. The longest period I have heard is twenty-five years. The shortest period I have heard is three years, but this smaller requirement was to fulfill a pledge to a different place and deity—a kieri, or "Tree of the Wind." Thus, there appears to be considerable variation in practice.

There is more than one way to become a mara'akame in Huichol culture. Besides making the pilgrimages to Wirikuta, one may also make vows to other sacred sites that are dotted around Huichol territory. Many sacred sites are said to give shamanic powers as well as specific artistic abilities, such as skill at painting, embroidery, or weaving.

Mara'akate perform a variety of roles. They undertake private healings within family settings. They officiate at ceremonies to remove the effects of sorcery. They conduct funeral ceremonies five days after death. They act as senior priests in community-wide ceremonies at the ceremonial centers, and they select and

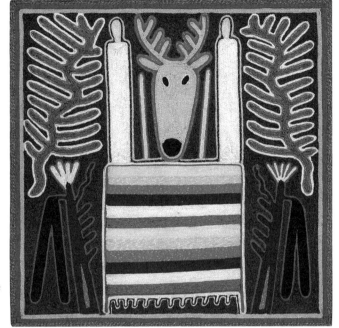

Fig. 3.3. José Isabel (Chavelo) González de la Cruz, yarn painting, 2002. 12" x 12" (30 x 30 cm). The twelve colored lines represent the staircase to be climbed (the annual pilgrimages to make) in order to reach the altar of the deer god and thereby complete one's journey to become a mara'akame. Photo credit: Adrienne Herron.

superintend governmental officials in the Huichol communities in the Sierra. The emphasis that the Huichol place on service to the family, the community, and the world is important. Becoming a mara'akame is not something a person should do for self alone.

An essential qualification for becoming a mara'akame is visionary ability: the ability to see into the world of the gods, to communicate directly with gods and spirits, and to influence them through prayer and ritual. According to what several Huichol have told me, shamans are able to:

» see colors and lights around people's bodies, which help the mara'akate divine those persons' spiritual development and the state of their health;

» see through people (and their clothes) as though they were transparent, like a bottle;

» see illness and its cause, inside a person (for example, seeing illness as a moth circling around in a person's stomach);

» see gods or spirits who may be attending ceremonies or taking part in human activities;

» soar into the sky and see the world as though it were very small, and then focus in on activities taking place elsewhere;

» see into the ocean as though the water were lit up by a searchlight, and communicate with the underwater people who live there;

» communicate with powers located in the cardinal directions and sacred sites, see colors emanating from those sites, and understand them.

When I speak of "shamanic vision," I mean these types of abilities.

Visionary ability is not limited to shamans. There seem to be variations in how much ability people have and in the forms that vision may take. Some people can see on a spiritual level as though with their eyes. Some can see only with the help of peyote, while others can see without it. Some can see all the time, and some only in certain circumstances, such as during a ceremony when the mara'akame helps by opening the door to the other world. Some can hear rather than see. Some perceive through other means, such as dreams or thought (thinking of an idea or image without actually seeing or hearing it).

Vision alone does not make a person a mara'akame, although it means that he or she has some talent that can be developed. I know of one man who was considered consistently visionary but who was not considered a shaman because he lacked the courage to act on what he saw. Benítez (1975, 84) also mentions an aspiring mara'akame who lacked the necessary boldness and self-confidence. Another aspiring shaman told me that he had developed the ability to see what was wrong with people, but the gods had not yet told him what to do about it. Therefore, he did not consider himself to be a mara'akame yet. Some people have certain visionary abilities and a limited ability to heal; however, even these people must complete themselves through a prescribed period of commitment before they are considered ready to be mara'akate. The ultimate test seems to be the consistent ability to control what is seen, to use the powers at will, and to show results when called on to heal or act.

A shaman who has success in curing develops a reputation, and people seek out him or her. Respected shamans are often called upon to sing at ceremonies. These marks of community respect and recognition are one way of distinguishing true shamans from aspiring ones. (Some Huichol claim to be shamans, and manage to persuade Western devotees of their abilities, but have little or no recognition within their own communities. To evaluate their claims, it is important to spend time within the community, watch what is happening, and talk to

a number of Huichols with differing opinions. All of this takes time as well as linguistic fluency.)

These qualifications are important to understand in relation to Huichol shamanism and the discussion that follows. They indicate that shamanic ability and visionary ability are neither simple nor absolute—all-or-nothing—qualities in Huichol culture. There are degrees and shades of ability, which vary by person and over time. As I discuss different yarn painters, it will be seen that these degrees of ability come into play in their art, in their explanations, and in their careers.

4

gifts for the gods

I was sitting with Domingo González, Lupe's brother-in-law, in his small house on the outskirts of Tepic. We were preparing offerings to leave at a sacred site along the Santiago River. Domingo was making a prayer arrow (Hui.: *ürü*) for his grandson. He cut a thin cane (Hui.: *haka*; Lat.: *Arundo donax*) and whittled a pointed tip of reddish-brown brazilwood (Lat.: *Haematoxylum brasiletto*). He mixed dark red and blue paints and drew zigzag lines down the sides of the cane. Then he cut a tiny pair of wrist guards (Hui.: *matsuwa*) and sandals from cardboard. He tied these to the cane with strings and added a tiny round netted deer snare (Hui.: *nierika*).

"He is making an arrow to pray that my son might become a shaman," María explained. "So that he can find his nierika."

Several years later, in the temple of San Andrés, I watched a woman decorate a carved wooden doll. She spread beeswax around the edge of the doll's skirt and decorated the doll's face, heart, and hem with beads. The doll was to be left in a field as an offering for abundant crops. The woman's husband cut layers of brightly colored crepe paper to make paper flowers, which were then tied to the horns of a bull calf. Meanwhile the mara'akame prepared ceremonial candles by dribbling pale yellow native beeswax down a cord until the wax was thick enough that the candles could stand on their own.

Scenes such as this are an integral part of Huichol religion. Before every ceremony or pilgrimage, a Huichol family gathers together to make their offerings. Some Westerners might call these offerings "art," but in Huichol culture, they have another purpose. Decorated objects are a visual prayer to the gods. As Lumholtz (1902, 2:200) explained, "The wishes of the supplicant are itemised in many ways, by coloring or carving or representation in or on textile fabrics, or else by attachment." The Huichol often decorate their offerings with designs and symbols representing the deity or specific prayers. Some designs are paint-

ed. Others are made using beads and yarn, either alone or together. These are glued to the object with beeswax.

Offerings such as these, which are deeply rooted in Uto-Aztecan culture, probably represent a Proto-Uto-Aztecan substrate of belief. For example, the sixteenth-century Dominican Diego Durán (1971, 269) recorded that Aztec women made offerings to Chalchiuhcueye, goddess of springs and waters, by throwing jars, little pots, dolls, and countless baubles made of beads into streams and springs. Far to the north, early-twentieth-century Paiute continued to leave offerings of beads at a sacred site known as "doctor" rock (Wheat 1967, 20). Prayer arrows called *pahos* are an integral part of Hopi relations with their deities (Malotki and Gary 2001, 77, 101).

Lumholtz (1900) illustrates many types of Huichol offerings. A prayer arrow has tiny objects attached, such as a scrap of fabric embroidered with a deer or a person with arms upraised, a miniature wristband and sandals cut out of cardboard, or a circular netted deer snare. Each represents a particular prayer to the gods. The embroidered fabric may symbolize a woman's desire to embroider well. A gourd-shell bowl (Hui.: *xukuri*, also pronounced as *rukuri*) may have tiny wax figures of people pressed into the side, their eyes and hearts sketched by a few dots of colored beads. These represent a prayer for health and good fortune for the family. Other offerings include flat wooden boards (Hui.: *itari*, also pro-

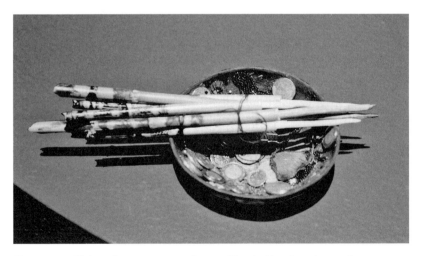

Fig. 4.1. An offering of prayer arrows and a gourd bowl with coins, given to the statue of Coatlicue in the National Museum of Anthropology in Mexico City. Photo credit: Hope MacLean.

nounced as *itali*) used as a base for bowls and statues, and statues of deities or animals, carved in wood or stone.

Yarn paintings are one kind of offering. Sacred yarn paintings were, and sometimes still are, made using a small piece of wood, roughly shaped in a circle or oval. They have fairly simple designs of a few symbols shaped in wax and outlined with yarn, beads, or both. The wax may be fully covered, but more often there are gaps between the yarn, and the wax shows through. Sometimes, both sides of the board are covered with symbols. The paintings are small, from a few inches or centimeters in diameter to about nine and a half inches (twenty-four centimeters).[1] In the past, yarn paintings were small and light since the Huichol had to carry them on long pilgrimages, walking all the way.

According to Huichol mythology, yarn paintings have the power of bringing into creation whatever is painted on them. Once painted, things "simply came to life, and the world knew them as real things, plants, animals, and the *santos*" (Zingg 1938, 629). A myth describes how the culture hero Kauyumali made a yarn painting to bring animals into the world after he got the wax to make candles:

> When *kauymáli* [sic] finished making the candles, he took the wax that remained and used it to make a painted board *itáli*. The people asked him to come and sing for them. But he bade they wait until he had finished his painting. So they decided to wait because they were curious to know what he was painting.
>
> *Kauyumáli* was painting prayers that he wished to be granted by the great gods. With beads and colored wool placed in the wax on the board, he painted a snake, a rattlesnake, a fish, a coyote, and a skunk . . . He also painted the opossum (*iáuSu*), lion, bear, deer, dog, horse, mule, burro, female burro, stud-jacks, male and female goats, male and female pigs. . . . He also created the royal eagle (double-headed Hapsburg symbol), hawk, parrot, parakeet . . . quail, 'tiger,' wolf, and a singing-shaman. All the animals, hens, turkeys, and everything else in all colors he painted. The colored rocks of the five points were represented in the painting. (629)

The images of many animals and colored rocks representing the five directions are often used in modern commercial yarn paintings.

The yarn itself has mythological significance. According to Schaefer (1989, 192), the Huichol associate yarn with the life force. Cotton, from which early yarns were made, is associated with life energy (Hui.: *kupuri*). When Takutsi Nakawe, the earth-creator goddess, spun the first thread, she spun her memory (Hui.: *iyari*, "heart-soul-memory") into it, thus creating the world and life in

the world. Thus, in a sense, the cotton yarn incorporates both kupuri and iyari, which are aspects of the soul.

Yarn paintings are related to other sacred objects. In particular, yarn paintings have their roots in the god disk (Hui.: *tepari*, also pronounced as *tepali*). God disks are round stone disks carved out of solidified volcanic ash (tuff). Designs are painted on the disk or incised into the stone. Often, the god disks have a hole in the center so that the eye of a god may look through the disk into the world of human beings. Sometimes a family will place a god disk on their altar in the small family temple, or god house, called a *xiriki*, one of several buildings in a rancho. Others embed a god disk in the wall of the xiriki over the door. A god disk is also buried in the floor of a community temple (*tuki*), and offerings for the gods are placed under the disk. A god disk may also be buried in a family's fields and used for offerings (Stacy B. Schaefer, personal communication).

Lumholtz (1900) illustrates a number of god disks that he collected in the 1890s. The designs painted on them represent various deities, their animals, and their powers. Some have simple designs, such as a central hole or circle surrounded by a spoked figure representing the sun, or two deer facing each other. Some have complex designs of plants, animals, and geometric figures. The disks showing many kinds of animals are reminiscent of the yarn painting in the myth cited above, which Tamatsi Kauyumari made in order to create the

Fig. 4.2. Two god houses (xiriki) with thatched roofs, next to a concrete-block house at a rancho in Santa Catarina. The god house at right has a round god disk embedded high above the door. Photo credit: Hope MacLean.

animals. Another design was an arrangement of figures representing the center and the cardinal directions. Yet another god disk represented astrological constellations. Many of the designs in god disks reappear in modern form in commercial yarn paintings.

Fig. 4.3. Stone disk (tepari) of Grandfather Fire, used as a stand for a statue of the god in a Huichol temple. The center is marked by a small round mirror called the "eye of the god" (sikuli). The four round figures with a design of beads surrounded by wool represent the four cardinal directions. The long strands of beads crossing the disk represent the intercardinals, as do the diamond-shaped figures of wool. Credit: Carl Lumholtz, *Symbolism of the Huichol Indians* (New York: American Museum of Natural History, 1900), 31.

The designs on god disks may be repeated in sacred yarn paintings. According to artist Chavelo González, when a person makes a yarn painting as an offering, the painting may be a copy of a god disk. The disk stays in the temple, but the yarn painting is taken to a sacred site and left there as a representation of the family's spirit. Thus, one way of conceptualizing a yarn painting is as a portable copy of a god disk.

In fact, the substrate, or base material, may be the main difference between a stone god disk and a wooden one. Lumholtz (1900, 24) pointed out that god disks were occasionally carved out of wood or molded from clay. Wooden god disks could be used in the same way as stone ones. In particular, substitution was frequent in god disks used as stands or bases for other objects. Lumholtz (1900, 26) collected a statue of the fire god standing on a stone god disk. Robert Zingg (1938, 628–632) found painted boards used as stands for votive bowls, noting that in mythology, Kauyumari made the first board as a stand for the votive bowls of Rapauwíeme (Rapawiyeme), one of the rain goddesses. Zingg named the stands *hawime itali*, or "sacred round boards." He also collected square boards, which were used in the same way in Tuxpan and which he called simply *itali*.

I believe that Zingg's use of the term "hawime itali" as a general term meaning "yarn painting" is a misunderstanding. None of my consultants recognized it as a term for yarn paintings. When I checked the meaning of "hawime," Eligio Carrillo translated it as "when the corn is dry (Sp.: *cuando el elote está seco*). I believe that the term probably means "the disk representing the time when the corn is dry," or the itali of hawime.

Some authors have used "itari" as the Huichol term for yarn paintings generally. This word links the yarn painting to another sacred concept, the bed or mat that draws the gods to lie on it so that they may read the prayers of the maker in the pictures depicted. Juan Negrín (1979, 25–26) defines itari as "a bed on which the ancestral gods come to rest and also a field that is prepared for . . . planting." Itari is also the name of a ceremonial mat that the mara'akate use as a kind of portable altar. When the mara'akate sing during a ceremony, they spread a mat on the ground in front of them, where they put their takwatsi (or shaman's basket), gourd bowls, and offerings of cash or food given by participants. Traditionally, the itari was a woven mat (Schaefer 2002, 306), but nowadays the itari may be simply a commercial *costal*, or grain sack, woven of plastic strips. Modern Huichol also use the word "itari" for an ordinary bedsheet (Sp.: *sábana*; Consejo Supremo Huichol 1990, 8).

While the term "itari" may be used for a yarn painting, I found that all the Huichol artists I interviewed used the term "nierika" instead. Knab (2004, 268) records a third term, *wewia*, for yarn painting, but I have never heard Huichol use this term.[2] Because of its wider aesthetic meaning, I have given preference to the term "nierika" (plural: *nierikate*), which has multiple meanings in Huichol, all of which shed light on the deeper significance of yarn painting.

Nierika: Face of God

The word "nierika" is derived from *niere*, "to see," and *ka*, "habitual" (Liffman 2002, 140). It suggests the ongoing ability to achieve vision. As I talked to the artists, it became clear that nierika is a tool for achieving shaman vision as well as a representation of visionary experience. Because "nierika" has these multiple meanings—both a representation of the world of the gods and a prayer for vision—a nierika can take many forms. Lumholtz (1900) collected many different objects, all of which the Huichol called "nierikate." Some look quite similar to yarn paintings, while others are linked only in theory. Even objects with another Huichol name, such as a tepari (Hui.: god disk) or a *tsikürü* (Hui.: god's eye), can be considered *nierikate*. This flexibility of naming may reflect the fluidity of Huichol thinking about sacred objects generally.

Lumholtz tried to organize his collection of nierikate by making a rough division into two categories. He called one group "front-shields," and all the others "special" nierikate. Even this division is unsatisfactory. As Zingg (1938, 616) pointed out, the term "front-shield" is inaccurate, since the nierikate that Lumholtz describes have little to do with a shield used for protection. Lumholtz tried to synthesize what he knew about nierikate in this description (1900, 108):

> The front-shield or neali'ka [*sic*] is primarily round, because first of all it symbolizes the buckler, which was round; but it has also come to symbolize the face (hence a mask is a neali'ka) or aspect of a god or person: in fact, it may be said to be the Indian expression for a picture, therefore rock carvings are called neali'ka. The round mirrors bought in Mexican stores are also called by the same name. My Huichol informants, who understood a little Spanish, sometimes even used to call these symbolic objects "mirrors," alluding to the pictures shown on them. The holes in the walls of a god-house,—one above the entrance, and a corresponding one at the rear,—which are always round in shape, are also called neali'ka. The round netted shields . . . are neali'ka, as are also the diminutive ceremonial deer-snares. We shall call these symbolic

objects "front-shields," substituting at times "face," "aspect," or "picture" as names expressive of the Indian thought in particular cases. The front-shields express prayers for rain, corn, or health.

The objects that Lumholtz called "front-shields" have some similarity to yarn painting. Front-shields are round objects made of bamboo sticks wrapped with white cotton or colored yarn to form a pattern. Like god disks, some illustrate animals, people, stars, or clouds. Some have a circle or geometric design at the center, surrounded by bands of color. Some are entirely filled in with yarn, while others have holes or gaps in the yarn. Some have feathers attached to the center of the shield or puffs of cotton around the edge. Also like god disks, the designs of front-shields often reappear in modern yarn paintings.

"Special front-shields" were made in various shapes and out of various materials (Lumholtz 1900, 131–137). They include arrangements of sticks, twine, and arrows to represent the waxing or waning moon; circular stone disks and wooden rectangles with designs in beads, wool, and paint; a lump of glass with a circular frame of beeswax and red beads; and even a pear-shaped heart molded from amaranth (Hui.: *wave*) dough. The Huichol considered all these to be faces or images of gods.

A third type of nierika is ceremonial face painting. The Huichol paint elaborate designs on their faces during ceremonies such as the peyote pilgrimage. The paint is made from a yellow root called *uxa*, which grows in Wirikuta. Through the painting, a person's face literally becomes a representation of the face and symbols associated with the god. Lumholtz (1900, 197,199,201) illustrated a number of these designs.

Lumholtz seems to have struggled to understand the concept of nierika, perhaps because he was trying to find a unifying principle in the objects themselves—in their shapes or external forms—rather than beginning with the idea itself. I suggest that it is the *concept* that links all the related objects. Lumholtz did manage to tease out some of the basic ideas encompassed by nierika, including the relationship of a face to a mirror, to a picture, to a rock carving, and to various symbolic objects. All these are significant, as I will show below.

Like Lumholtz, Zingg struggled to understand the relationships among nierikate. He lamented the difficulty involved:

The symbolism of the *nealika* [sic] is even more puzzling than the term. The Huichol conception of this is so obscure that Lumholtz got only a glimmering of

it. I feel that my data adds a little more. That it is the "face" and not the "front-shield" of the god seems certain. The mythology specifically attributes to the "face" the power of "sight." (1938, 616–617)

Zingg's sections on nierikate and sacred yarn paintings repeat Lumholtz's information, since he was trying to replicate Lumholtz's work. The information

Fig. 4.4. Front-shield of Father Sun. Symbols include *a*, the sun; *b* and *c*, water serpents; *d*, a moving serpent; *e* and *f*, two children; *g*, a mountain lion; *h*, a tiger; *i*, a wolf; *j*, a tiger; *k*, shaman's plumes; *l*, butterflies; *m*, insects. Credit: Carl Lumholtz, *Symbolism of the Huichol Indians* (New York: American Museum of Natural History, 1900), 119.

Fig. 4.5. Face painting of Elder Brother Deer, showing deer snares. Credit: Carl Lumholtz, *Symbolism of the Huichol Indians* (New York: American Museum of Natural History, 1900), 197.

he added to Lumholtz seems fragmentary, since Zingg did not understand the visionary implications either.

I believe that to understand the deeper meaning of nierika—and thus of what the yarn paintings represent—we must talk about Huichol beliefs regarding shamanic vision. This means exploring the abilities of the shamans, including abilities that might be labelled "psychic" in Western society. In Chapter 1, I addressed the need to understand that whether or not Western readers agree that these abilities exist, the Huichol are operating on the assumption that they do. Beliefs about shamanic vision underpin the symbols and objects that Lumholtz and Zingg tried to interpret and are essential for understanding what they mean.

Nierika and Shamanic Vision

Eligio Carrillo gave me some of the most forthright and articulate explanations of the nierika. Because his answers were so extensive and formed a connected whole, I have quoted him at length. I draw also on my conversations with other Huichol consultants about nierika and shamanic vision.

Early in his career, Eligio described the idea of nierika to an American friend, a yoga practitioner named Prem Das (1978, 132), also known as Paul C. Adams. Eligio said, "I want to see into the visionary world . . . to make good yarn paint-

ings of the gods, spirits, and powers who teach the mara'akate . . . Only by truly seeing them and their hidden world can I attempt to portray them in my paintings."

Prem Das later compared the nierika to the idea of a doorway in the mind that humans enter after death (1979, 1): "There is a doorway within our minds that usually remains hidden and secret until the time of death. The Huichol word for it is *nierika*. *Nierika* is a cosmic portway or interface between so-called ordinary and non-ordinary reality. It is a passageway and at the same time a barrier between worlds." In this passage, Prem Das is using popular Western notions about near-death experiences and the image of a door in the mind that opens at death. It is a Western point of view, not a Huichol one; however, it does give Westerners a framework for understanding the Huichol concept, and to that extent it is useful.

The idea of a door in the mind, or shamanic "portal," has been picked up by some anthropologists, psychologists, and New Age writers. George MacDonald, John Cove, Charles Laughlin, and John McManus wrote about shamans using mirrors as portals into the visionary world, and defined "portalling" as "the cross-culturally common mystical experience . . . of moving from one reality to another via a tunnel, door, aperture, hole, or the like. The experience may be evoked in shamanistic and meditative practice by concentration upon a portalling device (mirror, mandala, labyrinth, skrying bowl, pool of water, etc.)" (1989, 39). Charles D. Laughlin (personal communication) describes some sacred art as portals, such as Tibetan mandalas, which are believed to induce visionary or spiritual experiences when people meditate on them.

Nevertheless, when I tried to translate the idea of a door in the mind back into Spanish to Eligio, he did not understand Prem Das's metaphor.

> HOPE: And does "nierika" mean a door also?
> ELIGIO: "Nierika" means a face. That's what it is. It is as though a nierika is coming from the gods; it is what you look for there. It is a face. You look for it there, then you carry it here in the mind.
> HOPE: It is the face of the gods?
> ELIGIO: Yes, which remains here with the person.

Here he refers to one aspect of nierika, which is the face of the gods that a person sees when looking into a shaman's mirror. Once the person has seen the face of the gods, he or she carries that face in the mind.

Eligio also translated the word "nierika" as mirror: "'Nierika,' this means the

mirror. It is used to cure or, accordingly, to see what there is [in the world of the gods]. That is the meaning of 'nierika.' It is the mirror of the Deer God." Eligio refers here to the mirror as one of the tools that Huichol mara'akate use to see into the world of the gods. These are often just inexpensive round mirrors about two to three inches (six centimeters) in diameter that are sold in Mexican markets. A mara'akame may look into a mirror during a curing ceremony in order to diagnose illness or to communicate with spirits.

The Huichol use of mirrors is similar to a Western psychic's use of a crystal ball or to some forms of divination that use water as a reflective surface (scrying). Eligio refers to this function here. A mirror is a tool with which to see into or reflect the world of the gods. The use of a mirror for divination has deep roots in Mesoamerican thought. For example, Durán described an Aztec idol of Tezcatlipoca that carried "a round plate of gold, shining and brilliant, polished like a mirror. This [mirror] indicated Tezcatlipoca could see all that took place in the world with that reflection . . . It was called Itlachiayaque, which means Place from which He Watches" (1971, 99). In Durán's time (the mid-1500s), the Aztec still resorted to fortune-tellers "who divined fates by looking into tubs of water."

A Huichol who wants to achieve the ability to see into the world of the gods makes a nierika as a prayer. Then he or she offers the nierika to the gods, praying that the power will be granted. According to Eligio: "Well, then we look for it [the power of vision], carrying it [a *nierika*] to these places. For five years, you have to be travelling to these places carrying this [offering]." Yarn paintings are one of the nierikate offered to the gods at sacred sites. Thus, a sacred yarn painting can be a prayer for the power of shamanic vision.

"Nierika" also means the vision itself, or that which is seen by using shamanic visionary power. The Huichol artist Alejandro López de la Torre crystallized all these meanings in one elegant metaphor. He told me that when we look into the world of the gods, it is as though we are looking through a telescope. The gods appear very tiny or far away. The same thing happens when shamans look into their mirrors. The gods are visible as small round images, just like images seen through the wrong end of a telescope. When an artist makes a yarn painting, he or she may try to paint the image of the gods as it was seen in a shamanic vision. Some artists even make their paintings round in order to emphasize their similarity to a round mirror. Thus, a yarn-painted nierika is a physical representation of what the shaman sees in the mirror nierika.

For this reason, nierikate often emphasize circular imagery, with objects

Fig. 4.6. Prayer arrow with a notched tip and a netted deer snare, representing the nierika. Credit: Carl Lumholtz, *Symbolism of the Huichol Indians* (New York: American Museum of Natural History, 1900), 94.

arranged around a central figure or around a hole at the center. Some yarn paintings even have a small mirror embedded in the center of the painting.

The idea of the nierika as a circular, mandala-like image may draw on visionary experience. Eger (1978, 39–41; see also Eger Valadez 1986a) documents the experience of a young Huichol aspiring to become a shaman. He saw spiral-shaped images while eating peyote. He identified the designs as nierikate belonging to various gods and said they were shown to him by the Deer God. Later he made pen-and-ink drawings of the designs. The designs he drew are circular images with a central figure surrounded by concentric circles of designs.

The tiny round netted deer snare is a particularly meaningful expression of nierika. The Huichol originally made large rectangular deer snares to hunt deer (illustrated in Lumholtz 1902, 41, 203). The miniature deer snare is attached to a prayer arrow as a prayer for shamanic ability. One way of thinking about it is as a snare to trap the Deer God, Tamatsi Kauyumari, who may confer the ability to dream and envision.

The tiny snare is remarkably similar to a "dream-catcher," a popular craft item made by Native people in Canada. I wonder whether the modern dream-catcher comes from an older concept, perhaps once widespread throughout North America's Native people and still practiced by the Huichol. Klein (1982, 21–25) writes of the "plaited door," a netted hoop, disk, or shield that represented a "means of passage through the cosmos." The netted hoop is seen in Aztec and Mayan art and is said to represent the face of the sun. To the Yucatec Maya, it represented the ability to traverse the cosmos. The Arapaho said a netted hoop represented the entire cosmos as well as the sun and believed that it conferred the ability to fly. Hopi myths contain references to a flying textile, basket, or shield that transported people to the world of the gods and animal spirits (Malotki and Gary 2001, xi, 65–69, 70ff, 79, 228–231). Perhaps these references to travelling the cosmos or flying are figurative references to the shaman's ability to travel to another plane, and the netted hoop may be a representation of the concept.

Uxa: Face-painting, Colored
Lights, and Pollen

The ceremonial face paintings called nierikate have a deeper visionary meaning as well. According to Eligio and some of my other Huichol consultants, shamans can see designs of colored lights on people's faces and around their bodies. Some have said to me that it looks as though the person's face is painted

with colored lights. The colors give the shamans information about people's character and state of spiritual development. Different colors may represent different characters or varying levels of spiritual growth. (One consultant told me that dogs can also see these face paintings and that that is why dogs are good judges of human character.)

There is some confirmation in myth of this mystical interpretation. Zingg (1938, 617) recorded an example of this belief, although he did not understand it as an actual ability of shamans: "[The] 'face' of the god functions as a true face in indicating the sacred condition of the god. For instance, when the great gods of the sea were baptizing the bad shaman, Jimson-weed-man, to wash out some of his villany [sic], the color of his nealíka changed to correspond to the change in his heart." In this myth, the colors in Jimson-weed-man's nierika changed according to his state of spiritual development.

People may have these visionary colors and face paintings from birth or as a result of their personal life path. Some people appear very beautiful to a shaman; their beauty is not because of their physical features, but rather because of a beautiful light that only the shaman can see. This beauty may be a quality the person is born with. However, people can also seek spiritual development, at which time their face painting changes. In particular, when pilgrims go to Wirikuta, the gods give them face paintings that the shamans can see. Pilgrims retain the colored lights after the pilgrimage. Hence, acquiring visionary colored lights is part of the process of becoming a shaman. Some consultants have told me that people can lose their lights if they go off the shaman's path, especially if they violate a vow of sexual fidelity or celibacy. They can regain the lights only when they restart the pilgrimages.

As mentioned above, during the peyote pilgrimage, the pilgrims use uxa, a plant with a yellow root, to paint designs on their faces. The plant grows in the desert and was first identified as Mahonia trifoliolata (Moric.) Fedde var. glauca I. M. Johnson, or Berberis trifoliata Hartw., ex. Lindl (Bauml et al. 1990, 101), and more recently as Berberis trifoliolata (Moric.) var. glauca I. M. Johnson (Bauml 1994, 194). The pilgrims cut a piece of the root, and then rub it on a stone with a bit of water to make a thick yellow paint. Then they use a stick and a small round mirror to draw designs on their faces. These are the face-painting designs that Lumholtz called nierika. Lumholtz (1900, 196) translated "uxa" as "spark," and suggested that the name symbolically linked the peyote pilgrimage to the fire god. However, a spark is a flash of light, and I wonder whether Lumholtz's consultants were really telling him that "uxa" meant light.

I would suggest that these designs painted with uxa root are far more than just decoration. They may in fact be representations of visionary face paintings. They may also be prayers asking the gods to bestow visionary face paintings or colored lights on the pilgrims. The ceremonial face paintings are much more than just symbolic designs; they may be an indication of what shamans see in shamanic visions.

According to Eligio Carrillo, the visionary face paintings are called *Tatei teima wa urrari*. His term might be translated as "Sacred colors of our Mother-goddesses." "Tatei teima" means "our Mothers," the Mother goddesses who live in Wirikuta and in other places. Eligio elaborates that "Tatei teima wa urrari" is "the nierika, the painting of the gods"; in Spanish, he called the designs "*la pintura de los dioses*" (Sp.: the paint of the gods). Eligio uses the word "*urra*" (plural: *urrari*) instead of "uxa" because he speaks the San Andrés dialect of Huichol, which uses *r* in place of *x*.

> ELIGIO: That is the paint of the gods. That is how the gods are. For that reason, the people who travel on the pilgrimage paint themselves like the gods are. And they paint themselves here that way, to pay a visit the same as those others [*pointing to his face and cheeks*]. [The pilgrims paint themselves] in order to be received with pleasure. [To show the gods] that you are with them [and that] you want to learn something. With them. And then, you should paint so that they will also receive you with pleasure. It is as though [the gods are] my friend. Friends. You should be. That's how that is.

Eligio also explains that the real uxa (Sp.: *la mera uxa*) is not just the yellow root used for face paint. The real uxa is the pollen or flower of the peyote. More than that, uxa is the spiritual power that peyote pollen carries. During the pilgrimage ceremonies, the shaman touches the flower of the peyote to the cheeks, heart, wrists, and legs of each pilgrim. If the peyote is not in flower, they use the flesh of the peyote. I have also seen Huichol touch peyote to themselves when gathering or eating peyote. This touch transfers the uxa, or colored lights, and the spiritual energy from the peyote to the person. Thus, the shaman is painting with light on the person, using the peyote flower almost as a kind of paintbrush.

Again, a myth recorded by Zingg confirms Eligio's explanation. When the first divine peyote pilgrims went to Wirikuta, they travelled to the upper world and hunted a deer, which transformed into a huge peyote plant with five different colors.

Slowly, in a long line they began to encircle the deer. . . . Then each helped to enclose the circle . . . In the middle a spray of foam sprang up. This was the deer, which was an enormous peyote. One side was green, one white, one red, another black, and another yellow. By means of these colors from peyote each of the hunters painted his face. These colors are the life. . . . The color put on their faces went to their hearts and made them curers. (2004:32)

Thus, in the myth, the uxa, or colors, are powerful in themselves. They have the power to transform the pilgrims into healers and shamans. Mata Torres's (1980, 84) consultants told him that uxa appeared in much the same colors as the peyote described in the myth: blue (comparable to green), white, red, black, and yellow.

A person's uxa may also be an omen or predictor of the person's fate. The Huichol artist José Benítez had a dream that he had only four years to live. He depicted the fateful omen in a yarn painting in which "the face of his shadow self is spotted with yellow *uxa* root design. Some of the spots on the right side of his face are slightly smeared, but most of them are intact" (Negrín 1975, 32). In a footnote, Negrín added: "When the soul is hungry, one's *uxa* fades" (35). A Huichol consultant told Liffman (2002, 151) that uxa designs on faces are like records kept in writing on paper, because a person's "knowledge and the *uxa* designs that embody it are 'written around one's eyes.'"

Eligio's explanation adds a great deal to the current ethnography of the term "uxa." Several authors (Bauml et al. 1990, 99; Lumholtz 1900, 196; Mata Torres 1980, 80, 84; Myerhoff 1974, 147) have written about uxa as the plant with a yellow root or about its use as face paint in ceremonies. Eligio adds much more to our understanding of uxa's deeper shamanic and visionary meaning.

Eligio also added information on varieties of the uxa plant. He made me a yarn painting of a sacred site on the route to Wirikuta, a place where uxa grows; he called the site Urra Moyehe. He said there were two forms of uxa. One is male and yellow and grows at a particular sacred site that has rocks surrounding it (shown as jagged lines in the painting). The other uxa is female and whitish (Sp: *medio-blanco*); it grows elsewhere at a sacred spring. Eligio's statement is confirmed by one of Bauml's (1994, 194) consultants from San Andrés, who mentioned two forms of uxa—a white form, which grew in a nearby canyon, and a yellow form, which grew in Wirikuta. Bauml's consultant did not link the two forms of uxa to gender, but some of Bauml's consultants did distinguish between male and female forms of other plants.

Another of my Huichol consultants added more information on uxa. He pointed out to me that the yellow pollen falling from a white pine tree in Can-

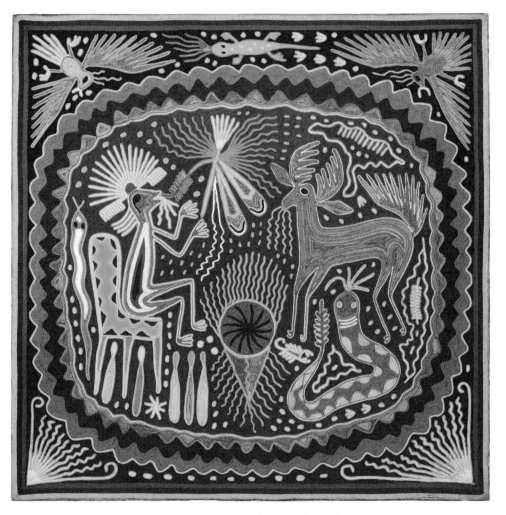

Fig. 4.7. Eligio Carrillo Vicente, yarn painting of the sacred site where uxa grows, 2007. 24" x 24" (60 x 60 cm). Uxa is the yellow root used for face paintings. The shaman prays for the power it bestows on his shaman's basket (takwatsi). Photo credit: Adrienne Herron.

ada was a type of uxa. He also showed me a tiny red insect in the earth and said that it also had uxa.

Thus, even in Huichol thought, uxa is not just the yellow root, as anthropologists have supposed, but is a more general term referring to plant pollen, colors, and the sacred properties inherent in these elements.

I would go further and engage in some creative speculation about the ritual

use of pollen. Is it possible that the visionary meanings of uxa might also attach to the use of pollen by other indigenous groups? The Hopi, for example, use corn pollen as a blessing in ceremonies. Corn has sacred powers among the Huichol, including the ability to transform into deer and peyote.

There is an even more suggestive reference to pollen among the Navajo. The Navajo are Athapaskans, but are heavily influenced by Puebloan cultures and, in particular, by the Hopi, who are Uto-Aztecans. It is possible that the Huichol and the Hopi share similar ideas on the meaning and use of pollen. The visionary meaning of uxa and pollen may have been transmitted to the Navajo, where it emerged as "the Pollen Path."

The psychiatrist Donald Sandner (1979, 222–225) discussed the Pollen Path with Natani Tso, a *hataali*, or medicine man. Tso said that the Pollen Path was not a symbol, but rather a living reality that any person could access. It led to "beauty and harmony" (a simplified translation of *Sa'ah naagháí bik'eh hozhóón*). Tso explained: "The Pollen path is the pollen from all kinds of beautiful plants. The wind blows the pollen along the trail and you travel on it." The Navajo sprinkle pollen as a blessing during ceremonies. They use pollen from corn or cattail rushes, or blue "pollen" made from the ground petals of larkspur. Yellow pollen floats on the surface of water and is called water pollen. (In eastern Canada, where I live, the yellow pollen from white pine trees is often found floating on water in early summer. Perhaps this is what the Navajo refer to as water pollen.) Pollen dusted on an animal absorbs its particular life quality. Pollen used to smother an animal for ceremonial purposes absorbs the animal's life force.

Tso did his own hand trembling, a form of divination, using corn pollen (Sandner 1979, 31–32). He put corn pollen down his arms as an offering to Gila Monster, then prayed and sang. He began to feel a series of shocks running through his fingers, his hand began trembling, and he was able to guess the right answer. Then the hand stopped shaking.

Sandner cites Reichard, who found that associations with pollen are extended to "include *glint* or *sheen* as an essential part of an animal, object or person, a quality represented by pollen" (1950, 250–51; emphasis added). The glint can be seen as a haze or sheen around all natural forms. Sandner seems to be referring again to a light like an aura around objects. Reichard (1944, 29ff) derived the Navajo term for pollen, *tádídín*, from the word for light, and said it means "it emits light, here and there, everywhere."

A similar concept of "glint" or "sheen" may be shared by the Huichol. Peter Furst (2003, 36–37) recorded a myth told by Ramón Medina about the birth of

the sun. An orphan boy offered himself for sacrifice, saying, "I am painted, *my face is shining*, it is painted with the yellow face paint of the peyote country" (emphasis added). When the boy rises as the sun, the animal people bet on

> which color he would emerge . . . They did not know what his color would be. How he would look. What his face painting would be.
>
> When a ray emerged, one would say, "Ah here he comes, yellow." Then another ray would break through and that one would say, "Ah, here comes a blue one, he will come out blue." Thus all were betting there.

Could it be that the reference to a shining face and colored lights are not simply fanciful images in myth, but derive from shamanic experience?

The Huichol idea that shamans have a special light is shared with other cultures. For example, the Inuit believe that shamans acquire a light within the body, which the spirits are attracted to: "Compared with the shining shamans ordinary people are like houses with extinguished lamps: they are dark inside and do not attract the attention of the spirits" (Knut Rasmussen, cited in Blodgett 1978, 38, 48).

Eligio's description of nierikate as colored lights is remarkably similar to descriptions of colored auras around people's bodies. There are many accounts of colored auras in popular literature (see, for example, Brennan 1987; Andrews 1991). The colored light is also reminiscent of the Hindu concept of chakras, which are energy centers of the body, each with its own color. Yogis say that these chakras can be seen as rapidly whirling colored lights (Leadbeater 1927, 4–5). Is it possible that Huichol shamans, Western psychics, Navajo singers, and East Indian yogis are all describing the same phenomenon—energy fields around people's bodies that some people are capable of seeing? Perhaps different cultures describe and interpret these lights in their own ways.

Eligio's description and the Huichol concept of nierikate add something new: the idea of colored lights that appear on the face as designs or paintings. I have not encountered the idea of auras as *designs* in Western or East Indian literature, but perhaps other researchers with more esoteric knowledge or personal experience of working with mystics may have heard of this concept.

Evidently, nierika is a complex and multifaceted concept in Huichol thought. Nierika includes the following concepts:

» face
» painting on a face made with a yellow root (uxa)

» colored light or painting on a face bestowed by gods and visible mainly to shamans (also described as a specific form of uxa called Tatei Teima wa urrari)
» an eye
» an object with a hole or an eye depicted at its center
» the eye of a god looking at humans
» a mirror
» an object with a mirror at its center
» a mirror as a tool for seeing into the world of the gods
» a mirror as a tool for divination and healing
» a picture, a visual representation
» a picture of the gods or symbols associated with gods
» a vision (and the content of a vision)
» the power of shamanic vision or seeing
» spiral-shaped images seen while eating peyote
» a circular netted deer snare
» a rock carving, petroglyph, or design made in rock[3]
» a yarn painting

Clearly, a nierika is linked to the idea of faces and eyes, and the depiction of these features. The mirror reflects the face and eye and is, in a way, a depiction of the face, so it too is a nierika. The hole in an object is a means of seeing through it, and the eye of the seer looks through it. The ability to see can be two-way, since the eye of a god can look at humans, but a human's eye can also look at a god.

Neither Lumholtz nor Zingg seem to have grasped the visionary meanings of nierika. Both saw a nierika mainly as a symbolic object representing either the world of the gods or a prayer for shaman's vision.

Nierika is a basic aesthetic concept in Huichol art. In a sense, most Huichol art is a nierika, since most art depicts the world of the gods in one way or another. A yarn painting is simply a particular form of nierika. However, nierika is not just a synonym for the Western word "art." Nierika extends beyond the art object itself to encompass the capacity of the artist to see. It includes both the visionary capacity and the content of the vision itself.

5

sacred yarn paintings

When I did my PhD fieldwork, I was reluctant to focus on the sacred paintings because I was concerned about whether the Huichol would be willing to make this information public. There can be ethical concerns about publishing ceremonial and sacred information belonging to indigenous peoples. Therefore, I did my research on the commercial paintings, which the Huichol are comfortable showing and explaining. I did not ask to photograph or even to look at sacred yarn paintings. I asked my consultants only a few general questions about the use of sacred paintings.

Since then, I have done in-depth research with Eligio Carrillo, and he has assured me that he is telling me information so that it can be recorded and published. He gave me a comprehensive statement on the origins, designs, and uses of the sacred paintings from the point of view of one artist. He discussed much information that has not been published elsewhere, particularly the effect of sacred yarn paintings on the mind and body of the painter, and the paintings' possible relationship to rock carvings or petroglyphs.

This chapter records that interview. I have added information from other interviews with Eligio and supplemented it with information from the literature. Traditional yarn paintings are still made as offerings to the gods. I use the term "sacred yarn paintings" to distinguish them from commercial paintings.

Purposes of Sacred Paintings

I began by asking Eligio what the sacred yarn paintings are used for. He replied that the yarn paintings are taken to particular sacred sites, such as caves, depending on the vows petitioners have made and what they have asked for. In his case, he asked for the ability to make yarn paintings. The result was that over the course of five years, he developed the ability to dream and see images.

ELIGIO: Those yarn paintings that they make are original [traditional], which are taken to the sacred caves. They take them; that is to say, it is according to the promise that a person makes, the bargain that one is asking for. . . . For example, I did not know how to paint before. I didn't know anything. And then I asked at the sacred cave, that is to say, at Wirikuta. There I asked the place to focus me so that I would know how to paint everything well, to know how to lay on the colors, everything. And that's what I asked for.

And then, between that time and five years later, I began to dream. I saw a lot of designs, colors, things like that. Designs in the rocks that they [the gods or spirits] showed me . . . everything. And that's how I began to dream, but I was seeing [envisioning]. And then, for that reason, when someone makes a request, takes away designs, paintings, [it is] because you have asked for it at that place.

A person who asks the gods for help must pay the gods for their gifts. The offering is made as a kind of payment in advance. Eligio refers here to a belief that if the gods are not paid, they may make the person ill or strike his family or his animals with sickness or misfortune. In effect, a relationship with the gods is a form of contract.

ELIGIO: You have to take [an offering] to it [the sacred place], because they [gods] are also charging us. The gods charge a person. If you are just selling [your artwork] and eating [buying food with the money you get, then the deity says,] "Well, I want something too." And for that reason, we take [the yarn painting] to those places. And it's very expensive too [that is, costly to make the pilgrimages and offerings]. For that reason, it almost doesn't seem appropriate to sell that painting, but nonetheless we sell them. We are selling them. But you have to complete, just by going every year. I always do it like that. Every year, and then I take money because they [the gods] are charging us also. And furthermore, they can punish me.

I questioned his use of money, but he reiterated that he paid the gods with both a yarn painting and money. This may be because he sells his commercial work and gets money for it; therefore, he gives the gods their share. Nonetheless, even on other family offerings I have seen, the Huichol often include a coin as a way to ask for good financial fortune.

HOPE: You take money to the sacred sites?
ELIGIO: Yes, I take that.
HOPE: To pay for a part of that?

ELIGIO: Yes, I take it. There it stays. That way, they don't punish us. And it is the same thing, it's also bad, if you don't pay, if you don't leave anything. And you have to make a nierika, that kind, and take it there also. To that place. That is everything a person does.

A yarn painting is an appropriate offering to any god. There is no restriction on which particular god to give a painting to.

HOPE: Can you offer these to any god? Or are there certain gods that want yarn paintings?
ELIGIO: All the gods.
HOPE: All?
ELIGIO: All, all.
HOPE: At whatever place?
ELIGIO: At any place. That one, to take a design, off you go with it, it's a gift.

I asked Eligio whether he was required to use specific designs for an offering or whether he could make up the designs. He replied that the gods showed him what designs to make. In this he may be exceptional, since he already has the power to dream and envision. A person just starting out may be confined to more conventional sources of imagery, such as repeating commonly used designs.

HOPE: And do you make up the yarn painting [design], or are there traditional designs that a person should put into the yarn painting?
ELIGIO: Well there are designs, and . . . how can I tell you? Well, they [the gods] tell them to me. And I see them [the designs]. What I am making. And that is why I say, before [in the past] I was asleep [mentally], I did not know anything. I couldn't paint, I didn't know how to. I wasn't focused, to paint or do anything else. But now, no. And when I am about to make a painting, it is as though that one comes to me like this. [makes a "shhh" noise and gestures from behind his head] And [it is] all ready to paint. And sometimes I dream. When I am sleeping, they are teaching me everything. The images come on their own.

Eligio has told me that designs and colors come to him directly in a visionary communication from sacred sites. He describes colors as a language the gods use to talk with. The colors come to him in a type of synesthetic communication that can be understood by shamans. He makes a gesture with his hands from behind his head to the board in front of him, and a noise that is almost like wind. He seems to say that the images and colors come like a wind and seat themselves in his painting.

He went on to say that a person is not restricted to a single design. A person may make a painting that expresses his or her own thoughts, according to what is in their heart and soul (iyari).

> HOPE: When it is a nierika to take to a sacred site, do you always have to make the same design, or different ones?
> ELIGIO: No, different ones.
> HOPE: Whatever you want?
> ELIGIO: Whatever a person likes. According to your heart, that is the one that is guiding you. That one is guiding everything. Whatever idea you have, [if you think,] "Oh, I want to make that one!" [then] make it.

Eligio is typically flexible and open about how to proceed in sacred matters. He does not usually say there is only one right way that a person must follow exactly. With the same flexibility, he asserted that a person was not required to go to just one sacred site. There are many sites, all of which have power.

> HOPE: Are there special places where you take yarn paintings? Or any place?
> ELIGIO: Any place. Any place. As long as it's a sacred place.

The painting can be taken to any sacred site, such as one of the sacred caves in the Sierra. The real temples are the sacred caves, and that is where the painting should be left. The artist should bless or empower the painting with sacred water taken from a sacred site. The painting cannot be kept permanently; it must be offered. Otherwise, it will lose its power. Moreover, a painting should be handled correctly. It is not kept in the artist's house. It may be stored temporarily in a xiriki, or god house, which is an appropriate place to keep nierikate (or any sacred object.)

> HOPE: And do you put it in a xiriki or a *calihuey* also?
> ELIGIO: Well, to be exact, over there—in the Sierra, that's where the *calihueys* are [that is, the caves and sacred sites of the Sierra are the real temples or *calihuey*]. I take it over there and leave it. All you have to do is take some sacred water, bless it, and take it. . . .
> HOPE: And you don't keep it in your god house [xiriki] here? Or your temple [tuki] here?
> ELIGIO: Yes, I have it here.
> HOPE: Oh, also. Or do you have another one here?
> ELIGIO: They are all kept safe, those things, the nierikate, all of them, the arrows and everything. Then, after a year, I take them to the sacred site. Or before a year is up, whenever I can go, I take them. That's where I leave them.

HOPE: You don't have to keep it forever here in your tuki?

ELIGIO: No, that [the power] withdraws itself. No, you have to take it to those places.

I asked what powers the sacred paintings have. He used a commercial painting of a deer to illustrate the relationship between image and sacred power. The painting shows a grey and blue deer surrounded by red with blue dots, then a blue and green circle with golden rays radiating from the circle, and small peyote buttons in the cardinal directions.

HOPE: What power does a sacred yarn painting have?

ELIGIO: Well, it depends on the painting that you might make. For example, this one contains the power of Kauyumari [the deer god]. It is as though he is a

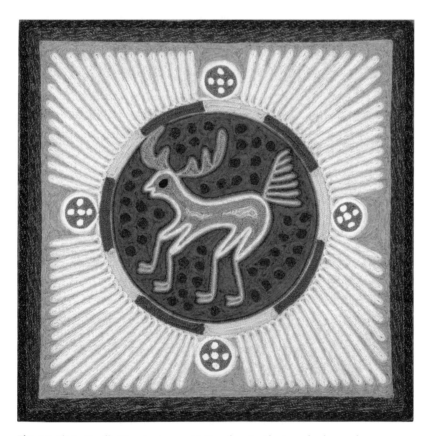

Fig. 5.1. Eligio Carrillo Vicente, a yarn painting showing the sacred colors and powers carried by Tamatsi Kauyumari, 2000. 12" x 12" (30 x 30 cm). Photo credit: Adrienne Herron.

peyote. But at the same time, he turns into this [a deer]. And he transforms into
a nierika. He transforms into nothingness and into pure light. That is the power
it [the yarn painting] contains . . . It is [Kauyumari] who makes all those images,
who creates that image, that peyote.

Eligio refers here to the Huichol idea that the spirit of the deer can transform
into corn and peyote. He adds the information that the deer god can transform
into pure light or nothingness. Even though this painting was made for sale, he
asserted that it had all the powers of a sacred painting because the powers are
carried in the image itself. This is because the design is one also used in sacred
paintings, and it is complete. The colors are also significant: the deer god *wants*
these colors to be used.

> ELIGIO: The peyote . . . and the colors that he wants, all the colors come out.
> HOPE: Then this yarn painting carries the power of peyote and of the deer.
> ELIGIO: Exactly. Sacred. It is a nierika, this one. Because it is complete [that is, it
> has all the sacred elements]. Because [Kauyumari] is the one who guides every-
> thing. He appears and [then disappears]. He turns into pure designs.

A yarn painting has the power of the deity or sacred place depicted in it. It
is the power of the kakauyari, the divine ancestors. I checked whether it was
the personal power of the human artist, but Eligio insisted that once the artist
painted the painting, the power of the god entered it.

> HOPE: Then the nierika contains . . . the power of the god it depicts?
> ELIGIO: That's it. . . .
> HOPE: It doesn't contain the force of the person who is the artist?
> ELIGIO: No, it is the power of the kakauyari, those ones. The person just makes
> the design itself.
> HOPE: And those ones [gods] put the power in? When someone makes the de-
> sign, . . . it is like a spirit that it contains? It seats itself in the nierika?
> ELIGIO: That's it.
> HOPE: Have you seen it happen? When the power comes?
> ELIGIO: Yes, when . . . all of a sudden, it comes this way. And then I begin to paint
> it. And I carry them here. The designs are all ready. That is what it is, that is what
> it contains.

How Sacred Paintings Are Made

I continued on with questions about how the paintings are made. Eligio said
that in the past, the sacred yarn paintings did not have many colors. He remem-
bered making paintings with just the natural colors of sheep's wool—white,

black, and brown. It was also possible to use a native white cotton. He did not know what the Huichol used before sheep. (Since sheep arrived with the Spanish 500 years ago, it is possible that the Huichol have been using wool for almost that long.)

Eligio's references to two, or three, or four reflect a Huichol figure of speech translated into Spanish. It is quite common for Huichol to say the preceding numbers when referring to a number. For example, they might say, "There are one, two, three ways to do something. Four ways of doing it."

> HOPE: And in the time long ago, they didn't have so many colors, right? Yarn of many colors. How did they make [the paintings]?
> ELIGIO: How did they make them? They made them with only about three or four colors, and that was it. [Or] with two colors, no more. They always had in those times white and black, and a medium brown, like this. Just three colors. And with those, they were making them, nothing more. With white and black and mid-brown. No more than three colors.
> HOPE: And many years ago, they didn't have yarn, right? Or sheep's wool?
> ELIGIO: Yes, they just made them with sheep's wool.
> HOPE: Of wool?
> ELIGIO: White and black. There are some sheep that are medium brown, nothing more. With that yarn they made designs. But out of pure wool.
> HOPE: And did they use other things? Like cotton or other?
> ELIGIO: Well, with cotton also. Because it is white also, to make that.

I probed to see whether the Huichol ever used other materials. I was speculating that Huichol yarn paintings might be related to sacred paintings used by other Uto-Aztecans, and wondered whether the use of other materials was part of a broad Uto-Aztecan pattern. Jane Hill (1992) has described a widespread Uto-Aztecan complex of flower symbolism that is related to a spiritual "Flowery World." For example, the Hopi of the Southwest used sand paintings with flower symbols on their altars (Voth 1901, cited in Hill 1992, 129), as well as flowers as decorations on ceremonial clothing. The Navajo may have learned sand painting from Puebloan peoples, and Sandner (1979) records that the Navajo sometimes use flower petals in place of sand in dry paintings. Nonetheless, Eligio asserted that the Huichol had never used either flowers or sand in yarn paintings.

> HOPE: They never made them with flowers?
> ELIGIO: No, not with flowers. Just with pure wool, and cotton.
> HOPE: Not with earths, like sand or anything like that?

ELIGIO: No.
HOPE: Always just with thread?
ELIGIO: Yes, they made it with that. They twisted it, the wool. They twisted [spun] it, and with that they made the designs.

The Huichol do share other Uto-Aztecans' beliefs in the spiritual properties of flowers and pollen. Paper flowers (Hui.: *xuturi*) are attached to the horns of a bull about to be sacrificed. Modern offering bowls sometimes include flowers made from tissue paper. Zingg collected a myth that prescribes the appropriate offerings for Stuluwíakame, a rain-mother goddess of Tatei Matinieri. Her offerings include "votive bowls, *itali* [yarn paintings] . . . and other paraphernalia ornamented with flowers of all kinds, so she would be pleased with their fragrance" (2004, 128). These could be either actual flowers or flower designs.

I also asked whether the Huichol had used colored yarns in the past. Eligio said that the Huichol had begun to use multiple colors of yarn only after these colors were available commercially. He referred here to the use of acrylic yarns, dyed with aniline dyes, which are now widely available in Mexican stores.

HOPE: And when they began to sell these threads with many colors, the Huichol began to use many colors in the yarn paintings?
ELIGIO: Well, afterward, when these began to come out, already dyed. Then they began to put on more colors, because there were more colors. . . .
HOPE: And before, they couldn't put them on?
ELIGIO: No, they couldn't put them on. No, there weren't any. . . .
HOPE: Before, did they have colors to dye the threads? Like colors made of plants?
ELIGIO: Yes, that also. Also, the Indians dyed that, the wool of sheep. There are dyes to dye that. With that, they dyed them. With that, they made designs, bags of that kind [*points to bag with shoulder strap (Hui.: kütsiuri)*], embroidered suits, and of pure wool, just spun, just woven. With that, they made embroidery.

I asked whether he knew any dyes for wool. He knew of two trees used for dyeing, both of which give shades of red and pink. One he called *brasil*, or brazilwood, which is probably *Haematoxylon brasiletto*, a tree widely used for dyeing in Mexico (Sayer 1985, 136). The other is a tree he called *cuachalala* in Spanish (probably *Amphipterygium adstringens*, in the family Julianiaceae). Zingg (1938, 149; 2004, 141) refers to this tree as *culiakai* in Huichol, or *kuacha-lala* in Spanish, and records a myth that its bark is spotted because it absorbed smallpox from a

curing. Eligio's repetition of "cooking" suggests that the dyes are simmered and stirred for a long time.

> HOPE: Do you know how they made the colors to dye the wool for yarn? Do you know what plants they used?
> ELIGIO: Plants from around here . . . They are trees that are called brasil. And the other is called cuachalala. It is a tree that gives red bark. And the other, the [brazil] tree gives cherry red [Sp.: *guindo*], the dye. With that they colored them. They cooked it, and stirred it, cooking, cooking. That way the dye was fixed.

Nevertheless, Eligio did not remember the Huichol using these red dyes for yarn painting. Eligio grew up during the 1940s and 1950s in the Santiago River region. His information may reflect the experience of Huichol living in that region at that time. His statements were confirmed by Guadalupe de la Cruz Ríos, who grew up in the same region about twenty years earlier, that is, during the 1920s and 1930s. She also told me that she mainly remembered working in the natural sheep colors. The anthropologist Stacy Schaefer is currently collecting information on Huichol natural dyes used in the Sierra; her research may expand our knowledge of changes in Huichol color use over time.

As with design, the choice of which colors to use is up to the artist and his or her perception of the gods. There are no particular rules for which colors to use or how to combine them.

> HOPE: Are there rules that you should put one color with another? For example, always black with blue, or red with green? Are there rules like this when one is painting?
> ELIGIO: Well, when you make contact, many colors come forth. Many colors come.
> HOPE: It doesn't matter?
> ELIGIO: No, it doesn't matter.
> HOPE: No one teaches you that you should put this [color] with this?
> ELIGIO: No, not that.

His reference to many colors coming forth when he makes contact means the sacred colors he receives in communication with the gods. In effect, he said that visionary experience guides the choice of colors, not rules made by humans. This concept is explained in more detail in Chapter 10.

I wondered whether use of yarn paintings was gendered, that is, whether it was particular to either men or women. Eligio replied that both men and wom-

en can make sacred yarn paintings. Eligio said that women sometimes made them as a petition to learn to sew.

> HOPE: Is it only men who make yarn paintings as offerings? Or can women?
> ELIGIO: Also the women. Also the women can make them. The nierika, also they can make it. According to whatever they think to ask for, they can make it. They carry it there, and so on. To know how to sew, and everything.

Peter Furst (2006, 88) observed a yarn painting made by Varadara, the wife of Catarino Ríos, that depicted a calf. Nevertheless, it is relatively uncommon for women to make sacred yarn paintings. I asked Eligio why this was so. He did not seem sure of any specific reason, but thought that it might be because the women are trained in other arts, such as sewing and weaving. Therefore, they prefer to use the skills they have learned. Many women memorize existing patterns, so perhaps they are less used to innovating designs. Moreover, the person who originates yarn-painting designs should operate out of some shamanic or visionary ability. This is harder work than copying previously learned designs.

> HOPE: But usually it is men, right? That make them?
> ELIGIO: Yes.
> HOPE: Why is it normally men?
> ELIGIO: Well, because . . . it interests men more than women. Because the women always, many women, or their mothers teach them, to do sewing. But it comes from the same source. But one has to take hold of the embroidery. Those ones [the women] copy because it seems to them easier than to think about it. Then they make copies, then with that it is enough. But for the person who wants to originate, that is much harder work. Only the ones who are going to originate.
> HOPE: Yes, it [making original designs] is always harder work.
> ELIGIO: Harder work. Because he is . . . not seeing nothing. He is seeing something.

Eligio's comment here is reinforced by Stacy Schaefer (1990, 245), who notes that only some women learn to weave original designs. Those who are most advanced in a spiritual career learn to weave designs from the heart, or iyari. The other women are content to copy traditional patterns.

Another reason may be that women have their own offerings. Gourd bowls are a standard prayer offering for girls and women, just as prayer arrows are for boys and men. The bowls are powerful objects of protection and prayer in their own right. A gourd bowl made by a mother is a prayer for the health and welfare of her family as a whole.

In fact, Eligio said that a gourd bowl can be equivalent to a yarn painting and serve the same functions. A bowl with the same design as a yarn painting has the same powers, particularly if it is a large bowl. A gourd bowl also has the power of colors, or of bestowing shamanic vision.

> HOPE: Do a yarn painting and a bowl have the same power? Are they equal?
> ELIGIO: They are the same. This one, the bowl, a large bowl, that has the same design, it has the same value. The place that you take it to. And you will receive the same sacredness. At the place where you take it, the sacred [place]. Because this also has colors. If you take it to the sacred cave of Tatewari, Paritsika, Aitsarie, Aariwama, all those places.

The sacred yarn paintings are made ritually, with prayer and fasting. Ideally, Eligio said, a person should fast for four days before making a painting. At the end of the four days, he or she may make the painting. In contrast, an artist can sit down and make a commercial painting any time. As Eligio said, "Commercial paintings are *para lujo*" (Sp.: a luxury good). It is the difference in how they are made that most distinguishes sacred paintings from commercial ones. Sacred paintings are made in a sacred manner, with the intent of offering them to the gods. Commercial paintings are not.

Imagery of the Sacred Painting

Only a few authors have published images of sacred paintings.[1] I review the published images here and highlight common characteristics.

Juan Negrín (1985, 42; 2005, 43) reproduced a photograph of four sacred yarn paintings. He identified them as petitions for supernatural vision from the sun. All four are roundish, have a central hole, and show two deer facing each other. Two include an eagle. All have small circles and triangles whose meaning is not explained. (Perhaps the triangles represent the rocks of sacred sites.) Negrín photographed only one side. He does not mention whether there is another image on the other side.

Pablo Ortiz Monasterio photographed twenty-two yarn paintings during a ceremony, probably in Santa Catarina; he photographed only one side (Ortiz Monasterio, Nava, Mata Torres 1992, n.p. [73]).[2] He gives no explanation of their purposes or symbolism. Three paintings show one or two deer, with circles and triangles. Several show a coiled serpent or spirals that could represent a serpent. A number have arrangements of geometric figures such as triangles, straight lines, and crosses.

A verbal description of a sacred yarn painting is provided by Knab. He saw offerings left for a *kieli* plant in Santa Catarina. He describes a "wool drawing" with designs of cattle "done in brightly colored wool pressed into wax," which he explained as a prayer to increase the fertility of the animals (1977, 83–84). Knab (2004, 151) also records that a person who wants to be a shaman must go to San Blas and find all the places where the sea serpent mother-goddesses emerged; these are marked by *haiku*, a coiled water snake, pecked into stone.

Several anthropologists collected sacred yarn paintings. Lumholtz (1900, 133–134) reproduced one that he called a "special front-shield," a form of nierika. It has bands of blue and white beads representing sky and clouds, and around it are zigzag rings of red and yellow wool; coils of black, yellow, and red yarn representing grains of corn; and a large paper flower. It is a prayer for rain.

Lumholtz and Zingg both collected yarn paintings, which are illustrated in Berrin (1978, 152–153). The Lumholtz painting shows two deer facing a crisscross or starlike object. There are wavy lines that could be serpents. On the other side is a circular sun-like motif with radiating lines. The larger Zingg painting is reproduced in color in MacLean (2001a, 45; 2005b, 23). It shows a mixed group of animals, including deer, serpents, and birds, on one side; on the other side is a mirror surrounded by a starburst of crisscrossing lines and a wavy circle around the perimeter. All three Zingg paintings contain a sun-like image with radiating lines on one side. The obverse sides vary. One painting has a group of animals, including two deer, a bird (possibly an eagle), and serpents. A second has another sun-like design. The third, an odd bottle shape, has what looks like a human figure.

An unusual yarn painting, also collected by Zingg, is an oblong board painted blue (MacLean 2010, 64). It has a design of a sun, a cross representing the four directions, rows of humped mountains, and at least two serpents.

All together, these published photographs show about thirty-two sacred offerings. If we may generalize from this small sample, it appears that there are several basic designs for a sacred yarn painting. A central hole or circle with radiating rays is a common design. A second motif is one or two deer facing a circle, a criss-cross design, or a star. A mixed group of animals and birds is another basic design; in particular, this group often includes deer, an eagle, and one or more serpents. A fourth design is a single coiled serpent or spiral. The geometric designs photographed by Ortiz Monasterio may represent another category or group of images.

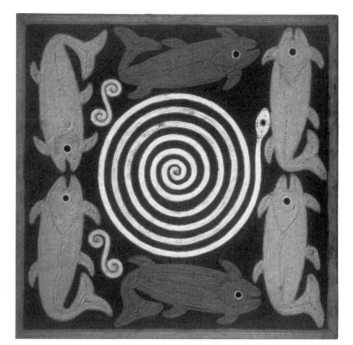

Fig. 5.2. Pablo de la Cruz, an older style of yarn painting showing a coiled serpent in the center and six fish, date unknown. 24" x 24" (60 x 60 cm). Photo credit: Hope MacLean.

Most of these designs, except the geometrics, are also found in god disks and other offerings. Similar imagery is found on stone god disks (tepari) collected by Zingg (Berrin 1978, 147; color version in MacLean 2001a, 44; 2005b, 22) and by Lumholtz (1900, 26, 28, 30, 34). I have seen the coiled serpent or spiral in clay or stone disks left as offerings at a sacred site in Santa Catarina.

Little has been recorded about the interpretation of the sacred yarn paintings. Therefore, I asked Eligio to tell me what some of these designs meant. I began by sketching the image of a coil or spiral. I have seen some versions of this design that are clearly a coiled serpent with a head.[3] Others are simply a rough design of a spiral. Eligio immediately identified it as a design representing Aariwama, a rain goddess.

> HOPE: I wanted to ask what the designs mean in the original yarn paintings. For example, I have seen one time in Santa Catarina, there was a sacred site where they leave a design like this one.
> ELIGIO: Yes, that is the sacred water. The sacred water. That is called Aariwama.
> HOPE: Aariwama.

Fig. 5.3. A page from my field notes, showing sketches that Eligio and I made as we discussed the designs of sacred yarn paintings.

ELIGIO: That is the one that sends the water, that snake. At the same time, that snake is also lightning bolts, that create thunder. That is the snake. It goes about among the clouds. That is it.

HOPE: And we went to a spring near Nueva Colonia, and there is a place where the people leave these. I don't know if they are made of clay or of rock.

ELIGIO: They make them from rocks also. [*sound of chipping*] They make them. They make the designs . . . a snake. Those are called . . . at the same time, it is called Aariwama, it is also a nierika. Of the shamans. They take them so that the god will see what is in their mind. It is a magical power, to receive that from this.

HOPE: It is a shamanic power?

ELIGIO: Yes, of shamanism.

I decided to try asking him about other designs I had seen in yarn paintings. I drew several concentric circles, with another circle around the outside with toothed or jagged edges. He immediately identified it as the nierika of the sun, which should be taken to a cave sacred to the sun. The cave is located in Teekata, in a canyon near Santa Catarina.

ELIGIO: That is a nierika of the sun. The sun. They take it there. There are many caves. There are all kinds [of caves]. There is one for the sun. One for Tatewari. One for Aariwama. One for Paritsika. One for Takutsi Nakawe. And, well just five. But at the same time, there are these five, there are another one, two . . . there are three missing, four, five gods.

HOPE: Can you show me?

He drew several more pictures of yarn-painting designs in my notebook. One was a stick figure of a child. He identified it as Aitsarie, a sacred site that is a place to take children. A second design was a stick figure of a standing woman. He identified this as Takutsi Nakawe. Because she is the owner of the earth, she is given offerings related to corn.

ELIGIO: The other is, here is Takutsi Nakawe, like this. This is a god also, this way. Takutsi Nakawe. Well then, I have to . . . when the fiesta of *elote* [Sp.: corn on the cob] is held. This is the owner of the earth. According to what it indicates and everything, this one remains in the rock there. The image appears in the place of that god there. So we take offerings there—arrows or muwieri or candles, here in this place. . . .

But sometimes a person asks her—for example, I asked her for power. I have to keep on carrying [offerings] here to this place. Here to this place, I am going to take candles, and I am going to take arrows here, and offerings. Most impor-

tant, a nierika hung from this one [an arrow] or this one [a muwleri]. I go leaving offerings here for five years. When I ask. Or here as well. It is the same.

Then he drew a fifth design, a spiral coil with a scorpion beside it. It represented the sacred site of Paritsika, Lord of the Deer. He reminded me that the snake and the scorpion can transform into each other.

> ELIGIO: And which? Oh yes, Paritsika, here it is. There is a snake here also. At the same time, it can turn into a scorpion. A scorpion here [draws snake and scorpion in circle]. Paritsika. It is a magical secret. Almost miraculous. With this god, I also have to carry [offerings] here to this place. For five years. But only if I am making requests from all these gods do I have to leave offerings here, here, here, here, and here. All these [places]. I have to carry . . . It is as though they [the gods] are eating. But if you are just going with one only, you only have to go to this place. That is how it is. For this reason, they carry their offerings and leave them there. So that they [gods] see them.

I asked him about one more image: one or two deer, either by themselves or facing a design of a circle or concentric circles with a toothed circle around it. He identified it as a yarn painting to be used once one had finished the pilgrimages needed to become a shaman. Even though a person was no longer bound to make pilgrimages, the gods did not want to be forgotten. They might remind the person by making him or her ill if they feel neglected. Therefore, the painting represented a promise that the person would continue to leave offerings of arrows, blood collected from sacrificed animals, candles, and sacred fire or copal incense.

> ELIGIO: It is a promise. It is a promise that when I have completed with those gods, finally completed five years, six years. Well, I will stop going after those five or six years. Well, the gods are going to . . . I am going to make myself sick, because I am no longer visiting those sacred caves. Well, if I get sick, then I am going to try to kill a deer. I will kill [it]. Then we take a little bit of its blood to paint on this magical power.

The design in the middle he identified as the source of food (Sp.: *comedero*; literally, "feeding trough") for the deer.

> ELIGIO: The comedero. It is a candle, a plate full of candles. And if not, a sacred fire, they burn it. They burn it to bless the arrows. And then, already blessed, they carry it to him. That is what this consists of.
>
> HOPE: [pointing to the jagged circle in the middle] This is like copal?

ELIGIO: Exactly, that one.
HOPE: This means "copal"?
ELIGIO: Yes.
HOPE: And "copal" means "the sacred fire"?
ELIGIO: Yes, sacred fire.

I queried whether this yarn painting was used only when a person became ill and felt that the gods were punishing him. However, he said it was used before that point, as a preventive measure. The person made that painting after finishing a series of pilgrimages and being released from his or her vow to the deity of the place.

HOPE: And do they take it only after the person gets sick, or—?
ELIGIO: Yes, already. After they finish. After they finish.
HOPE: After finishing?
ELIGIO: After you go about free. If not, they will capture you again. [The gods will say:] "Why don't you bring us something to eat? We are going to find you. We are going to make you sick." Then the shaman has to discover this. [The shaman says:] "Oh, they are asking you something over there. They are already waiting for you." But now you are going to make something like this. They will say to you, "What thing are you going to make?" You are going to carry this thing to that place. And this way, with that color. The color. You will put this color on it. Fill it in with that color. You will take it there. They will clean you off. And then it is finished.

Eligio felt that these designs were the most important ones he could think of and a fairly comprehensive representation of the sacred designs. Most of these designs are quite simple. They consist of a simple geometric shape, such as a circle or a spiral, or one or two stick-figure shapes, such as a child, a goddess, a scorpion, or a deer. The designs are not the same as the elaborate, storytelling narratives or compositions that have evolved for use in commercial paintings, designs containing many figures and showing ceremonies. Nonetheless, the images Eligio described do appear quite often as elements in commercial paintings.

Eligio did not cover all the designs illustrated in other books, and unfortunately, when I interviewed him, I did not have copies of the books with me to show him. There is more to be learned about the meaning of sacred designs, such as whether the meanings are standardized or whether different artists, shamans, or communities have their own interpretations.

It is noteworthy that Eligio linked his principal yarn-painting designs to particular deities and to the sacred sites belonging to each deity. This gives us a clue to what may be the indigenous or emic system of categorizing sacred yarn paintings.

Kindl (2003, 187ff) received a similar explanation for the meaning of sacred bowls. She interviewed Doña Andrea Rosa Medrano, who told her that her family's bowls represented sacred sites and sacred geography as it was understood by her family. Doña Andrea and Eligio Carrillo live in the same region and share many links, so it is not surprising that there is overlap in their explanation of sacred objects. Doña Andrea is a daughter of Don José Ríos (Matsuwa), a shaman and elder from Colorín. Eligio accompanied Don José on many pilgrimages to Wirikuta and considers him one of his main teachers of shamanism. José Ríos was also the brother of Guadalupe de la Cruz Ríos's mother, and one of Lupe's teachers as well.

Sacred Paintings and Rock Carvings

I asked Eligio whether there was a story about how yarn paintings originated. I expected a mythological explanation, such as the myth of Kauyumari and the animals recorded by Zingg (1938, 629; see Chapter 3.) Therefore, my first question was whether the gods made yarn paintings. Some Huichol ceremonies, such as the pilgrimage to Wirikuta, are replications of activities first performed by the gods. I thought that yarn painting might have been given this supernatural sanction. But Eligio replied that it was not the gods who first made yarn paintings, but the Huichol shamans. Then he launched into a fascinating explanation about the origins of yarn paintings being in designs found in rocks, and predating the Huichol. I have translated the Spanish word "*huellas*" as "signs," although my dictionary also gives the possibility of "traces" or "footprints," which is suggestive of images left in rock by something that passed through long before.

> HOPE: And is there a story about the ancient ones that explains the origin of the cuadras? Like of the gods, that they made yarn paintings, or something like that?
> ELIGIO: No, they didn't make anything. Absolutely, that came from the shamans. And it happened that, from the gods, from before, there existed signs [Sp.: *huellas*], as I told you. Yes, signs. They existed in the rocky places, and the shamans discovered that they should make them like designs. The first design

that was made, the shaman was there to make it. Because he had the head for it, [the knowledge] of what colors to use, of how it was shaped, what he saw in that place. And from there they began to make things like that.

Eligio may not know the myth recorded by Zingg, or he may have been taught a different origin story. Zingg's myth came from the southern community of Tuxpan, while Eligio's family came from San Andrés. There can be considerable variation in lore between communities and between different shamans and storytellers.

In his description, Eligio seemed to refer to preexisting rock carvings that the Huichol copied—or he may have meant that the Huichol shamans envisioned these designs from the stones of sacred sites. I will return to this ambiguity below.

In another reference to preexisting designs in rocks, Eligio described two huge stone serpents in the cave of Aariwameta. The cave, a sacred site near San Andrés, contains a spring of water. I do not know whether the serpents were carved by people or are a natural rock formation. I have never visited this sacred site and so I must rely on his description. (The Huichol are protective of their sacred sites, and one must wait for an invitation to visit them.)

ELIGIO: There in that place of Aariwama, there exist among the rocks, designs (Sp.: *dibujos*) of the serpent.
HOPE: In the rocks themselves?
ELIGIO: There, that is where they are. Aariwameta. There are two serpents. This big [*holds his hand about three feet (one meter) from the ground*]. They are in the cave. But those things, I don't know who made them. They were born there. Among the rocks. That's how they are. They look like serpents. . . . It is like a huge cave, a huge rock. You go down below, and there they are. And the water is there also. And there are many things [offerings] that they bring there, nierikate, arrows, feathers—well [everything]. And for that one.
HOPE: And what power does it give?
ELIGIO: The power there? To become a shaman.
HOPE: Of a shaman?
ELIGIO: And to know how to paint also. Everything. Also to know, to know the study [of shamanism] also. It is good for everything, that one.

Aariwama is a rain-mother goddess whom Lumholtz called Mother East-Water (1900, 163). I have spelled her name as Eligio pronounced it. Some authors have transcribed her name as "Nu'aariwame" or "Ne'ariwama."

Zingg (2004, 157–160) recorded a myth of Aariwama (which he renders as "Na'aliwaeme") that seems to refer to the same cave as Eligio describes. Na'aliwaeme goes to live in a cave, where she makes designs of a snake.

> The girl spat in the centre of the cave, and there was a teapáli [god disk]. She spat again and this time a snake appeared on the top of the teapáli. Then she painted marks on the walls of the cave. . . . This cave is [N]a'aliwaeme kokalita, and is near Santa Catarina. . . . In the cave the water-goddess had a large water jar about twelve inches high. It was painted with five snakes. . . . [The people] were to have a ceremonial bath in the waters of the cave, pray, and take candles to her cave.

The myth goes on to describe offerings to the goddess that are to be left in the cave, and how she gives increase of money, cattle, and other animals.

Eligio's references to designs and carvings in rocks are intriguing. The origins of the designs are, of course, lost in time—but it is interesting that Huichol oral history has preserved this account of them.

I puzzled over Eligio's cryptic references to designs in rocks. I was not certain whether he was talking about actual designs in rock or something envisioned with shamanic vision. Several years later, I returned to Mexico and asked him for more details about the sources of the designs in rocks. This time, he spoke about his own experiences in receiving designs or images from the gods. He seems to be speaking about designs that come from the rocks, and perhaps from the rocks of the sacred caves. He clarified that he was talking about shamanic vision, but I was still not certain to what extent these were preexisting designs that he began to understand the deeper meaning of, or whether these were visions stimulated by the designs or sent by the gods.

> HOPE: Before, you said to me that the Huichol . . . that the designs in the yarn paintings were designs in the rocks. That the shamans saw designs in the rocks.
> ELIGIO: Yes.
> HOPE: And that afterward they put them into the yarn paintings. And was it that the mara'akate saw with shamanic vision? With vision? Or did they see the real design, as though it was painted or something?
> ELIGIO: Well, those things . . . during the years that I have spent learning to become a shaman. Well, I never wanted to become a shaman or anything like that. I wanted to learn to make designs. To know how to make yarn paintings. To know a lot. So that a lot of visions would come to my mind. That's what I wanted. I spent about ten years, and then I began to receive a lot of visions. Through the rocks, I saw many designs. But I understood that they spoke as a de-

sign. Well. What it is that they meant. But those designs are words of the gods. From long ago—I don't know when. I don't know what they may be. But they exist. And I began to base myself in that, in those designs, to teach myself to make designs, yarn paintings. From there, I began to draw out designs, to make up designs. Now I have the ability to understand the designs, what they mean. They are a part of some things.

He went on to say that the ability to see the designs was linked to knowledge of shamanism. He often describes shamanism as a study that has no end.

ELIGIO: Not everyone can do designs. It is something very big. It doesn't have an end. It is something that is thus. It will not give you any ending, of the designs that there are. And different words, many words. It is very difficult to understand them. . . .

No one taught me. My father never said to me what was in this world. Of those things in the world, no one said anything, nor my mother either. Nor my grandfather. He was a shaman, but he never said anything to me. Nor the other grandfather, who was also a shaman. They never told me what it is that the shamans see, what they are seeing because they are shamans. They never told me that. All by myself, I caught on. But by visiting [those places], in that way. The sacred sites. And then, in order to learn, I went by myself. But my mind-heart [Sp.: *pensamiento*] alone knew what I was doing. I wanted to learn something. And for that reason, I know a lot of things. I know them. But those things came to me. God gave me that. His mind [Sp.: *mente*], and here I have it in me. And that is what is helping me work, nothing else.

Once again, I tried to clarify whether this was an ability unique to shamans or those who could exercise shamanic vision. He agreed that only those who believed or had faith were likely to receive the designs and their meaning from the gods. However, he went on to say that even though other shamans might share his experience, they did not necessarily translate it into art. Some did not really pay attention to what the gods were telling them, nor did they use it. They did not focus on that other reality. Eligio speculates that he may have gained insight into understanding these images because he specifically asked the gods to make him a painter.

HOPE: So then, it is not every person who can see these designs in the rocks? It is only someone . . . a person who has learned about shamanism?
ELIGIO: Yes.
HOPE: If another person goes to a cave, he will not see anything?
ELIGIO: No, that one won't. Only those to whom it has been given. Not every-

one. For that reason, . . . I was saying to my wife, . . . "There are a lot of shamans. There are lots of shamans. Why don't they do any kind of work [like painting]? Because they know, they know very well. And I don't know—perhaps they are lost. Or is it because the voices of the gods also come to their ears? They hear them. Their voices, the words, the [shamans] hear them. But only some of my comrades base themselves in that. They are never looking at what there is, what the lessons from the past are, of the gods. But I, perhaps I was different because I asked to know how to paint designs. That was all I asked, was to know how to paint. I wanted that. But through that, on the basis of that, I received a lot of things. I learned how to be a shaman, all of that.

HOPE: Because you asked to know the designs, they have showed you the designs?

ELIGIO: Original images [Sp.: *muestras*] of the gods. Yes, that is it.

The Huichol often use the word "muestra" to refer to a pattern, template, or an original image. For example, they may copy the pattern from a beaded bracelet and refer to the original as the muestra. Eligio seems to have the same concept in mind when he said that the gods showed him designs or templates for yarn paintings.

Eligio's answer still seems to leave open the relationship between designs in rock and their use as images in painting. To be frank, it is not always possible for an academic asking questions to receive crystal-clear answers from an indigenous consultant. Eligio took my questions in his own direction and answered according to his own priorities. Therefore, I have included here a discussion of rock carvings in the Huichol Sierra. It may well be possible that some Huichol imagery derives from these carvings, or that the carvings and offerings come out of a common source.

The only reference to a link between rock carvings and the designs of yarn-painted nierikate is a brief reference in Lumholtz (1900, 108): "It [nierika] may be said to the Indian expression for a picture, therefore rock carvings are called neali'ka." Lumholtz did not expand on the link further and seemed not to have deemed it significant.

Perhaps the huellas, or signs, Eligio referred to are petroglyphs or rock paintings and engravings. Lumholtz was particularly interested in petroglyphs and wrote about examples he discovered as he journeyed through the Sierra Madre. In eastern Sonora, he recorded finding petroglyphs similar to those found in Arizona, including ones of deified dragonflies, concentric circles, spirals, and meander designs, as well as deities drawn with "their hands and feet defined

with 3 radiating lines like a bird track" (1891, 392). He found the petroglyphs in association with deserted pueblos that included square stone houses, fortified hilltops, and terracing. Perhaps these ruins were remnants of the Chalchihuites or other cultures that had occupied the eastern slopes of the Sierra Madre.

Lumholtz (1902, 2:305) saw other petroglyphs south of Ixtlán del Río, in what may have been Huichol territory when the Spanish arrived. The petroglyphs depicted two small deer with an arrow point above each, and a large coiled serpent. Lumholtz (1902, 2:109) located another group of "pickings" in two caves on Mesa del Nayar. The figures represented mainly snakes, suns, and female genitalia, and he concluded that the artists were Huichol, although his reasons for this conclusion are not given. While he noted that the Huichol had, until recently, owned the country, he also referred to the ruins of a small pueblo that he concluded could not have belonged to the Huichol tribe.

Hrdlička (1903, 392–394) found many petroglyphs three miles (4.8 kilometers) south of Nostic in the Bolaños canyon. The petroglyphs consisted of broad, deep grooves, principally curves, cup-shaped hollows in grooves, many coil shapes, and humanlike figures with headdresses or striae radiating from their heads. (The last image sounds strikingly similar to depictions of kupuri, or life-energy, in commercial yarn paintings.)

The uncertainty about the artists could be significant. Hrdlička, who saw petroglyphs in Santa Catarina in 1902, said that the Huichol "could offer no explanation except that they were made by 'other people'" (quoted in P. Furst 1996, 48; Furst goes on to discuss the problem of who the other people might be). This explanation supports Eligio's statement that the Huichol shamans found the designs in rocks already in place.

The Huichol themselves told Zingg (1938, 355–357) that they were not the earliest inhabitants of the Sierra, and that a semimythical people called the Hewi preceded them. The Hewi may have been a northern extension of a Mesoamerican culture such as the Juchipila-Bolaños or Chalchihuites cultures. Or, as Peter Furst postulates, the Hewi may have been a group of Uto-Aztecans who were related to the Pima and Papago of Arizona and moved back to the South along the spine of the Sierra Madre after the great droughts of the thirteenth century, surviving as the historic Tepehuane and Tepecano. A third possibility is that the rock carvings may date from even earlier. They could be from the original wave of Uto-Aztecans who moved northward around 2500 BC. Any one of these cultures could have been the artists of the designs in the rocks.

Possibility 1: Mesoamerican Cultures Moving Northward
between about 100 BC and AD 1350

Some archaeologists have theorized that the Chalchihuites culture was a northern extension of the great Mesoamerican city of Teotihuacán in the Valley of Mexico. The archaeological ruins of Teotihuacán are famous for magnificent fresco paintings of subjects such as the paradise of Tlaloc, the rain god. Snakes are an important theme in temples of this region. It is quite possible that such a culture also produced the designs painted or carved on rocks in the Huichol Sierra. A later arrival was the Malpaso culture, which may have been derived from the Toltec culture. Snakes were also prominent in Toltec architecture.

Could the snakes in the cave of Aariwama come from a Mesoamerican source?

Possibility 2: Uto-Aztecans Moving
Southward after AD 1300

The Tepehuane/Tepecano undoubtedly brought their artistic knowledge and designs with them when they moved southward. There are concentrations of petroglyphs in the American Southwest and in northern Mexico. The Tepehuane/Tepecano could have brought the designs and an interest in rock carvings with them. This might account for the petroglyphs observed by Hrdlička in the Bolaños canyon, which was occupied by the Tepecano in historic times. Hrdlička also saw petroglyphs near the Huichol community of Santa Catarina, which at one time was occupied by the Tepecano.

Possibility 3: Proto-Uto-Aztecans Moving
Northward about 2500 BC

Petroglyphs are closely associated with what were probably early Uto-Aztecan cultures, such as the Anasazi of the Four Corners region (some of whom later became the Hopi) and the Fremont culture in southern Utah. It is likely that proto-Uto-Aztecans migrated northward in a relatively short time. They may have taken a sophisticated system of designs with them and left their carvings on the walls of rocks and caves. As a Uto-Aztecan culture, the Huichol may have shared the knowledge of these designs,

I have seen some striking similarities between designs found in petroglyphs of the Southwest, Huichol sacred yarn paintings and other offerings, and contemporary yarn paintings. For example, one common theme is the coiled spi-

ral—defined either as a spiral or as representing a coiled snake. I have discussed the coiled serpent as a Huichol image sacred to Aariwama and as the subject of petroglyphs at San Blas. I have seen a very similar coiled serpent used in a Navajo sand painting and in Huichol commercial yarn paintings.

Even more striking is the similarity between Fremont culture rock carvings of magnificently dressed people and the goddess Tateituli Iwiekame (Flower Skirt) as depicted in a commercial yarn painting. Domingo González, the Huichol artist who made the painting, emphasized to me that he had shown the goddess with all her accoutrements, including her earrings, her arrows (stripes on her shoulders), and her uxa, or paintings, which shine like the sun (star-shaped figures). Kupuri, or life energy, rises in wavy lines from her body. The same features, such as jewelry and overall shape, are lovingly detailed in Fremont petroglyphs. The petroglyph figures may be divine, since one includes deer horns, which the Huichol often use to indicate shamanic powers. The Fremont culture was located in southern Utah and dates from around AD 400 to 1300 (López Austin and López Luhan 2001, 21). Its members were sedentary agriculturalists who lived at the northern edge of pre-Puebloan cultures and whose links to modern peoples are uncertain (Dubin 1999, 313).

Use of the god's eye (or thread cross) and prayer arrows or plumes as prayer offerings is shared by the Huichol and the Puebloan peoples in the Southwest (Bandelier 1971, 100). A dart shaft almost identical to a modern Huichol prayer arrow was found in Gypsum Cave, in southern Nevada; it had a notched top and was painted red and green, with solid bands alternating with vertical zigzag lines (Tanner 1973, 15). Painted designs similar to modern Huichol embroidery—such as the lobed peyote with rounded edges, also called the *tutu* flower—are found in Mimbres Classic black-on-white pottery from around AD 1000 (Giammatei and Greer Reichert 1975, plates 16, 28). There are also striking similarities between traditional clothing of the Huichol and that worn by members of a Puebloan culture, such as the routine placement of embroidery on the shoulder, upper arm, and wrist (Howard and Pardue 1996, 9).

I think it likely that these similarities are ancient, because of their wide geographic distribution and deep embeddedness in Huichol thought. The similarities probably stem from the Uto-Aztecan migration northward, rather than from having been diffused during the comparatively recent migration of Uto-Aztecan Tepehuane and Tepecano back south. Future research may reveal even more overlap between Huichol nierikate and petroglyphs.

Another interesting question is whether sacred yarn paintings are unique

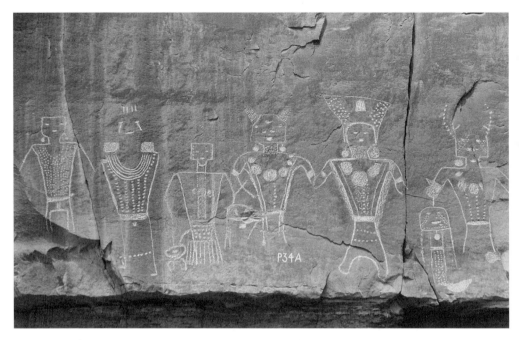

Fig. 5.4. Life-size effigy petroglyphs from Dry Fork Canyon, Utah; Fremont Culture, c. AD 950. Photo credit: Cat. #70. 1/365. Reagan Collection. Archives, Laboratory of Anthropology, Museum of Indian Arts and Culture, Santa Fe.

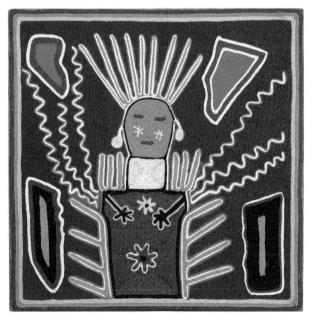

Fig. 5.5. Domingo González Robles, a yarn painting of the earth goddess (Tatei Ituli Iwiekame), 1996. 12" x 12" (30 x 30 cm). Photo credit: Adrienne Herron.

to the Huichol or are found elsewhere. Do any other Southwestern or Uto-Aztecan cultures make them as offerings? So far, yarn paintings made by applying thread to boards with wax seem to be found only among the Huichol. The uniqueness is rather odd, since other Uto-Aztecan sacred offerings, such as prayer arrows, thread crosses, and the nierikate known as front-shields, are more widespread. All of these are found among related cultures, such as the Cora, the Tepehuane/Tepecano, and the Puebloan cultures of the Southwest. So why not yarn painting?

I found one hint that something like yarn painting might exist elsewhere. James Faris reproduced a long myth from the Nightway, a Navajo ceremony. The myth was dictated by Hosteen Klah, one of the Navajo's most knowledgeable singers. In Klah's version, Spider Woman taught Dreamer Boy to make string pictures.

> Though the gods were in a hurry, she [Spider Woman] insisted that the Dreamer learn how to make the pictures and the Spider Woman and Man made the boy sit down on the floor and made string pictures all over him from feet to head, treating him with the string pictures in the same way that the Medicine Man would with the sandpainting. They made thirty-two string pictures over the boy and after the treatment the boy took a piece of string and after making each string picture four times he had learned them all by heart. There are songs about this part of the story. (1990, 206)

There is no further description of how the string pictures were made or what they depicted. The fact that they were taught by a deity and have a power to cure equal to that of a sand painting shows that they were conceptualized as powerful ceremonial objects. The myth sanctions the transfer of knowledge from a supernatural to a quasi-human hero, but I have not found any other reference to Navajo using string pictures in ceremonies.

Facing page

There is remarkable similarity between this petroglyph from the Fremont culture of Utah and a modern Huichol yarn painting, perhaps reflecting the proto-Uto-Aztecan roots of each. Notice the similarities in the shapes of the heads and bodies, as well as the emphasis on earrings. Antlers, seen in one petroglyph, are an indicator of shamanic power in Huichol culture, and they resemble the straight lines of kupuri around the head of the Huichol goddess.

. . . .

To summarize, a sacred yarn painting is a prayer for power, as Lumholtz and Zingg understood it to be. However, Eligio's discussion is much more subtle and nuanced than Lumholtz's or Zingg's straightforward equivalence between making an image and prayer. This complexity is one reason I have quoted Eligio's statements so extensively. He draws in many more ideas and talks about the artist's relationship with the gods and the ways that the gods and shamans communicate. He sees the nierika as a vehicle for power, since the spirit comes and suffuses the object with its power. The artist who is visionary makes a representation of the powers and colors of the spirit in his or her painting. However, the shaman can also see the colors a person has and can use them to read the person's state of development and relationship with the deities. The sacred yarn paintings are powerful magical objects, saturated with the energies of the gods and capable of transmitting life force to the maker. They require ritual observance to make and must be given away at a sacred site and not kept in the maker's house.

What then happened to these potent offerings when the Huichol began to make them for sale?

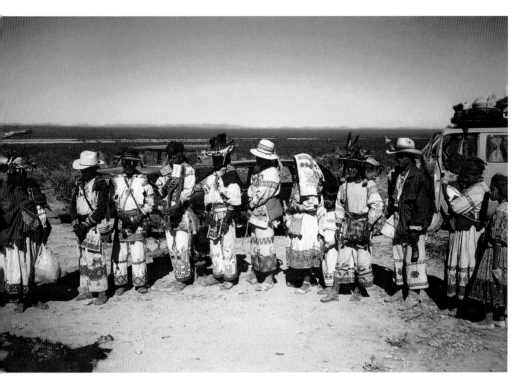

The family of Guadalupe de la Cruz Ríos circling the fire during a ceremony in the desert of Wirikuta. Photo credit: Hope MacLean.

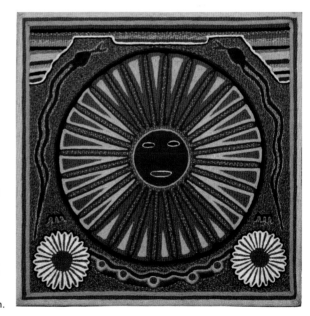

José Isabel (Chavelo) González de la Cruz, yarn painting, 2000. 12" x 12" (30 x 30 cm). The colored lines at the top represent the sacred words (niwetari) of the sun god. Their colors are remarkably similar to the Pantone colors selected by Eligio Carrillo. Photo credit: Adrienne Herron.

Eligio Carrillo Vicente, yarn painting of a mandala nierika, 2002. 24" x 24" (60 x 60 cm). The painting shows multicolored deer spirits, like those in the author's dream. Photo credit: Hope MacLean.

Facing page, bottom

Urra Temai, an early yarn painting of the myth of birth of the sun god at Reunar, c. 1975. 24" x 24" (60 x 60 cm). Multicolored rays of life energy (kupuri) radiate from the volcano, which is in Wirikuta. Photo credit: David E. Young.

Eligio Carrillo Vicente, yarn painting of his vision of a face in the sacred spring of Aariwam-eta, 2000. 12" x 12" (30 x 30 cm). Communication takes the form of lines of light. Photo credit: Adrienne Herron.

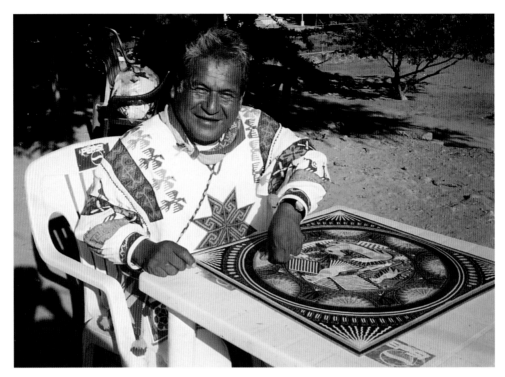

Eligio Carrillo completing a yarn painting, 2005. The Huichol say that the colors in their clothes replicate the colors of the clothes the gods wear. The gods are pleased when they see humans wear the same kinds of clothes that they do. Photo credit: Hope MacLean.

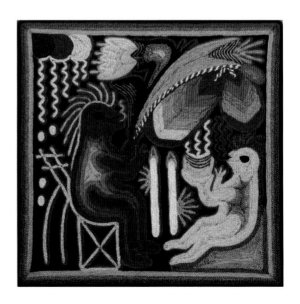

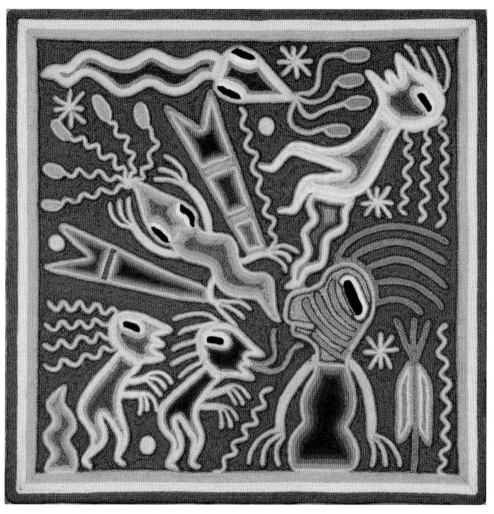

Unknown artist, yarn painting of the spiritual power of shamans, 2005. 12" x 12" (30 x 30 cm). The image is painted in the style of José Benítez Sánchez. Photo credit: Adrienne Herron.

Facing page, bottom

Santos Daniel Carrillo Jiménez, yarn painting of a shaman curing a patient who appears very pale and weak, 2005. 8" x 8" (20 x 20 cm). One technique for combining colors is to move through a gradation of colors, such as pale yellow moving to dark yellow in the flowers, and the dark red moving through pinks to white in the figure of the shaman. Color combining of this type became increasingly popular in yarn paintings of the 1990s, particularly among artists from the Huichol community of San Andrés. Photo credit: Adrienne Herron.

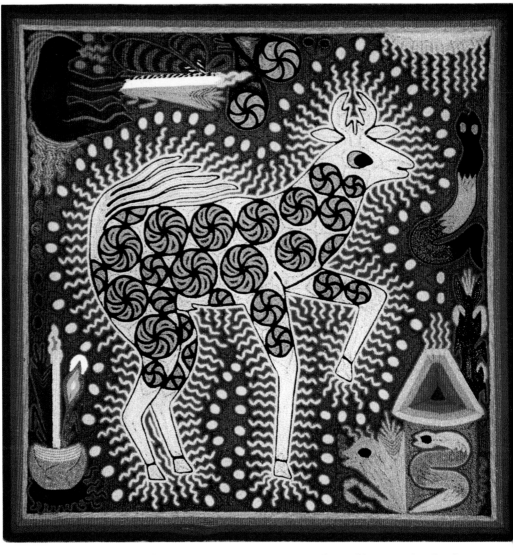

Santos Daniel Carrillo Jiménez, yarn painting, c. 1996. 15 ¾" x 15 ¾" (40 x 40 cm). Colored lights of the fire surround the deer god, Tamatsi Kauyumari. According to Eligio Carrillo, this is a visionary experience seen by shamans. Photo credit: Hope MacLean.

Unknown artist, embroidery, c. 1996. Cotton manta cloth, acrylic yarn, thread. The vibrant colors of Huichol embroidery suggest the vibrating, kaleidoscopic colors that many people report seeing during peyote visions. Photo credit: Adrienne Herron.

Fabian González Ríos, yarn painting, 2005. 4" x 4" (10 x 10 cm). When the shaman beats the drum, lightning comes out of the drum at night. This painting illustrates that visionary experience. Photo credit: Adrienne Herron.

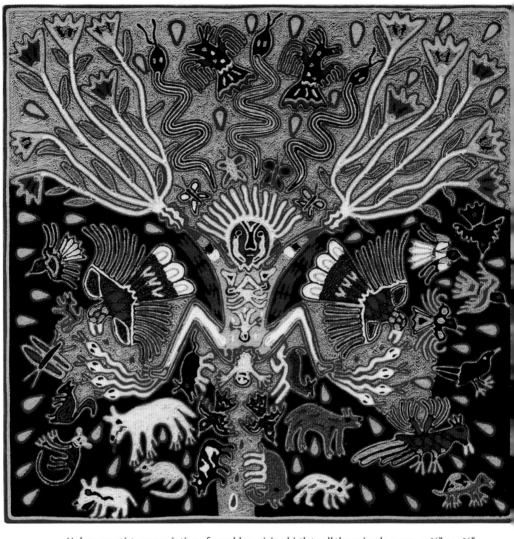

Unknown artist, yarn painting of a goddess giving birth to all the animals, 2005. 15 ¾" x 15 ¾" (40 x 40 cm). This is a variation on a famous painting by Mariano Valadez. Photo credit: Hope MacLean.

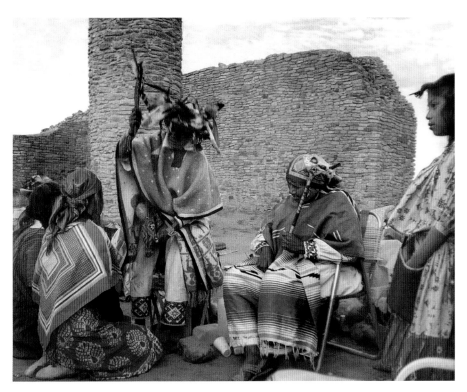

The shaman Tacho Pérez Robles brushing a patient with his shaman's plumes (muwieri) while Guadalupe de la Cruz Ríos watches, 1990. Photo credit: Hope MacLean.

Pantone colors (marked with dots) that Eligio Carrillo selected as representing the sacred colors he sees in communications from the gods, 2010. Photo credit: Adrienne Herron.

Bautista Cervantes family, yarn painting, 2000. 12" x 12" (30 x 30 cm). This group of Tepehuane began to make yarn paintings in the 1990s. Photo credit: Adrienne Herron.

Eligio Carrillo Vicente, yarn painting of the sacred site where uxa grows, 2007. 24" x 24" (60 x 60 cm). Uxa is the yellow root used for face paintings. The shaman prays for the power it bestows on his shaman's basket (takwatsi). Photo credit: Adrienne Herron.

Facing page, bottom

Eligio Carrillo Vicente, yarn painting, 2000. 12" x 12" (30 x 30 cm). According to Eligio, the power of Tamatsi Kauyumari entered the painting once he applied the sacred colors and made the image. Photo credit: Adrienne Herron.

Unknown artist, wooden log drum with yarn-painted decoration, c. 1994. Wooden drum, yarn, beeswax, deer-hide cover, feathers, huastecomate gourd, wooden sticks (possibly brazilwood). The yarn cross or god's eye (tsikürü), a rattle, and a shaman's plume are all used in the Drum Ceremony. The shaman plays the drum and symbolically flies the spirits of the young children to Wirikuta. Photo credit: Hope MacLean.

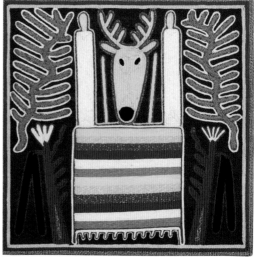

José Isabel (Chavelo) González de la Cruz, yarn painting, 2002. 12" x 12" (30 x 30 cm). The twelve colored lines represent the staircase to be climbed (the annual pilgrimages to make) in order to reach the altar of the deer god and thereby complete one's journey to become a mara'akame. Photo credit: Adrienne Herron.

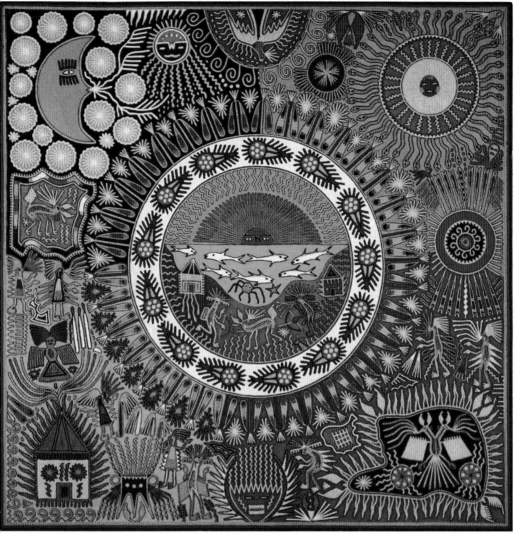

Modesto Rivera Lemus, large cosmological yarn painting of the everyday world being interpenetrated by the spiritual world, 1994. 48" x 48" (120 x 120 cm). Photo credit: Hope MacLean.

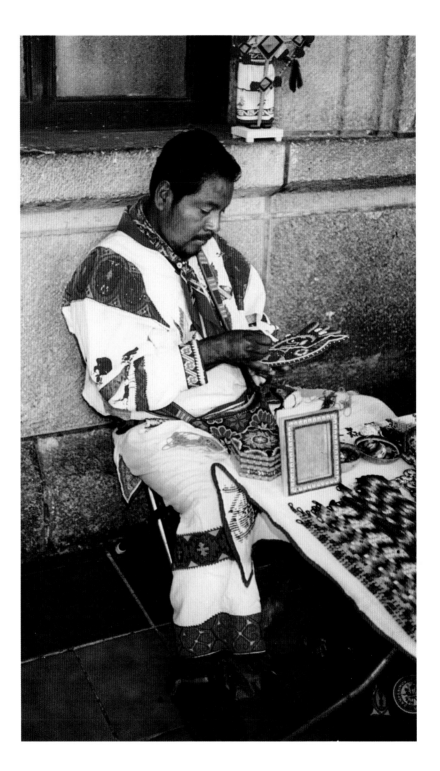

Miguel Silverio Evangelista; wood, glass beads, beeswax; 2005. 10 ¾" x 9 ½" (27.4 x 32.5 cm). The Huichol now press beads into wax to make many commercial products, such as this beaded eclipse. Note the small dots of contrast color and the use of traditional symbols such as deer. Photo credit: Adrienne Herron.

An offering of prayer arrows and a gourd bowl with coins, given to the statue of Coatlicue in the National Museum of Anthropology in Mexico City. Photo credit: Hope MacLean.

Facing page

A Huichol artist using a needle to apply beads to a wooden eclipse plaque while waiting for customers in the plaza of Tepic, 2005. Photo credit: Hope MacLean.

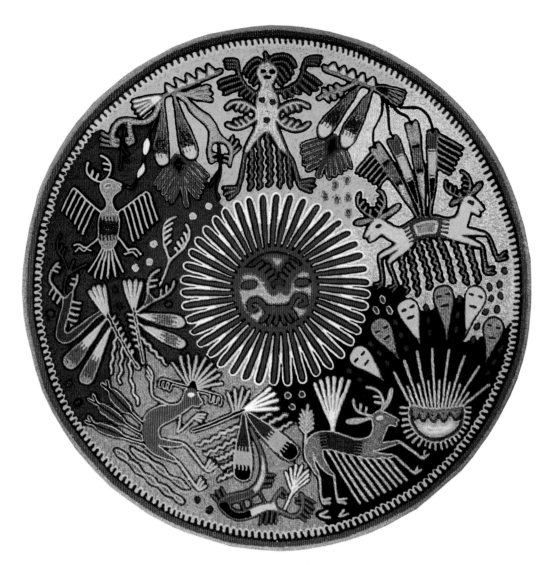

Eligio Carrillo Vicente, yarn painting of the sun god, 1994. 24" (60 cm) in diameter. The deity appears as a human figure in the zenith of the blue sky at midday. The image is painted in fuerte colors, representing the strength of the sun. Photo credit: Hope MacLean.

commercialization
of the nierika

Who first had the idea of transforming the Huichol's small sacred offerings into a commercial art? When, how, and why did it happen? There were no definitive answers to these questions when I began my research.

I found several versions of the story, but few details. According to Negrín (1979, 26), a Mexican anthropologist named Alfonso Soto Soria was the first to exhibit and sell yarn paintings. Negrín stated: "Yarn boards first appeared on the market in 1951, when Professor Alfonso Soto Soria held an exhibition of them in Guadalajara in Mexico." Salomón Nahmad (1972, 157, 162) stated the first exhibition was held in 1954 at the Museo Nacional de Artes e Industrias Populares.

To shed light on this question, I located Professor Soto Soria in Mexico City in 1996 and recorded his version of the story. He told me that he was the guilty party ("*Yo soy el culpable*") in the transformation of yarn paintings from sacred to commercial art. Soto Soria reminded me that after the Mexican Revolution, there was a growing interest in the arts of the common people.

To understand the birth of Huichol yarn painting, I realized that I had to look at the broader picture of Mexican policy on arts and indigenous culture. During and after the Mexican Revolution, intellectuals and artists such as Diego Rivera and Frida Kahlo were part of a political movement that celebrated the indigenous roots of Mexican and mestizo culture. After President Obregón took office in 1921, he and José Vasconcelas, his minister of education, initiated a program to restore Mexico's pride in itself. Believing that the country could find its personality in indigenous arts and culture, they sponsored open-air schools to teach folklore and popular arts. Artists such as Rufino Tamayo and Miguel Covarrubias volunteered as teachers (Williams 1994, 12).

Yet even by the 1920s, there was concern that traditional crafts were becoming decadent because of a burgeoning tourist trade. Therefore, the Ministry of

Fig. 6.1. Alfonso Soto Soria, the Mexican anthropologist who fostered the invention of modern yarn paintings, 1996. Photo credit: Hope MacLean.

Education sponsored a program to revive traditional crafts in indigenous communities. For example, René d'Harnoncourt worked with the painter Roberto Montenegro to revive the almost-extinct lacquer trade in Olinala as a viable community business. They took good pieces of old lacquer to the village and encouraged the elders to make them again and to teach the young people. Later, the ministry hired d'Harnoncourt to find other ways to preserve traditional folk arts and make them economically fruitful (Schrader 1983, 126).

Meanwhile, the U.S. ambassador to Mexico, Dwight Morrow, was anxious to improve U.S.-Mexican relations by changing the popular image of Mexico. He approached Robert de Forest, the president of the Metropolitan Museum of Art, and, through him, the Carnegie Corporation, which agreed to finance a collection of Mexican folk art. D'Harnoncourt was hired, and spent 1930 putting together a collection of 1,200 objects, which were exhibited by the Ministry of Education in Mexico City. Then the exhibition was taken to the United States. It opened at the Metropolitan Museum of Art in New York, then made a triumphant tour of fourteen other cities (Schrader 1983, 124–128; Kaplan 1993; Delpar 2000, 544–547). D'Harnoncourt moved to the United States and became director of the Indian Arts and Crafts Board (part of the U.S. Department of the Interior) in the 1930s.

Building on this momentum, Mexico went on to establish a Museum of Folk Arts (Museo Nacional de Artes e Industrias Populares) in Mexico City. Here, Soto Soria took up the story and told me that in the 1940s, the museum's initial goal was to make an inventory of all the folk arts being made in the republic. The museum's director, Daniel Rubín de la Borbolla, hired fieldworkers, including Soto Soria, who was then a twenty-eight-year-old anthropologist. Soto Soria was assigned to explore the mountains of northwest Mexico in order to discover what arts were still being made there. He was asked to investigate all the indigenous arts of Northwest Mexico, including those made by groups such as the Cora, Huichol, Tepehuane, and Tarahumara. However, he found the Huichol's artistic production so rich and varied that he concentrated on them and brought back examples of weaving, embroidery, and sacred offerings.

Soto Soria took copies of Lumholtz's and Zingg's books with him to use as guides to discover which kinds of arts were still being made. Lumholtz included illustrations of small boards that were decorated with yarn and used as offerings to be taken to caves and sacred sites hidden away in the mountains. Therefore, Soto Soria asked the Huichol to bring him examples of these offerings or to make him some. He specifically asked for yarn paintings. On his next trip, the Huichol brought him small paintings made on boards taken from wooden soapboxes or on very rough pieces of wood with the bark still on them. These had designs made of yarn glued with beeswax. The designs were abstract or symbolic, but the whole group understood them.

In 1954, the Museum of Folk Arts exhibited his collection—apparently the first display of Huichol art ever held—and published a catalogue. Soto Soria had a copy of the catalogue, now rare, and I made a photocopy of it. Several yarn paintings are illustrated: one has a design of a spoked figure surrounding a mirror, and others have designs of deer (Museo Nacional de Artes e Industrias Populares 1954, 47, 57). Most of the text and illustrations from the catalogue were republished a year later in the popular Mexican magazine *Artes de México* (Soto Soria 1955). Raúl Kamffer visited Soto Soria at the museum and watched a Huichol from San Andrés "sticking colored yarn on a waxed board, designing a curious eagle with two heads, one normal and the other in the shape of a cross" (1957, 13).

Then, by a twist of fate, the sacred offerings were transformed into a commercial art. The governor of the state of Jalisco was an erudite writer named Augustín Yáñez, who shared the interest of other Mexican artists in indigenous arts. He admired the exhibition so much that he decided to award a prestigious

art prize to the Huichol artisans. Since the prize was normally given to a Western artist, Yáñez needed to justify his choice. He decided to hold a second exhibition of Huichol art, but in a form that would appeal to Western tastes. He felt that the people of Guadalajara would appreciate the colors the Huichol used, but that the paintings were too small. He provided Soto Soria with an airplane and materials and asked him to persuade the Huichol to produce larger paintings that could be exhibited. Soto Soria flew to Tuxpan, Jalisco, which had an airstrip by then. There he enlisted the help of a local leader (he remembered the name, Guadalupe Cruz), who soon organized a group of fifteen or twenty Huichol men to make paintings. Their productions were the first modern yarn paintings designed to conform to Western concepts of art—that is, the paintings were flat and decorated on one side only so that they could hang on a wall.

These paintings were shown in an exhibition in Guadalajara in the late 1950s, about four years after the first exhibition. (Soto Soria was not sure of the exact date.) Yáñez's support and the exhibition made the paintings popular, and stores in Guadalajara began to sell them, as did the Museum of Folk Arts in Mexico City. So the modern commercial yarn painting was born.

As an aside, I will mention that Governor Yáñez's agenda may have been more political than Soto Soria's story indicates. The states of Jalisco and Nayarit had a long-standing political battle over the border between them, particularly where it runs through the canyon of Camotlán. Nayarit backed the mestizo ranchers who claimed the region for that state. Yáñez was offering political support to Pedro de Haro and the Huichol of Tuxpan and San Sebastián, who claimed the land for Jalisco. (The controversy is described in Rojas [1993, 180ff].) Yáñez's backing of a Huichol art movement may have been part of a political strategy to win public support and interest for the Huichol generally.

Soto Soria went on to say that the first paintings Yáñez commissioned were done on thick wooden boards so that they would replicate the look of traditional paintings. He took about 150 12" x 16" (30 x 40 cm) boards strapped to the undercarriage of the plane on the flight into the mountains. The wood was so heavy that the plane had to make two trips. Later, someone from the Museo de Artes Populares had the idea of asking the Huichol to use plywood rather than lumber. The museum was trying to find ways to help the Huichol develop a viable art business and felt that the paintings would be easier to sell if they were lighter. This advice was part of a conscious museum program to improve the economic plight of impoverished indigenous peoples. Governor Yáñez may

also have wanted to promote economic development in Jalisco, and this practical reason may have been part of his motivation for sponsoring an exhibition.

While the development of displayable paintings may have resulted from creative brainstorming, the commercialization of yarn paintings was no accident. The museum had a mandate to preserve traditional folk arts, and part of that mandate was to develop folk arts as a business (Williams 1994, 191). The staff was concerned that the public did not generally appreciate crafts and so paid little for them. The craftspeople had little incentive to do their best work, since they could not make a living from time-consuming artisanry. Therefore, the museum hoped to encourage both art and artists by exhibiting the works and fostering appreciation for the skill involved. The museum also had a store, which sold high-quality crafts on the theory that the best way of preserving crafts was to pay artists well for good work and give them reliable markets for their wares.

Soto Soria's account makes it clear that it was not the Huichol who had the idea of commercializing their sacred arts. The initial impetus came from Westerners, and they directed the shaping of yarn paintings into marketable forms. Moreover, the invention of marketable yarn paintings was far from casual. On the contrary, it was the outcome of more than thirty years of concerted effort on the part of Mexican politicians, bureaucrats, funding agencies, museum officials, anthropologists, and artists. All of these worked between 1920 and 1950 to develop marketable crafts that could be produced by indigenous communities. The Huichol were one of many communities that benefited from this concerted program.

In 1964, Soto Soria went on to curate an exhibit on Huichol culture for the new National Museum of Anthropology (Museo Nacional de Antropología) in Mexico City. According to the museum's archivist (Trini Lahirigoyen, personal communication), Soto Soria brought a group of Huichols from the Sierra to Mexico City to help construct the exhibits. Soto Soria also ordered a comprehensive set of yarn paintings from the Huichol. He particularly asked for a representative series with three examples of each type of yarn painting. Each design was sacred to a particular deity.

Judging by the catalogues, the yarn paintings of the 1950s and early 1960s were comparatively simple. Designs include a sun or spoked figure, two deer that may be facing each other or a spoked figure, an eagle with one or two heads, or a small group of animals such as serpents, birds, and deer. These designs are similar to the stone god disks and other offerings collected by Lumholtz and Zingg.

Within a few years, yarn paintings were filled with radically new images. The simple designs have continued to be used in small yarn paintings and often form part of larger compositions even today. But the 1960s also brought creative innovations in the range of designs and subject matter as well as the invention of a new visual vocabulary to express Huichol religious concepts.

Invention of a Visual Vocabulary: Ramón Medina Silva and Guadalupe de la Cruz Ríos

I was remarkably fortunate that Lupe was my first contact with the Huichol world. Lupe and her late husband, Ramón Medina Silva, were the first Huichol to become internationally known by name as individuals rather than as anonymous "folk" artists. They were key innovators in the process of transforming yarn paintings from small sacred offerings into elaborate paintings depicting ideas and stories from Huichol religion. Between them, Ramón and Lupe originated a visual vocabulary for Huichol beliefs. Their influence on subsequent artists was impressive. Here I will explore their life histories, their styles, and their creative influences.

I never met Ramón Medina, who died in 1971. My knowledge of him comes from conversations with Lupe and her family and from what other authors have written about him.

. . . .

Lupe and I were at her rancho in the hills outside Tepic. It was 1994. We sat on plastic mats on the ground, working on our embroidery. I asked Lupe how she and her husband had started making art. She began by telling me the story of her childhood and how she met and married Ramón.

Lupe was born near the Santiago River in the state of Nayarit. She thought her birth year was about 1918, just after the Mexican Revolution ended.[1] Her father was a Huichol from Santa Catarina named Humberto de la Cruz. Lupe's cultural roots (and three of her four grandparents) were from Santa Catarina, and Lupe spoke the eastern dialect of Huichol.

Lupe's mother, Jesusita Rosa Ríos, was from a well-known family of mixed Huichol and mestizo ancestry. The family was named "Ríos" because they lived along the Santiago River. The patriarch of the family, Inés Ríos, was born in about 1850 to a Huichol mother. He achieved fame as a mara'akame, a healer, and a mariachi musician. He passed on his skills to his children and founded a dynasty of Huichol mariachi musicians in the Santiago region (Jáuregui 1993).

When Lupe was growing up during the 1920s, the Santiago River region was remote and isolated backcountry. There were no roads, and it was a two-day walk along a narrow trail to the agricultural town of Tepic. Many Huichol refugees from different parts of the Sierra settled along the river. There was considerable intermarriage between people from somewhat different Huichol traditions and dialects. There were no schools for the Huichol, and there was relatively little interference from the government or the Catholic Church. Huichol was the main language. Families maintained a traditional cycle of fiestas, and people continued to go on pilgrimages to Wirikuta.

Lupe's parents arranged for her to marry when she was about thirteen, as was customary in Huichol families (Zingg 1938, 130–134). Lupe married a boy about her own age, but he died shortly after. From her description of how his foot swelled up after he cut it, he may have died of gangrene. A year later, Lupe was married to an older man as a second wife. The Huichol still practice polygamy even now, but Lupe said she did not want to be a second wife, and so she resisted this marriage. She never told me how it ended. When Lupe was about eighteen, probably sometime in the mid-1930s, she went with her sister Manuela to work in the fields on the coast of Nayarit. There she met her third husband, Ramón Medina Silva.

 Ramón came from the Huichol community of San Sebastián in the Sierra, and was born at a rancho called Las Cuevas. His Huichol name was Ürü Temai, meaning Young Arrow Person (P. Furst 2003, 34). According to Myerhoff (1968, 17; 1974, 31–36), his paternal grandfather was a mara'akame, and his mother had made many trips to Wirikuta. His father left the family while Ramón was still a child, and so the family was quite poor. To support them, Ramón began to work on mestizo haciendas in his teens. Both Ramón and Lupe were working as migrant laborers on the coast when they met.

Ramón was a year younger than Lupe, and she said that she was not interested in him because he was still a wayward young man.[2] However, Ramón held her tightly in his arms through a long night in front of the fire while he begged her to marry him. "What could I do?" she said to me. "I agreed to marry him."

For the next twenty years, Lupe and Ramón lived a fairly traditional lifestyle, farming and attending ceremonies in the mountains, or going to the coast to work. Their life changed and entered the historical record when they moved to Guadalajara in about 1961.

In the early 1960s, Huichol art was just starting to become popular. The Franciscan priests at the Basilica of Zapopan, a cathedral on the outskirts of Gua-

dalajara, were selling Huichol art to help support their missionary work in the Sierra. Ramón and Lupe moved to Guadalajara and began selling art through the basilica. According to Lupe, there were very few Huichol selling art at this time. They were almost the only ones.

The next part of the story comes from the American anthropologist Peter Furst. Furst went to Guadalajara as the director of the regional center of the Latin American Center at the University of California at Los Angeles (UCLA). A former journalist, Furst was finishing his doctorate at UCLA. He was researching the exquisite ceramic sculptures found in shaft tombs in Nayarit and Jalisco— the region inhabited by people who may have been among the ancestors of the Huichol. Furst told me that he was especially interested in shamanic themes used in the sculptures. One day, he saw a Huichol yarn painting in a government office in Guadalajara. He asked what it was, and was directed to the Basilica of Zapopan for more information. There he met Father Ernesto Loera Ochoa, a Franciscan priest who had an unusual affinity for Huichol culture. Padre Ernesto, as he was called, came from a well-to-do family in Guadalajara, and this may have protected him when he took the unusual step of allowing the Huichol to build a temple at the basilica.

In 1965, Padre Ernesto introduced Furst to Ramón and Lupe. Furst interviewed Ramón about Huichol shamanism, hoping to get some clues that might shed light on obscure elements in the shaft-tomb sculptures, such as the horns worn by some "warrior" figures. Furst said that, at first, he was mainly interested in seeing whether Ramón could help him interpret imagery in the shaft-tomb sculptures, and indeed, Furst's dissertation (1966) uses information from Ramón extensively.

Shortly after, Barbara Myerhoff arrived in Guadalajara. She was a young graduate student who was also working on a doctorate in anthropology at UCLA and looking for a dissertation topic. Ramón was proving to be a knowledgeable and enthusiastic source of information on Huichol mythology and shamanism. Furst and Myerhoff recorded Ramón's myths and stories. Their productive collaboration led to a considerable output of articles by both of them.

In 1966, they published the first article resulting from their collaboration with Ramón (P. Furst and Myerhoff 1966). The article, which analyzed myths about an evil sorcerer and plant spirit called Kieri, is illustrated with three yarn paintings by Ramón. It is the first article in English to discuss yarn paintings in depth.[3]

Ramón invited Furst and Myerhoff to accompany him on a peyote pilgrimage in the winter of 1966–1967. Their accounts of this pilgrimage were something

of an anthropological coup. Myerhoff's dissertation (1968) and Furst's articles (1972, 1975) are the first eyewitness descriptions of a Huichol peyote pilgrimage. While previous anthropologists, such as Lumholtz and Zingg, had discussed the pilgrimage, they had not personally experienced it. Myerhoff received her doctorate for her analysis of the pilgrimage and published the charming book *Peyote Hunt* (1974). In 1968, Furst and his wife, Dee, accompanied Ramón and Lupe on another peyote hunt. This time they made a film called *To Find our Life: The Peyote Hunt of the Huichols of Mexico* (P. Furst 1969). While Myerhoff died in 1985, Furst continues to publish material from this period (see, for example, P. Furst 2003, 30–46, 2006; Medina Silva 1996).

Ramón was in the process of becoming a shaman. His guide was Lupe's mother's brother, Don José Ríos Matsuwa, who was quite fond of Ramón. (José Ríos has since become well known as the mentor of American students of shamanism such as Joan Halifax, Brant Secunda, and Prem Das). Lupe herself began the process of becoming a shaman, and made her first pilgrimage in 1966.

Furst and Myerhoff described Ramón as the shaman who led the peyote pilgrimages they witnessed. There has been some controversy in the literature about whether Ramón was a shaman or not; in 1966, he had not completed the first five or six pilgrimages usually required (Fikes 1985, 54; 1993, 66–70). Lupe's family told me that Ramón's parents took him to Wirikuta when he was young. This is one way Huichol parents may single out and encourage children who show the potential to be a shaman; some develop shamanic powers while still in their teens. Therefore, when Ramón began the series of pilgrimages as an adult, he developed shamanic abilities very quickly.

Lupe's niece, Kuka González de la Cruz, told me that both she and Don José Ríos were on the 1966 pilgrimage that Ramón led.[4] I wondered whether José Ríos was really the one who had assumed the dangerous responsibility of caring for the pilgrims, while Ramón, with his greater cross-cultural fluency, had presented himself as sole leader. However, Kuka assured me that Ramón already had the ability to cure and that Don José considered him competent to lead a pilgrimage. Lupe and other members of her family also insisted to me that Ramón was a visionary—that is, he experienced shamanic visions, and these were the inspiration for the subjects he illustrated in his paintings.

Furst commissioned a collection of yarn paintings from Ramón on behalf of the UCLA Museum of Ethnic Arts. These paintings were exhibited at the Los Angeles County Museum of Natural History (P. Furst 1968–1969). The catalogue shows twenty paintings with associated texts. Furst's article from the catalogue

was later translated into Spanish, and the same twenty pictures were reprinted in the Mexican book *Mitos y Arte Huicholes* (P. Furst and Nahmad Sittón 1972).

Ramón and Lupe went to Los Angeles for the exhibition. They stayed with Barbara Myerhoff, who later told Richard DeMille (1980) how the couple adapted to U.S. life. Having never lived in a Western-style house before, they camped out on the floor and tried to build a fire in the living room. Myerhoff took them to a department store and found that all eyes went to Ramón, even though he was dressed in American clothes: "He had a presence that was extraordinary . . . the glance of kings . . . There are people who have this sense of another realm, and they move differently through this realm because of it" (DeMille 1980, 344). Myerhoff introduced Ramón to Carlos Castaneda, her schoolmate at UCLA and author of the much-disputed Don Juan "novels" about a Yaqui sorcerer. The two men took an immediate liking to each other because they were both "tricksters," and they spent a happy day together visiting power spots in the hills around Los Angeles.

Carlos Castaneda continued to visit Lupe in Mexico. When I asked Lupe what she thought of him, she commented that he was more interested in his books than in genuinely learning about Huichol shamanism. I feel that some of the characters and events in Castaneda's books were modelled on the Huichol rather than the Yaqui.

An analysis of Ramón and Lupe's paintings shows rapid evolution in design and subject matter. Within just a few years, Ramón and Lupe devised a new visual vocabulary in yarn painting. Ramón's early paintings were typical of the simple paintings made in the 1950s. He usually painted either a single object or a group of symbols such as "deer, flowers, eagles, butterflies, snakes, sun, moon, clouds, trees (P. Furst 1968–1969, 21–22)." These symbols were drawn from Huichol arts such as sacred yarn paintings, carved stone god disks, and weaving and embroidery patterns. Ramón called his early paintings *adornos* (Sp.: decorations). Although the symbols had religious significance, Ramón disguised their meaning because he felt the priests wanted to learn about Huichol culture only in order to change it (P. Furst and Myerhoff 1966, 7). Padre Ernesto had already persuaded Ramón to make yarn paintings that depicted "the characters of Huichol ceremony or tradition," but Furst (1968–1969, 22) maintained that Ramón continued to regard these paintings as purely decorative art without sacred meaning.

The first major innovation was the narrative yarn painting, which illustrates myths or traditional stories. Furst encouraged Ramón to make yarn paint-

ings that illustrated Kieri myths (Furst tape-recorded Ramón's accounts of the myths; see P. Furst and Myerhoff 1966). Ramón produced three paintings: a woman being tempted by Kieri; the deer god Tamatsi Kauyumari shooting Kieri with an arrow; and Kieri in his death throes.[5] These paintings seem to be the first yarn-painting representations of people and deities carrying out activities in a story. The relatively few figures or objects in each painting are those central to the narrative, such as a kieri plant, a fox, and a takwatsi. The landscape is suggested in two paintings, which show the rocks of a cliff or hill. However, these landscape elements are very roughly indicated by geometric blocks of colored yarn, and the figures mostly seem to float in space.

The second innovation in the Kieri paintings was the depiction of a simple stick figure as an actor in the drama. A human stick figure was not new; it is used in several traditional Huichol arts. Lumholtz (1900, 105) illustrated a small embroidered offering of a person with arms upraised. Human stick figures were also represented in front-shields, made by wrapping colored yarn around sticks of split bamboo (Lumholtz 1900, 109, 117, 119). However, in the older arts, the human figure appeared as a single symbol or one of a group of symbols rather than as an actor in a story.

Ramón expanded his range of subjects in the next group of paintings commissioned by Furst (1968–1969). Some paintings illustrate more myths, such as a myth of the origin of the sun, or of how the Huichol acquired maize; other paintings branch out in new directions. Four paintings (P. Furst 1968–1069, 20; there is a similar painting in Berrin 1978, 163) illustrate the Huichol funeral ceremony and the journeys of the soul after death. Another painting shows the journey of a mara'akame's spirit after death (P. Furst 1968–1969, 19; 2006, cover).[6] These might be considered depictions of ongoing events in the supernatural world rather than myths per se. That is, the paintings show what is presumed to happen to the human soul after death. Since the Huichol believe that the soul travels after death, a depiction of its journey is not mythological or folkloric. It is an effort to show activities, invisible to most of us, happening in the supernatural world.

Another painting is of Tatewari, the fire god (P. Furst 1968–1969, 19; for a similar painting, see Berrin 1978, 139). Lupe told me that this painting represents a vision of how Tatewari appears when shamans are communicating with him. He shows himself as a head or face with glowing eyes among the coals.

These paintings begin to render the world as a shaman might see it. We might call this "nonordinary reality," as opposed to the everyday reality that

most people perceive. Harner (1980, 26–27) calls this the world as seen in a shamanic state of consciousness. Whatever term we use for it in Western science, the fact is that the Huichol illustrate it in some of their yarn paintings. Ramón Medina seems to have originated the use of yarn painting to depict nonordinary reality.

The representation of shamanic perception in yarn painting became even more explicit in four paintings made after Furst and Myerhoff accompanied

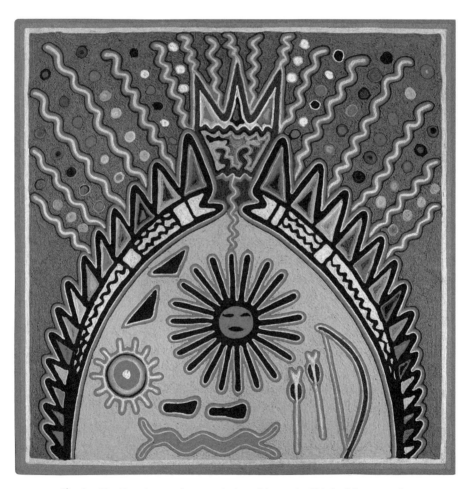

Fig. 6.2. Urra Temai, an early yarn painting of the myth of birth of the sun god at Reunar, c. 1975. 24" x 24" (60 x 60 cm). Multicolored rays of life energy (kupuri) radiate from the volcano, which is in Wirikuta. Photo credit: David E. Young.

Ramón and Lupe on a peyote pilgrimage (P. Furst 1968–1969, 23). Three paint-
ings show a human interacting with events or deities in the spiritual world. In
The Hunt for the Peyote in Wirikuta, Ramón ritually shoots peyote with an arrow. The
life force of the peyote, called "kupuri" in Huichol, rises in a fountain of colors,
an event that Ramón said he saw on a visionary level (Myerhoff 1974, 154). This
painting is important because it created a visual vocabulary for the Huichol con-
cept of kupuri, which is an aspect of the soul. Two paintings (Berrin 1978, 66–67)
show Myerhoff and Furst receiving the names of deities. Ramón said these were
shamanic dreams he experienced. The fourth painting is of a peyote vision, as
Furst (1968–1969, 23) explained:

> The individual experience of the "dreams" or visions induced by the peyote
> are [sic] considered to be too sacred to be discussed or shared . . . Neverthe-
> less, Ramón agreed to try to translate some of his peyote "dreams" into picto-
> rial form . . . In this yarn painting Ramón shows how he experienced the fire,
> *Tatewari* . . . The fire is shown exploding in a shower of multi-colored flashes and
> rays of great brilliance and luminescent splendor, each ray dissolving into its
> component colors. Below ground are *Tatewari*'s "roots," above, the night sky—a
> deep blue shot through with fiery reds—is turned into a blinding yellow, the
> color of the noonday sun in the desert sky.

Ramón's yarn paintings are the first to represent ordinary beings and objects
simultaneously with beings that exist in the alternate reality. That is, ordinary
humans and everyday objects are shown alongside deities and events that can
be seen only with shamanic vision. The two forms of reality are shown in the
same style, a flat, slightly cartoonlike idiom, all on one plane.

Ramón Medina developed a visual language for the Huichol cosmological
view of the world, one in which things of the spirit and things of the everyday
exist simultaneously on the same plane. The two forms of reality interpenetrate
each other just as, in the yarn paintings, the images of humans and deities in-
teract with each other. Subsequent artists would build on this method of de-
picting nonordinary reality.

Lupe claimed to me that many paintings attributed to Ramón were made by
both of them. She said that it was she who taught Ramón how to make crafts,
including yarn paintings. Lupe said she learned skills such as embroidery and
weaving as a child. She remembered fasting all morning as a young girl while
she practiced a new embroidery pattern; that way, she said, she would learn it
quickly and not forget. I was unable to confirm Lupe's claim directly. However,

Furst (personal communication) confirmed that she filled in the backgrounds of Ramón's paintings. Some paintings have been attributed solely to Lupe, and Lupe continued to make paintings after Ramón's death.

Lupe originated what I think of as the first "feminist" yarn painting. *How the Husband Assists in the Birth of a Child* shows a man in the rafters of a house, a cord tied to his testicles. As the woman delivers the child, she pulls on the cord "so that her husband shared in the painful, but ultimately joyous, experience of childbirth" (reproduced in Berrin 1978, 162; MacLean 2001b, 72; MacLean 2005b, 34). There has been some question about what custom this painting refers to, since there is no record of the Huichol practicing this custom. Schaefer (1990, 204–205) records that she could not find anyone who knew of the practice and cites a personal communication from Furst, who said that it might come from an old trickster legend about Tamatsi Kauyumari. Whether it refers to a myth or a practiced custom, the image of a woman—usually a goddess—giving birth has become popular. The Huichol artist Fabian González Ríos told me "*la mujer dando luz*" (Sp.: the woman giving birth) was his best seller, and I photographed many versions of it.

A tension between innovation and conservatism pervades Ramón and Lupe's work. They introduced new images and themes to yarn paintings, such as the depiction of myth and vision as well as abstract concepts such as kupuri. At the same time, they drew on a vocabulary of images already existing in Huichol art, such as stick figures, geometric shapes, and rows of repeated figures. Their figures are outlined in one color, then filled in with a second color. The backgrounds are filled in with large expanses of solid color, and often only one or two colors are used. In the 1960s, the painters used comparatively thick wool, so there was not much space for elaborate detail.

The compositions in their paintings are often based on strong geometric shapes, such as circles or triangles, which organize the other figures in the paintings. For example, a triangle dominates *The Dead Soul's Journey to the Spirit World*. Circles dominate two paintings illustrating punishments for sexual offenses (P. Furst 1968–1969, 23).

Lupe and Ramón also built on one of the most important traditional compositions—rows of repeating figures. Rows of repeated figures are a basic design used constantly in backstrap loom weaving, beaded jewelry, and embroidery. For example, a woven belt may have rows of deer, birds, flowers, or twining vines. An embroidered pouch may have rows of peyote or animals, and most

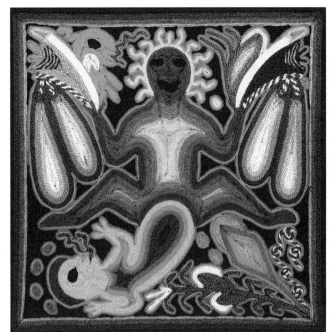

Fig. 6.3. Santos Daniel Carrillo Jiménez, yarn painting of a goddess giving birth to humanity, 2005. 8" x 8" (20 x 20 cm). Although this is a popular theme in commercial paintings, it is not found in sacred paintings. Photo credit: Adrienne Herron.

embroidered clothing has bands of flowers, stars, or peyote around the hem or along seams. Some figures are identical; others vary somewhat.

In Lupe and Ramón's paintings, the rows of repeated figures are used dramatically. For example, a painting by Ramón shows a repeating row of little girls and little boys attending the Drum Ceremony (MacLean 2001b, 69). *Sacred Colors of Maize* by Lupe shows a repeated row of corn plants (Berrin 1978, 159). Lupe's painting *Peter Furst Receiving the Name of a Deity* has a geometric border of triangles, much like the geometric designs used in women's embroidery (Berrin 1978, 67).

Artistically, there is considerable development in Ramón and Lupe's paintings, from a few crudely drawn figures floating in space in the Kieri series to the considerably more sophisticated paintings of dreams and visions experienced during the peyote hunt.

As graphic art, their work is powerful and still viable in the contemporary marketplace. Ramón and Lupe's designs have been used on book jackets (Berrin 1978; P. Furst 2006) and on T-shirts, which sell briskly in airports and tourist centers.

The style originated by Ramón and Lupe dominated yarn paintings in the 1960s and 1970s. Many painters used their style or directly copied their paintings. Even today, I have seen copies of their paintings made by other Huichol for sale at the Basilica of Zapopan in Guadalajara and the Nayarit state government shops in Tepic.

Lupe's family also continues to sell copies of their designs and regard them as part of their family heritage. In a way, their attitude is like the Huichol view of embroidery designs. Designs are "owned" by particular women and their families, and women decide to whom they will give or teach the designs. It is customary to give a gift or payment in exchange for learning a new design. Some women even go so far as to wear their embroidered clothes inside out so that other women will not copy their designs without their permission.

The Huichol do not particularly value originality in art, which is a Western aesthetic concept. They are quite happy to reproduce successful or well-liked designs, though they may vary the colors and designs to suit their personal taste. This tendency to copy dismays some art dealers, who want to assure Western buyers that their paintings are "originals."[7]

There is no doubt that Ramón and Lupe were creative innovators. They played an important role in the commercialization of Huichol art, taking it from a simple repetition of symbols to elaborate paintings showing narrative and even visionary events. Nonetheless, Westerners played a part in the transition, just as they had done during the earlier period when Alfonso Soto Soria and Augustín Yáñez helped transform sacred offerings into gallery art. Padre Ernesto may already have begun to encourage the making of mythological yarn paintings before Furst got involved. The anthropologists Furst and Myerhoff introduced the idea of narrative painting and fostered Ramón and Lupe's creativity by purchasing the results.

By 1967, the Mexican government was becoming interested in promoting yarn paintings. Stromberg (1976, 156) explained that the government was especially interested in the art of northern Guerrero and the Huichol because their "somewhat psychedelic quality" was in harmony with the artistic theme of the Summer Olympics, staged in Mexico City in 1968.

Nevertheless there was concern that commercialization was already starting to corrupt Huichol art (P. Furst 1968–1969, 21). Imitation Huichol art was diverting revenue from Huichol artists to mestizos. Some entrepreneurs were encouraging the Huichol to make tourist souvenirs, such as Mickey Mouse and Donald Duck yarn paintings (Enfield Richmond de Mejía, personal communi-

cation). To preserve high quality and traditional workmanship in yarn paintings, the Instituto Nacional Indigenista invited Ramón Medina to come to Tepic and teach yarn painting to the Huichol living there. Ramón and Lupe had just been evicted from their small rancho north of Guadalajara as the city expanded around them. They moved back to the Sierra (P. Furst, 1968–1969, 18; 1978, 30), then accepted the INI's invitation to move to Tepic.

Shortly after their move, Ramón met the Mexican journalist Fernando Benítez, who was writing a series of books on Mexican Indians called *Los Indios de México*. Benítez (1968, 353–382) wrote that in November 1967, he received a telephone call from Salomón Nahmad Sittón, the director of the Cora-Huichol Center of the INI in Tepic, telling him that a good Huichol consultant had become available. Benítez immediately took a plane to Tepic, where he met Ramón. According to Furst (2006, 112), Benítez hired Ramón as a guide and interpreter. Ramón invited Benítez to a fiesta at his mother's rancho at Paso del Muerto along the Santiago River. Benítez's account of this rather unhappy visit sheds light on Ramón's character, expanding on Furst's somewhat guarded references to Ramón's less than desirable qualities.[8] Ramón, who had taken a second wife, was spending his money literally on wine, women, and song, hiring Mexican musicians to play at the fiesta and drinking heavily. In the uproar, Lupe left him and moved to Tepic, resolving to start a school for teaching crafts with several other women. However, shortly after, Benítez met the couple in Tepic and commented that they were apparently reconciled.

Benítez (1968) devoted one volume of his five-volume series to the Huichol and the Cora. Like Furst and Myerhoff, he relied heavily on Ramón for mythological information, although he accompanied a different group of Huichols on a peyote pilgrimage. Benítez commented that Ramón was a good source of information, and he illustrated his book with three yarn paintings by Ramón (Benítez 1968, 514, 529, 577).

Furst said that the INI had asked Ramón to teach yarn painting in a school setting, but I did not find much evidence of his activity there. I spoke to one Huichol artist, Fabian González Ríos, who attended the government school. He told me that Ramón was not involved when he was there and that the school was directed by the Mexican anthropologist Miguel Palafox Vargas. Furthermore, Fabian said that most of the students were mestizos who knew nothing about Huichol customs, and so they could paint only things they knew, such as cows and pigs. Perhaps the government school took in mestizos because the Huichol were not particularly interested in this form of teaching. My interviews

with other artists show that most Huichol did not learn through the INI school. Many Huichol began to make yarn paintings in the late 1960s, but they learned by apprenticing themselves to other Huichol artists.

A number of artists learned yarn painting from Ramón Medina and later from Lupe, during the late 1960s and early 1970s. Many of their students were, in fact, their relatives, either through kinship or marriage, or else they came from the same communities. Guadalupe González Ríos and his brother, Fabian González Ríos, were *primos* (cousins) of Lupe through the Ríos family. José Benítez Sánchez was a primo of Ramón Medina through family in San Sebastián. Cresencio Pérez's brother was married to one of Lupe's sisters, and Domingo González was married to another sister. Chavelo González was married to Lupe's niece. Eligio Carrillo came from the same region as the Ríos family and became a *compadre* of Ramón and Lupe. Many of these students have, in turn, become leading yarn painters.

Ramón died in 1971. He was shot during a fiesta in a dispute over a woman. Afterward, Lupe continued to support herself by making crafts. As a result of their contacts and publicity, Lupe had large orders for yarn paintings from museums and buyers in the United States. She hired Eligio Carrillo to work with her. She had photographs of paintings by Ramón, and she asked Eligio to help make copies of Ramón's paintings for her to sell. Some of the paintings attributed to Lupe may, in fact, have been made by Eligio Carrillo or by other apprentices who worked with her during the 1970s.

A large collection of paintings was purchased from Lupe by Peter F. Young. They are now in the San Diego Museum of Man (Grace Johnson, personal communication), and the records show they were purchased between 1972 and 1974. I have reproduced seven paintings from this collection in books and articles (MacLean 2001a, 2001b, 2005b). Some are variations of paintings by Ramón, while others appear to be original. These may be the paintings that Eligio helped Lupe make.

During the 1970s, Lupe gradually sank into poverty and obscurity. She was crippled by what may have been arthritis in her knees, and she spent all her money seeking cures from shamans. Many of the buyers and contacts seem to have been friends of Ramón's. They formed associations with other Huichol families, and she did not see them again after a while. In 1988, her fortunes took another turn when Edmond Faubert took her and her family on a trip through Canada and the United States to visit Indian reservations. It was on this trip that I first met her.

In the 1990s, she traveled in Canada and the United States and acquired new friends in places like California and New Mexico. These friends helped her and her family by buying crafts from them, an extremely important consideration for impoverished indigenous people. In return, she taught them about Huichol culture and performed basic healing ceremonies. When visiting indigenous communities, she promoted the importance of retaining their culture and traditions. Her health continued to deteriorate. Her family told me that she developed liver cancer, and she died on 9 May 1999 at the age of eighty-one. She was buried at her rancho outside Tepic.

Early Artists from Other Regions

While Lupe and Ramón were influential among Huichol in the state of Nayarit, Huichol artists from other parts of the Sierra were making crafts for sale as well. Several artists told me that during the late 1960s and 1970s, there were houses in both Guadalajara and Mexico City where Huichols could stay when they came to the city. The house in Guadalajara was run by the Franciscans of Zapopan. The house in Mexico City was sponsored by a government department that wanted to encourage Huichol artists, but the artists were not sure which department it was. The artist Miguel Carrillo Montoya told me that when he lived in the house in the 1960s, it was the building near the Zócalo now occupied by the Museo Franz Meyer.

The houses seem to have functioned as centers for apprenticeship where Huichol could teach one another and so spread the knowledge of how to do yarn painting. Several artists from the Chapalagana communities told me how they had learned to make crafts in these houses. Here I will tell the story of two of these young artists: Alejandro López de la Torre and Santos Daniel Carrillo Jiménez. Their accounts give a picture of what life was like for young Huichol who came to the city and of how the knowledge of yarn painting was passed down to them.

Alejandro López de la Torre

Alejandro López de la Torre is from Santa Catarina. He was born in Nueva Colonia in 1955. His family lived in the *barranca* (Sp.: canyon, that is, the region below the pine-forested heights of the Sierra), and there were no Huichol living in Nueva Colonia then. When he was a child, he said there were no schools. The first Huichol schoolteacher arrived in 1967, when he was about twelve. The teacher opened a school in Nueva Colonia. Alejandro's father sent him to the

school, where he stayed for about one year. The Huichol parents donated blankets and food to maintain the school; now the government supplies them. Alejandro's teacher was also responsible for resolving land-tenure problems. He was preparing a plan to ensure that no mestizos could invade the comunidad and was trying to secure titles to protect Huichol land. Therefore, he did not have much time for teaching and often was in school for only a week or two before leaving again. As a result, Alejandro did not learn much in the school.

The artist Miguel Carrillo Montoya, who attended the school at the same time as Alejandro, confirmed Alejandro's statements about the teacher's role. He told me that the teacher's name was Augustín Sandoval and that Sandoval left (or perhaps was forced to leave) the Sierra; as of 1996, he was living and working as a healer in Durango.

The following year, when Alejandro was about thirteen, his father took him to the coast of Nayarit to work in the fields. The whole family made the journey, which required a week of walking west through the mountains. His father knew how to make bead earrings, rings, and bracelets, so he bought Alejandro some beads and taught him the craft of beading. Then Alejandro went to Guadalajara, where he sold beadwork and learned how to make god's eyes. This was in about 1969. He lived in Zapopan on the outskirts of Guadalajara, where a priest (probably one of the Franciscans) had donated a house with many rooms and a patio. Many Huichols arrived from the Sierra and stayed there to work on crafts. Alejandro started helping an artist from San Sebastián who was making yarn paintings. Someone had ordered a huge painting, and his teacher asked him to help make it, but Alejandro just filled in the background. The following year, Alejandro went to Mexico City, where he spent the years from 1971 to 1975, and supported himself by making crafts. Then in 1975, he began to work with the artist Mariano Valadez, helping him make yarn paintings by filling in backgrounds. After working with Mariano, he developed the skill to make yarn paintings on his own.

Alejandro returned to Santa Catarina in 1985. In the late 1980s, he travelled to San Diego and Santa Fe at the invitation of Susana Eger Valadez, where he performed dances and demonstrated yarn painting. When I met him, in 1993, he was operating a grocery store out of his home and selling crafts. He was taking on progressively more responsible *cargos* (positions) in community administration, as well as temple *cargos* in pilgrimages to Wirikuta. In 1997, I saw him in Toronto, where he had travelled on an intercultural exchange program. Thus, he combines traditional life in a Sierra community with international travel as an artist.

Alejandro remembers that when he was young, he did not have any understanding about the Huichol religion or traditions. He wasn't interested in explanations of the paintings. Since he had no ideas of his own, he just sold the paintings "as though they were apples." As he grew older and began making pilgrimages, he became more interested in the paintings' meanings. Through his *cargos*, he began to understand the concepts underpinning the religion, and the reasons the Huichol sacrifice themselves by fasting and undertaking arduous pilgrimages. Now he tries to present this knowledge in the yarn paintings he makes, and he tries to explain the paintings to any buyers who ask about them.

When I met Alejandro in 1993, he was not a mara'akame. He began the process of becoming a shaman and made the necessary pilgrimages to Wirikuta for five years. Unfortunately, he said that the gods did not grant him the abilities he asked for. Now he is more interested in understanding Huichol philosophy and learning explanations of the stories and images that are presented in yarn paintings. He is equally interested in learning about the customs of other indigenous peoples.

Santos Daniel Carrillo Jiménez

The artist Santos Daniel Carrillo Jiménez is another artist who left the Sierra as a youth and lived in Mexico City. Santos, who is from San Andrés, was born in about 1964. His father was a mara'akame, and Santos participated in all the ceremonies as a boy. In 1977, when he was about thirteen, he left San Andrés with an uncle to work in the fields on the coast of Nayarit. One day, he went to a nearby town to have fun at a fair. There he met a Huichol friend who told him that they could make a lot of money in Mexico City and that people were practically giving money away in the streets. Santos joked that he thought that sounded wonderful. So after persuading his uncle to give him his wages, he paid for two tickets to Mexico City. Then his friend asked him to pay for materials for yarn paintings—wax, three-ply boards, and Colibrí (Hummingbird) brand yarn. Santos watched his friend make paintings and began to learn how to do them. Then his erstwhile friend vanished suddenly, taking the paintings and materials with him.

Santos stayed on in Mexico City in a house where there were a number of Huichols making crafts. Since Santos did not really know how to make any crafts, he would take ten or twenty god's eyes to sell on the street, then bring the money back to the owner, who would give him a few *centavos* for himself.

One day a Huichol from Santa Catarina came by and persuaded Santos that he should learn to paint with wool and beads. Santos learned from him, but said that the resulting paintings were not very good. Santos intended to stay in Mexico City. He had registered in an elementary school for adults because he loved to study. Then in 1978, his father sent Santos's brother to retrieve him. His father invited Santos to go on the pilgrimage to Wirikuta, and Santos went two times.

The following year, when he was fifteen, Santos began primary school in the Franciscan convent in Santa Clara, a village close to San Andrés. He spent the next few years in school in the Sierra and forgot about art. He stayed five years at the convent, then finished sixth grade in the government school in San Andrés. This completed his primary education, but he wanted to learn more, so he went on to secondary school in Guadalajara. While there, he got married; needing money, he began to make yarn paintings again. He has been making them on his own for more than twenty years and is now one of the top-ranked artists, according to the dealers.

Santos now lives in Tepic. He maintains close contact with friends and relatives from San Andrés, who are constantly visiting on their way to and from the Sierra. After continuing his studies in an extension program, he finished *preparatoria* (similar to high school graduation), a comparatively high level of education among the Huichol. His goal was to become a schoolteacher, but he found the jobs were scarce and poorly paid. For a while, he supplemented his income as an artist by working as a night watchman.

He wants to stay in Tepic so that his children can get a good education, but costs are high for rent, food, and school fees. Some Huichol artists are returning to the Sierra, where it is cheaper to live, and Santos has considered making the move as well.

The stories of Alejandro and Santos illustrate typical career paths for artists who started making yarn paintings in the 1960s and 1970s. As I interviewed more artists, I found that several themes were repeated.

One theme is the casual, almost accidental way that young Huichol learned to make yarn paintings. Many artists mentioned similar experiences: at some point, they encountered a teacher who knew how to make paintings and who encouraged them to learn. Their stories emphasize the importance of transmission from one Huichol to another.

Their stories also challenge the idea that the early yarn paintings were made only by acculturated Huichols who lived in the cities and who had no roots in the culture (Weigand 1981, 17–20). On the contrary, all the artists whom I inter-

viewed and who began to make paintings during this period grew up within the culture. They had parents or family members who were mara'akate. They had learned the myths and ceremonies as children and then used this knowledge as a basis for their paintings. Many spoke only Huichol as children.

Formal schooling can be a major force for acculturation among Native peoples. Therefore, I asked whether these artists had attended school as children. Only two had, and those two only for a year. Several artists began attending schools as older teenagers or young adults, doing so willingly because they wanted to learn. Most others had never attended school and were illiterate. Therefore, schooling per se does not seem to have been a major force for acculturation during this early period.

While urban living can be a cause of acculturation, it should not be used as the only indicator of cultural change. It is possible to live in a city for many years yet remain relatively uninvolved in the dominant urban culture. Nor is it necessarily true that a Huichol artist who lives in a city for a time will lose his or her culture. The reality is that there is a great deal of movement back and forth between the Sierra, the coastal agricultural region, and the cities. It is quite common for artists to commute regularly outside the Sierra to work, or even to live for a few years in the city, and then to go back to the Sierra.

A tendency to move around may well be a traditional Huichol custom. The peyote pilgrimage involves a long trip across the central desert of Mexico. Weigand (1975, 20) suggests that the Huichol were once travelling traders who moved caravans of salt, feathers, shells, and peyote back and forth between the Pacific Ocean and the desert of San Luis Potosí. I have seen Huichol who were deeply engaged in a ceremony in the Sierra a week earlier calmly demonstrating art for tourists in Puerto Vallarta. They seem to move back and forth between two worlds rather than lose one when they take part in the other.

The artists' stories also demonstrate the economic value of art for young Huichol. As indigenous people with little or no education, the artists had few options for making a living. Most started out working in the fields, doing physically taxing work for low pay. Art gave them a career path outside of field labor, and a way of supporting themselves in the cities (although one wonders whether they could have supported themselves fully without the free rent provided by institutional donors such as the church or the government). It is not surprising that many young Huichol began to consider art as a career during the 1970s.

Making art was also a career path that brought some respect and acceptance within Mexican society. Prejudice and discrimination toward indigenous peo-

ple is still widespread in Mexico, as I can attest after having travelled with the Huichol. Even now, I have seen Huichol ejected from stores and restaurants and pushed out of their seats on buses. Therefore, artists appreciate buyers' praise, people's interest in the stories, and the validation of their culture and ethnicity.

Some artists were prompted to learn more about their culture at least partly because of buyers' interest in it. They began to explore the mythology and ceremonies in order to improve their art. For some, the result was a stronger commitment to traditional values rather than a movement away from the culture. For others, the art may at least have stimulated an interest in the culture, although their motivation may have mainly been commercial.

Exhibitions and International Recognition

By the early 1970s, yarn painting was becoming more widely known. Several authors helped promote the art. In 1969, Alfonso Soto Soria published a second article on the Huichol in the popular Mexican magazine *Artes de Mexico*. The cover featured a yarn painting of a shaman conducting a ceremony. In 1972, Furst and Salomón Nahmad Sittón published *Mitos y Arte Huicholes* in Mexico; the book contained color reproductions of the Ramón Medina yarn paintings collected by Furst. Then in 1974, *Artes de Mexico* published two full issues on Huichol art and culture, both written by Mexican author Ramón Mata Torres.[9] One issue included a short article on ceremonial art forms and commercial yarn paintings as well as yarn-painting illustrations. Unfortunately, the artists of the paintings were not identified. Mata Torres (1980, 31) noted that commercial yarn paintings were an urban phenomenon and that he saw only small sacred paintings in the Sierra.

During the 1970s, there was a new effort to move commercial production of arts and crafts into the Sierra communities. The impetus came from Plan HUICOT (Huichol-Cora-Tepehuan), a government development project that opened up the previously inaccessible Huichol Sierra. In 1993, I interviewed Alfonso Manzanilla González, formerly the executive coordinator of the program. He provided me with a mimeographed copy of the final report on the program (Manzanilla n.d.) and many helpful insights into its activities. The following description is based on this interview. The skeptical comments on development are my own.

Plan HUICOT was part of an even larger program known as Plan Lerma, conceived in the 1950s and taking more than half a century to come to fruition. I

will jump forward in time for a moment here. Plan Lerma is the ongoing Mexican government plan to develop the Santiago (or Lerma) River system, which includes several rivers draining the Sierra, such as the Huaynamota, Chapalagana, and Bolaños Rivers. In the mid-1990s, the government built a gigantic dam on the Santiago River, called the Presa de Aguamilpa. It is one of the largest dams in North America and a major source of electricity exported to California. The government intended to make the reservoir behind the dam into a tourist resort comparable to the recreation area surrounding Lake Mead in the United States, but so far has not succeeded in encouraging much tourist development except for a few seedy restaurants at the boat launch. A second huge dam, named El Cajón, was completed in 2006; it lies farther up the Santiago River in the heart of what have been isolated Huichol communities. These projects have been funded by the World Bank, despite heavy criticism and belated recognition by the World Bank itself that dam megaprojects are almost inevitably expensive disasters for the environment and for surrounding populations. If the planned tourist resorts materialize, the Huichol may end up as golf caddies and hotel chambermaids in their formerly isolated homeland.

Plan HUICOT preceded the building of these dams. The plan, which operated in the early to mid 1970s, was a massive effort by the Mexican government to develop modern services in the indigenous communities of the Sierra. Alternately, Plan HUICOT can be seen as an effort to create economic participation and dependency among people who up until then had little interest in the products of a Western economy. Even now, the Huichol buy remarkably few consumer goods, limiting their consumption to a few products such as soap, bleach, cotton *manta* cloth, beads, acrylic yarn, and the occasional bottle of Coca-Cola.

The government built an access road through the north end of the Sierra from Valparaíso to Ruiz; this road opened the Huichol community of San Andrés to vehicular traffic. Land for airstrips was bulldozed in a number of communities. The government also brought in services such as subsidized grocery stores (CONASUPO), radio, electricity, and potable water systems, as well as health clinics, day schools for lower elementary grades, residential schools with dormitories for higher elementary grades, and agricultural instruction for adults.

There were some efforts to foster the production of commercial arts and crafts in the Sierra, but generally crafts had a relatively low priority in Plan HUICOT, according to Manzanilla. Perhaps more influential was the improved access to the Sierra, as well as the novelty of being able to visit there. In the mid-

1970s, during the heyday of Plan HUICOT, planes flew in and out of the Huichol Sierra almost daily. One man from Nueva Colonia told me that it was easy to visit San Andrés because planes went back and forth so often carrying government officials and hitchhiking Huichols. Now communication is more difficult than it was then because few planes are flying in or out; sometimes there are none. Now everyone has to walk or go by vehicle.

The Mexican government's craft-marketing agency (Fondo Nacional para el Fomento de las Artesanías, or FONART) began flying into the Sierra to purchase crafts. Some observers commented that FONART contributed to a decline in quality of the crafts because it purchased almost everything that was offered, regardless of quality. Several Westerners who moved to San Andrés during this period also helped make it a center for the production of arts and crafts. In particular, two Americans—Peter Collings and Susan Eger—supplied materials, encouraged the Huichol to do higher-quality work, and marketed the products.

With the new air and road transportation, it became possible to make yarn paintings in the Sierra and ship them out. Nonetheless, it does not appear that many yarn paintings were made in the Sierra. Muller (1978, 96) discusses governmental efforts to foster a commercial arts-and-crafts program, but notes that yarn paintings were seldom made in the Sierra because of the cost of transporting the heavy plywood.

Even today, my observation is that most artists do not try to make yarn paintings in the Sierra and carry them out. The plywood is too heavy to carry in any quantity, and the paintings are too fragile. I met one artist who made yarn paintings in the Sierra, but he lived in Nueva Colonia at the end of one of the few roads. Most Huichol live farther down narrow mountain trails, where the only transportation is by foot or animals. Instead, artists from the Sierra go to the city to make yarn paintings. There, they can buy materials, sell the paintings, and then go back to the Sierra with needed cash or goods. Because beadwork and textiles such as embroidery and weaving are lighter to carry, they tend to be made more often than yarn paintings in the Sierra.

In the 1970s and 1980s, a growing Mexican and international excitement about Huichol arts was fostered by gallery and museum exhibitions. An exhibition of Huichol art was held in 1975–1976 in California (Sacramento and San José). The exhibition was curated by Juan Negrín Fetter and featured work by José Benítez Sánchez (Huichol name: Yucauye Kukame) and Tutukila (Spanish name: Tiburcio Carrillo Carrillo). Negrín mounted further exhibitions in Guadalajara, Mexico City, and Europe and published several books, articles, and

catalogues featuring Benítez, Tutukila, Juan Ríos Martínez, Guadalupe González Ríos, and Pablo Taisan (Huichol name: Yauxali); for descriptions of these exhibitions, see the accounts by Negrín (1975, 1977, 1979, 1985, 1986).

In 1978–1980, the Museums of Fine Arts in San Francisco sponsored a major exhibition of Huichol arts, which also toured to Chicago's Field Museum and New York's Museum of Natural History.[10] The exhibition included artifacts collected by Carl Lumholtz in the 1890s and Robert Zingg in the 1930s as well as contemporary Huichol crafts. The Huichol artist Mariano Valadez demonstrated yarn painting on-site, and his then wife, Susana Eger Valadez, answered questions (Berrin and Dreyfus n.d.).

The catalogue for this exhibition, *Art of the Huichol Indians* (Berrin 1978), is a superb source for photographs of traditional and modern Huichol arts. Unfortunately, as Berrin explains, a decision was made not to illustrate many modern yarn paintings because they are not, in themselves, sacred objects used by the Huichol, although they do illustrate sacred stories or mythology (1978, 14). The catalogue presents yarn paintings by five early artists: Ramón Medina Silva, Guadalupe de la Cruz Ríos, José Benítez Sánchez, Cresencio Pérez Robles, and Hakatemi (whose Spanish name is not recorded). Furst (1978), in an article in the catalogue, describes his collaboration with Ramón Medina.

During the 1970s, some smaller exhibits of Huichol art were organized, perhaps through local art galleries and museums. Several artists told me that they had participated in tours to the United States and Canada, but there is little reference to most of these exhibits in the literature. In September 1978, Stacy Schaefer curated a small exhibition of Huichol art, including yarn paintings, at the University of California, Santa Cruz. The catalogue (Schaefer 1978), entitled *Las Aguilas Que Cantan: The Eagles That Sing*, shows paintings by Eligio Carrillo, Raymundo de la Rosa, Fidela de la Rosa, and Martín de la Cruz.

A collection of forty paintings was purchased in Tepic in 1977–1979, and exhibited in Vancouver in 1980. The collection provides a valuable record of the types of paintings produced in the late 1970s. Although only a photocopy of the catalogue (Knox and Maud 1980) is available, it illustrates the paintings in black and white and gives the artists' names, the Spanish text written on the back of each yarn painting, and reasonably accurate English translations.

Nancy Parezo calls the twenty-year growth in popularity of Navajo sand paintings one of the quickest rises of a craft on record (1983, 189). Clearly, yarn paintings had a growth in popularity that was equally meteoric. In just twenty years, yarn paintings were transformed from a little-known religious offer-

ing to a commercial product sold on the world market. In 1950, the paintings were made only as religious offerings. Commercial painting did not begin until the mid-1950s. By the late-1970s, yarn paintings were being exhibited and sold around the world.

Both Huichol artists and non-Huichol supporters have played a part in this growth. Westerners recognized the commercial potential of the art, created opportunities for the artists to sell their art, and promoted the art commercially. Anthropologists such as Soto Soria, Furst, and Myerhoff brought the art to public attention by exhibiting and writing about it. The Franciscans of Zapopan and governmental officials of the INI marketed the art and established workshops to encourage the artists to teach other Huichol. Huichol artists such as Ramón Medina and Guadalupe de la Cruz Ríos responded to this encouragement with consistent creativity and innovation. They saw the opportunities that these new markets provided their traditional art forms, and they evolved an art that was able to transcend cultural barriers and appeal to buyers around the world.

footprints of
the founders

The birth of many indigenous art forms is lost in time, and so we know little about their evolution. This is not so for Huichol yarn paintings. Because the origins of commercial yarn painting are so recent, it is still possible to trace the footprints of its founders. We can ask such questions as who were the innovative artists? How did popular themes and designs originate? How did unique and recognizable styles arise? With some detective work, it is still possible to find and interview the original artists or those who knew them. Through collections of yarn paintings—some published in catalogues, some in museums or in private hands—we can trace the point at which new ideas may have entered the yarn-painting repertoire.[1]

Little has been written about the evolution of yarn painting, and so my research is a first attempt at reconstructing a history. It is not always possible to be precise. Sometimes one can say only that a particular theme seems to have entered the repertoire during a certain decade, since that theme does not appear in earlier paintings. New information, or the emergence of new collections, could change the chronology and bring into focus other significant artists.

The 1970s and 1980s saw a steady growth in Huichol art. Here, I look at three artists who have been particularly influential for the development of yarn painting: Eligio Carrillo Vicente, José Benítez Sánchez, and Mariano Valadez. Their influence is due to several factors. Cumulatively, their careers spanned more than forty years. They taught many family members and apprentices and so passed on their styles and knowledge to others. They developed unique and recognizable styles, which make their own work readily identifiable. And they innovated designs that are creative blends of traditional offerings and modern painting techniques.

Eligio Carrillo Vicente

Eligio Carrillo Vicente began his artistic career in about 1970. He is now considered by some dealers to be one of the best yarn painters because he has been consistently creative and innovative over many years. I introduced Eligio as one of my principal consultants in Chapter 1 and transcribed sections of a long interview with him in Chapter 5. Here I discuss his background, his art, and his influence.

Eligio's Huichol name is Ruturi, which means a "flower offering" (Lumholtz 1900, 202), such as the paper flower tied to the horns of a bull before it is sacrificed. Eligio's family came from San Andrés. They left during the Mexican Revolution and settled near the Santiago River. Eligio's father, Sidoro Carrillo, had one family with his first wife. He then married a second wife, with whom he had six boys and one girl, including Eligio. Eligio was probably born sometime during the 1930s. He grew up in Colorín, the community that was also home to the Ríos family. Eligio spoke only Huichol and never attended school as a child. Both of Eligio's grandfathers were mara'akate. His family practiced Huichol ceremonies, and his parents made pilgrimages to Wirikuta.

The Carrillo family had a number of boys, and the Ríos family had many girls, so Eligio and several of his brothers married Ríos girls. Eligio is married to Jacinta Ríos, a granddaughter of Don José Ríos. (Eligio has had other wives as well, but Jacinta insists that she is the only one he married legally in a church.) In about 1970, Eligio moved to Tepic, where he met Ramón Medina and saw his yarn paintings for the first time. Enchanted by Ramón's paintings, he resolved to become an artist. He bought some boards, started to make little paintings according to his own ideas, and sold them in the shops in Tepic. Ramón Medina then asked Eligio to become his compadre. Eligio had a young son, and Ramón offered to be his godfather. Then Ramón invited Eligio to work with him at his house and offered to pay him as an assistant. A week later, Ramón was killed at a fiesta.

Lupe asked Eligio to stay on with her and help fill an order for eighty yarn paintings. She had photographs of Ramón's paintings, which she asked him to copy. (This may be the collection that was purchased by the San Diego Museum of Man at about this time.) Eligio lived in Lupe's house, working with her for about a year. Then he left and worked on his own.

Subsequently, Eligio sold his art through American dealers, including Prem Das and Brant Secunda, who is now a leader of shamanic workshops. Eligio made two gallery tours to the United States and Canada in about 1977 and 1978.

He remembers going to San Francisco, Las Vegas, Santa Fe, New York, Chicago, and a city in Canada that may have been Vancouver, since he remembers that there were large snow-capped mountains. Since then, he has stayed in Mexico. Thanks to constant orders from dealers, he is able to sell everything he produces, which is a considerable volume of paintings.

Family members and apprentices help him, although he says that he draws the designs and directs which colors to use. He has shared his knowledge with a number of younger painters in the Santiago River region. Among those who have been influenced by his style are Modesto Rivera Lemus, Evaristo Díaz Benítez, Cristóbal González, and David González Sánchez as well as Eligio's son, Guarencio Carrillo Ríos.

Eligio has shamanic abilities, developed through pilgrimages with Don José Ríos Matsuwa (Lupe's mother's brother); he regards Don José as one of his main teachers of shamanism. When I first met Eligio, he was circumspect in telling me what he knew. When I asked whether he was a mara'akame, he answered only that he knew "some things." Later, a Huichol friend who was listening while I transcribed the tape pointed out that he was actually telling me that he knew a great deal when he said that.

A few years afterward, Eligio told me that when he went to Wirikuta, he never asked the gods to make him a shaman, but only to give him the ability to paint well. He became visionary and said that the gods taught him designs. Curing abilities have come to him after many years of making pilgrimages. In Huichol terms, he might be considered a "minor" or "junior" shaman. He told me that his shamanic curing abilities are limited to children's diseases, which is considered an intermediate stage along a progression of curing abilities.

Manuela de la Cruz Ríos described to me the stages of curing ability. She said that first one gains the ability to see inside the body and to see what looks like a fly or moth circling around in the belly. Then the gods may tell the novice shaman what to do about it. Curing children's diseases comes next, and some people spend years at this stage. The final stage is to be able to cure all forms of disease.

Eligio has the character of a natural philosopher, a person who is both curious and articulate about the mystical side of life. His explanations of the deeper meanings of his paintings far exceed those given to me by other painters, as do his explanations of shamanic cosmology. One example is his interpretation of sacred colors as a language that the gods use to communicate. Interestingly, he has none of Ramón Medina's flair for telling mythological stories, such as

the origin myths so well documented by Furst; in fact, Eligio seems somewhat bored by myths and, if asked, usually tells rather truncated versions. What he prefers to discuss is the world as the shaman sees it, and the activities of the gods and spirits.

Eligio has a distinctive drawing style. He draws elongated stick-figure shamans with flat hats and stick-figure deer. His apprentices copy his distinctive drawings, so it is easy to identify those who have worked with him. But what sets Eligio's paintings apart from others is a diamond-hard sense of color. His paintings have a sharpness of color contrast and a range of color use and invention that are exceptional. This assessment is echoed by some Huichol. When I showed a number of photographs of yarn paintings to some Huichol in San Andrés, they almost unanimously selected Eligio's work as the best. When I asked why, they said the reason was how he combined his colors.

The Mandala Nierika

Eligio Carrillo may be the originator of a basic yarn painting design that I have called the "mandala" nierika. This design does not appear in any of the collections from the 1960s or 1970s that I examined. The earliest painting I found that uses the design is a painting made by Eligio Carrillo in the late 1970s or early 1980s, now in a private collection.

The modern mandala nierika resembles an oriental mandala. It is symmetrical and formal, with a repetitive design. The outside shape is usually round. There is a main central figure, which may also be round. Often there are radiating rays or shapes around one or both circular figures. Around the circumference are repeated designs, which may signify deities or religious concepts.

The mandala nierika is based on a design that is fundamental to traditional Huichol arts, such as the circular stone god disk, with its central hole, or "eye," surrounded by rays and symbols important to the deity (Lumholtz 1900, 26, 28). Similar designs are found on front-shields (108–134), gourd-shell votive bowls, (161–168), and woven or embroidered bags, such as a large bag with a single large figure in the center and smaller surrounding figures (Berrin 1978, 201, lower left and right).

Modern versions of the mandala nierika often add the concept of multicolored radiating energies, which does not appear in traditional Huichol art or offerings. This image may have its roots in Ramón Medina's painting of his fire vision (P. Furst 1968–1969, 23). Ramón showed kupuri as multicolored, radiating lines of energy, but did not use the symmetrical circular form. The depiction of

multicolored radiating energy was widely adopted by other artists during the 1970s. From there, it was only a step to combine the circle form and the idea of radiating energy. The result is a painting that is very close to abstract art. The mandala nierikate are almost pure color and shape, without the narrative content of the myth-telling yarn paintings.

Even more sophisticated are Eligio's large compositions. He often still uses the central circular image with repeating figures. However, he spreads a variety of images and figures around it in a way that is reminiscent of the variety of animal figures around the circumference of stone disks. Most characteristic is the sophisticated color interplay, including a different colored background behind each figure. It takes great control to use such a wide range of colors in single composition and have them work harmoniously. Moreover, he seems to have almost endless inventiveness. He can repeat this process of color combining with an entirely new palette of colors in each painting. Few other artists use color with such virtuosity.

José Benítez Sánchez

One of the most important artists who emerged during the 1970s is José Benítez Sánchez; his Huichol name is Yucauye Kukame, which means "Silent Walker." Benítez began as a young folk artist in the 1960s, but by the 1970s had become an international star, partly because of his own talent, but thanks also to enormous help from his *patrón*, Juan Negrín Fetter. Negrín organized exhibitions in Mexico and internationally and published articles and catalogues featuring Benítez.

I wanted to interview Benítez in 1994. An official of the INI drove me up to Zitacua to introduce us. Night was falling as the government pickup struggled up a potholed road that seemed to go straight up a mountainside. We arrived at a plaza with a large, round, thatched-roof Huichol temple. The lights of Tepic glistened far below. The fiesta of the Virgin of Guadalupe was under way, and people were carrying a large portrait of the Virgin out of the temple. A group of women stood on one side, holding lighted candles. A corps of Huichol violinists began playing their shrill-sounding violins. Quickly, a parade formed, and the women and the violinists escorted the Virgin through the muddy streets of Zitacua. As we followed behind, the INI official urged me to keep well back so as to show respect for the Huichol.

After the ceremony, the INI official introduced me to Benítez, who agreed to do an interview and asked me to come back the next morning. When I returned,

he wanted a substantial payment for the interview. I was not paying other Hui-chols for talking to me, and so I was concerned about setting a precedent. In addition, it was more money than I felt I could manage as a graduate student on a limited budget. Regretfully, I decided that I could not afford to pay for the interview; therefore, my accounts of Benítez since then have relied on the pub-lished record about him and his paintings.

Furst (2003, 12–15) provides a brief biography of Benítez based on an account in a Mexican book, *Aguamilpas* (1994), but cautions that Benítez has given differ-ent versions of his life story to different people. I have supplemented it with the version given by Juan Negrín (1975, 28–29) and Olivia Kindl (2005, 57–59). Benítez was born in 1938. His father was a mara'akame from San Sebastián, and his mother came from Santa Catarina. He was raised by his maternal grandfa-ther, Pascal Benítez, a mara'akame. As a teenager, he left the Sierra and went to the coast to work in the fields. During the 1960s, Benítez got a job with the INI office in Tepic. He started by sweeping floors, and then he was given the re-sponsibility of buying handicrafts. He credited Salomón Nahmad, the director of the INI office, with encouraging him to make yarn paintings and other crafts for sale through the INI. In 1968, he was invited to perform Huichol music and dances at the Olympic Games in Mexico City. For the next three years, he head-ed a workshop on Huichol dance and tutored artists under the sponsorship of INBA (Instituto Nacional de Bellas Artes, or National Institute of Fine Arts). Then he returned to the INI to run a program to select authentic Huichol crafts.

According to Lupe, Benítez was a cousin of Ramón Medina through rela-tives in San Sebastián, and he began his career as a yarn painter by working with Ramón. Later, he worked for the INI school of yarn painting in Tepic while Miguel Palafox Vargas was the director, and she said the two were close friends.

Juan Negrín first met Benítez in Tepic in 1972; they were introduced by Cre-sencio Pérez Robles (Negrín 1975, 26–27). Benítez was teaching other artists to make yarn paintings. Benítez told Negrín that he was not yet a shaman. Al-though he began the pilgrimages as a child of eight, his practice ended when he was married, at age fourteen. Nonetheless, Negrín considered him one of the most inventive and creative of the Huichol artists. Benítez's work had already been exhibited in private galleries in the United States, but Negrín helped him by including his work in an important exhibition and the accompanying cata-logue, entitled *The Huichol Creation of the World*. The exhibition featured work by Benítez and Tutukila, another important young artist. It was shown at the E. B. Crocker Art Gallery in Sacramento (6 December 1975–18 January 1976), then at

the San José Museum of Art (5 May–6 June 1976). Negrín organized a series of exhibitions throughout the 1980s, both in Mexico and internationally, and published several catalogues. The later exhibitions featured Guadalupe González Ríos, Juan Ríos Martínez, and Pablo Taisan as well as Benítez and Tutukila (Negrín 1986).

By the 1990s, Benítez had formed an association with Celso Delgado, the governor of the state of Nayarit. Delgado was very supportive of the Huichol and made Zitacua available to the urban Huichol in Tepic as a place to live and hold their ceremonies. Benítez was appointed the first governor of Zitacua. He continued to live there, but by 2006 was no longer the governor. In 2010, I learned that he had recently died, apparently of heart failure (Jill Grady, personal communication).

Benítez worked with many apprentices. When I was doing my research in 1993–1994, he produced an enormous output of paintings, many of which were completed by apprentices, although he seems to have managed to control the quality and colors used.[2] A number of artists have worked with him and adopted his style, including Maximino Rentería de la Cruz, Emilio de la Cruz Benítez, Eliseo Benítez Flores, Martín de la Cruz Díaz, and Ceferino Díaz Benítez.

In 1994, with the encouragement of Peter Furst, the University of Pennsylvania Museum of Archaeology and Anthropology purchased a collection of paintings by Benítez from the collector Mark Lang. The museum exhibited the collection from 8 November 2003 to 31 March 2004, and Furst wrote a catalogue (2003), entitled *Visions of a Huichol Shaman*. It includes a short biography of Benítez and color reproductions of thirty-one paintings by him. According to Lang (personal communication), the paintings were made from the mid-1980s to the early 1990s.

The paintings are a valuable addition to the record on this important Huichol artist, but their usefulness for research is limited because their meanings were not recorded. The collector, who assumed that Benítez was making art for art's sake, did not insist on being given an interpretation. Furst wrote captions based on the imagery of the paintings, but Benítez's own interpretations are not known (MacLean 2004). The lack of interpretation is unfortunate, since Huichol artists repeatedly told me that the meaning is an important part of a yarn painting and that it is a poor artist who cannot explain the meaning.

Lang also mentioned that he had commissioned Benítez to produce five "masterworks"—the best paintings he could do.[3] The resulting paintings were surprisingly plain, with less color and less convoluted imagery than much of

Benítez's other work at the time. One is featured on the cover of *Visions*. Benítez's reasons for considering it a masterwork were not recorded.

Benítez's early paintings are in the style of Ramón Medina, with simple figures and clearly outlined images highlighted against solid-colored backgrounds (Berrin 1978, 155, 157, 158; Negrín 1979). I photographed one painting in a private collection, dating from the early 1970s, which is a variation on Ramón Medina's painting of the sexual purification of dead souls. The paintings illustrate stories, and there is a clear relationship between each figure and its meaning.

According to Negrín (1975, 27), Benítez's style changed rapidly between 1972 and 1975.[4] He began to completely fill the board with sinuous, interpenetrating figures. This style showed little massing of background color, unlike the older style, in which single design elements clearly stood out against a solid background. As a result, there was no longer a clear relation between figure and ground. Instead, the figures themselves became the background. It can be difficult to see what each figure represents or even where an image begins and ends. Color use became extremely varied in many of Benítez's paintings, and the color combinations were sophisticated and complex. A variation of his style featured bands of jagged lines with blocks of different color within them. The jagged lines often move diagonally across the board, and so the figures are arranged in diagonal rows. That style was unique, and radically different from any used by other Huichol artists working during the 1970s.

The Cosmological Map

During the 1970s, Benítez seems to have originated another type of painting, which has also become a part of the yarn-painting repertoire. This painting might be characterized as a representation of supernatural cosmology, a form of supernatural "map" showing the world and the deities that inhabit it.

An early, quite simple version of this painting is called *The Womb of the World* (Negrín 1979, 19). It uses the stick-figure style of Ramón Medina. The painting shows the world as the womb of the earth goddess, Tatei Yurianaka. Representations of the fire god, the sun god, the deer god, and the vulture god occupy the four directions, while the center is occupied by plants and animals placed there for people to eat. The world is surrounded with the water of the oceans, and four eagles guard the four corners of the earth.

Subsequently, Benítez produced more elaborate versions of this cosmological description of the world and the deities that inhabit it. Negrín (1986) gives long, detailed descriptions of three yarn paintings by Benítez in an attempt to

present the deeper philosophical underpinnings of Huichol cosmology. These descriptions are much longer than those usually attached to yarn paintings.

One extremely complex painting is called *Vista, Vida y Alma de la Tierra* (The Vision, Life, and Soul of the Earth) (Negrín 1986, 48, 61–64).[5] The lengthy explanation accompanying the painting sets out many concepts of Huichol cosmology, such as the idea of the earth goddess, Tatei Yurianaka, as a "patio" on which supernatural forces conduct their activities, and of kupuri, or life energy, as erupting in a continuously flowing fountain that feeds all living beings. A part of the long description of this painting gives an idea of its content.

> Our Mother the fertile Earth (*Tatei Yurianaka*) is the "patio" which the "gods," our great-grandparents, occupy in this world. They built and established their sacred sites on her. Our Mother is like a huge bowl that nourishes the life of the world. Her boundaries extend as far as that place where the heart and thoughts (*iyari*) of our great-grandparents can be heard. In reality, our Mother is like a sacred disk of stone (*nierika*), which is the navel of the gods. The large white ring defines the circumference of the Fertile Earth: it is sown with symbols that represent vision (*nierika*, represented as little blue spheres) and the spiritual life (*tukari*, represented as little yellow flowers) of our collective Forefathers. The center [a blue circle] is the collective soul (*kupuri*), the only source of all life. (61–62, my translation)

This painting is perhaps one of the most sophisticated expressions of Huichol cosmology to be published.

The Five-Cardinal-Directions Composition

During the 1970s, another basic composition entered the yarn-painting repertoire. By composition, I mean the arrangement of the figures in space and in relation to each other. This composition is based on the sacred directions: east, south, west, north, and the center, which represents the sky above and the earth below. For the Huichol, the five cardinal directions are an important religious concept. The directions refer to sacred sites in Mexico and also to deities who live there. The intercardinals, or intersecting diagonals, are also meaningful.

The five-directions composition is a fundamental design in Huichol sacred offerings and decorative art. One of the earliest examples is a stone disk made for Lumholtz (1900, 31); its meaning was explicitly linked to the geographic directions. Kindl (1997, 75, 126ff) found that some ceremonial gourd bowls were

maps of the sacred geography and depicted points in the directions. The composition is widely used in embroidery, such as the peyote flower motif, which is one of the most popular designs.

The five directions also are the principle organizing the figures in some yarn paintings. The motif can be seen weakly in some paintings by Ramón and Lupe, but most of their paintings do not use it. It emerges strongly in paintings by other artists in the 1970s. This composition is a harmonious and balanced geometric figure. Even to Western eyes, the paintings appear balanced and aesthetically pleasing. The composition is also central to Huichol cosmology. Thus, one can say that in this basic composition, the Huichol are expressing their worldview.

The 1980s

Perhaps surprisingly, there has been less information published on the development of yarn paintings from the 1980s than on those from the preceding decades. Authors such as Furst, Myerhoff, Fernando Benítez, and Negrín comprehensively documented the work of early artists such as Ramón Medina and José Benítez Sánchez, and the first major exhibitions and museum collections featured these artists and a few others. However, a great many other artists have remained undocumented and almost unknown. My research turned up dozens of artists who worked steadily from the 1960s or 1970s until the present, yet their names do not appear in the public record or are known only from a few works in small exhibitions or private collections.

The main artist who emerged as an influential figure during the 1980s was Mariano Valadez. Here I review his career and contributions.

Mariano Valadez

Mariano Valadez has become one of the best-known Huichol yarn painters in the United States. His paintings are widely reproduced on greeting cards and calendars, on a poster, and in the book *Huichol Indian Sacred Rituals* (Eger Valadez and Valadez 1992); in addition, he is featured in a children's book on Native artists (Moore 1993). Mariano's fame is due in part to his own excellence as an artist, but there is no doubt that it was also due to the promotional help of his energetic wife, the American Susana Eger Valadez. No other Huichol artist has come close to his level of market distribution and penetration, and it is not generally typical of how Huichol artists conduct business. Mariano Valadez is unique, and in describing his career, it is essential to keep in mind Susana's role.

I met Mariano and Susana Valadez at the Huichol Center in Santiago Ixcuintla, a town on the Santiago River in the flat, fertile coastal plains of Nayarit near the Pacific Ocean. This is the heart of tobacco-growing country, and the Huichol come down from the mountains every year to work as migrant laborers in the tobacco fields. Susana welcomed me and gave me a bed in a room set up as a dormitory for visiting workers. Mariano had agreed to do an interview, but I waited several days before he was able to speak to me. The 1994 Maya revolt in Chiapas was just then in the news, and Mariano and his Huichol friends were deeply concerned about the safety of their indigenous compatriots. He finally made time to speak to me early one morning. Mariano is a thoughtful man who chooses his words with care. His Spanish is more correct than that of most Huichol artists, and it was easy to translate his interview tapes into academic English prose.

Mariano was born in 1953. His family came from Santa Catarina, where his father was a mara'akame. Every year, they travelled to Santiago Ixcuintla to work in the tobacco fields. When Mariano was about twelve, his father was killed in Santiago Ixcuintla. His mother, in a panic and with other children to care for, left Mariano with their *patrónes*, a mestizo family, and returned to the mountains. Mariano spent his early teenage years with this family in Santiago Ixcuintla, although he continued to visit his mother.

As a young man in 1972, Mariano met a Huichol named Tutukila, or Tiburcio Carrillo Sandoval. Mariano gave me the last name "Sandoval" for his teacher, but he hesitated and seemed uncertain as he said it. I suspect his mentor may have been Tiburcio Carrillo Carrillo (also known as Tutukila), whose paintings are included in Negrín's catalogues. There is a strong resemblance between Tutukila's designs and Mariano's later paintings.

Tutukila invited Mariano to come to Guadalajara to learn to make yarn paintings. Mariano said he learned little directly from Tutukila at that time. He found work filling in the *fondo* (Sp.: background, the solid colors behind the main designs in the yarn paintings). He did this work for about two years, gradually improving and beginning to receive commissions. Then Mariano moved to Tepic, where he took a job as a manual laborer, until he met Tutukila again. This time, Tutukila taught Mariano more about painting, and they worked together until about 1975.

Subsequently, Mariano met the American dealer Peter Collings, who worked with Susana Eger in the community of San Andrés. Collings purchased art from Mariano, and Susana sold it in the United States. Mariano credited Collings with

encouraging him to improve the quality of his paintings, mainly by asking for explanations of them. At that time, Mariano was making simple designs with little content. Collings encouraged him to make more elaborate paintings and to explain the meaning according to Huichol tradition. Mariano believed that this concern for meaning was an important way to preserve Huichol knowledge and traditions and to make others aware of these traditions. He saw the yarn paintings as having an important teaching function, both for the buyers and for the Huichol.

Eventually, Susana and Mariano married. They lived for a time in the United States, then returned to Mexico. They founded a charitable organization called the Huichol Center for Cultural Survival and Traditional Arts in Santiago Ixcuintla. The center provided support services for Huichol workers, including food, clothing, a birthing room, and medical services. The Huichol were being poisoned by pesticides in the tobacco fields. The center documented this catastrophe, lobbied to improve conditions, and provided medical care for those who had been poisoned (Eger Valadez 1986b, 40; Díaz Romo 1993).

The center was supported in part by the production and sale of arts and crafts. A number of Huichols worked there and learned the skills of beadwork and yarn painting. In this way, the center functioned as a school and helped preserve and transmit traditional skills. Finally, the center maintained a collection of traditional designs, and one of its goals was to become a museum of Huichol arts.

In 1986, Susana and Mariano Valadez collaborated in a major exhibition of Huichol art at the San Diego Museum of Man, in California. The exhibition featured paintings by Mariano Valadez as well as traditional arts such as embroidery and weaving. *Mirrors of the Gods* (Bernstein 1989) is the proceedings of a symposium that accompanied the exhibition.

In the 1990s, Susana Valadez and the Huichol Center became part of a boom market in Huichol beadwork jewelry and sculpture. Susana adapted many of the traditional Huichol beadwork patterns, using colors that were more appealing to North American buyers. For example, the Huichol prefer opaque beads in saturated colors such as red, blue and yellow. North Americans often prefer transparent or metallic beads in softer, more neutral colors or monotones. Susana began importing Japanese Delica Beads rather than the size 11 Czech seed beads sold in Mexico and used by most Huichol. The center began to mass-produce jewelry and beaded sculptures and to sell them through high-end Manhattan retail stores (Grady and Eger Valadez 2001) or mail-order catalogues such as the one put out by the Southwest Indian Foundation.

Susana and Mariano Valadez undertook numerous tours and exhibitions in the United States. Often, they took Huichol families and apprentices with them to demonstrate art and dancing. I met several artists who participated in these tours and who said that they worked on Mariano's paintings. Mariano taught a number of apprentices, who adopted elements of his style. Some apprentices frankly produce copies of his paintings. Generally, Mariano seems to have had the most influence on artists from San Andrés and Santa Catarina, his community of origin. I did not meet any yarn painters in the Tepic-Santiago region who had learned yarn painting from him, though some had learned beading at the center.

Susana and Mariano have since separated. Susana opened a second Huichol Center in Huejuquilla el Alto, close to the Sierra communities. Mariano remained in Santiago Ixcuintla.

The Movement toward Realism
in Yarn Paintings

One popular branch of European or Western art is what Anderson (1990, 202–208) calls the "mimetic" tradition. Mimetic art uses realism to imitate the perspectives, textures, and colors of objects almost as the human eye sees them. One way of imitating human vision is through the use of perspective. Perspective creates an illusion of depth, showing objects in relation to each other in space; for example, nearby objects are depicted as larger, and distant objects as smaller. Another way is to draw objects, animals, or people with detailed outlines and to fill them in with their natural colors.

Early yarn paintings had little emphasis on realism. Most lacked perspective completely. The images were flat and one-dimensional. A human might stand on some squares representing rocks, as in Ramón's Kieri painting, but might equally well float in space, with little regard for gravity. Most objects were more or less the same size regardless of where they were located in the painting. Only occasionally is there an effort to show perspective, as in this depiction of the Ceremony of the Bull Sacrifice (Fig. 7.1), which has a woman in the foreground, a bull in the middle, and a small temple in the distance.

The style of representation in most yarn paintings ranged from stick-figure and cartoonlike images to somewhat realistic depictions. Plants, animals, and household objects were most likely to be rendered realistically. The painting of the bull sacrifice shows a fairly realistic piebald bull, modelled with volume, and a recognizable round jug catching the blood gushing from the bull's neck.

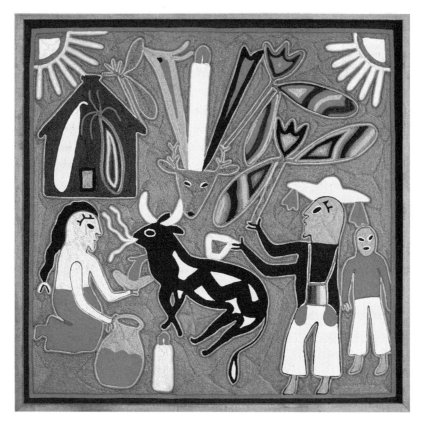

Fig. 7.1. Neukame, an early yarn painting of the ceremony of a bull sacrifice, c. 1975. 24" x 24" (60 x 60 cm). This image was painted in somewhat realistic style, using perspective. Photo credit: David E. Young.

Traditionally, realism was not important to the Huichol. Few yarn painters tried to mimic human vision or to employ perspective. They used a vocabulary of symbols that grew out of the older ceremonial arts. The images were recognizable as people, animals, and objects, but a cartoonlike style was enough to depict the stories and important concepts.

Mariano Valadez pioneered a shift toward realism. Mariano's paintings are large, detailed, and elaborate. They depict scenes more realistically than earlier paintings do. Landscape elements such as rocks, trees, flowers, mountains, and caves are more fully sketched. Some of his paintings use perspective when showing scenes of ceremonies. His humans are not stick figures or geometric

shapes with heads; they are rounded and modelled with volume, and they wear carefully drawn clothing showing details such as the embroidery so loved by the Huichol.

In particular, Mariano seems to have originated realistic animal drawings, which are unlike earlier stick-figure animals. A painting of wolf-people uses a mixture of brown and white wool to imitate the natural texture of a wolf's coat. A painting of eagles shows an effort to outline individual feathers. A painting of fish in the sea shows recognizable species, such as sharks or octopuses. His painting *Takutsi Nakawe Giving Birth* shows many recognizable animals, such as rhinoceroses, monkeys, turkeys, snails, lions, and mice (Eger Valadez and Valadez 1992, 20).

I heard one dealer complain that Mariano's animal paintings were not "traditional." "Whoever heard of Huichols painting all those animals, such as elephants and rhinoceros?" he scoffed. However, when I compared Mariano's paintings to traditional images, I realized that, conceptually, his paintings were solidly rooted in the designs of god disks that feature animals, such as those illustrated by Lumholtz. The most modern aspects are the somewhat realistic style of drawing and the portrayal of animals that the ancient Huichol never knew, such as elephants and rhinoceroses.

Mariano also developed a new type of cosmological painting. Unlike Benítez's cosmological paintings of supernatural geography, Mariano's cosmological paintings tend to depict the physical earth as we know it—the sky, land, and sea. One of Mariano's most important cosmological paintings is of the goddess Takutsi giving birth to all life (Eger Valadez and Valadez 1992, 20–21). It shows the goddess in the center with the birds and butterflies of the air above her, the animals of the land in the middle, and the fish of the ocean against a blue-green background below her. Two humans suckle at the goddess' breasts, while two more children are being born.

Like Benítez's paintings of Tatei Yurianaka, Mariano's painting depicts the Huichol goddess as the source of life, creating and feeding the creatures of the world. However, Mariano's painting is much more representational than Benítez's. The animals are drawn more realistically; and it is the animals themselves that are represented, rather than abstract concepts such as kupuri and tukari.

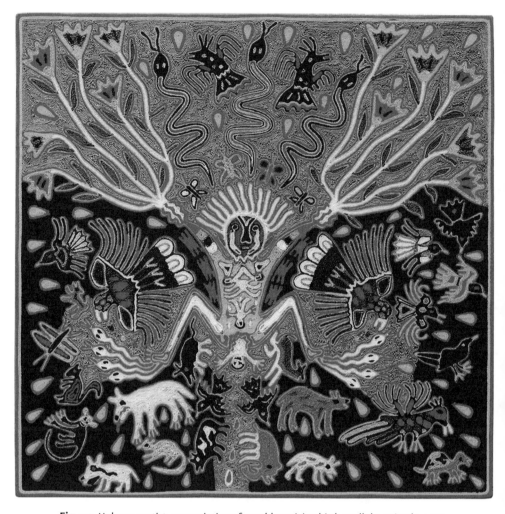

Fig. 7.2. Unknown artist, yarn painting of a goddess giving birth to all the animals, 2005. 15 ¾" x 15 ¾" (40 x 40 cm). This is a variation on a famous painting by Mariano Valadez. Photo credit: Hope MacLean.

Painting Subjects

The major subject categories of yarn paintings are well established. They include:

» portraits of deities

» myths, legends, and stories; depictions of events happening in the world of the gods

» ceremonies and pilgrimages; fairly explicit or naturalistic drawings of actual ceremonies and pilgrimages performed by the Huichol, often cataloguing the required offerings and activities; depictions of what the shamans, other human participants, and participating gods and spirits are doing in the ceremony

» shamanic activities, such as curing or helping women in childbirth; shamanic activities other than conducting ceremonies

» cosmologies, such as José Benítez's supernatural maps or Mariano Valadez's land, sea, and sky paintings

» mandala nierikate; symmetrical images with repeated figures, some moving toward pure abstraction

» single figures with minimal narrative content; simple designs such as an animal, a flower, a peyote, or a muwieri

» dreams and visions; depictions of the experiences of the artist

» miscellaneous; paintings, such as those depicting Christ on the cross, which do not deal with aboriginal Huichol cultural themes, but which may reflect what has become modern Huichol culture

Myths, ceremonies, and depictions of deities are some of the most popular themes. When painting myths and ceremonies, the artists often aim for accuracy and completeness of detail. In myths, they try to show all the main characters of the story. For ceremonies, they try to make sure that all the required offerings for the ceremony are shown, as well as the main actors and activities. Thus, the paintings might be considered a type of visual aide-mémoire: a guide to a myth, ceremony, or story, along with a list of its important elements.

The use of a straight line of repeated figures—a motif drawn from traditional weaving and embroidery—has become less popular over time. I found few examples of it. It has evolved into the mandala nierika with a circle of repeated figures. The mandala nierika has become an important item of commerce; several artists turn them out almost like assembly lines. It is probably a particularly easy design to reproduce because of the standardized circular shape and repeating symbols.

The "land, sea, and sky" cosmological painting has become a popular theme also. Made by artists who worked with Mariano, it has been adopted by artists who have not worked with him. Mariano's realistic style is being passed on to other Huichol artists, who copy his lifelike animals and human figures.

In 2000, for the first time, I saw a realistic yarn painting of a landscape with-

out figures. In a painting of fields and mountains, the artist used perspective to show distance, and fairly naturalistic colors for grass and trees. I expect that in the future, this trend toward realism in yarn painting will continue. The Western fondness for realism may well encourage the yarn painters to satisfy it.

I have seen some yarn painting with Christian themes. A yarn-painted *Christ on the Cross* was on display at the Basilica of Zapopan, and staff said the artist was a Huichol invalid living in Guadalajara. This yarn painting, with its Christian subject matter, does not reflect what is usually thought to be Huichol tradition; however, it may reflect modern religious practice in the Sierra. There is an active cult of *santos*, which are Christ figures on crosses. I saw these wooden santos displayed in the church in San Andrés and used extensively in ceremonies such as the Fiesta de Pachitas. Therefore, a yarn-painted version of a Christ is not necessarily a sign of non-Huichol imagery. It may grow out of what is "traditional" Huichol culture in the Sierra today.

A Huichol who had joined a Protestant evangelical church showed me his yarn painting of Noah and his ark full of animals. He identified it as Noah rather than the Huichol story of Nakawe and her ark. I would speculate that the reason Huichols make few yarn paintings on Christian themes is that Western buyers do not want them—they are not "Indian" enough.

Some paintings are attributed directly to visionary experiences. *The Mara'akame Talks to the Deer God at Night* by Eligio Carrillo shows a mara'akame in ceremony talking to a giant deer, which hovers over the fire; the colors represent the mara'akame's power, which lights up the night sky like a searchlight (Fig 9.4; MacLean 2005, 67).

Fabian González Ríos explained that his painting of an evil spirit and an owl is based on a vision he experienced as a young man. He saw these spirits come into the house one night and offer him powers. However, his father, a mara'akame, also saw the spirits and advised Fabian not to become a mara'akame, because those spirits would lead him to deceive people. So Fabian became an artist instead.

Religious subjects are primary. Everyday or natural events, such as daily life in a village or nature scenes and landscapes, do not appear in yarn paintings. Nor are yarn paintings abstract art—that is, pure form without content. They are always representational paintings. However, some paintings, such as the mandala nierikate, are on the edge of losing their link with empirical referents and becoming purely an exercise in color and design.

The subject categories for yarn paintings that I have developed here are arbi-

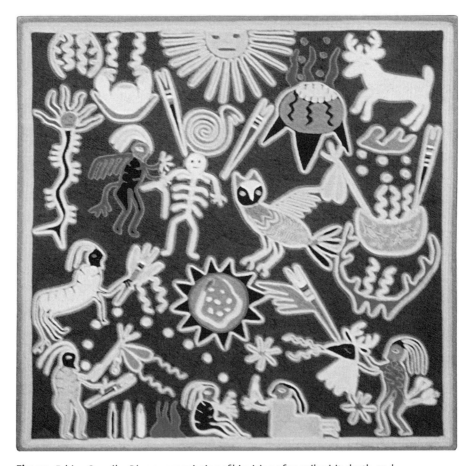

Fig. 7.3. Fabian González Ríos, a yarn painting of his vision of an evil spirit, death, and an owl, 1994. 24" x 24" (60 x 60 cm). The painting shows a mara'akame healing a patient, *bottom*. The devil, who wants to carry off the person, is passing his powers to death, represented as a skeleton. The owl is the companion of death. However, the other powers, such as the sun and the deer, will not let death take the person. The mara'akame bargains with death, promising him offerings in return for the patient's life. Photo credit: Hope MacLean.

trary groupings—a pragmatic way of organizing the paintings. Huichol artists may have their own categories, which likely will be different from mine. Several times during interviews, I noticed that artists categorized their paintings by the particular ceremony or myth depicted. An artist might say, "I know how to make a yarn painting of the Drum Ceremony, the Fiesta of the Peyote, the

Table 7.1. Comparison of Attributes of Sacred and Commercial Yarn Paintings

Element	Sacred offering	Commercial painting
Shape	Generally round or oval	Generally square; a circle drawn on a square board is a popular composition
Size	Generally small, up to 12" (30 cm) in diameter or along one side	Any size, up to about 4 yards (meters) in width
Materials		
Backing	Wood, bark, plywood	Plywood, Masonite, fiberboard
Wax	Beeswax	Beeswax
Medium	Yarn, beads	Yarn, beads
Process of manufacture	Made while fasting, in ceremony, as an offering to a deity	Made anytime, without ceremonial restrictions, as a commercial product
Design and composition		
Repetition of symbols	Not much repetition; usually one of each symbol (except 2 deer)	Symmetrical repetition of symbols popular (more like traditional weaving or embroidery)
Borders	Generally don't have straight lines	Generally have straight lines (may be based on the traditional god's eye)
Content		
Depiction of deity	Yes	Yes
Myth	Not usually	Yes
Ceremony	No	Yes
Activities of shaman	No	Yes
Cosmology	Yes	Yes
"Mandala" (sacred symbol)	Yes	Yes
Single figure	Yes	Yes
Dream, vision	Some have	Some have
Christian content	Not to my knowledge, but might be possible in modern ones, e.g., saints	Some have
Narrative	Possibly present	Often present

Birth of the Sun," and so on. Evidently, the artists were most interested in the ceremonies or myths, and used these as the basis of their categorization. Even more specifically, they seemed to see the most significant aspect of the paintings as the depictions of the offerings that were presented to the gods. Thus, in telling me about their paintings, the artists might list which offerings should be presented at each ceremony and explain how they had represented all the offerings in the yarn painting, not omitting any. I have touched on this role above, suggesting that the yarn paintings may almost serve as a form of aide-mémoire or perhaps as a historical record of what the artists consider important in the Huichol tradition.

The commercial yarn paintings retain many elements from the sacred offerings. Table 7.1 summarizes some of the similarities and differences.

Symbols and Imagery

I have debated whether to call the images in yarn paintings "symbols." The figures in yarn painting are not generally "symbols" in a theoretical sense—that is, images that stand for or represent something other than the image itself. The images represent exactly what they are, whether a man, a deer, or a prayer arrow. However, the drawings may be simplified or somewhat abstract. The artists usually paint figures that are simplified sketches of whatever they mean to portray, such as a stick figure for a person, or a wand with two oval feathers for a muwieri. The most abstract images may be the various stars, crisscrosses, or netted circles that depict the nierika.

Yarn painters use a basic vocabulary of symbols to convey stories and ideas. When one knows these symbols and the mythology they refer to, it is possible to "read" the figures in a yarn painting with some confidence. The specific meaning of a painting always depends on the artist's explanation. Each painter has his or her own style of drawing figures, but they tend to be variations on a theme. In general, there is a remarkable consistency in which objects are considered important and how they are portrayed.

The Huichol have evolved, and probably are still evolving, a pictorial vocabulary to depict their religious worldview. While some design elements are old, such as two deer facing a nierika, appearing in offerings and artifacts collected by Lumholtz and Zingg, many other images appear to be modern innovations. The stylized mara'akame with head plumes is one such innovation; it does not seem to appear in museum artifacts or in traditional Huichol weaving or embroidery designs. The combining of designs to tell stories is also new. It

seems that new figures and elements are being added to the vocabulary by innovative artists and then adopted by other artists. Examples include paintings such as the "land, sea, and sky" nierikate as well as those depicting myths and ceremonies.

Huichol drawing is remarkably conservative, and there is a great deal of continuity between the imagery in yarn paintings and the older Huichol arts. Many of the images can be found in offerings, weaving, embroidery, beadwork, and other arts collected by Lumholtz in the 1890s. For example, the stick-figure person is found in samples of embroidery, front-shields, and god disks. A diverse range of animals, ranging from stick figures to somewhat rounded representations, can be seen in Lumholtz's examples of stone disks, front-shields, embroidery, and weaving.

Far from being a completely modern invention, the symbols in yarn paintings are an outgrowth of symbols used historically. Over time, there has been a gradual evolution in the style of drawing, but many artists still continue to draw their symbols in ways quite similar to those used in the older arts. Perhaps what is most new in yarn painting is the freedom allowed by the medium. That is, the artists have the freedom to paint anywhere on the board, to use free-flowing lines, curves, circles, and shapes in a painterly way, to paint in a wide range of colors, and to use fine detail. They are not restricted by the linearity of a medium such as weaving, cross-stitch embroidery, or beadwork, which build up images in vertical and horizontal lines.

8

making yarn
paintings

Eligio Carrillo sits down to make yarn paintings in the morning. After breakfast, he brings a small wooden table out of his three-room concrete-block house and sets it down in the shade of a large mango tree on his patio, a level patch of earth swept clean of plants, debris, and insects. In front of him on the table is a plywood board spread with beeswax. To one side is a plastic bag filled with balls of acrylic yarn.

Eligio works in the midst of his family, surrounded by household activities. When I sat with Eligio, visitors came and went, young men fixed a truck engine, pigs and chickens wandered through the yard. Women gossiped and ground corn for tortillas, children ran through the cooking area, and dogs scratched their fleas.

Eligio works all day, stopping for lunch, his main meal, at about one. After a meal of thick homemade corn tortillas, boiled beans, a sauce of chile peppers or tomatoes ground in a stone *molcahuete*, and perhaps a fried egg or some meat stew, he resumes work. During the day, he moves the table around the patio, following the shade of the mango trees. By late afternoon, he is sitting in the shadow cast by his house. He works until about five or six o'clock, when the light begins to fade. Then he covers the painting with a towel to protect it from dust and animals and carefully takes it into the house. He packs up his balls of yarn, takes the table back into the house, and joins his family around a campfire for a few hours of conversation before going to bed by eight or nine. While Eligio lives in an area that now has electricity, power is costly and not to be wasted. He and his family organize their work around the daylight hours.

Techniques and Materials

Eligio begins his yarn painting by waxing the board. First, he softens the wax by rolling small balls between his hands. He places the balls on the edge of the

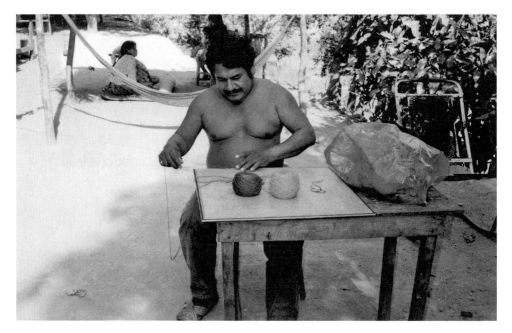

Fig. 8.1. Eligio Carrillo sitting at a table on his patio and beginning a yarn painting by making a border of lines around the outside to invoke the spirits, 1994. He presses the yarn into the beeswax with a finger. Photo credit: Hope MacLean.

board, then spreads them in strips with his thumb. He spreads the whole board at one time. An experienced artist can spread a board quite evenly this way. Some artists use a small tool to even out the thickness.

Eligio has a choice of two types of wax. One is a white beeswax mixed with pine resin. This is the only wax I saw in the late 1980s, and for a long time, it was the only kind available in Tepic. Eligio still uses this kind of wax, which he has been using since he was young. The white wax can be identified because it smells of pine. It may dry out over time, especially if kept in a hot, dry place, and the yarn can lift off the wax. Because it used to be cheaper, it was used more at the lower end of the market.

The second wax is called *cera de Campeche* and comes from a particular type of bee in Mexico. It is dark orange and smells like honey. Most painters now use cera de Campeche because it is easier to work with and stays sticky longer. It used to be sold only in Mexico City; in the mid-1990s, dealers started to sell it in Tepic.

Artists using white wax may have to put the board in the sun to warm it every time they work on it. Early morning is best. By midday, the sun may be too hot

and will melt the wax. If there is already part of a design on the board, the wax may melt through the yarn and ruin the painting. On a cool, cloudy day, it may not be possible to work because the wax will not become sticky enough. Cera de Campeche is more reliable because it remains sticky and pliable even when cool.

After waxing the board, Eligio takes up a ball of yarn to begin painting. He starts by making a border of straight colored lines around the outside edge. Eligio says that this is a way of acknowledging, or making a prayer to, the sacred powers or deities in the four directions and the center. Once he does this, he feels the sacred powers wake up and begin to communicate with him.

> ELIGIO: The three lines [around the border] refer to the four cardinal directions. They have always existed. Because we have that custom to do it this way when a person is translating [speaking shamanically to the powers]. And normally, we go to the right, then secondly to the left, *wa tuatüa, wa ku tu hi rrapa*. There are five points. And [the person] has to notify [the powers] so that they can give guidance on how to be able to do it at a ceremony over there, to guide you. That's how you can give them a gift [Sp.: *propina*, literally, a tip] to those four, five places. Because they are going to wake up then, because we are going to translate. Then we feel the power, making contact.
> HOPE: It is like waking up the powers?
> ELIGIO: Yes. Wake up the powers. To be able to work.
> HOPE: And then almost always you make [the border] first, right?
> ELIGIO: Yes.
> HOPE: And it is like a prayer?
> ELIGIO: Prayers, yes.

It occurs to me that the border is remarkably similar to a traditional god's eye or thread cross, with its concentric colored lines and its reference to the four sacred directions. I wonder whether the god's eye could be the antecedent for the border on yarn paintings.

Eligio usually uses three colors to make a border. He says there is no particular significance to the number three. It is simply a custom, and artists can use as many colors they like. Three-color borders are common, but some artists use as many as five or six colors. Some artists choose contrasting colors such as pink, yellow, and blue, while other artists prefer colors adjacent to each other on a color wheel, such as yellow, orange, and red.

A second type of border uses geometric shapes, such as a row of repeating triangles or a fretwork (Greek key) design. These borders have a close relation-

ship to the border designs used in embroidery, and have deep roots in ancient Mesoamerican and pan-Uto-Aztecan arts.[1] Similar designs are found in sacred offerings such as those collected by Zingg and Lumholtz (Berrin 1978, 152–153).

A few artists begin in the center and work their way outward. This method protects the edges of the painting from being damaged or soiled while the artist is working on the middle.

After completing the border, Eligio draws the main figures. Sometimes he begins by painting with yarn directly on the wax. Other times, he uses a sharp object such as a nail or the point of a metal compass to make a rough sketch in the wax. When he is making the circular design of a nierika, he uses his metal compass to draw a neat circle.

Eligio starts work on his figures, pressing the yarn into the wax. He holds the strand of yarn to one side, and presses along its length using a fingernail or his thumbnail. Most artists work with one strand at a time. Some can press two strands at once. Eligio works carefully, pressing firmly, making sure the yarn strands lie tightly against each other, and making many turns in the direction of the yarn.

As Eligio changes the direction of the yarn, the painting takes on a textured look. Rather than using straight lines, he fills in the background with solid colors and follows the curves of the main figures. The texture creates pleasing patterns and may also help preserve the painting. Yarn laid down with frequent turns in direction is less likely to snag and lift off the wax than yarn laid down in straight rows.

The technique of pressing the yarn neatly takes time to master. Some artists learn by filling in the background for other artists. Once they have mastered the technique, they may move on to doing their own paintings.

Eligio applies no fixative or protective coating to the surface of the painting after he finishes it.

Yarn

Eligio uses commercial acrylic yarn, dyed with aniline dyes. In fact, the Huichol prefer the bright colors and range of hues available in aniline-dyed acrylics. Acrylic yarns are cheaper than wool and easy to find in Mexican stores. Acrylic yarn may also be more practical than wool because it resists damage from acids in the wax as well as from insects and moisture.

I have never seen a yarn painter using sheep wool or natural dyes for commercial yarn paintings. There is very limited documentation suggesting that

sheep wool was used in the 1960s. Some Huichol still know about natural dyes, but they are seldom used. Schaefer (2002, 47–48) is collecting information on plant dyes from the few older women who remember how to make them. She records use of wild indigo for blue, a form of marigold (*Tagetes erecta*) for yellow, a cosmos for orange, brazilwood for reddish purple, and *palo dulce* (*Eysenhardtia polystachya*) for blue-green. Eligio told me that in the past, yarn for sacred paintings was dyed red with brazilwood or cuachalala.

A relatively recent innovation is the twisting or respinning of different colored yarns together. I have not seen respun yarn in paintings of the 1960s and 1970s; it first appears in paintings of the 1980s. According to Kiva Arts (1992), this procedure was invented by the yarn painter Tucarima (Elena Carrillo), who began unplying two-ply or three-ply yarns and then respinning two colors together. Respinning takes time and affects profitability, so few artists use it. It is mainly used by painters who can count on a good price for their work. The process gives a variety of effects, such as that of a two-tone cord or the mottled texture of an animal's fur.

The greatest change in yarn-painting materials over time has been the yarn itself. According to Lupe, in the 1960s, she and Ramón used a comparatively thick yarn sold under the brand name Indio. In the 1970s, the artists used a thinner yarn called El Gato para Todo (about the weight of a double knitting yarn). By the 1990s, the artists changed to even thinner, threadlike yarns, sold under the brand names Cristal, Diamante, Acrilan, and Estilo.

Changes in yarn thickness affect the design of paintings. Paintings made with thin yarn may have many more figures as well as more detail and more colors within each figure. When thick yarn was used, only a few figures could be fitted onto a standard-size yarn painting (for example, one that is 24" x 24" [60 x 60 cm]), and each figure had relatively few colors. A small yarn painting (for example, one that is 12" x 12" [30 x 30 cm]) might contain only one figure, as Mariano Valadez explained:

> HOPE: How has your art changed since you began?
> Mariano: The paintings I first did were 60 x 60 cm. The designs were very simple. It was possible to finish a painting in one day. We also did 30 x 30 cm, with designs of a single object, like an arrow, a ceremonial feather [Hui.: muwieri], and with that little bit, the painting was almost finished. We did a lot of 5 x 10 cm [paintings] also. . . .
> HOPE: Did you do them illustrating just a small peyote?
> Mariano: We did small designs, and only two types, such as a corn that had been

picked or a peyote flower or some flowers that we used in ceremonies. There-fore, there wasn't much need to tell the legend or the explanation.

The change to thinner yarn has also affected the amount of labor required to make a painting. It now takes artists longer to complete a painting because many more strands of yarn are required to cover a given surface area. In the 1960s, a 24" x 24" (60 x 60 cm) painting could be completed in one or two days. Now a painting of this size may require four to eight days to complete. The lon-ger production time affects the profitability of making yarn paintings. Even if the artists charge four times the price that they did twenty or thirty years ago, they may not be making much more for their labor, because the paintings take four times as long to make.

In fact, unless artists manage to sell at the upper levels of the market, they may not make much more than the Mexican minimum wage. As a result, yarn painting is not highly profitable for many artists. They may abandon it for other crafts, such as beadwork, if the return drops much below the minimum-wage level. The low profitability of yarn painting threatens the survival of the art. The Huichol, who are still acutely impoverished, cannot afford to make art for art's sake.

One aspect of yarn painting that favors its survival is that the work is done "sitting, in the shade," as one artist told me, rather than by working twelve hours a day in the blistering sun as an agricultural laborer. Thus, making art is preferable to field labor as long as the financial return is equal.

The techniques and materials for making yarn paintings have proved re-markably stable over time. Change has come slowly. From time to time there have been experiments with new materials, such as plywood instead of wood, or thinner yarns. If an experiment is successful—which ultimately means that buyers approve of the innovation and buy it—then the artists incorporate the change into their repertoires.

Boards and Sizes

Most artists cut their boards in standard sizes and shapes out of a sheet of ply-wood. A square that is 24" (60 cm) on each side is a standard size. This may be divided into four smaller squares of 12" x 12" (30 x 30 cm) or nine squares of 8" x 8" (20 x 20 cm). The most common shapes are squares, each of whose sides is 6" (15 cm), 8" (20 cm), 12", (30 cm), 17 ¾" (45 cm), 24" (60 cm), or 48" (120 cm). Another common shape is a rectangle, which can be 24" x 48" (60 x 120 cm) or

12" x 17 ¾" (30 x 45 cm). A large yarn painting can be as much as three or five yards (meters) long, but this is rare. Such large paintings, most often found in museums or governmental offices, may have been commissioned for exhibition or an institutional sale.

Some artists work on circular boards. This is a less economical shape to cut out of a sheet of plywood, since there is more waste, and it is harder to cut. Therefore, circles tend to be used more at the upper end of the art market. If particular buyers request circular paintings, artists will make them because they know the price they will bring.

The circle, square, and rectangle are the only shapes I have seen sold commercially. The artists do not seem to make commercial paintings in other shapes, such as ovals or irregular shapes. In contrast, the sacred offerings may be made in irregular shapes, such as the oval and bottle-shaped forms collected by Lumholtz and Zingg (Berrin 1978, 152–153).

There has been little change in the backing material since Soto Soria's early experiments with wooden planks. Most artists use three-ply plywood, fiberboard, or Masonite board. Older paintings in museums were made on the same materials. In general, the better artists work almost exclusively on plywood. It is artists selling in the souvenir market who use cheaper or poorer-quality backings, such as Masonite.

Most artists sell their paintings unframed. Some artists put a rough frame on the back, one consisting of long, thin strips of wood nailed onto the backing. The roughly square strips measure from half an inch to an inch (one to two centimeters) on each side. The strips strengthen the plywood and keep it from warping. However, they add to the weight and cost of the painting, so few artists use them. Artists who take their paintings to market themselves may have to carry them on a bus and from store to store to sell them. These artists are not inclined to increase the paintings' weight by adding a frame.

Mixed Media

Occasionally, the Huichol use other materials in their paintings, such as a small round commercial mirror set into the wax. The mirrors can be purchased cheaply in Mexican markets. They are the same as the mirrors used by the shamans for divination. An embedded mirror emphasizes the nierika concept of the yarn painting as an image seen in a shaman's mirror.

Some artists fill in small sections of their paintings with beads. Mixing beads and yarn is an old practice, also found in sacred offerings (Lumholtz 1900, fig.

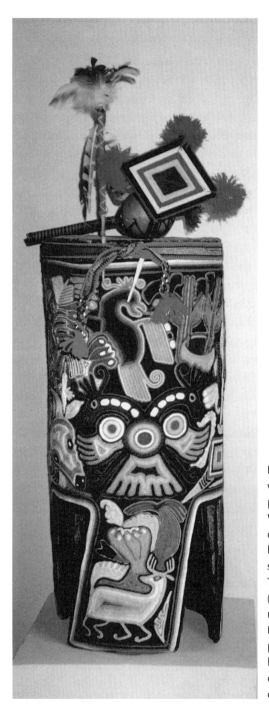

Fig. 8.2. Unknown artist, wooden log drum with yarn-painted decoration, c. 1994. Wooden drum, yarn, beeswax, deer-hide cover, feathers, huastecomate gourd, wooden sticks (possibly brazilwood). The yarn cross or god's eye (tsikürü), a rattle, and a shaman's plume are all used in the Drum Ceremony. The shaman plays the drum and symbolically flies the spirits of the young children to Wirikuta. Photo credit: Hope MacLean.

8). In 2000, I saw some experimental paintings that included feathers and snakeskins. The dealer told me they had been made by a Huichol from Zitacua. If so, the mixed media could reflect the influence of José Benítez and his contacts within the art world. It is quite possible that a visiting artist or dealer suggested using these materials.

Yarn painting is also used on other bases, such as gourd bowls, masks, drums, and animal sculptures made of wood or papier-mâché. This is partly due to the explosion of interest in Huichol beaded sculpture since the 1990s. The art market values novelty, so dealers and the Huichol are constantly searching for new objects to bead. Sometimes these objects are yarn-painted instead. However, the beads are far more popular with tourists, so the yarn-painted versions are less common.

Texts and Signatures

Yarn paintings often have the text of a legend or story written in Spanish on the back. Some have text written in Huichol. In paintings I examined in the 1990s, only those by a few artists—mainly, Cresencio Pérez Robles and José Benítez Sánchez—had text routinely written in Huichol. Occasionally, one also sees paintings with text written in English. Very rarely will the person who wrote the text sign his or her own name.

Most Huichol born before 1950 had little or no schooling and are illiterate. Artists born after 1950 are more likely to have at least some basic literacy, while artists who reached school age by the 1970s or later are more likely to have at least some elementary school. (It should be remembered that in Mexico, especially in rural areas, illiteracy is still widespread and that few adults have more than a sixth-grade education.) A few Huichol have completed *secondaria* (ninth grade) or even *preparatoria* (equivalent to a high school diploma). Only since the 1990s has it become possible for Huichol to attend college.

Most artists dictate the meaning of their paintings to a person who can write. I have met only a few Huichol artists who can comfortably write the meaning of their paintings legibly and grammatically. Some can sign their name, while others cannot.

It is often difficult to read the text of yarn paintings, even for Spanish speakers. It is quite typical to find little or no punctuation and many run-on sentences. Spelling may be phonetic rather than standard, such as "*asea*" for "*hacia*," or "*pellote*" for "peyote." Some words are from rural Mexican dialects, such as "*macuche*" for "tobacco," or "*ocote*" (from the Nahuatl "*ocotl*") for "pine." Others are

Spanish terms that have special meanings for Huichol; for example, Huichol use the word "*tendedera*," which can be translated as "drying blanket" (Knox and Maud 1980, n.p. [14]), for an itari, the mat that the shaman spreads on the ground as an altar during a ceremony.

Paintings are rarely dated. Some show the place of manufacture. It seems mainly to be several artists from San Andrés, as well as José Benítez and his apprentices, who make a point of writing the place and date. A few artists note their communities of origin and write that the paintings were made by a Huichol or indigenous artist.

It is not always straightforward to discover which artist made a painting. Huichol artists often use variations of their names when signing a painting; for example, the following signatures were represented in one collection (Knox and Maud 1980): Guadalupe Barajaz de la Cruz, Lirma Guadalupe Barojo de la Cruz, Guadalupe Baroja del Naranjo, Lirma Guadalupe Baroja del Naranjo. All these signatures refer to the same person.

A related problem is that the person who signs a painting or sells it is not always the person who made it. Sometimes a wife will make a painting, but give it to her husband to sign and sell. Sometimes an artist will ask another Huichol to sell it, and then that vendor is the one who will sign it. Usually, these cases can be sorted out when one has a good collection of a particular artist's work and can compare painting styles to signers. Often, an artist will have what is almost a recognizable trademark or style when painting a particular item, such as a peyote or a bird; however, it helps to watch while the work is being done or to have some paintings whose provenance is clearly known. The samples can then be compared to other works to determine who the artist might be.

Many Huichol seem to see nothing wrong with the practice of one person making the painting and another signing it. As far as they are concerned, signatures have little meaning. They know little about the Western world's interest in authorship or copyright. Some artists who are more familiar with the Western art world may understand the importance of signatures in Western eyes. For example, the artist José Benítez Sánchez and his apprentices seem to sign their works separately. However, other artists sign the work their wives or apprentices do.

Perhaps unwittingly, some dealers foster the practice of one person making art while another signs it. Some dealers consider Huichol art to be folk art, which, by definition, they consider anonymous. They do not want to buy signed paintings. Therefore, the Huichol take their paintings to market unsigned and

ask at the time of sale whether the dealer wants it signed. If the dealer wants a signature, and the seller is not the real artist, the seller's name may still end up on the work.

Huichol Artists' Technical Criteria

The Huichol's aesthetic criteria can be deduced by looking at one of the most basic aspects of a yarn painting: what constitutes skill in making yarn paintings at a technical level. I will rely on comments made by Guadalupe de la Cruz Ríos and her family when they assessed a yarn painting by an inexperienced artist.

Lupe's first comment was "*Los colores quedan bien*" (Sp.: The colors match well). She and her family then launched into a critique of the painter's basic skills, such as how the yarn and wax were applied. In a well-made yarn painting, the wax is spread smoothly on the board, without lumps or gaps, so that the yarn will adhere well. The yarn should be laid on evenly so that the strands are neat and lie tightly alongside one another. There should be no gaps between the yarn, nor any yarn lifting off the wax. If a yarn painting is well made at this basic level, the Huichol will then go on to assess its other qualities. However, if it is poorly made technically, it will be judged deficient and not fit to sell, no matter how good its design or colors may be.

These comments also suggest that there is a hierarchy of skills in making yarn paintings. The Huichols' aesthetic judgments may be based on their perception of this feature. The first level is the technical skill of using the materials correctly.

The second level of technical skill is how to use colors well. In Lupe's words, the colors should "*quedan bien.*" A yarn painting with poor color use would be judged deficient. This evaluation was echoed by the artist Chavelo González, who told me that it wasn't hard for someone to learn the physical technique of yarn painting, but that it had taken him years to learn to combine the colors well.

Their comments pointed toward what I had already suspected in looking at yarn paintings, namely, that color played an extremely important role in Huichol aesthetics. In the next chapter, I will begin to explore what color means in Huichol spiritual philosophy and in yarn painting.

the colors speak

Yarn painting, embroidery, weaving, beadwork—all Huichol arts use vivid colors. The Huichol use color with a bravado matched by few cultures around the world. Their love of colors is particularly evident in the clothes they wear. A well-dressed Huichol man in fiesta gear wears a rainbow of colors—an embroidered suit and cape, several multicolored woven bags slung over his shoulders, several more woven belts around his waist, a belt of little embroidered pockets with bright red tassels bouncing around his hips, beadwork bracelets and pendants, and a sombrero encircled with beadwork dangles and covered with multicolored feathers.

A love of colorful clothing has deep pan-Mesoamerican roots. Aztec women wore clothing with embroidery and painting of flowers and imperial eagles (Durán 1964, 128–129), designs still used by the Huichol today. According to Vogt (1969, 107), the Maya were extraordinarily interested in clothes, and used them as a marker of social status and community of origin.

For the Huichol, brightly colored clothing is clearly a key aesthetic value. Unlike Westerners, the Huichol do not hang art on their walls; instead, decoration of the person is one of their most beloved art forms. The clothes a person wears are a walking advertisement for personal skill in manipulating color and design. The main manufacturers are often women, who demonstrate their skill in weaving and embroidery in the clothing worn by their husbands and children.[1]

Yarn paintings too celebrate the Huichol love of color. The artists seem fearless in their use of strong colors in a wide variety of combinations, yet somehow it all works. The paintings do not seem garish or ugly.

I asked the artists how they use color in yarn paintings, whether some theory governs their color use, and whether their use of color has any relationship to shamanism. One theory is that Huichol interest in color is linked to their religion and, in particular, to peyote. Many people who eat peyote report seeing

brilliant colors and vibrating patterns. This type of peyote experience seems to resemble the shifting geometric shapes and colors seen through a kaleidoscope. According to Eger Valadez (1978, 47, 51) and Schaefer (1990 ,127), Huichol artists value these colors and patterns and try to reproduce them in their weaving and embroidery. My own Huichol consultants have told me they saw embroidery patterns while eating peyote.

Nevertheless, despite the antiquity of peyote use in Huichol culture, the use of a rainbow of colors in yarn paintings and other Huichol crafts seems to be recent. Samples of Huichol clothing collected by Lumholtz in the 1890s and Zingg in the 1930s include some dyed colors, such as orange, gold, yellow, blue, green, and navy blue. However, most clothing used red and black for embroidery, and natural white, brown, and black wool for weaving. Lumholtz (1902, 2:219) commented that the Huichol obtained red by unraveling red blankets sold to them by Mexicans.

This limited color use is confirmed by a report from Captain G. F. Lyon, a British traveller who visited Bolaños in the 1820s and who described the clothing of some Huichol he saw selling salt in the marketplace:

> The dress of the Indians was principally of a coarse blue or brown woollen of their own manufacture, formed into a short tunic, belted at the waist and hanging a little way down before and behind. Many had no other clothing of any kind; but the breeches of the few who wore them, were of ill-dressed deer- or goat-skin. . . . The men wore round the waist or over their shoulder several large woollen bags, woven into neat and very ornamental patterns . . . [and hats] bound round with a narrow garter-shaped band of prettily woven woollen, of various colors and having long pendant tassels. (1828, 293–294)

Lupe told me that when she was growing up in the 1920s, the main colors they worked with were red, blue, and black. She remembers that they used only blue and white or black and white for beadwork. For textiles, they used the natural colors of sheep wool, such as brown, black, and white. They also used the natural white of a native cotton plant. Thus, the early style of Huichol work used one or two dark colors contrasted with white or natural beige.

Nowadays, there has been a tremendous increase in the variety of colors used. One factor is that the Huichol can now buy a wide range of dyed yarns at a reasonable cost. The invention of aniline dyes and acrylic yarns, which are cheaper than wool, has put a wide range of colors within the Huichol's economic grasp. Their increased participation in the wage economy has given them cash to buy materials.

Lupe also pointed out that there are regional variations in color use, which are particularly apparent in how people dress. The older style of dress is preserved in Santa Catarina. Often, the men wear only one or two colors, usually with strong contrast, such as a solid dark-blue shirt and white pants. Many crafts from this community maintain the strong contrast of a dark color against white. Woven belts are often dark blue or black on white. A man's cape might feature dark-blue and red embroidery on a white fabric with a dark-red flannel trim.

In contrast, Lupe said that the "Lupeños"—the Huichol of San Andrés and Guadalupe Ocotán—emphasize color "combining." They put together a number of different colors and are admired for how they combine the colors. This practice is particularly evident in embroidery. In the Lupeño style, one often sees wide bands of geometric or semiabstract patterns around the borders of clothes. These are filled in with embroidery, sometimes by using shading that runs through a gamut of adjacent colors, such as pink to rose to red to orange, and sometimes by using strong primary-color contrasts, such as bright red, blue, and yellow. In the Lupeño style, there is also more emphasis on filling in the patterns, creating solidly worked blocks of embroidery. In the Santa Catarina style, the embroidery tends to be more open, with white space showing through and incorporated into the design.

My own observation in the Sierra is that there is now a fair amount of movement, intermarriage, and sharing of ideas between Huichol communities. Thus, this contrast between the Lupeño and Santa Catarina styles is not solely a regional one, although it may be regionally emphasized. One also sees multicolored work in Santa Catarina, although it may be less common, and one- or two-color contrasting in communities such as San Andrés. In Lupe's own family, which has roots in several parts of the Sierra, both styles are used, and they can identify in which style a piece of work was done.

Lupe's comments indicate that there are several main styles of Huichol workmanship and use of color and that the Huichol are quite conscious of these different styles. Perhaps the style with high contrast and limited colors was used more in the past simply because it was harder to get colored materials.

The use of relatively simple colors is often preserved in sacred offerings even now. For example, Lupe's family makes an offering bowl decorated with a small figure of wax that includes a few white or blue beads to indicate the eyes and heart. Sacred arrows are made with designs in dark red and blue paint. Mod-

ern sacred yarn paintings use a limited range of highly contrasting colors, such as bright red, yellow, blue, and white (Negrín 1986, 42; Ortiz Monasterio et al. 1992, n.p. [73]).

Since the 1960s, yarn painters have been using progressively finer yarns and a broader palette of yarn brands and colors. This change of materials has allowed them to incorporate finer detail into yarn paintings, and to increase the number of colors used, both in a single figure and in a painting as a whole. As more colors are used, the combinations of colors become even more complex and important than they were in the early paintings.

One aspect of color combining is outlining. This is the practice of using two, three, or more colors to form a shape. Once again, this may reflect an underlying indigenous aesthetic preference. Gladys Reichard (1936, 116–117) noticed that the Navajo had a strong preference for using a second and even third color to outline a figure when making rugs, even though the additional color might be only one warp wide and involve much additional labor. She realized that outlining was also an outstanding feature of sand paintings, such as the very thin lines of white used to pick out the red and white stripes in a rainbow; these details were never omitted. She also pointed out a related feature, which is "contrast to the contrast"; for example, a tiny feather in a sand painting might have a contrasting color at the end and a tiny dot of another contrasting color at the tip.

Many Huichol artists use similar principles in yarn painting. They use multiple colors for borders and for outlining. Even in a very small painting, an artist may make outlines only one thread thick, but use several different colors around a figure. Small dots of contrasting color, like punctuation points or exclamation marks, are a feature of the work of many better artists. The small dots of contrast often bring alive the rest of the work.

Both outlining and the small dots of surprising contrast colors are also outstanding features of modern commercial Huichol beadwork, particularly some jewelry patterns. They are also used when making flowers, stars, or peyote flowers in embroidery; the juxtaposition of undulating multicolored lines is also found in traditional bargello-like, zigzag designs. The technique does not seem to be found in traditional Huichol arts such as the two-color weaving used to make belts and bags.

Looking at color combinations, and the bravado that the Huichol use in combining them, I began to think there must be some theory, implicit or explicit, guiding how colors were put together. In fact, I wondered whether the

Fig. 9.1. Miguel Silverio Evangelista; wood, glass beads, beeswax; 2005. 10 ¾" x 9 ½"
(27.4 x 32.5 cm). The Huichol now press beads into wax to make many commercial prod-
ucts, such as this beaded eclipse. Note the small dots of contrast color and the use
of traditional symbols such as deer. Photo credit: Adrienne Herron.

Huichol use of color—such a striking part of the culture—might have deeper
aesthetic or philosophical implications. These intuitions were confirmed as I
talked to artists.

Fuerte and Bajito

My first lead came from listening to the San Andrés artist Vicente Carrillo Me-
dina talk about a large papier-mâché deer he was decorating with beads. He said
he was using *colores fuertes* (Sp.: strong colors) so that the deer would appear *muy
fuerte* (Sp.: very strong). I asked whether he always used strong colors. He replied
that he could if he wanted to, but he preferred to use a combination of fuerte
and *bajito* (Sp.: low or soft) colors because the combination was subtler than
using only fuerte ones.

Because of the implications of the terminology he used, I will continue to use the Spanish words "fuerte" and "bajito" in the following discussion. In Huichol, he used the term "*arrukai*," meaning "*muy chico*" (very small, little), for "bajito," and the term "*waukawa*," meaning "*grande*" or "*mucho*" (large or a lot), for "fuerte"; then he thought a bit and added "*echiwa*," meaning "*chico*" (little), as an intermediate. When I asked Lupe, she gave the Huichol word "*tukwilye*" for "bajito," and "*tükali*" for "*subedito*," a synonym for "fuerte." Eligio gave the Huichol words "*tulükau yemi*" for "fuerte," and "*nene a neme*" for "bajito."

I asked Vicente to point out which colors of beads were fuerte and which were bajito. I had heard Huichol use these color terms before, but thought that they meant color terms similar to those used by Westerners (Itten 1973, 17, 34–36). Bajito colors might be pastel hues with white mixed in, or greyed or dull shades with black mixed in. I expected fuerte colors would be pure or intense.

However, when Vicente pointed out the colors, they were not what I expected. Some colors that I would call dull, greyed, or pastel he called bajito, but sometimes he called them fuerte. Colors I would call strong, like a bright orange, he defined as bajito. Often, two shades of the same color, which I thought were virtually identical, would be categorized differently. A blue of one shade he would call bajito, and a very similar blue (to my eyes) he would call fuerte.

I began to think his judgments were based on a system of categorizing colors that was different from the Western concepts of pure hues and shades. I tested this idea with other artists. They all understood the terms "fuerte" and "bajito" and, if asked, would immediately categorize any color into one of the two categories. Nevertheless, the artists' definitions of fuerte and bajito were idiosyncratic. They each defined the colors differently and explained the reasons differently.

Several years later, I returned with a set of Pantone color swatches, which I intended to use as a research tool, to define more precisely the colors and their symbolic meanings. Pantone colors are widely used to identify colors of ink in printing and the graphic arts. (Pantone swatches are similar to paint-color swatches.) The advantage of the Pantone color system is that it is an international, standardized system of numbering colors. Any printer can reproduce the desired colors by knowing their numbers. Computer graphics programs also use Pantone numbers for identifying colors so that the colors can be reproduced electronically. The Pantone swatches I used were a set made for printing. They had colors numbered from 100 to 877, plus separate swatches for basic colors I and II (colors frequently used by printers) and the four colors used in four-color-process printing.

Using the Pantone color swatches, I tried to get the artists to be more precise about the differences between fuerte and bajito colors. The results were somewhat mixed, since artists still had idiosyncratic interpretations. Most artists became bored with the exercise after a few minutes and either went off on a more interesting conversational tangent or refused to continue (a lesson to those of us who think that Western research methods may be easy to use with indigenous people). Nonetheless, some interesting ideas emerged, suggestive of further research directions.

For example, Vicente pointed out that the individual Pantone swatches were arranged from bajito to fuerte and back to bajito. The swatches for a particular color family go from very light hues to dark shades. Vicente said that the top color is bajito, then it moves to fuerte by the middle range, and back to bajito in the darker shades at the bottom. His definition indicates that a very dark color may be bajito to the Huichol, even though the color is strong or intense in Western terms.

The artist Chavelo González explained that he considers bajito colors to be the colors one finds in nature; so, for example, the blue of the daytime sky, the brown of the earth, and the green of leaves or plants are bajito. He also defined the natural white of cotton or wool, as well as black wool, as bajito. Man-made colors, or colors not found in nature, are fuerte.

Vicente Carrillo agreed that natural colors are usually bajito, and added that the sun is always fuerte, whereas the moon is bajito when it is new and then becomes more fuerte as it becomes full. He added that people were also fuerte or bajito. He commented that I was very bajito, and defined it as "*tranquilo, calmado*" (quiet, calm). I asked which type the mara'akate were. He replied that there were all types, but that most were bajito.

Eligio Carrillo was willing to use the color swatches to give a more systematic definition of fuerte and bajito. I prompted him with the Spanish term, such as *azul fuerte*, and asked him to identify the Pantone color and give me the Huichol word for it. Table 9.1 shows his definitions of some common colors. Spelling is based on my transcription of his words.

Since this research is still preliminary, I am reluctant to draw many conclusions from Eligio's categorization. Some interesting points are that in several cases, he selected adjacent colors in a swatch—that is, colors that were quite similar shades—and defined one as fuerte and the other as bajito. His definition of *tarauye* (yellow) is intriguing, since there has been some discussion in the literature of what *tarauye* (*taaxauye*) signifies. For example, Grimes defined it

Table 9.1. Fuerte and Bajito Colors, according to Eligio Carrillo

Spanish term	Huichol term	Pantone color
Azul fuerte	Kwini epti yuawi	301C (a dark blue with some black)
Azul bajito	Yoawime	300C (bright cobalt blue)
Rojo fuerte	Pu sule	Red 032C, basic colors II (orangish red)
Rojo bajito	Pu seta	185C (red with a bit of blue)
Amarillo fuerte	Tarauye	Warm red C, basic colors I (orange red)
Amarillo bajito	Ya kü pu tarauye	120C (dull yellow) or yellow C, basic colors I (bright primary yellow)
Verde fuerte	Chulauye	340C (dark bluish green)
Verde bajito	Ya kü chulauye	339C (light bluish green)
Blanco fuerte	Mu tusa	[He pointed to yarns to define this.]
Medio blanco	Ya kü tusa	[He pointed to yarns to define this.]
Negro fuerte	Mu yuwi	426 (very dark grey)
Medio negro	Me yea yuwi	425C (light dark grey)

as the yellow of dried grass (Bauml et al. 1990, 100). Eligio's selection of a very warm orangish red as *tarauye fuerte*, and a bright yellow or a dull yellow as the *bajito* version, suggests that the cultural category of tarauye runs a gamut from orangish red through orange to yellow (and in another exercise, Eligio also identified yellowish green as tarauye). The Huichol may define or cut the color continuum at a different point than the English or Spanish do.

Fuerte and bajito are more than just categories of color. Vicente Carrillo talked about the importance of combining colors for subtlety. An artist has a choice. He or she can use only fuerte colors, in which case the object will appear extremely strong, or a combination of fuerte and bajito, in which case there will be a subtle change from one to the other. If the artist prefers, he or she can use only bajito colors. Not all Huichol color combinations are intense contrasts, and some artists prefer to work in bajito colors.

The alternation of fuerte and bajito describes an artistic strategy of complementary opposition. The alternation between the two poles is important. The use of all fuerte or all bajito colors is sometimes less interesting than the move-

Fig. 9.2. Santos Daniel Carrillo Jiménez, yarn painting of a shaman curing a patient who appears very pale and weak, 2005. 8" x 8" (20 x 20 cm). One technique for combining colors is to move through a gradation of colors, such as pale yellow moving to dark yellow in the flowers, and the dark red moving through pinks to white in the figure of the shaman. Color combining of this type became increasingly popular in yarn paintings of the 1990s, particularly among artists from the Huichol community of San Andrés. Photo credit: Adrienne Herron.

ment back and forth between them. I began to see that the preference for movement between poles described a great deal more than color combinations. In fact, fuerte and bajito were key concepts in Huichol philosophy and aesthetics, and an understanding of this conceptual structure helped explain some of my experiences living with the Huichol.

From my first encounters with the Huichol, I noticed profound mood shifts in the tenor of events. Days might go by with very little happening. The women would make tortillas, the dogs would bark, the men would chop wood or work on crafts. Everything would seem even, unexciting, almost too calm. When I first visited the Huichol, I learned Huichol embroidery in order to occupy myself during these long periods when nothing seemed to be happening and I

had no real job to do. Then suddenly, a startling event would shake me out of my complacency. We would suddenly shift into mystical time and supernatural events. A mara'akame would arrive and might begin a healing, waving his shaman's plumes and sucking objects out of a family member. We might stay up all night for a ceremony, fasting and singing. Intense emotions would be aired, people would cry and talk. The gods might visit. The ceremony would rise to a crescendo of emotion, then gradually taper off until after dawn, when we would finally stagger off to sleep. The next day, I would be left groping for some explanation or swimming in a state of excitement while everyone else went about his or her business as though nothing had happened.

At first, I thought that my perception of excessive shifts of emotion was an inevitable part of fieldwork, a result of being in the midst of another culture. Everyone else knows what is going to happen and what it means. It seems so obvious that they do not think to explain it to someone from another culture. Since I alone did not know what to expect, events took me by surprise and seemed particularly intense. However, as time went on, I noticed that these pronounced mood shifts seem to characterize most Huichol ceremonies I attended. Ceremonies often begin very quietly, with a rather contemplative air. A mara'akame may begin singing while children run around him and women continue cooking. People fall asleep and wake up again. During the course of the ceremony, more and more attention is paid as the ceremony builds to a crescendo of power and emotion and then moves back again to a state of tranquility and *alegría*, or good humor.

As I listened to descriptions of the differences between fuerte and bajito, I began to realize that movement between poles might, in fact, be a central value in Huichol culture. To test this theory, I described to Chavelo González the state of mind that I aim for in my own life, a state of calmness and equilibrium, sometimes described by the Buddhist concept of the one-pointed mind. He laughed at the notion and asked me, "When are we ever the same? Only when we're dead!"

He and another family member, a Huichol schoolteacher, went on to explain that staying the same, which I thought of as calmness or equilibrium, is not a goal in Huichol culture. In fact, equilibrium is seen as unattainable. Rather, the goal is to move back and forth from one extreme to another through a range of emotions while maintaining one's balance and control. This is what is meant by fuerte and bajito. It means to run a gamut back and forth from powerful and intense to restrained and subdued, rising and falling. Maintaining this rhythm—

orchestrating the moods of fuerte and bajito—is what the mara'akate try to do when they sing and conduct ceremonies, and participants in a ceremony judge the mara'akate on how well they orchestrate the movement.

The concepts of fuerte and bajito may be similar to a concept termed "shamanic equilibrium." Furst (1974, 59–60; 2006, 35–51) and Myerhoff, interviewed by DeMille (1980, 336), described an incident in which Ramón Medina tried to explain to them what he meant by balance. Ramón took them to the top of a waterfall and proceeded to leap across slippery rocks, close to a steep drop into the barranca below. Furst described this event as a concrete demonstration of shamanic equilibrium, the balance required during the dangerous journey over the chasm between the worlds, when a moment's hesitation or misstep may mean death.

While the concepts of fuerte and bajito seem to contain elements of the idea of shamanic equilibrium, I question whether they are exactly the same. Balance and equilibrium in and of themselves seem to be part of the idea of stillness that Chavelo González scorned. Dynamic equilibrium, a state of balance in motion, might better describe the Huichol aesthetic value.

Myerhoff (1974, 74–75) touches on this concept when she says that in Huichol religion, the "notion of sacred . . . seems to embrace above all the concept of attaining wholeness and harmony . . . a dynamic condition of balance." She goes on to illustrate this idea of dynamic balance with a reference to the dynamic tension between strong and weak woods used to make an *uweni*, the armchair used by the mara'akate. Her discussion suggests that the ideas of fuerte and bajito may pervade other Huichol manufactures as well.

A second concept may also play a part in explaining the idea of complementary oppositions. This is the concept of rising and falling, or going up and coming down. So far, I have used the terms "fuerte" and "bajito," and given "bajito" the translation of "low" or "soft." However, "bajito" derives from the Spanish word "*bajar*," meaning "to come down" as though descending a ladder or staircase. I noticed that artists frequently used a second word, "subedito," either in place of or as a synonym for "fuerte." "Subedito" derives from the Spanish word "*subir*," meaning "to go up." The combination of subedito and bajito suggests rising and falling.

When I questioned Chavelo González about the meaning of fuerte/subedito and bajito, it became clear that this pair of words related to the idea of going up and coming down, a basic concept in Huichol religion. When a person begins the pilgrimages to become a mara'akame, the process is considered to be like

Fig. 9.3. A Huichol armchair (uweni) whose design balances strong (fuerte) and weaker (bajito) woods.
Credit: Carl Lumholtz, *Symbolism of the Huichol Indians* (New York: American Museum of Natural History, 1900), 70.

climbing a staircase. Each year of pilgrimage represents one step on the stairs. In Lupe's family, the first six years of pilgrimages are considered to be climbing the staircase. A person may end his or her commitment at this point. However, the family constantly stresses that to learn well, and to be fully capable as a mara'akame, a person should complete a second six years so that he or she can descend the staircase and finish well.

Other authors have noticed the idea of going up and coming down in Huichol thought. According to Lumholtz (1902, 2:204): "Life is a constant object of prayer with the Huichols; it is, in their conception, hanging somewhere above them, and must be reached out for." Grimes suggests that to the Huichol, time is thought of like climbing a hill, always going upward. This distinction is marked within the grammar itself: "Progress through time is treated linguistically in much the same way as progress up a hill. The future is 'higher' than the speaker, the past 'lower'. . . . The later of two events is . . . 'uphill from' the earlier, the earlier, . . . 'downhill from' the later" (1964, 29). Future linguistic research may reveal that the distinction between fuerte/subedito and bajito is deeply embedded within the Huichol language as well.

One Huichol ceremonial object collected by Lumholtz (1900, 62) reflects the idea of going up and coming down. It is a miniature carved-stone staircase. Lumholtz was told that it represents travel, especially the travels of the gods, and that each step represents one stage of the journey. The Preuss collection in the Berlin Ethnological Museum has a version of such a staircase shaped more like a pyramid and painted in alternating stripes of red, yellow, and black (Valdovinos and Neurath 2007, 51).

The ladder is inscribed in the landscape of sacred sites. Schaefer (1990, 352–355) was told that the sticks of the loom symbolize a ladder that marks pilgrimage sites and mountains from east to west. The top of the ladder begins in the east at a mountain lake, passes through the mountains of Reunar and Kauyumari in Wirikuta, then through the Huichol Sierra, after which it descends to the Pacific Coast at Haramara. This is conceptually similar to a map of sacred sites that Eligio drew for me. He placed the east, and Wirikuta, at the top of the page so that the pilgrims would be going upward as they travelled from the Pacific Ocean to Wirikuta.

The staircase, a well-known theme in Mesoamerican thought, has wide implications. Jill Furst and Peter Furst (1980, 8) maintain that there were pan-Mesoamerican concepts that formed the foundation of indigenous aesthetic systems. Among these concepts were the ideas that the universe is multileveled and that the stepped pyramid, like a staircase, serves as a cosmic model of the sacred world. I have heard similar ideas expressed by Huichol.

Thus, the Huichol describe colors as rising and descending or as strong and soft, and use colors to express these oppositions. Their use of colors may express deep-rooted traditional aesthetic concepts, even if current practices employ modern forms and materials.

Color and Meaning

Up to this point, I have been describing general patterns in color use or aesthetic principles that underlie the Huichol use of color. These principles guide artists' color choices and the overall effects that the artists try to achieve. However, another aspect of color has significance for the understanding of yarn paintings. This is the meaning ascribed to individual colors and to combinations of colors.

Art galleries sometimes give out little pamphlets on Huichol color symbolism. The dealers say they provide this information because Western buyers often ask what the colors and the symbols mean. The pamphlets seem to be compiled from interviews with passing Huichols and from anthropological

texts such as Lumholtz's (1900) classic work on symbolism. While the information contained in these pamphlets generally appears correct, it is very simplified and limited. For example, the pamphlets equate red with fire, yellow with the sun, and so on. These equivalences are generally true, but oversimplified, since Huichol symbols typically have multiple meanings that relate to and extend one another. For example, red is equated with fire, but also with blood; and since blood carries the life force, with life itself.

Lumholtz (1900) catalogued the Huichol use of colors in art. He described in minute detail a wide range of ceremonial objects, the colors used to make them, and the meanings attributed to them by their makers. Nevertheless, Zingg (1938, 243–244) cautioned that contrary to the impression given by Lumholtz, there is no clear correspondence between colors and deities or directions, except a general association of blue and green with rain goddesses. Zingg's warning seems justified when one reviews the colors and associated meanings described by Lumholtz (1900) in his index. While Lumholtz noted that there are certain general meanings for colors, such as an association of red with life, the rising sun, and fire, or of yellow with the setting sun, fire, and grandfather fire, other data he collected on the meaning of colors show that, in many cases, these associations do not apply strictly; for example, all of the following color combinations can represent rain: red and yellow lines; red and blue lines; white and yellow lines; white and blue lines; green, red, and blue lines (Lumholtz 1900, 221–222). In other words, most colors, including red and yellow, can also be used to depict rain.

Some cultures do seem to have a clearly defined color symbolism, with meanings that are comparatively fixed and unvarying. One example is the colors in Navajo ceremonial sand painting. Each element in the design is a particular color, which must be replicated exactly. The symbolism of color is important, and there is a one-to-one correspondence between color and meaning.

In my experience, the Huichol are more flexible and allow for significant variation. This is certainly true of commercial yarn painting. In many cases, the colors are personal choices or preferences of the painters, and are not necessarily symbolic in and of themselves. It would be oversimplifying to suggest that there is a one-to-one correspondence between the colors used in yarn paintings and their meanings, or that an analysis of the paintings can always be done based only on the colors. The artists often have pragmatic selection criteria for colors, as the following comments by artists show.

Finding particular colors is one problem. The artists may just use whatever

colors of yarn they happen to have on hand or that they were able to find In the shops. Mariano Valadez reflected on the difficulty he had in maintaining a supply of the colors he prefers.

> HOPE: And do you buy your yarn in Mexico or in the United States?
> Mariano: In Mexico, in the city of Mexico.
> HOPE: You can't buy them here in Tepic?
> Mariano: No, because the material, every two or three years, is discontinued. They don't have it.

I watched one artist ask a person who was going to Mexico City to buy him a selection of yarn from the Diamante brand; he was not particular about which colors, saying he would take any colors the buyer liked.

The artists are also constrained by a limited selection of colors within particular yarn brands. This restricted palette affects an artist's choice of colors, as Santos Daniel explained. We discussed the change in yarn brands over time. He said that when the artists changed from using El Gato to a thinner yarn, Cristal, they had to adjust to much duller colors. El Gato had brighter colors. He usually works with Cristal, but it has few fuerte colors, mostly just red and green. The main reason he changed was that a dealer who complained of having trouble selling paintings made with the thicker yarn asked him, "Why not change yarns?" Now Santos uses several brands of yarn to get the color range he wants, including Diamante, Cristal, and Estilo. Which one he uses depends on the design he is doing. Now he finds El Gato a bit fuerte, and it looks a bit spongy. *Cristal* is more threadlike and harder. In general, he prefers to work in Diamante because it is a bit thicker. Estilo is very thin. He likes to work with three types together. That way he gets many colors. The Diamante and Estilo brands each have relatively few colors, and so the others complement them. He can get all the brands in Tepic, but at times the stores suddenly run out of stock.

As this interview makes clear, the artists may be obliged to make up a full palette of the colors they prefer by using different brands of yarns. Moreover they are constrained by the limited color selection in each brand.

The artist Modesto Rivera Lemus echoed Santos's concerns. He told me that he preferred Diamante because it has more natural, or bajito, colors and that his own preference is to work in bajito. He likes the colors because they are very *claro* (Sp.: clear, light) and more natural. The other brands have *brillante* (Sp.: shiny) colors, and they are not very natural. Still, he likes to use a range of colors, including fuerte, bajito, and subedito. Diamante is the best for colors. He

doesn't like Estilo much because the colors aren't pure. They are mixed colors, which he explains by showing me an example of Estilo in which two threads of different colors were plied together.

Personal taste is an important factor in the artists' choices of color. The artists are not in any way bound or obliged to use a certain color to express their meanings, although the small pamphlets imply that they are. Chavelo González explained that an artist can change the colors in a yarn painting without changing the meaning of the painting. The artist can use whatever colors he or she likes.

Salability is also a factor in color choice. For example, in 1993–1994, José Benítez Sánchez produced a large quantity of paintings, all made in bright oranges and cobalt blues. According to the dealers, those colors sold particularly well. A Huichol artist commented that these are almost exclusively fuerte colors. Benítez's repeated use of the same colors suggests that he discovered a color combination that strongly appeals to Western buyers.

Artists can have many pragmatic reasons for their color choices that have nothing to do with deeper religious or symbolic meanings. So before drawing any conclusions about color and meaning, it is important to determine whether the artists chose certain colors just because they were readily available in the stores, appealed more strongly to buyers, or better suited their own personal tastes. Having pointed out these cautions, I will now explore how color and meaning may be linked.

Eligio Carrillo declared that he would like to paint with pure color some day, without using any designs at all—just color. He did not seem to know that in Western society, many artists paint with color only and that it is called abstract art.

> HOPE: How do you decide which colors to use?
> ELIGIO: Well, this also comes with the learning. You have to know how to put the colors [together] with each other, because the colors speak also. . . . With colors, it [the meaning of the yarn painting] can be understood. There is this also. You have to know with which color I am going to speak, with which color I will be understood, with which color it is possible to speak. Also, with colors and nothing else, even if it doesn't have this [a design], with colors it can still be understood.
> HOPE: The colors speak to the gods?
> ELIGIO: Yes, with that too. With pure color also.

He went on to say that certain colors have meanings that can be understood by the gods or by a person who already has the abilities of a mara'akame. Such a

person can look at the colors in a yarn painting and determine what it means, regardless of whether it has a design.

> ELIGIO: So I like colors. Without designs. With pure colors, like this. And I know what I am making. What I am going to make. What is in it, right? But I have never made one like this, with pure colors, even though I have it in my mind. To make a yarn painting with nothing but with pure colors, you can do it.
> HOPE: Have you made a yarn painting like this for yourself? Or if it is not to sell, have you made a yarn painting with just colors?
> ELIGIO: Yes, if it's not to sell, it is possible.

Fig. 9.4. Eligio Carrillo Vicente, a yarn painting of his vision of the deer god, 1994. 24" (60 cm) in diameter. During a nighttime ceremony, the deity hovers over a shaman, whose offerings are being blessed with copal incense, the food of the deer god. Photo credit: Hope MacLean.

Eligio was concerned that if a painting did not have a design, no one might want to buy it. Therefore, he might make such a painting only for his personal use.

He explained how a yarn painting could convey meaning through its colors, by using the painting *Deer God at Night*, a round painting of a deer spirit communicating with the mara'akame in a nighttime ceremony. He explained that this painting is done mainly in bajito colors. It has a black background all around the outside rim, with little spirit figures around the circumference. In the center is a huge head of a deer, with a comparatively small mara'akame beside it. Below is a bowl filled with fire and the smoke of copal incense. All the central figures are made in gold tones, with white light all around them, against a background of light burgundy red. Eligio explained how the colors in the painting reflected the meaning:

> ELIGIO: This [painting] is for the shaman, who translates [messages from the gods] better in the night. That is, this is at night, outside, and they [the shamans] light it up. With the power he has, it's almost as though it was dawn, even though at that moment it is night. And here [*points to the center of the painting*], this could be by night, and it is as light as though it was day. That is what the color means in this one. And here it is by night that they are doing the ceremony. He presents himself to the deer, which is the power. At the same time, [it seems as though] it is midday, but it is really part of the night.
>
> HOPE: And he is doing the ceremony?
>
> ELIGIO: Yes. That is how we see it, as though it was in daylight. That is to say, he is translating it [the mara'akame is translating for the gods during the ceremony].

In contrast, Eligio showed me a second yarn painting, *Sun-God at Midday*, that uses fuerte colors such as bright turquoise blue and hot pinks and reds. The design represents the sky, and the sun at its zenith transforming into a person; therefore, it shows the power of the sun to light up the sky in the daytime, just as the shaman did at night. The fuerte colors emphasize the theme of power.

Because of the deeper levels of meaning that can be expressed by combinations of colors, Eligio emphasized that it was important for artists to understand the significance of colors and to know what they are trying to express.

> ELIGIO: [The] artist should understand the knowledge, what I am going to make, what color I am going to put on, more or less, and know and understand what I am going to make. What can it indicate? How can I explain it? That is what there is [that is, the powers contained in the colors].

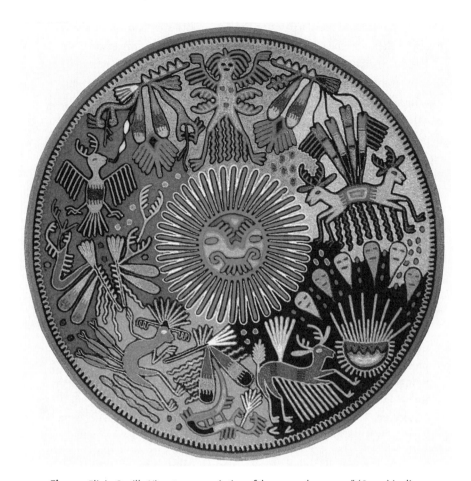

Fig.9.5. Eligio Carrillo Vicente, yarn painting of the sun god, 1994. 24" (60 cm) in diameter. The deity appears as a human figure in the zenith of the blue sky at midday. The image is painted in fuerte colors, representing the strength of the sun. Photo credit: Hope MacLean.

The conversation with Eligio demonstrates that color and meaning are associated; however, the associations may be more complex than a simple one-to-one correspondence between a single color and a single concept, such as "red equals fire." Meaning may lie in the particular combinations of colors in the painting as a whole. The combinations may be more important than each color is individually. The combinations express complex concepts about ceremonies or spiritual properties, concepts not immediately apparent from looking at the painting. As Eligio said, although a mara'akame may understand the meaning simply by looking at a painting, the rest of us will need to ask for an explanation.

10

sacred colors and
shamanic vision

Eligio's comments on color and meaning were intriguing. After completing my PhD fieldwork, I had a feeling that there was much more to be learned about what color really meant to the Huichol and that I was still only scratching the surface. A breakthrough came one day as I was talking to Eligio. He had used the phrase "the colors speak" before, but I thought it was just a reference to the colors having meanings of some sort. Suddenly, I realized that he was talking about something else: he was saying quite literally that color was a language used by the gods and spirits of sacred sites to communicate with a shaman. Color in yarn paintings can be a representation of the visionary language experienced by a shaman. This led to a whole series of questions about which gods use colors to speak, which colors they use, and how the communication is understood.

Michael Harner (1980) proposes that the shamanic state of consciousness (SSC) is a biophysical capacity of the human body. Alternate states of consciousness may be entered through techniques such as fasting or rhythmic percussion (drumming or rattling). Then a person may experience entry into another world or communicate with power animals or other spirit beings.

Members of many cultures enter SSCs through ingesting hallucinogenic plants such as mushrooms (Psilocybe), various species of Datura, or ayahuasca (Banisteriopsis, with additives made from other plants such as Psychotria [Kensinger 1973, 10]). Color visions seem to be part of the experience associated with SSCs, particularly when using hallucinogens.

For example, ayahuasca seems to generate powerful color visions. The ethnobotanist Wade Davis (1998, 159) described seeing brilliant colors, snakes, the sky opening, and rivers unfolding as though blossoming. A series of paintings by the artist Pablo Amaringo (Luna 1990) shows the rainbow-colored wavy and jagged lines associated with taking ayahuasca. A drawing by a Jívaro shaman

shows similar jagged lines representing a golden halo around the head of a person (Harner 1980, 29).

Many people who eat peyote report seeing brilliant colors and vibrating patterns, often in geometric or lattice-like shapes (Cordy-Collins 1989, 41–43). Their experience resembles seeing the shifting geometric shapes and colors in a kaleidoscope, as Ramón Mata Torres (n.d., 107; my translation) describes:

> [I see] a marvelous world of color in which everything changes into a fountain of forms and colors. . . . The colors are alive and breathing, like the stained-glass windows of Gothic cathedrals. . . . The conviction grows that all the colors can combine themselves, that no color excludes another. All can mix together without appearing ugly. But the way the color gradually shades is important, even decisive. Greens with violet, magentas with greens, dark blues with greens, yellows with lime green, reds with blues or oranges, which move from the softest to the strongest shades. . . . There are in front of me shapes of rhomboids, squares, stars, triangles. . . . It is a world of architectural shapes that seems more logical than the world we usually see and more geometric than the world we know.

Geometric color imagery is only one type of peyote-induced experience. The Huichol say that it is only a beginning. Some people never see any more than this. However, a person who develops shamanic abilities goes beyond color imagery and feels himself or herself to be entering into direct communication with gods, spirits, or sacred places. The images that a shaman sees are meaningful on a more important level, not just pretty designs.

I should make clear here my own experience as a researcher. I have participated in ceremonies, including the pilgrimage to Wirikuta. During some ceremonies, I have eaten peyote and experienced several types of visionary phenomena, including seeing spirits such as deer and hearing voices speak to me. I have not seen the type of colorful, shifting, kaleidoscopic imagery described by Mata Torres. Nor have I experienced the phenomenon described by Eligio of colors that can be understood as language.

My interviews with Eligio brought out another dimension of shamanic visionary experience. This is the idea that color itself is the means used by the gods to communicate with a shaman. A shaman hears and understands by means of color. These colors are not words or symbols in a linguistic sense—that is, they do not function as a symbolic language in which color x means one thing, and color y another. Rather, the colors themselves seem to be comprehended in a multisensory way that is meaningful to the shaman. According to Eligio, colors

are words, and at the same time, they are songs. He also proposed that colors could speak to one another.

> ELIGIO: The colors are words, and they are magical songs. The colors are songs. They are words, and they understand each other.
> HOPE: Are they a language of the gods, the colors?
> ELIGIO: Yes, colors are the voice or the words of the gods. They come from the gods, and they arrive with you and [you have to say them].

The word-colors come from the gods directly in the form of songs.

> HOPE: Do they come from the gods when the gods sing? And those songs come out from them?
> ELIGIO: It is exactly the same for the gods as it is with us. That is exactly how the gods talk. Just like us. In those moments when the shaman is in communication with them, so he can translate their words, the gods are speaking. As though they were chatting in conversation. But who knows how far they are able to see? From here, the shamans make contact as though by telephone. And then the shaman sees also, sees the gods. For a moment. The vision is just a period of light. Then when the shaman stops singing to have a rest, the vision also withdraws. In that moment. And when the shaman begins again, the gods make contact again.

The words of the gods arrive at the shaman's body, particularly to his or her mouth. No one teaches the shaman to understand them. The ability to comprehend and translate the word-colors is part of becoming a shaman.

> HOPE: When the gods speak to you by colors, does anyone teach you to understand? Who taught you to understand them?
> ELIGIO: [*laughing and shaking his head*] No, those ones [the gods and the shamans] understand each other. With colors, they understand each other. Because it is the image that speaks. Almost you speak to it, because wherever you are, the god can reach that place through the image. That is how it speaks to you with an image. And that is how you speak to it: with the image that is opening up your mouth, the image that is coming to your body.
> HOPE: Is it an image like a dream?
> ELIGIO: It is . . . how can I tell you? . . . It is like a picture.
> HOPE: Like a yarn painting?
> ELIGIO: That is how it will reach you, like a picture. It will come to your mouth. You are eating it . . . almost [*makes a gesture with his hand of stuffing something into his mouth and eating the words or colors*]. You are seeing, chatting.

HOPE: You are almost eating the colors?

ELIGIO: Yes, the colors. They come to your body.

HOPE: Then no one taught you to understand them. It is only possible if some-one has the capacity.

ELIGIO: Yes, they come to your body.

HOPE: It seems to me that I am almost at the end of what I can ask you because we are going very deeply into the knowledge of the shamans, right? And I lack the words, or I lack the understanding. I want to ask about the colors, but I al-most don't know how to ask the questions.

ELIGIO: No, well, the colors, you would have to learn about them. You would have to experience them. For example, if we were holding a ceremony and you were using peyote. That would allow you to do something to concentrate or fo-cus yourself so that you could see the colors, could hear the colors. You would know what the colors are, what it takes to understand them, what you need to hear them. That is where you can begin to comprehend the colors.

Eligio seems to be describing a phenomenon whereby colors and visual pic-tures are perceived by means of multiple senses, by the mouth and the ears as well as by the eyes. I have not been able to clarify this ambiguity further. Eligio usually uses language precisely to express his meaning. Hence, the ambiguity is not due to the confusion of someone who has difficulty expressing himself in a second language. The limitation is mine because I have not experienced this phenomenon, and therefore, I find it difficult to describe.

Eligio's explanation of colors as language and song is difficult to understand from the point of view of Western thought. Westerners usually express percep-tions as separate and independent sense experiences. For example, we see col-ors or images and hear words or songs. It is difficult to imagine the two hap-pening simultaneously. However, there are cases of people who can combine sensory perception, in a phenomenon known as synesthesia.

Barron-Cohen (1996) defines synesthesia as the mixing of two (or more) senses so that sensation in one modality is triggered by sensation in another. One example of synesthesia is hearing music as colors. I once heard a radio pro-gram in which a musician described how certain instruments might cause him to see a cascade of silver, blue, or some other color.[1] Barron-Cohen describes a case of a woman who heard sounds when she saw colors; however, he notes that she was so overwhelmed that she was obliged to withdraw from society. Barron-Cohen hypothesizes that synesthesia may be a natural state among newborn children and that only later do the senses become differentiated.

When Eligio describes seeing colors that turn into magical songs, he may be describing synesthesia or a similar phenomenon.

Eligio's experience may be compared to Gebhart-Sayer's (1985) description of a Shipibo shamanic ceremony in Peru. The Shipibo shaman sees designs float down during the ceremony. When the designs reach the shaman's lips, he sings them into songs. When the songs come into contact with the patient, the songs turn back into designs, which penetrate the patient's body and heal the illness. The shaman also states that the songs have a fragrance, which itself is powerful. There is a striking similarity to Eligio's description of the visual image that reaches the shaman's mouth, where it turns into song. One wonders whether this experience characterizes other shamans' experiences as well.

Possibly, colors are specifically associated with trance experiences or altered states of consciousness, and not with everyday consciousness. In a follow-up interview, I asked Eligio whether he saw colors when he heard music played on the radio or during a party. He said that he did not. He only saw colors when communicating with the gods during a ceremony. Then he qualified this statement slightly by saying he did see something when the ceremonial violin or guitar was played. What he saw was more like a kind of wind or transparent wave coming out of the instruments. These statements indicate that his experience is something other than ordinary synesthesia, which is always triggered by a particular stimulus.

To clarify these concepts, I asked him who can see these colors. Are they available to anyone, or are they limited to the shamans?

HOPE: Do the gods speak to people like us [that is, to non-shamans] with colors also?

ELIGIO: Yes, well, only this way. The colors come to some people. But they come with more enthusiasm [Sp.: *más gana*] to a person who wants to know [about shamanism]. Not to everyone either. It's only some people.

The anthropologist Charles Laughlin (personal communication) points out that only some people are synesthetic. Eligio seems to be saying the same thing.

To see the colors, a person has to fast and fulfill the requirements of becoming a shaman. Abstaining from salt and sexual intercourse is a basic requirement for participation in many Huichol ceremonies. At times, one may also be required to abstain from food and water for part of the day. Both shamans and non-shamans may observe these proscriptions, depending on the ceremony and the degree of their participation in it.

ELIGIO: You have to fast to learn. To fast from salt, water, food, to be able to hear this . . . If you do it with peyote, it will come with even more force. And by that means [of peyote], a lot of words from the gods will come to you. But they are colors that come.

HOPE: They come as colors?

ELIGIO: That's how they come.

Is this means of perception unique to Eligio, or is it shared? I asked him whether other Huichol know about the colors as words. He affirmed that shamans, at least, know about it and perceive this way.

HOPE: Do the other Huichol know what you told me about the colors and the magical winds?

ELIGIO: Yes, the shamans do. The shamans know. Because all the shamans work with these, translate [the communication from the gods] with colors.

HOPE: And it is by means of colors? It isn't by means of sounds or words?

ELIGIO: By means of colors. They are words that originate as colors.

HOPE: You are almost at the end of what I can understand, I think. If I had experienced this, I could grasp it, but right now I can't grasp the idea very well, of a color that is a word.

ELIGIO: Yes, it is very difficult. Well, it is for you. For me, it is easy.

The understanding of colors as words is shared among shamans, so if one shaman depicts a visionary experience in a yarn painting, another shaman can comprehend it.

HOPE: And when a person makes a yarn painting, can another shaman understand it through the colors you use?

ELIGIO: Yes, of course. [Others can tell] by seeing it, and then the shaman says what it is [that is, others can also know if the shaman gives a verbal explanation]. A person who has this knowledge. A person who doesn't know [is not a shaman], doesn't understand anything. As for me, I can just look at the painting, if someone makes a design, and I can tell whether he is a shaman and, therefore, whether he knows. And moreover, if he hasn't completed [shamanic training], he isn't a shaman.

Eligio felt that most of the Huichol artists used these concepts, whether they were shamans or not. The depiction of colors is therefore at the heart of Huichol yarn painting.

HOPE: Of the Huichol artists that you know, such as [José] Benítez or [Mariano] Valadez or others, who are the ones that you think are using the colors in the manner of the shamans?

ELIGIO: All of us who work on yarn paintings are using this, the colors, with the help of Kauyumari and the gods. We also make designs with the help of the sacred fire, which is called Tatewari. He produces colors also. Colors are born from the fire as well. Kauyumari hears him. They understand each other, they speak to each other. And by means of this, of colors, they translate [relay communications to the shaman] from the sacred places [sacred caves and other geographic locations]. For this reason, all of us who make yarn paintings base ourselves in the colors from these places, from the sacred fire and Kauyumari, in order to make a [yarn painting] design using the colors of the gods. From the sacred fire and everything. Such as Benítez, myself, Valadez, Santos, and various others who are informing themselves. By this means, they make their designs. Of those who listen to the places of the gods, they make designs. They dream, they see, and they make their designs on the basis of these songs of the gods.

HOPE: And does one see the same process in beadwork, such as the beaded masks?

ELIGIO: Yes it is the same. It is entirely the same. In the beadwork, it is the same. One can draw what one sees through dreams.

Besides the professional artists, some women also use the sacred colors as part of their work in textiles, such as embroidery or weaving.

HOPE: Do you see this also in the clothes [made by] the women, the colors that they put in the clothes?

ELIGIO: Of the women? Well, some women, not all of them either. But as I say, if a person doesn't know this study [of shamanism], one can use it, but no more [that is, depict the colors but not originate them]. If the person is a shaman, then yes.

HOPE: The clothes that the Huichol have are always very decorated with many colors.

ELIGIO: Well, when the person [the maker of the clothes] is translating, yes. [Eligio uses "translating" to mean that a shaman is communicating with and interpreting the words of the gods]. When she is translating. And when she is not translating, it is not. When the person is translating, yes, because that is directly guided by the place from where the person is translating.

HOPE: The gods send the colors to the clothes?

ELIGIO: You have to arrive at the sacred place.

Eligio affirms that the colors that a female shaman uses in textiles will be guided by the gods of a particular sacred place. However, the woman must have made pilgrimages to that sacred place in order to receive colors from it. Women who are not shamans will be able to copy shamanic designs and colors, but not

originate them. Thus, Eligio confirms the opinion of the anthropologist Stacy Schaefer (1990, 245), who cautioned that not all women are capable of using information from dreams or visions in their designs. Schaefer felt that it was mainly those women who were most mature in a religious career who were able to use this source of information.

Which Colors Are Sacred

In addition to the question of who perceives colors, other logical questions are, Which colors is Eligio talking about? Do the gods use all colors, or are there only certain colors they use? How many colors do the gods use? Are the sacred colors shown in yarn paintings or other Huichol arts?

To bring this discussion down to basics, I gave Eligio my set of Pantone color swatches and asked him whether he could identify which colors the gods use to communicate. Eligio used the series on shiny, coated stock to make his selection.

I was surprised that he chose comparatively few colors—16 out of a possible 777. All were selected in pairs of adjacent colors on a swatch. The pairs were different shades of a single color. Hence, only about eight distinct groups of colors are represented. I asked him several times whether he wanted to add any more colors, but he insisted that his list was complete with those sixteen.

Fig. 10.1. Pantone colors (marked with dots) that Eligio Carrillo selected as representing the sacred colors he sees in communications from the gods, 2010. Photo credit: Adrienne Herron.

Table 10.1. Pantone Colors Identified as Sacred Colors by Eligio Carrillo

Huichol term	Pantone color
Tarauye	150C + 151C, slightly brownish oranges
Tarauye Kwima tarauye	809C + 810C, fluorescent greenish yellow and fluorescent orange yellow (like the Day-Glo colors on psychedelic posters of the 1960s)
Talauye	231C + 232C, strong bluish pinks (close to rhodamine red)
Yutsi kimauye Kwima yutsi kimauye	258C + 259C, purple
Muye yuawi	265C + 266C, violet
Kwima yuawi Kwini mieme mu yuawi	300C + 301C, blue (shading between process blue and reflex blue with black)
Yu muki	470C + 471C, chocolate browns
Kwiamauye	479 + 480C, light dove-grey browns

These colors are not what Western artists use as primary colors; that is, primary red, yellow, and blue. Eligio's red is a shade closer to bluish pink. His yellow shades lean toward green or orange. There is no green, black, or white. There are several shades of blue, which lean toward black or violet and purple. The selection made here is not clearly related to a rainbow or the light spectrum, since it includes several shades of brown, such as chocolate brown and dove-grey brown.

Nor are these colors the same as those used in Plains tribes' medicine wheels or in other popular versions of colors associated with the cardinal directions in Native American thought. In Canada, one often sees the medicine wheel depicted with primary red and yellow, black and white. In some versions, blue is substituted for black. However, Eligio's version contains no black or white, and the reds and yellows are not primary colors.

Perhaps coincidentally, I received independent confirmation of Eligio's color choice from another Huichol artist, Chavelo González de la Cruz. Chavelo lived in a village some distance from Eligio, and as far as I know, there was no direct communication between the two while Eligio was telling me about the colors. Chavelo is learning to become a shaman, and claims a certain amount of shamanic vision, but says he does not yet have the ability to heal.

I had asked Chavelo to make me some paintings, and he arrived with a painting of the sun god. It showed the sun as a face, with parallel lines of colors at the top. When I asked what the lines represented, he said they depicted the sacred words that come from the sun. The colors bear a remarkable similarity to the ones identified by Eligio, especially when one keeps in mind that Chavelo had to use colors of yarn that he could find commercially in the shops. In most cases, the shades are quite similar.

I had not told Chavelo about what Eligio had said on the subject of color, nor did I ask him to make a painting showing this. Thus, Chavelo's painting is independent confirmation both of Eligio's statement that colors are words that the gods use to communicate with, and of the actual colors used.

There are several terms for the sacred colors the gods use to talk with. Chavelo said his painting showed *niwetari*, which he defined in Spanish as *palabras sagradas* (Sp.: sacred words). Eligio offered several different Huichol words to refer to the sacred colors.

HOPE: How do you say "colors" in Huichol? Is there a word?

ELIGIO: "Colors" in Huichol? They say *ukitsikatcha pu yeina*. *Tatei teima wa ukitsikatcha*

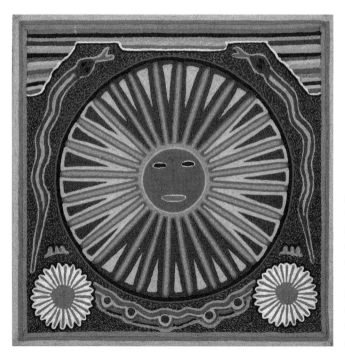

Fig. 10.2. José Isabel (Chavelo) González de la Cruz, yarn painting, 2000. 12" x 12" (30 x 30 cm). The colored lines at the top represent the sacred words (niwetari) of the sun god. Their colors are remarkably similar to the Pantone colors selected by Eligio Carrillo. Photo credit: Adrienne Herron.

pu yeina . . . Or else, *wa urrari* also. It is more straightforward. *Tatei teima wa urrari xi pu yeni.*

HOPE: And the word "*uxa.*"

ELIGIO: That means—didn't you say it to me in Spanish? "*Ukitsika*" or "urrari." It is the same.

HOPE: "*Wa urrari*" is the same as "uxa." "*Urra*"? You say here "*urra*"?

ELIGIO: Yes, "*urrari.*"

Eligio speaks the San Andrés, or *r*, dialect of Huichol; thus, he uses "*urra*" (plural: *urrari*) for the word often written in the literature as "uxa" (pronounced "oo-sha" in the eastern dialect of Huichol). "Uxa" is usually used to refer to a yellow root that is used as a face paint during the pilgrimage to Wirikuta. However, while "uxa" alone may mean the root or paint or color, Eligio is using "Tatei teima wa urrari" to mean the sacred colors used by the gods to communicate. "Tatei teima" means "our Mothers," the mother goddesses who are part of a constellation of deities the Huichol believe in.

Colors, Symbols, and Meaning

One of the first questions any anthropologist might ask is, Are the colors that Eligio identified symbolic in some way? That is, does Pantone color 150C mean one thing, while 151C means something else? Is there a symbolic equality between one meaning and one color? Or is meaning more complex? Perhaps there is a language of symbolic meanings that the shamans learn to understand?

As I delved into the meaning of colors, it quickly became apparent that the simple equating of color with meaning was not what Eligio was talking about. Instead, he said that the colors usually come as combinations, not singly. That is, one usually sees a group of colors together in a communication from the gods.

ELIGIO: [The colors come] combined. They don't come alone, they come combined.

For example, the deer god often appears surrounded with blue. In a sense, blue is a sign of the powers of that deity. However, as soon as the deer god comes to a ceremony and makes contact with the fire, it is surrounded with other colors, such as red and orange, whose source is the fire. Therefore, when Eligio is making a painting, his goal is to try to represent the colors he sees as accurately as possible.

ELIGIO: Well, I am only using that [power or communication] that the color carries. . . . I make that [the painting] with these [same] colors.

HOPE: If you are making a god [in a painting, do] you make it with the color [you see] . . . ?

ELIGIO: That is combined [in the god]. That's how I combine them.

HOPE: For example, if you see Tamatsi Kauyumari, with blue?

ELIGIO: Yes, you should see him with blue.

HOPE: And you will paint him with the same blue?

ELIGIO: Yes, with the same.

As the deer god contacts the fire god, other colors leap out.

ELIGIO: If I make Tamatsi Kauyumari, if he is . . . when the fire is there, [with] Tamatsi Kauyumari, I make it with blue, coffee color [brown], and blue, coffee around the outside . . . and red and orange. He is in contact with the sacred fire. Combined. Because the deer alone is only blue. But he carries part of Tatewari once he makes contact.

HOPE: When the deer is touching the fire, it carries the colors of the fire also?

ELIGIO: Yes, of the fire also.

The colors of the fire can be seen as colored lights shining around the deer spirit. (The Huichol artist Santos Daniel Carrillo Jiménez quite often depicts these red- and orange-colored lights surrounding the deer in his yarn paintings.)

HOPE: And it can be seen as light outside the deer?

ELIGIO: Like lights, like lights.

The blue deer (Hui.: *Maxa yuawi*) is a well-known image in Huichol art. Eligio was quite clear that the reason the deer is called "blue" is because that is how the shaman sees it. He added that the blue deer is a different deer from Tamatsi Kauyumari and comes from a different sacred site. Moreover, there are other deer spirits that can be identified by their colors. As each sacred deer makes its appearance, the shaman sees its color and hears specific sounds.

HOPE: That is the reason the Huichol say the blue deer, then?

ELIGIO: Yes . . . The blue deer comes from the ocean. And Tamatsi Kauyumari comes from Wirikuta.

HOPE: And does it have another color?

ELIGIO: There are other colors [of deer spirits]. There is a white deer. There is a yellow deer. And that one from the ocean is blue.

HOPE: And do they have other names?

ELIGIO: Yes, *Mara türa* is the name of the white deer. *Wirü tara* is the name of the yellow deer.

HOPE: Yellow? Then you know where the spirit comes from by its color?

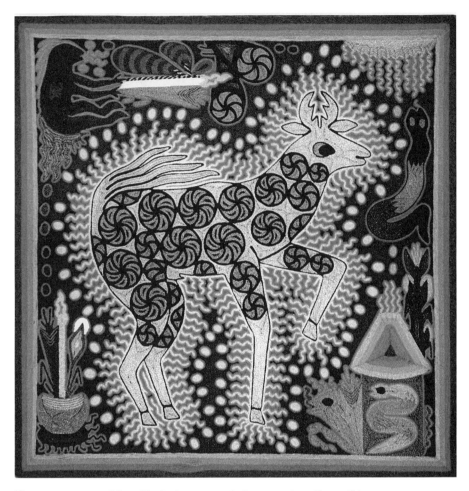

Fig. 10.3. Santos Daniel Carrillo Jiménez, yarn painting, c. 1996. 15 ¾" x 15 ¾" (40 x 40 cm). Colored lights of the fire surround the deer god, Tamatsi Kauyumari. According to Eligio Carrillo, this is a visionary experience seen by shamans. Photo credit: Hope MacLean.

ELIGIO: And then a wind comes. It starts to make a "shhh" noise [*makes sound of hissing*] like an eagle when Kauyumari is going to come. When he arrives . . . When he touches. Until he arrives.

Clearly, Eligio is not using colors as symbols, which represent something other than themselves. He is quite literally representing reality as he sees it through shamanic vision. That is, if he paints a deer spirit with blue, it is because that is how he sees it. If he surrounds it with red and yellows, it is because

that is how he sees it when the power of the deer god combines with the power of the fire god.

The colors "mean" the powers of the gods. But they do not necessarily "mean" anything else. Nor are the colors a language in the sense of a set of symbols to be manipulated. They are a language that can be understood by the shamans, according to Eligio, but clearly he is not thinking of a language that can be learned and spoken by anyone, with or without shamanic ability.

Eligio himself said that the colors could not be understood intellectually as symbolism. He felt that the best way for those who are not shamans to understand is through the yarn paintings.

> HOPE: In the university, many people have asked me what do the colors mean to the Huichol. But if I try to explain this, they are not going to understand me. They are looking for some kind of symbolism.
>
> ELIGIO: Only this way, how they can understand, is through [yarn] painting. Just as I was painting what this means [in] the painting of the sun that I told you about. [*Sacred Spring of Aariwameta* shows] what colors it is made with, what colors you work with, what colors it can be translated with.

The Relationship of the Sacred Colors to the Fuerte-Bajito Color System

I tried to find out how the magical colors are related to the fuerte-bajito color system described by other artists. Eligio's perspective again reflected his shamanic experience. He said the fuerte colors are the ones the gods use to talk with; thus, fuerte colors and magical colors were the same thing. Bajito colors were ones that had little or no magical power.

> ELIGIO: Colors that don't translate [communicate from the gods] are bajito colors, such as bajito blue or yellow combined with blue. Since they are bajito, they have less magical power. They don't have as much power.

In contrast, fuerte colors can be used to send and receive messages from the sacred places where the gods live.

> ELIGIO: Fuerte colors, such as when everything is blue, yellow, red, and pink mixed together, it is a fuerte color. This is capable of translating or communicating with the places that are sacred sites. And these colors also translate when the person receives these colors. It is as though [the shaman] can translate or communicate with the places of the sacred gods, which is where the gods send signals from.

I tried to establish whether there was a hierarchy of colors, from the most to the least fuerte. However, his answers again were much more complex than I had expected, and they did not point to a simple ranking system. The most fuerte color was blue, he said. Blue carried the power of the deer god and seemed to be one of the most common colors used by gods.

> ELIGIO: Fuerte colors are blues. They are "mixed" with the place of the gods, where the magical power of the deer god is located, which the shaman uses to translate. These are colors of blue. Yes, blue is the most powerful.

However, when I asked him what followed blue, he said that it was the other colors in combination. Most colors appeared in combination. This seemed to be why he could not identify a single, linear hierarchy. The lack of hierarchy became even clearer as I questioned him about some specific colors. Each time, he answered mainly in relation to the role these colors played in ceremonies or in shamanic visions. For example, the shamans become able to see on a visionary level during the night. When everything is dark, they are able to translate messages from the gods or enter into direct communication with them. Eligio often uses the term "translating" to refer to the role of the shaman as an interpreter of a god's messages. The deer god is the one who helps the shaman interpret.

> ELIGIO: This color—black—is the time of the night. When the person [shaman] can translate. At night, when he sees [the gods] as though it were day. The shaman is seeing everything; he translates it; he is hearing the sounds. When he is singing, that is when a magical air comes to him and he hears it. It is at night when he does this, but at the same time, it seems like day. However, the person who doesn't know anything [a non-shaman] won't be able to see anything.

Black represents the night, when the shamans are able to see the signals being sent from the places where the gods live.

> ELIGIO: The color black . . . it comes into being at night. During the night, this is called *tukari ku*, when the magical songs of the gods can be heard. That is when the deer god comes in [to the ceremony], in order to translate from the sacred places. So that these ones may have magical power, they only work during the night. In order that the sacred place may send signals to investigate the place. It is the place of the gods. That is the role [of the time] of the night.

Similarly, I tried to identify whether red was fuerte, but he answered by discussing how red appears during a ceremony.

> HOPE: And is red a fuerte color?

ELIGIO: Red. Well, it appears combined with yellow or orange, and with pink and blue, more or less combined. But it is a part of one fiesta. It is used for the fiesta of the bull, when they kill the bull. During that [fiesta], which is for the spirits of the people. And also the magical blue comes in when it is time to enable the spirits to arrive [at] the place [of the fire], of the sacred circle of the shaman. Or at the sacred site of the gods, which is in Wirikuta. With these colors, [the spirits] come down.

I tried asking about several other colors. He identified pink and orange as the colors used by the gods in their face paintings.

HOPE: Pink or orange?
ELIGIO: Those mean the colors of the [face] painting of the gods. For that reason, the women do it also [paint their faces in ceremonies]. And they [women] make designs, but concentrate on the ones that belong to hikuli. They make paintings.
HOPE: And what others? What does green signify?
ELIGIO: Green means . . . we are accustomed to hold the fiesta of elote [corn on the cob]. That's what green is. We call it Tatei Niwetsika; that is the corn, but in Huichol we call it Tatei Niwetsika. It [green] is the color of corn, and it also has the same meaning as peyote. Those two also change into each other.

I tried once again to establish a hierarchy of colors that are more or less fuerte, but Eligio answered from quite a different point of view.

HOPE: And are some colors more fuerte and are others less strong?
ELIGIO: Well, to be precise, it comes from using peyote. Among the colors of corn, there is yellow, there is white, there is red, there is blue, there is spotted. And from there, depending on the color that you use, that is the effect it will have on you. Not on everyone. Each thing has its own power. For example, if you eat the yellow corn, or this one, the peyote, it will have a lot of effect on you. It is as though you will wake up, that is to say, even though it is night, you will see many colors. That's how it is.

Clearly, Eligio was thinking of something very different from a rank order of colors. I concluded that asking questions from the point of view of a Western researcher was not yielding the results I expected. It was more productive to listen closely to what Eligio was saying and to try to enter into the cultural and psychological framework he was describing.

Colors and Sacred Directions

The Huichol have a system of sacred sites around their territory. These sacred sites are considered to be homes of the deities, or places where their power is concentrated, and where humans may make contact with them. The sites include particular caves, springs, or rocks within bodies of water, such as a large white rock in the Pacific Ocean at San Blas (Tatei Haramara), as well as mountains and regions such as the peyote desert. The deities include powers located in the cardinal directions.

In Native American and Mesoamerican belief, particular colors are often associated with the cardinal directions. Contemporary Native peoples of Canada use the following colors for the medicine wheel: east is yellow; south is black; west is red; and north is white. The Aztecs, close relatives of the Huichol, used other colors in a painting of their calendar wheel, recorded by Diego Durán (1971, 392, plate 35): east is green; south is blue; west is yellow; and north is red. According to Stacy Schaefer (personal communication), her Huichol consultants assigned colors to the directions that differed from those the Aztecs used.

> From the women with whom I worked I learned the colors for the cardinal directions when I mistakenly bought the wrong colored ribbons to tie onto my votive candles. I was told that red = east, Wirikuta where the sun rises; black = west, Haramara where the sun sets and where the souls of the dead go; green = north, Ututavita—a sacred cave in Durango; blue = south, Chapala; yellow = center, the sierra where "we" live; and white = above, the clouds.

Schaefer added: "I know there must be a lot of variation, but it would be interesting to see if there are any patterns." Tim Knab (1977, 84) noted that the Huichol of Santa Catarina associated the colors of kieli flowers with the cardinal directions. Kieli can have yellow, blue, white, or dark-violet flowers.

In an effort to confirm Schaefer's research, I asked Eligio whether there was any particular color associated with the directions. To my surprise, he once again reversed the conceptual order of the question. Rather than making a simple association between color and direction, he said that what was important was that the directions—the sacred places—talked to the shaman in colors. There was no one color for each direction. Instead, the spirits of the directions used all the sacred colors to speak, and so did the shaman to reply.

> HOPE: Are there colors that are linked with the sacred directions also? Is it like each sacred direction has a color?

ELIGIO: Well, the colors . . . these come forth when the shaman is using the powers of the sacred places of the gods. It is like an electricity. Those are the colors. Those colors arrive from the sacred places. They arrive at the sacred temple [that is, the fire lit during the ceremony] of the shaman.[2] He is singing for them [the sacred places] to reach them. They come to the place [where the shaman is] and to the *takwatsi*. It is as though it were an image. You are calling it. With your spirit-mind [*pensamiento*], nothing else. With that. And then it comes.

I repeated the question in order to make sure that he was not thinking of symbolic associations between colors and directions. He replied by elaborating on the theme of how the colors contact the shaman. He added the information that the shaman has colors also, which can communicate with the colors of the sacred sites.

HOPE: And it doesn't make . . . for example, here is [the cardinal point in] the north, the south, Wirikuta, the ocean. There isn't one color that is linked to each direction?

ELIGIO: Well, the colors, they have them there, those ones [that is, the sacred sites]. That is to say, those ones over there. In those places, that's where they are. And the shaman has a color also. Well then, with those [colors] they [shaman and place] make contact. [*makes "ssh" sound*] At the moment that he is speaking. It is like electricity, right? To the four cardinal directions. For example, if I speak to the four cardinal directions, here from the center [*makes "ssh" sound*], it has to touch to the four points with this [sound of wind].

It is noteworthy here that Eligio refers to certain sounds as he describes the experience of receiving the colors. The anthropologist Marie-Françoise Guédon (personal communication) points out that sounds can be a component of altered states of consciousness and that certain characteristic sounds may accompany particular states. For example, an out-of-body state, which she experienced in a workshop, was accompanied by particular sounds. She later recognized these sounds in other descriptions of shamanic experiences, such as an Inuit description recorded by Knut Rasmussen. Since my interviews with Eligio were tape-recorded, the exact sounds he made are on tape. Verbally, I can describe them as hissing or "ssh"-ing sounds, like air coming out of a tire.

Referring to previous conversations on the combining of colors, I clarified that this is what happens when the shaman communicates with the directions. The channel of communication is open as long as the shaman sings. When he stops, the communication ceases. It reopens when he begins to sing again.

HOPE: And the shaman has colors also. His colors are talking to [the sacred sites?]

ELIGIO: In the moment, yes. In the moment. Because . . . it is coming to the takwatsi, the colors, the rays. It is those ones who hear the magical air [Sp: *aigre mágico*], yes.[3]

HOPE: And the rays . . . the colors are like rays that are arriving from those places to the shaman?

ELIGIO: Yes, to the shaman.

HOPE: From the different places. And they are colors, such as many different colors. They aren't just one.

ELIGIO: No, [they are] different colors.

HOPE: As though combined?

ELIGIO: Combined, exactly. That's how it is. They [the colors] have different powers. For that reason, they make contact.

Is there other research that records the idea of shamans using a language of color and song, or of deities communicating by these means? Is this concept unique to the Huichol? Probably not.

For example, in the description of Shipibo shamanism by Gebhart-Sayer (1985, 162), there are some significant similarities to Eligio's perception. Shipibo shamans recounted that under the influence of ayahuasca, they saw luminous geometric configurations that took the form of designs. They also described this phenomenon as "rapidly flashing 'sheets' of designs" (167). The article mentions that colors play a role in these designs, but does not discuss which colors in detail or what they mean. There is one mention of red and black (155), a reference to "colored stripes" (157), and a description of the colored infill of design units (147), as well as several references to the brilliance or shininess of designs. In the past, her consultants had said that it was possible to read these designs as though they were words in a book. However, the knowledge of how to do this was passing away. She was told how this reading might be done (168), reading lines and motifs by starting at the lower right and tracing the meanders of the designs with a finger, but it seems as though the consultant did not tell her the meaning, and she was not sure whether it was still known. Her research provides another case in which there is a strong association of the idea of visual designs, light, and song with a form of language or meaning comprehensible to a shaman.

Eligio's perspective on sacred colors and the cardinal directions also sheds a new light on the usual symbolism of the medicine wheel. Why would colors be

associated with cardinal directions? Is it possible that the concept originated in the shamanic perception of multiple colors communicating from the sacred sites located in the cardinal directions? Perhaps later this became simplified and stereotyped as a single color for each direction.

What Color Perception Looks Like

Toward the end of our interviews, I asked Eligio to make me some yarn paintings. I did not request any particular topic. When I returned, one of the paintings he offered me was a painting of the colors as he sees them coming from a sacred site. The painting depicts a deity located in a cave with a spring in it. He called it Aariwameta. The cave is a sacred site where Huichol go to request powers, including the shamanic ability to heal as well as the ability to paint and draw well.

The painting shows the sun god floating on the surface of the water. Eligio explained that this image is what a person with shamanic vision sees upon looking into the water of the spring. All around the spring are jagged lines in colors of bluish purple and pink. He explained that this is how he sees the colors when they emanate from the sacred site.

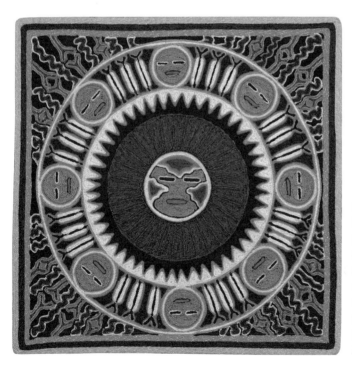

Fig. 10.4. Eligio Carrillo Vicente, yarn painting of his vision of a face in the sacred spring of Aariwameta, 2000. 12" x 12" (30 x 30 cm). Communication takes the form of lines of light. Photo credit: Adrienne Herron.

I will not try here to "explain" or interpret his design. I note only that one of the amazing aspects of studying shamanism among the Huichol is their readiness to draw a picture of visionary experience for an anthropologist. Since I was having trouble imagining what the colors look like when they come to the shaman, Eligio helped out by making a yarn painting to show me. It is up to us, as anthropologists, to decide how we wish to interpret this very explicit demonstration of shamanic perception.

Eligio may be giving us some very important information about how shamans perceive and about what form of communication gods or spirits use. By listening closely to descriptions of shamanic experience and gathering comparative information, we may begin to comprehend the nature of this aspect of human perception. As Eligio said, "If you experience the colors, you will understand what they mean and what they are saying. If you have not experienced them, it is very difficult."

If we look at Eligio's discussion of sacred colors in a wider, cross-cultural perspective, his insights become even more tantalizing. There are many cryptic references to colors and spirituality in the anthropological literature. Often, they seem to be passing references to symbols, legends, or miscellaneous religious beliefs, with little explanation. But what if these color references were more than poetic metaphors? What if they were grounded in shamanic experience? That would give us a basis for interpreting their meaning as something more than fanciful creations of the human imagination. They may be expressions of a basic, underlying capacity of the human brain and of the trance experience.

In the following sections, I draw together miscellaneous references from the literature. I confine myself mainly to the Uto-Aztecans and to nearby cultures in the Southwest or Mesoamerica that may have exchanged ideas with the Uto-Aztecans. In a few cases, I draw in examples from more distant Native Americans if they illustrate strong connections. In this section, I am frankly doing some creative brainstorming, pulling together fragments of information from the literature. I suspect that there is much more to be learned about sacred colors if someone asks the right questions of the right consultants.

Sacred Colors and Uto-Aztecan Aesthetics

In her review of Uto-Aztecan imagery, Hill (1992) uses Claude Lévi-Strauss's term "chromaticism" to refer to symbols that focus on color, light, and visual imagery. Chromatic symbols include "colored flowers and other brightly col-

ored and iridescent natural phenomena, including dawn and sunset, rainbows, hummingbirds, butterflies and other colorful and iridescent insects, shells, crystals, and colored lights and flames" (117).

While chromatic symbolism is probably widespread throughout the Americas, it is found with special frequency in the songs of the Uto-Aztecans, whose significant themes include "the glitter of iridescence in the wings of hummingbirds, butterflies, and dragonflies and in precious stones and shells . . . [and] special qualities of light, such as blue or crimson" (Hill 1992, 118). The Yaqui, for example, sing of a spiritual Flower World, which "is a world of brilliant colors, where 'the light glitters and shines through the water' . . . especially . . . 'light blue,' the light of the early dawn" (119).

Hill found that chromatic symbols are associated with spiritual experience. In songs, references to colors, lights, and flowers signify spiritual qualities; they lift the reference from everyday experience to divine and visionary ones. She notes that visionary experiences from hallucinogens may be sources of chromatic imagery; other sources are dreams and the waking experience of the beauty of the natural landscape. She concludes: "The use of chromaticism in the construction of spirituality is so widespread that it must represent a very ancient level of religious thought" (1992, 118). She finds chromatic imagery particularly intense among the southern Uto-Aztecans of Mexico and Arizona, including the Huichol; its use dwindles among the most northerly Uto-Aztecans and some groups in California. The distribution of the imagery suggests that its use goes back several thousand years to Proto-Uto-Aztecan and may be linked to a similar complex found among the Maya farther south.

Eligio's description of sacred colors ties closely into the Uto-Aztecan aesthetic of chromaticism. His discussion suggests one reason why color and light are associated symbolically with the spiritual. It is because they have their origins in the visionary experiences of the shamans. For example, Eligio described the sacred colors as lights or as brief, punctuated episodes of light that last as long as the shaman sings.

It would be interesting to find out whether other Uto-Aztecan groups share the Huichol view of colored lights as a language used by the gods. I suspect that the belief system may be there, at least among some groups. I have been struck by some similarities between the Huichol description of sacred colors and some accounts of shamanic perception among other Uto-Aztecan cultures, such as the Hopi, Yaqui, and Tohono O'odham (Papago), as the following examples demonstrate.

When seeking to purify himself after war, a Tohono O'odham man sat under a mesquite tree waiting for visions to come. A *light* came to him and told him what to do (Underhill 1979, 44). The shamans use crystals, which give them power. The crystals "are little shining things, as long as a finger joint, but they cast light like fire" (48). They are like shining stones that shamans may send out to light their way and that glow like a torch on lurking enemies or disease (Underhill 1938, 142).

Malotki and Gary (2001, 109) recorded a Hopi story about a witches' dance. The sorcerers chanted a song:

> There is no light
> On my blue-green face paint,
> There is no light.
> Shine firelight on it.

The sorcerers' face paint was not usually visible, but when the fire was stoked up, all their face paintings lit up and became clearly visible. They were repulsive and looked like skeletons. This is clearly the same concept as the Huichol view of colored lights (uxa) painted on peoples' faces, which the shamans can see and which reveal people's true characters (see Chapter 3).

The Yaqui's spiritual Flower World is called the *huya aniya*. It is the world of the woods and mountains, still wild and untamed, where animals and other spirit beings live. In the heart of the mountains are snakes with rainbows (that is, multiple colors of light) on their foreheads, which can give spiritual power to human beings (Spicer 1980, 64). The power from the huya aniya is embodied in flowers (85), and the flowers are symbolized by the headdresses of multicolored ribbons worn by Matachin dancers.

The Huichol share with the Yaqui a belief that flowers are associated with the spiritual. During ceremonies, flowers are used as offerings (xuturi or ruturi) or to represent sacrifice (Lumholtz 1900, 202). For example, paper flowers are tied to the horns of a bull that is about to be sacrificed. Fluffy pink flowers (probably *Pseudobombax palmeri*) were tied to the offerings I saw during a Drum Ceremony in San Andrés.[4] According to Bauml (1994, 71, 77ff), the Huichol attach a domesticated form of the Mexican marigold (Hui.: *puuwari*; Lat.: *Tagetes erecta*; Nahuatl: *cempoalsuchitl*) to the drumhead during the harvest ceremony. Negrín (1975, 35) says "xuturi" is the term used by the ancestral gods to refer to all Huichol adults, and one is reminded of the Aztec term "flowery wars," which refers to wars waged to take captives for sacrifice.

The flower imagery extends into Huichol dress. The Huichol love to decorate their clothes with bands of embroidery in abstract or geometric patterns; they identify a number of patterns as "peyote flowers." Other patterns are twining vines with or without flowers attached.

Flowers are brightly colored. Perhaps one of their properties is the ability to represent the visionary colors seen by the shamans. In the past, before the Huichol had easy access to colored beads and yarns, flowers may have been the most easily available means of representing the sacred colors.

Colorful Clothing and Vision

One more aspect of visionary experience is also linked to color. This is the link between color, clothing, and shamanic vision. Once again, it seems to cross cultural boundaries, since it not only is found among the Uto-Aztecans but also is widely distributed among other Native American groups.

I first perceived this link while participating in a pilgrimage to Wirikuta with Lupe's family. We were standing, facing the east at sunrise, after a night of eating peyote. The mara'akame was facing east and praying, waving his feathered wand toward the horizon. I turned to a Huichol friend to say something.

"Hush," he replied. "Don't you see him coming?"

I followed his eyes, but saw only the shaman.

"There he is," he said. "Here comes the mara'akame. It is the sun coming, walking across the desert towards us."

I realized that the shaman was praying and speaking to the image of the sun as a shaman walking toward us out of the east.

Afterward, my friend elaborated: "The sun comes dressed in beautiful clothes. His clothes are all embroidered, just like the clothes the Huichol wear."

There are strikingly similar references elsewhere in the anthropological literature. Other Native groups also assert that supernatural beings can appear as beautifully dressed humans. For example, a Hopi myth records that the spirit of the sun appeared to a boy, dressed in beautiful clothes and shimmering with color and light (Malotki and Gary 2001, 70): "It was a man, very handsome in appearance. He was dressed most beautifully and covered with colorful body paint. Each time he moved, bright light reflected from him. In addition, his breath exuded warmth."

The Cree also describe the sun as a handsome man walking in the sky and beautifully dressed in a costume of many colors. When he enters the shaking tent, a ceremony for calling in spirits, there is "a beautiful clear light visible,

through the covering" (Brown and Brightman 1988, 37, 41, 51). Farther south in Mexico, a Mazatec described the spirits of hallucinogenic mushrooms, who are like shadows or people seen during trance, dressed like the Mazatec but with brilliant multicolored clothing (Estrada 1981, 199).

This visionary experience is the Huichol explanation of why they wear beautifully embroidered and colored clothing. It is not just a love of color and decoration for its own sake, but rather because this is the way the gods appear, and the gods like to see the Huichol dressed the same way.

Vision as Synthetic Knowledge

In a discussion of Navajo ceremony, John Farella (1984, 9–14) proposes that there are three levels of knowledge underlying ceremonial practice.

» The first level is rote. The person has learned how to carry out the ritual, but does not know why the activities are being carried out. Knowledge at this level leads to a preoccupation with taboo and making mistakes.

» The second level is ritual. The world is not seen as a given, but is subject to alteration. Ritual corrects mistakes and fixes things. If a ritual does not lead to a desired result, the assumption is that a mistake was made. This leads to a preoccupation with details, and can easily balloon into paranoia.

» The third level of knowledge is synthetic or theoretical. This level originates from the main principles underlying practice. The person knows why the ceremony takes a particular form and how to innovate and change it, depending on circumstances.

Farella concluded that when culture is lost, it is synthetic knowledge that goes first. As a result, the external forms of ceremony remain, but the understanding of why they exist is lost.

It seems to me that Eligio's discussion of sacred colors is synthetic knowledge. He is describing the principles underlying Huichol color use and linking them to original shamanic experience. Aspects of color use such as the fuerte-bajito color system relate to the way shamans experience color as communication from the gods. Fuerte colors are those that the gods use to communicate with, while bajito colors have less of this magical power. Eligio's choice of colors illustrates the shamanic visionary experience. His yarn painting reflects this deeper understanding, and this is what leads to his constant innovation in color.

Eligio seems more advanced than some other artists. Not all artists are shamans, nor do they all share visionary ability. For example, many artists understand the idea of fuerte and bajito colors and use them as a principle for painting. Nevertheless, their knowledge may be rote: they learn which colors are fuerte or bajito and then use them accordingly. I suspect that there is a "trickle down" effect whereby artists who are not visionary still derive images and color combinations from artists who are visionary. Thus, an artist such as Eligio can paint from firsthand experience, while others may paint from more general cultural knowledge about such experience.

The same principle may be in operation when one tries to reduce a color system to a system of symbols. Simple equations such as "red equals fire," "yellow equals sun," and so on may be the most basic way of understanding meaning. Some Huichol artists' knowledge may stop at this level, the level explored by anthropologists such as Lumholtz. Others go on to a level in which colors are combined according to more general principles. Eligio consistently resisted interpreting the relationship between color and meaning according to either of these levels. Instead, he moved on to a higher level of generality, which is the relating of color to the referents that give it meaning in the first place. Eligio's analysis challenges us, as anthropologists, to move to a broader level of generality in order to understand the relationship between shamanism and meaning.

11

the artist as
visionary

When I first began to study yarn paintings, I was intrigued by statements that they were spiritually inspired. The dealers told tourists that all Huichol artists were shamans and that all their art was the product of dreams and visions. As time went on, I began to question this romantic statement. Not all the yarn painters I met were shamans—and many of their paintings seemed to be about myths or legends or ceremonies. The images may or may not have had their sources in visions. Perhaps the dealers were being overly enthusiastic in order to sell art. The statement certainly seemed to catch the buyers' interest, giving Huichol art a cachet that ordinary Mexican folk arts did not have.

A growing literature suggests that the art of indigenous peoples is spiritu-ally inspired or shamanic (Halifax 1982; Lommel 1967). But how much do we understand of what this generalization means? What is it that makes an art sha-manic? How are shamans inspired, and how do they translate inspiration into art? Is it simply a matter of "seeing" a vision or dream and then replicating the image in art, or is some other process involved?

Several authors have suggested that one source of shamanic art may be the trance experience created by hallucinogenic plants such as *yage* (ayahuasca; Harner 1973) or peyote (Cordy-Collins 1989). This has led to observations that certain plants produce characteristic patterns and images: users of ayahuasca see writhing snakes, peyote users see geometric, lattice-like color combina-tions. Other sources of visionary art may be altered states of consciousness in-duced by physical stress brought on by fasting, dancing, or drumming.

Some authors have proposed that the stimulation produced by peyote and its chemical component, mescaline, is responsible for the designs made by the Huichol. This theory was popular in the 1970s, when there was considerable interest in the effects of hallucinogenic plants generally. Cordy-Collins (1989,

43) took this idea to mean that most or all Huichol art originates in chemical stimulation:

> The origin of Huichol art is to be found in such [peyote-induced] hallucinations; it is the direct product of the chemical alteration of the brain's synapsing system. The sensory overload which is thus brought about is "translated" by the brain into colors, shapes, and sounds . . . There are two stages of mescaline hallucinations: the former is one of intensively color-saturated geometric forms. In the latter stage such abstractions are replaced by familiar, identifiable objects, people, and places . . . This two-part sequence is clearly reflected in Huichol art: the cross-stitched embroidery and the woven textile patterns . . . replicate the early stage of geometric images, while the beaded gourds, the yarn paintings . . . and other more "realistic" creations more ably evoke the sorts of images experienced in the later stage hallucinations.

Several other articles in the literature support the idea of a visionary source for Huichol arts. Furst (1968–1969) was the first to identify dreams and visions as sources of inspiration for yarn paintings made by the Huichol artist Ramón Medina Silva. Furst made no claims that Ramón considered his vision-inspired paintings to be better than his other works.

Subsequently, Eger (1978, 39–41) discussed mandala-like drawings made by a young shaman after eating peyote. She went on to say that some women's embroidery and weaving was better than others and that following a path of completion similar to that of a mara'akame was the reason for the difference. A caption identified "embroidery . . . inspired by the artist's dreams and hallucinations," adding that "the women who have 'completed themselves' in the Huichol religion seem to have the most success in creating these patterns" (47). The author highlighted the important role of visions, particularly those induced through the use of peyote: "Through the process of her initiation to and continued ingestions of peyote, the completed woman also develops the ability to 'dream' her designs and remember them. Striking color combinations and hallucinatory geometric forms are typical examples of these dream creations. Variations on traditional designs, with enhanced feeling for form, composition and highly saturated colors also typify the work of the women possessing these divinely inspired talents" (52).

Eger added that such women are not the only ones who make excellent artwork and that many Huichol are highly skilled artists; rather "the difference . . . is a whole level of existence . . . [that is] particularly obvious in regard to the

Fig. 11.1. Unknown artist, embroidery, c. 1996. Cotton manta cloth, acrylic yarn, thread. The vibrant colors of Huichol embroidery suggest the vibrating, kaleidoscopic colors that many people report seeing during peyote visions.
Photo credit: Adrienne Herron.

symbolism, which ordinary women who have not completed themselves are fairly oblivious to" (52).

Schaefer (1990, 225–248) reiterated the role of dreams and visions in relation to women's weaving. She noted that a woman who has completed herself will see through her heart, called "iyari" in Huichol, and will receive and originate designs from many sources, including dreams, peyote visions, and natural designs such as those on the back of a lizard or a snake ally.

Eger and Schaefer emphasized the important role of dreams and visions in Huichol art. However, visions are not the only source of imagery, since many designs are transmitted from person to person by the ordinary methods of teaching and copying. Dream and vision designs represent an aesthetic ideal in Huichol culture, although only some artists are able to achieve it.

Has this aesthetic ideal been transferred into yarn paintings? In fact, there has been an ongoing debate in the literature about whether the paintings are products of shamanic experience or only stereotyped reproductions.

Some authors maintained that the paintings are nothing but commercial merchandise, reproductions of symbols that originally had religious meaning within Huichol culture, but have since lost any connection to their original purpose. Muller (1978, 96) called yarn paintings a "degeneration" of the original religious offerings. While he observed that the inspiration for them often came from Huichol mythology, and that the Huichol were capable of turning out artistic masterpieces if given the right incentives, most paintings were mass-produced in cities and had little original content.

Weigand (1981, 17–20) expressed doubt about the usefulness of yarn paintings as a source of information about Huichol traditions. There had been a considerable mixing of information from different communities in the urban environment where yarn paintings were produced, and sometimes the information contained in them was drawn from secondary sources. He cited the example of a yarn painting based on a myth published in a booklet. He added that some painters were what he termed "professional Indians"—that is, Indians who made a living by presenting themselves as well-informed Huichols; he considered them to be rather unreliable sources of information. The paintings responded to the demands of the tourist market and could be ordered according to tourists' preferences, perhaps even combining several myths rather than having a traditional meaning.

Perhaps most critical of the yarn paintings was Fernando Benítez, a Mexican journalist who is widely read and quoted in Mexico as a source of information on indigenous people, including the Huichol. Benítez (n.d., 7) called yarn paintings a falsification and an industry, completely unlike any other traditional Huichol art. He blamed the anthropologist Peter Furst for inventing them while listening to the Huichol artist Ramón Medina singing his myths. Benítez claimed that the cartoonlike paintings that resulted from this collaboration, such as Ramón's painting of dead souls in the underworld, looked more like floating heads drawn by Walt Disney than any authentic indigenous art.[1]

Benítez's criticisms should probably be read with caution. He was a journalist, not an anthropologist. Moreover, as an ardent Mexican nationalist, Benítez (1970, 285) deplored the fact that most writing about Mexican Indians was done by foreign anthropologists. This may have biased his view of Furst's influence. Still, Benítez's documentation of Huichol traditions was sensitive (P. Furst 1972,

144–145). Benítez is one of the main authors that many Mexicans read for information on the Huichol, so his criticism carries weight, at least in Mexico—it was repeated to me by various Mexicans. Therefore, it is worth investigating further.

On the other side of the debate, some writers have claimed that yarn paintings can be an important source of information about Huichol religion. Negrín (cited in Manzanilla n.d., 124) agreed that the yarn paintings sold commercially were often of poor quality, reproducing designs that once had magical and symbolic significance, but have been deprived of their significance through commercial exploitation and the need for economic survival. Nevertheless, Negrín proposed that the best of the artists could create original designs, based on mythology and their personal visions; however, such masters were rare, and they needed to practice their religion in their personal lives: "To keep in his spirit the vitality of this mythology, to feel it genuinely and sense the urgency of re-creating its images, which weigh on his mind, the Huichol artist must live out the reality of his cultural beliefs and record his always-changing visions, concentrating his attention on the ritual path of difficult pilgrimages and dramatic celebrations of his traditions" (Negrín, cited in Manzanilla n.d., 124; my translation).

These opposing points of view suggest an interesting problem. What exactly are Huichol artists depicting in their yarn paintings? Are the paintings a source of information about religious beliefs? Are they depictions of dreams and visions? Or are they only commercial products, albeit lovely ones, containing no more than sterile repetitions of once-authentic myths and symbols?

Dreams and Visions: Huichol
Artists' Opinions

Despite the assumption that Huichol art is visionary, there is little documentation in the literature of Huichol yarn painters' points of view. Therefore, I decided to ask Huichol artists how they create their art and whether it is shamanic or spiritually inspired. I also asked whether artists use peyote as a source of their art and whether yarn paintings are records of dreams and visions. As I will show, the artists' answers to these questions led me in unexpected directions. In particular, I found that the Huichol concept of the soul is central to understanding how spiritual inspiration occurs.

At first, I thought that dreams and visions might be the source of inspiration for the paintings. I assumed that the process by which spirituality is translated into art consisted of the artist "seeing" an image, through dream or vision, and

then transferring this image directly into a painting. By "dream," I mean our common nighttime experience while asleep. By "vision," I mean an experience while awake or in some form of trance. Visionary experience can include both auditory and visual components. Artists quite often described "seeing" particular images and also hearing sounds or holding a conversation with particular spirits.

All the artists had eaten peyote. Some said they did not use peyote as a source of their imagery. For example, the artist Mariano Valadez told me that he is not a shaman and does not rely on peyote to generate images. Moreover, he questioned whether this process was possible.

> HOPE: Have you seen things when you are eating peyote? Things that you put in your yarn paintings. Or do you not put these things in your yarn paintings?
> MARIANO: No, because the thing is, when you are eating peyote, it is as though time is passing. When the effect ends, I don't keep in my mind what I see or what I imagine. I don't do that. Nor can I eat peyote in order to do my work.
> HOPE: You don't remember afterward what you have seen?
> MARIANO: No, I don't remember. Because I cannot lie in my explanations and say that I can take something in order to be able to paint better. No, because I cannot . . . And regarding the peyote, I don't do it [that is, use it as a source of imagery]. Many of my colleagues say that they use peyote to do their work, but I don't believe it. I can't lie. I want to speak honestly.

Another artist, Modesto Rivera Lemus, explained that peyote gives energy but is not itself a source of images. He is referring here to a Huichol belief that peyote is a source of spiritual and physical energy (or life force) called kupuri in Huichol. (When I interviewed Modesto in 1994, he had just begun the training required to become a shaman, but had not yet acquired visionary ability. He has continued to make pilgrimages since then, and his knowledge may have deepened by now.)

I asked him whether he had seen visions. He told me that when a person takes peyote, he or she has the energy that comes from peyote. This energy stays with the artists and gives them the energy to invent images. He thinks that the things of the Huichol religion are not things a person can actually see. For example, one does not see things in the sacred water, but one has a mental idea or image of what they represent; it is this idea that the artist presents in a painting. Sometimes he depicts the energy of sacred places or of the sacred gods. For him, the source of images comes from his childhood. His father always performed the ceremonies and attended fiestas, so he knows Huichol traditions.

The artist who was most explicit about using dreams and visions as a source of imagery was Eligio Carillo. However, even he stated that dreams were more important as a source than visions, including peyote visions.

> HOPE: And do you get your designs from visions?
> ELIGIO: Oh yes, that, yes. From visions. Sometimes from dreams. Which represent a lot through dreams.
> HOPE: And is there a difference between the designs that you get from dreams and designs that you get from your imagination?
> ELIGIO: Yes, there is that also, from my imagination. There is also that. That is to say, it comes from many places. I have learned that it is thus, things that I learn well [that is, through shamanism]. Many things result.

When I asked him whether it was possible for a person looking at his paintings to tell the difference between designs derived from dreams or visions or imagination, his answer was that a person who was already a mara'akame or visionary would know without being told. Otherwise, it was up to the artist or mara'akame to explain it. Without an explanation, an observer could not really understand.

> HOPE: And do the two types look different? . . . If I am looking at a yarn painting, can I know if it is from a vision or if it is a dream or something else?
> ELIGIO: Yes.
> HOPE: How can I know this?
> ELIGIO: Well, for me it is easy. But perhaps that person, there, who doesn't know anything [that is, does not have shamanic ability], for him it is very difficult. That's how it is. Because I . . . when I see it . . . I have to say it, because I have the knowledge, right [that is, a shaman should explain what he sees]. [I should say to the person]: "Good, then, that is an image that is the representation of where they made the beginning of the ceremony." Perhaps I should say it. But if he doesn't say anything to me, I will only look at it to see what it contains, right. And that too. If another person makes it, I just [look at] what he made, right. Just look at it. I understand. That's what that means.

As Eligio explains, it is the learner's (or the purchaser's) obligation to ask what the painting means or what sort of vision it may contain. Once asked, the artist is obligated to explain; for example, he may explain that this painting represents a vision of what occurred at the beginning of a ceremony. If the learner does not ask, the artist will not explain but will only look at the painting himself, knowing its meaning. Similarly, if Eligio sees a painting by another artist, he can understand its meaning without asking.

Among artists who said that they had occasionally experienced dreams or visions, the responses were mixed. Some artists could describe a vision that they had experienced, but said that they had never tried to depict it in a yarn painting. Others had experienced one or more visions that they had then put in yarn paintings; but they said that most of the paintings they made did not depict visions, but rather culturally derived themes, such as myths. An artist such as Ramón Medina may produce some paintings that express visions, but also make paintings that narrate myths. I found it was not uncommon for painters to point out to me which paintings were their own visions and which were not; this ability to distinguish between the two showed that they used both types of inspiration in their work.

Some artists used what might be called a secondhand version of dreams and visions as a source of inspiration. I have called this process "borrowed vision." During ceremonies, the mara'akate may tell in their songs about what they are envisioning at that moment; often, the mara'akate tell stories from the Huichol body of myths. The artists listen to what the mara'akate say and then use their imaginations to paint what they hear. Mariano Valadez explained how he applies this idea.

> HOPE: When you make your yarn paintings, do you paint things you have seen in ceremony, or from your imagination?
> MARIANO: I make yarn paintings in my own style, according to my imagination. But also, many times, the shamans give me ideas, because whenever they talk about the religion of the Huichols, I am thinking how it is, with my imagination. When I hear the myths or the song or the prayers or the stories, at the time I record in my memory, and afterward I have it. That's how I am.

He emphasized his respect for the sacredness of the tradition and for the work that the mara'akate do to understand and teach it. It was this fidelity to the tradition that he attempted to portray in his art.

> MARIANO: For me, the shamans and the Huichol religion, . . . for me, it deserves a great deal of respect because of the work that is done. And the myths of the shamans, all the offerings, are things belonging to the gods of the Huichol, all of them. They are pure, pure religion through and through, that is being recorded.

A third source of yarn-painting imagery is the artists' own imaginations or thoughts. Some artists used the Spanish words "*memoria*" or "*mental*" for this source of inspiration. Memoria is what we might commonly think of as intel-

lectual or "thinking" processes, rather than subconscious or unconscious processes, such as dreams or visions. However, memoria is also linked to the heart, as I will explain in the next section.

Most yarn paintings have more conventional origins. The symbols and designs, such as deer, eagles, peyote, or the sun, are widely known and used in other Huichol arts, such as embroidery and weaving. Some images are traditional, such as designs used in traditional offerings and god disks. Some images are more modern, such as the recent, somewhat realistic paintings of myths, sacred stories, or ceremonies. All these images can be learned or copied from other artists.

Clearly, the evidence regarding the use of vision in yarn paintings is quite variable. Some artists are limited to their own imaginations or intellectual processes; some use dreams and visions of the supernatural plane. Moreover, some artists use their own dreams and visions, while others borrow the dreams and visions of mara'akate.

The artists' comments also shed new light on the theory that peyote is a major source of yarn-painting imagery. The statements of the artists I interviewed indicate that peyote itself is not a principal source of designs for yarn painting; as I have shown above, most yarn paintings use culturally derived designs, such as those from myths and ceremonies. Probably more accurate is Schaefer's (1990, 245) cautious statement that only a few of the artists who are most mature in their religious careers are able to use vision as a source of design.

A related question is whether the artists themselves are shamans. This can be determined with some confidence because Huichol culture has fairly specific criteria for becoming a shaman. An aspiring shaman makes a vow to certain deities and must complete a prescribed number of years of ceremony and fasting. Most artists I talked to did not claim to be "completed," or practicing, shamans. A few had never tried to learn. Others were partway through the process and had developed varying degrees of shamanic and visionary ability. One artist, Eligio Carrillo, did claim a fairly advanced level of shamanic ability. Eligio's statements were especially important in clarifying the relationship between an artist and spiritual sources of inspiration.

Paintings Identified as Visionary

Of the paintings that I photographed, only some were identified to me as the products of vision. For example, the artist Gonzálo Hernández had a collection of twelve paintings for sale when I met him; one of them represented a vision—

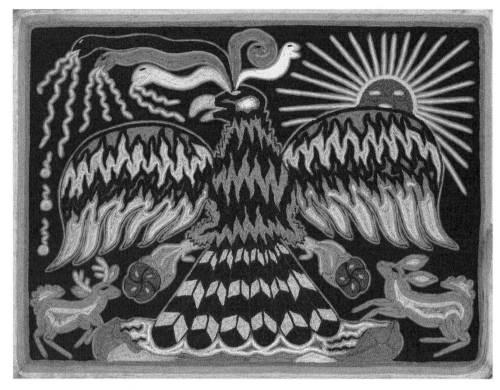

Fig. 11.2. Gonzálo Hernández, a yarn painting of his vision of the volcano Reunar being transformed into an eagle, 1993. 12" x 17.75" (30 x 45 cm). Photo credit: Adrienne Herron.

a painting of a mountain in Wirikuta transforming into an eagle. Similarly, Fabian González Ríos had five large paintings and a number of small ones when I interviewed him; he identified one as representing a vision he had had when he was young, of a bad spirit that appeared to him in a dream and offered him power.

The fact that the artists distinguish between visionary and nonvisionary paintings means that they are aware of the difference. Nor did they try to tell me that all their paintings were visionary in order to increase sales. On the contrary, most of their paintings were of myths, ceremonies, deities, or sacred sites. The artist who most explicitly used vision in his paintings was Eligio Carrillo. But even he claimed vision in only some of his paintings, not all.

12

the "deified heart"
huichol soul concepts and shamanic art

The relation of dreams and visions to art is more complex than the simple yes-no debate presented in the early literature. As I talked to the artists, I began to feel that I was missing the point of what they were telling me. I was concentrating on the source of the image—whether it was a dream, a vision, peyote, personal experience, or traditional or culturally derived themes. The artists did not seem too concerned about which of these sources they used. What was important was the process of envisioning, of how vision and artistic inspiration occur. This process is less variable, being inherent in each artist. It is closely related to concepts that Westerners might call body, mind, and soul.

The important question was whether the artist's soul or spirit was open to the gods. If the soul was open, then ideas, images, and inspiration would flow in to the artist. The art could then be said to be shamanic or spiritually inspired, no matter what the artist painted. If the artist's soul was not open, then the art was not particularly spiritual, no matter how well executed in its technique or drawing.

There are hints in the ethnographic literature on Mesoamerica that soul concepts may play a part in the production of art. Evon Vogt (1969, 371) wrote of the Maya: "The ethnographer in Zinacantan soon learns that the most important interaction going on in the universe is not between persons nor between persons and material objects, but rather between souls inside these persons and material objects." This statement suggests that religious art, a material representation, might somehow be linked to concepts of the soul.

Another clue is provided by Richard Anderson (1990, 152–3), who wrote that the Aztec model of aesthetics was based on a "deified heart" and that "true art comes from the gods, and is manifest in the artist's mystical revelation of sacred truth." The spiritual blessings of art come only to the enlightened few who have learned to converse with their hearts. The Mexican scholar Alfredo López Austin

(1988, 231–232) proposed that the heart in Aztec, or ancient Nahua, thought was a component of what is often called the soul in English, and that the heart may play an important role in the production of art.

While Anderson regretted that the Aztec aesthetic tradition may not have survived the conquest, I began to wonder whether the Huichol might still retain some of this tradition. The Huichol language is related to Aztec and Nahuatl, and some terms appear similar, as I will show below. Could the soul somehow play a part in Huichol art? If so, how do the artists conceive of the soul, and what role do they think it plays in the making of art?

Understanding what Huichol artists mean by the term "soul" or "spirit" is central to understanding the role that the soul plays in their art. Recent research by López Austin (1988) has provided a dramatic impetus to the understanding of soul concepts in Mesoamerica. In *The Human Body and Ideology*, he examined ancient Aztec and Nahua concepts of the body. He related the ancient Nahuas' internal model of the human body to their concepts of the exterior world, the spiritual world, and the cosmos.

López Austin (1988, 181–184) stated that "the words *souls, spirits, animas* all lack precision." To refine these terms, he tried to locate them at points that he calls "animistic centers" in the body. These are the points of origin of the impulses for life, movement, and psychic functions; they may or may not correspond to particular organs. He drew an important distinction between animistic centers of the physical body, and animistic entities that might be called souls or spirits and that may live on after death.

According to López Austin (1988, 190–194), the heart was most important to the ancient Nahuas. It is mentioned most frequently in writings by and about them, and "it includes the attributes of vitality, knowledge, inclination, and feeling." He adds that "references to memory, habit, affection, will, direction of action, and emotion belong exclusively to this organ." *Cua*, the top of the head, is the seat of the mind. It is the intellectual process, the seat of memory and knowledge. López Austin proposed the following model:

> Consciousness and reason were located in the upper part of the head (*cuaitl*); all kinds of animistic processes were in the heart (*yollotl*); and in the liver (*elli*) the feelings and passions . . . a gradation that goes from the rational (above) to the passionate (below), with considerable emphasis on the center . . . where the most valuable functions of human life were located. The most elevated thoughts and the passions most related to the conservation of the human life were carried out in the heart, and not in the liver or head. (199)

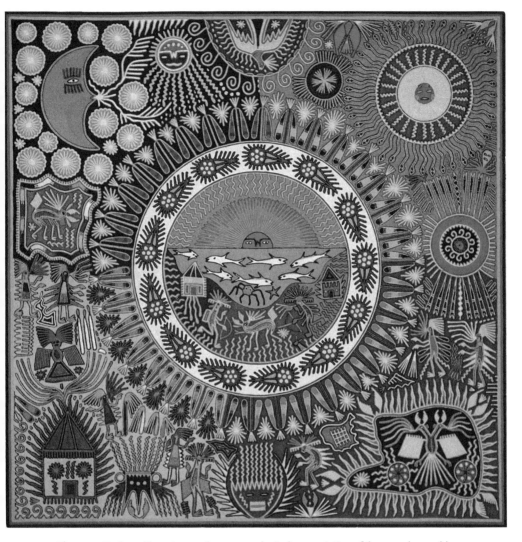

Fig. 12.1. Modesto Rivera Lemus, large cosmological yarn painting of the everyday world being interpenetrated by the spiritual world, 1994. 48" x 48" (120 x 120 cm). Photo credit: Hope MacLean.

In ancient Nahua belief, the heart played a central role in artistic production. It was thought to receive some divine force. The person who was outstanding for brilliance in divination, art, and imagination had received divine fire in the heart, whereas a person who was a bad artist lacked it (López Austin 1988, 231–232).

Since the Huichol language is related to Aztec and Nahuatl, I hypothesized that the Huichol might share similar conceptual categories. Two of the three main ancient Nahua animistic centers—the top of the head, called "cua," and the heart, called "yol"—seemed very close to Huichol concepts kupuri and iyari.[1] However, as will be shown below in my interviews with Eligio Carrillo, the functions of kupuri seem more like the Nahua word "*tonal*," which López Austin defines as life force or an irradiation contained in the body.

The most complete information on Huichol concepts of the soul in relation to the body comes from an article by Peter Furst (1967), which is based on interviews with Ramón Medina. Other authors, such as Zingg (1938, 161–173), Lumholtz (1902, 2:242-243), and Perrin (1996), also discuss soul concepts, but they write mainly about the soul after death rather than about its relation to the living body and its attributes. Here I will review the Huichol soul concepts as described by Ramón.

Ramón located the soul—or, more accurately, the essential life force—in the top of the head or fontanelle. He called both the soul and the fontanelle kupuri in Huichol and *alma* in Spanish. A mother goddess, Tatei Niwetukame, places kupuri in a baby's head just before birth. It is placed in the soft spot where the bones have not yet closed; this is its life, or soul. Kupuri is attached to the head by a fine thread, like spider's silk (P. Furst 1967, 52).

Myerhoff (1974, 154) added a few more details about kupuri, also based on information from Ramón: "A great many plants and animals and all people have this *kupuri* or soul-essence; it is ordinarily visible only to the *mara'akame*. Ramón has depicted it in his yarn paintings as multicolored wavy lines connecting a person's head or the top of an object with a deity. Verbally he described *kupuri* as rays or fuzzy hairs." When Ramón shot peyote with an arrow as part of the peyote hunt ceremony, he said that rays of color spurted upward like a rainbow; these rays are the kupuri, or lifeblood, of the peyote and the deer.

Kupuri is needed to maintain life. When a person loses kupuri because of a blow, he or she feels ill and cannot think properly. The mara'akame is called. Because the person is still alive, the mara'akame knows "that the *kupuri* has not yet become permanently separated from its owner, that is, the metaphorical life between them has not yet been severed by a sorcerer or by an animal" (P. Furst 1967, 53). The mara'akame hunts for the soul and finds it by its whimpering; seeing the soul in the form of a tiny insect, he or she catches it with the shaman's feathers, wraps it in a ball of cotton, and puts it in a hollow reed. The mara'akame brings the soul back and places it in the head. The cotton dis-

appears into the head along with the soul. Then the person comes back to life (53–56).

Occasionally, Ramón used the term "*kupuri-iyari*," which Furst (1967, 80) translated as "heart and soul." "Iyari" was also used in terms such as "he has a Huichol heart" or a "good heart." Furst did not talk in any detail about iyari. He noted only that during a funeral ceremony held five days after death, the soul is called back and captured in the form of a luminous insect called *xaipi'iyari* (Hui.: "*xaipi*" meaning "fly" and "iyari" meaning "heart" or "essence"). When the soul takes the form of rock crystals, which incarnate the spirit of respected ancestors, the word "iyari" is also used; it is known as *tewari* (Hui.: grandfather), *uquiyari* (Hui.: guardian, protector, or chief), or *ürü iyari* (Hui.: arrow heart).

Thus, whereas López Austin (1988) separated the ancient Nahua ideas related to kupuri and iyari, Furst's analysis appeared to combine them. For example, Furst described kupuri as the soul that leaves the body, both during life and at death, and that returns to the family one last time during the funeral ceremony. However, the Huichol have two separate words for the ideas, which seem to correspond to the Aztec words in other ways.

It is possible that Ramón himself did not make a clear distinction between kupuri and iyari, since Furst later said that he corrected himself on other points; or perhaps Furst did not identify a difference between the two words and their related concepts. For example, as noted above, in describing the soul that comes back after burial as a luminous fly or a rock crystal, Ramón apparently used the word "iyari," not "kupuri." Furst (1967, 80) noticed the change of name and commented on it, but did not identify iyari as a different entity. Therefore, Furst's article described the soul as seated in the top of the head; and Furst gave the head greater importance in comparison with the ancient Nahua emphasis on the heart. Perrin (1996, 407–410) identified the confusion between kupuri and iyari, and tried to distinguish the capacities of the two. However, he did not make the link to animistic centers of the body, as I have done here.

The usual translation given for the Huichol word "iyari" is "heart" (P. Furst 1967, 41), "heart-memory" (Schaefer 1990, 412), or "heart-soul-memory" (Fikes 1985, 339). I have also heard the Huichol translate "iyari" into Spanish as "*corazón*" (Sp.: heart) or "*pensamiento*" (Sp.: mind, personality), a Spanish word that they use broadly to refer to a person's character, as in, for example, a person of *buen pensamiento* (Sp.: good character, good intentions). Peyote is the iyari of the deer and also of the gods (Fikes 1985, 187; Schaefer 1990, 342).

There is little discussion of iyari in the literature. The fullest account is in

Schaefer (1990, 244–246), whose Huichol weaving consultant, Utsima, explained that one's iyari grows throughout life like a plant. When a person is young, he or she has a small heart, but it becomes much larger as the person grows. However, the iyari must be nourished to grow; eating peyote and following the religious path to completion allow one to develop this consciousness. At the highest level of mastery, the iyari is the source of designs used in weaving: "The designs she creates are a direct manifestation from deep within, from her heart, her thoughts, and her entire being. . . . Those inspired to weave *iyari* designs learn to view nature and the world about them in a different perspective, as living designs. When they tune into this mode of seeing their world, they tap into a wealth of design sources and consciously bring their imagination into visual form" (245). Weaving from the iyari is so difficult that many women never attempt it, preferring to copy designs all their life. Nonetheless, achieving this goal is the peak of Huichol artistic expression, and women who achieve it receive elevated status and are recognized for their designs (248).

The Soul of the Artist

On the basis of the importance of the iyari in weaving, it seemed to me that iyari might have considerable significance for the production of yarn paintings as well. Moreover, the general aesthetic significance that the heart had for the ancient Nahua suggested that its role in Huichol thought might have been neglected by scholars. Therefore, I asked the yarn painters what they understood iyari and kupuri to mean and what role they thought these entities played in their art.

Young artists tended to give one-sentence answers to these questions, such as "iyari means life." The Huichol artist Eligio Carrillo gave the fullest explanation of the meaning of iyari and kupuri, and their significance in art. Because his answers were so complete and form a connected whole, I quote him at length; what he said was consistent with my discussions with other artists.

According to Eligio, iyari contains a number of ideas. Iyari is a form of power that comes from the gods. It is the breath of life, sent from the gods, as well as the person's own life and breath.

ELIGIO: Iyari, that means the breath [Sp.: *resuello*], the breath of the gods. . . . That god sends the power to continue living. To think. And it is what guides you. That is iyari. What makes you able to think. In every place you go, with that you walk around. It is what protects you. The iyari. It is the thought [Sp.: *pensamiento*] that gives you ideas and everything.

The iyari includes the heart, but is more than the physical organ. I interpret what Eligio says here to mean that while iyari is seated in the heart, it has many meanings and pervades a person's life. It is also a person's being or identity, which we might call in English the unique personality or the person who knows and sees.

> ELIGIO: It is the heart, of the body. But it is the whole body, not just the heart, the iyari. It is as though it were a magical air. Magical air. That iyari. The iyari tries to translate from many directions [Sp.: *traducir de muchas partes*].
> HOPE: If a person is understanding things from many directions, it is by means of the iyari?
> ELIGIO: Yes, that power, that is iyari.

"Translating from many directions" is a Huichol expression in Spanish that means a person with shamanic abilities is receiving messages from the gods. I clarified this point in my next question.

> HOPE: And when a person is receiving messages from the gods, it is by means of the iyari?
> ELIGIO: Yes, exactly. But [only] if it [the iyari] is already in tune [Sp.: *ya coordina*] with them. You make it in tune when you are studying [that is, learning to become a mara'akame], and you are in tune by means of this. An electricity.

Here he means that a person "tunes" the heart to the gods through the pilgrimages and other actions required to become a mara'akame. Once a person is in tune, it is as though an electrical current passes between the person and the gods, carrying messages.[2]

Even though a person develops the iyari so that it can receive messages from the gods, using the capacities of the iyari alone are not enough for the making of yarn paintings. A person must also use mind, for which Eligio uses the Spanish word "*mental*." Here is how Eligio distinguishes the two capacities. He talks about the mind and about the knowledge of shamanism, by which he means knowledge perceived through the heart. Both are required in order to paint.

> ELIGIO: Shamanism is one thing, and mental power is something else. Because even if I know something about shamanism, I need to have mental power to do my work. Mental is different, it is to translate and make things. And you need both powers, right, to do the work.
> HOPE: Shamanism is in order to see?
> ELIGIO: Yes, it is to see.
> HOPE: And mental power is to translate and make the yarn painting?

ELIGIO: That's it.

HOPE: You need the two, then?

ELIGIO: That shaman has to have the two powers to be able to make things, and if he doesn't have both, even if he is a good shaman, what will he gain? He won't be able to do anything. That's how it is.

He distinguishes between painters who have developed both capacities and those who have not. Some painters use only the mind; Eligio is careful to say that they too can paint well, since they are focusing just as a person focuses through shamanic study.

HOPE: And are there some people who do yarn paintings who are not shamans, and others who do them who are shamans?

ELIGIO: Well, those who do yarn paintings who are not shamans, they only base themselves in mental powers. Or it is mental power that they have opened. They just take note of something and more or less have an idea, and they make it. But still, more or less, I don't think they are very deficient. They do well with their minds. They are also concentrating. They do that.

To clarify the difference between mind and iyari further, I groped for an analogy and hit upon the perhaps awkward idea of a car and driver. The mind is like the steering wheel, and the iyari is like the motor; without a motor, the car goes nowhere; but without a steering wheel, the strongest motor can only spin its wheels.

HOPE: And the mind is like the guide . . . as though I were driving a car, I hold the wheel.

ELIGIO: Exactly. That's how the mind is.

HOPE: And iyari is like the motor of the car?

ELIGIO: It's the most important. It's what you need. That is iyari. In Spanish, they say "heart"; in Huichol, we say "iyari." It is the power that is the breath of the whole body.

I then asked him about the link between iyari and becoming a shaman. He clarified that through the training and pilgrimages required to become a mara'akame, a person opens the heart so that it will be able to receive messages from the gods.

HOPE: And if a person is becoming a shaman, do they strengthen the iyari, or do they open it?

ELIGIO: They open it. Now they begin to understand. After, it [the idea] comes out and then they are ready [to make art].

HOPE: The ideas, the messages, come out?
ELIGIO: You think of them, then they come out.

A mara'akame is a person with his or her heart open. During the training, a mara'akame who has been given the power by the gods can help another person open his or her heart.

ELIGIO: Oh yes, there is among shamans—if that one is not . . . if his iyari is covered, many healers know how to open it.
HOPE: Does the shaman have his heart more open?
ELIGIO: Yes, because the shaman has it open, well, and those who don't know, well, it is closed. For those who know . . . For example, [*pointing to a child*] this one doesn't know, and if I were a shaman, very good, I could open his mind [Sp.: *mente*] so that he would learn faster. That's how it is, but with the power from the deer, with the power from the gods. It is because they have given me power that I can do this. And that's how they do this. The iyari.

I then shifted to the idea of kupuri and asked about its role in relation to iyari.

HOPE: And kupuri—I don't understand what is the difference between kupuri and iyari.
ELIGIO: Little difference. Kupuri means the same [as I have been saying]. And kupuri means a thing very blessed, which is the iyari. It can be blessed with the iyari of the gods—bless your body, it has been blessed. That is the word it means.

In Eligio's explanation, kupuri means energy, while iyari, or life, is the product of the energy. The energy of kupuri blesses, or irradiates, a person's entire body, including the iyari. The gods have iyari, and so do people; kupuri is the energy that is transmitted between them.

HOPE: And kupuri is like the electricity that comes?
ELIGIO: That comes to you from the gods who are blessing that person.
HOPE: And they send from their iyari the electricity that is the kupuri?
ELIGIO: Yes.
HOPE: And it arrives at my iyari?
ELIGIO: Yes.
HOPE: Now I understand it. . . .
ELIGIO: Iyari is breath. Kupuri is the life, is the life of the gods, that the gods may give you life. They give you power [Sp.: *poder*]. That's what that is.
HOPE: Is it like force [Sp.: *fuerza*]?
ELIGIO: Force, yes, force. More force from the gods is kupuri.

Kupuri can be transmitted from gods to humans with the help of a mara'akame. In this way, a person's life and energy are increased. Eligio uses the analogy of a glass of water (iyari) that can be filled up to the top with kupuri. If some water is lacking, a mara'akame can give more.

> ELIGIO: It [kupuri] is a power. Here among ourselves, that's how we use it. Among shamans, they give it—kupuri—and it is a power, a bit more. For example, to say, well, suppose this glass of water is a life, yes, an iyari. It's lacking a little bit, or here, like this. Good, I am going to give you a little bit more. I have to fill it up. It is one day more, a little bit more, then this glass will have this.
> HOPE: And are there people who lack kupuri?
> ELIGIO: Yes, a lack of . . .
> HOPE: Force?
> ELIGIO: Of force of the gods. That's kupuri.
> HOPE: And those people are very weak?
> ELIGIO: Exactly, yes.

We continued on with the idea of how kupuri appears to the shaman or how it is seen.

> ELIGIO: But that is the power—they are magic powers. No one can see them, only the shaman is watching what he is doing. That's how it is.

I then inquired where kupuri is located in the body. Eligio insisted that although kupuri enters through the head, it spreads throughout the body. And even though it is carried in blood, it is carried in other parts of the body as well.

> HOPE: Does a person have kupuri in their own blood?
> ELIGIO: Well, what you receive, the power, if you have it in all your body, all your body has it.
> HOPE: Is it seated in the head?
> ELIGIO: That is, it is seated in the whole body. It extends throughout the body. It does it—everywhere receives it.
> HOPE: Is it received via the head or via the heart?
> ELIGIO: It arrives via the head, then spreads throughout the body.

Finally, I returned to the idea of how iyari is represented in yarn paintings. Eligio interpreted this as a question about how images or visions arrive and how a person translates them into a painting. He explained that the messages from the gods that the person sees through the iyari appear as though tape-recorded there. Then the artist can use his or her mind to comprehend the im-

ages or the sounds and make a picture of it. In this way, a person learns many different designs.

> HOPE: And how do you represent iyari in the yarn paintings?
> ELIGIO: Iyari? Well, you can present it in the form that you think it. That which comes from them, that which happened, that which the gods did, it is as though you saw it, saw it and it stayed seated in your body. That is what can take place in the yarn painting. To make designs because you carry it in your mind. That is what you will make. No, it's no more than that. From there, then it [the designs] comes out. Different ones. About many things it comes out. They [the gods] tell you a thing, here it comes out [in art]. From the mind. It opens then, to be able to do that.
> HOPE: Many different designs come forth?
> ELIGIO: Now they come out of there.
> HOPE: From the heart, from the iyari?
> ELIGIO: Yes, from the heart. That is, from the moment when a person learns about this.

A person learns these designs at night during a ceremony, when a spirit arrives and teaches them. The expression "it comes walking" (Sp.: *viene caminando*) is another Huichol expression in Spanish referring to the arrival of a spirit during the ceremony. All night a person may learn. The next morning, the artist will have many new designs.

> ELIGIO: Because in one night, almost you will . . . let's suppose that [the ceremony begins] at six or seven o'clock [and lasts] until midnight. From midnight until five in the morning. That makes about eleven hours, you can be learning about this. It [a spirit or god] comes walking. It comes walking and [what it teaches to you] it stays with you here, here it will stay. In the moment that you do this work [that is, make yarn paintings], you can do it [that is, you have the power and designs], and now it comes out of you. Like a recorded tape, then . . .
> HOPE: And with that, a person can make many designs in one day? That many designs come forth quickly?
> ELIGIO: Yes, because there you go . . . well, this is all [that you need].

By using the mind as well as the ability of the mara'akame to see, an artist can develop many paintings, and all will have the same quality and power as the first.

> ELIGIO: Well then, since you have two, two powers—mental power and knowledge of that which is, that is to say, that which is of the shaman, and mental

power is another thing. You can originate [Sp.: *inventar*] more [designs]. But with the same power. And there are more. From one, you go on making . . . From one, you go on to make four, five, but by shamanic power. And with just mental power, you can go on making another five more. From one [ceremony], that's all. That is mental, to make up more, and that they always come out with the same power.

Fabian González echoed Eligio's explanations, in particular that both mind and iyari are needed to paint:

HOPE: Does a person paint with the iyari also?
FABIAN: The iyari. That is to say, a person thinks with this, right [*indicating head*]. But with this, what are we going to give? Because if we only had this [the head] and didn't have iyari, what would a person do?
HOPE: Only with the mind, with only the mind, it's not enough?
FABIAN: No, it doesn't work. With [only] the iyari, the mind doesn't work. Then the two work together for this [to make paintings]. Then also, if all you had was iyari, what good would you be? For this reason, a person has both. The iyari, and then the two work together. The iyari and the mind [Sp.: *mente*].

I asked Fabian what kupuri means. He interpreted this as a question about what functions it serves. He responded that a person who has kupuri lives a normal, happy, contented life; without kupuri, he or she acts thoughtless or crazy.

HOPE: And kupuri, what does that mean?
FABIAN: Without kupuri, a person is crazy. He goes around without thinking. And if you have kupuri, you live well, contented. There are five meanings. Living contented. Working. Eating. And without kupuri, you are crazy—that's how it is. Because you lack kupuri, so that you might be all right.

To summarize, artistic production ideally comes from having the iyari open to the gods. Achieving a state of openness is something that a person develops through the training required to be a mara'akame; another mara'akame can facilitate this process. When an artist's heart is open, tuned to the gods, images and ideas will flow in. Such an artist can attend a ceremony when the door to the spirit world is open and learn many new designs. By using the mind in conjunction with the heart, an artist converts the images and ideas into art. The artists emphasized that ideally both mind and iyari were required; iyari alone was not enough, although it is possible to do paintings solely with the mind.

The Huichol ideas are not unlike the Western ideas of heart and mind. A Western artist might say a painting has "heart" or "soul," but in Western terms,

this attribute tends to signify feeling or emotion. It is not specifically a reference to the supernatural. However, the Huichol take this concept one step further, since an open heart is filled by or linked to the gods. The gods have iyari, and so do people; ideally the two are linked, as though by a bridge. Kupuri is the energy that comes from the gods through this channel.

The Huichol aesthetic ideal is represented by an artist who has his or her *iyari* open to the gods. The artist's iyari receives, and is charged with, kupuri carried in this channel. If the artist also has a well-developed mind, he or she will be a good artist. Without a good mind, the artist will not be able to express designs through art.

This Huichol concept can be compared to the description of the good artist from an Aztec codex. The similarities are remarkable.[3]

> The true artist, capable, practicing, skilful, maintains dialogue with his heart, meets things with his mind.
>
> The true artist draws out all from his heart: makes things with calm, with sagacity; works like a true Toltec [that is, with skill]. (*Códice Matritense de la Real Academia*, cited in Anderson 1990, 153)

The artists' explanations also clarify why I began to feel that it is not necessarily important whether the subject matter of a particular painting comes from a specific dream or vision. What is important is whether the artist is in a state of receptivity or openness to the gods. Out of this openness comes the artistic work, which may have its specific source in a dream, a vision, or an intellectual thought.

The Huichol aesthetic ideal seems to be an artist in direct communication with the gods. The artist uses art as a way of developing a channel of communication with the gods and of reflecting back to others the results of the exchange. Huichol art is not only a visual prayer, as early anthropologists such as Lumholtz understood it to be, but also a demonstration that vision exists. The ideal artist has an obligation to explain to others his or her vision. The yarn painting is one way of doing this.

13

arte mágico
magical power in yarn paintings

Once someone showed me a large Huichol beaded bowl that she had bought in Puerto Vallarta. She asked me to see whether I could discover anything about the bowl and its maker. As I held the bowl, I had a strange sensation of tingling electricity running through my arms. Afterward, I felt drained and exhausted.

"What on earth did that bowl do to me?" I wondered. "Was it good or bad?"

Later, I told Lupe about the incident and asked her what she thought of it.

"That bowl was draining your energy," she said. "It must have been a strong shaman who made the bowl. He was able to transfer his power into it. When you held the bowl and connected your mind to it, you activated its power."

Our conversation led me to wonder whether yarn paintings themselves have any form of shamanic power. Are the paintings simply representations of vision, of nierika and iyari, or do they have in themselves some form of linkage to the supernatural? Most of my information on the powers of yarn paintings comes from Eligio Carrillo. It is supplemented by information from Chavelo González de la Cruz. The information is fragmentary, but suggests that even commercial yarn paintings have some shamanic power.

I asked Chavelo about sacred yarn paintings and how they should be handled. He described the traditional functions of the paintings this way: the Huichol always used to make yarn paintings round because they represent vows owed to all the powers of nature—the air, the ocean, the earth, all the things that make up nature. It is modern to make them as a square, even though they may contain original designs.

I asked whether the Huichol ever displayed sacred yarn paintings, the way that Western buyers do. He replied that according to an old tradition, they could not put yarn paintings in a house where people lived. If a person made a yarn painting, he had to put it in a xiriki. It should not be left hanging around. Once

214

inside the temple, the yarn painting never left it. It represented the temple itself. A person could take out the other offerings, but never a yarn painting.

I asked whether all Huichol had these in their xiriki. According to Chavelo, everyone does—well, some may not. Perhaps for some people, their parents never taught them the meaning. But it is very important not to take them out. It is like cutting off your arm to do so. Chavelo elaborated that a painting is as much a part of the temple as a person's arm is of his or her body. He asked whether you would cut off your own arm. A person can go in and look at it, but not take it out.

Given these restrictions on sacred yarn paintings, I asked whether it was considered acceptable to make yarn paintings to sell. He replied that it is all right to make copies and sell them as long as you do not move the original. The copies can have the same meanings, but it is all right to move them.

It is likely that this distinction between sacred originals and copies is an old one in Huichol culture. Lumholtz (1902, 2:169–171, 181–182), for example, found that the Huichol refused to give him the original statue of the fire god kept in a sacred cave near Santa Catarina, but would make him a copy of the god for his collection.

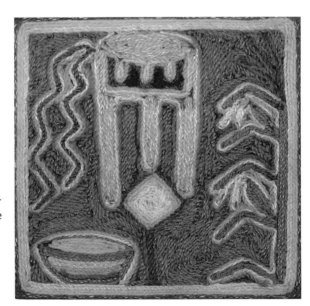

Fig. 13.1. Fabian González Ríos, yarn painting, 2005. 4" x 4" (10 x 10 cm). When the shaman beats the drum, lightning comes out of the drum at night. This painting illustrates that visionary experience. Photo credit: Adrienne Herron.

The original yarn paintings, the oldest designs, are representations of a temple itself and the offerings inside it. *The Temple of the Deer God* (MacLean 2005b, v) represents an original painting. Chavelo describes this painting as a representation of the temple of the Huichol. The temple is the deer god itself; the candles, prayer arrows, corn, and plumes in front are offerings to the deer. He commented that this is an excellent painting because it is original, that is, it is an old style of painting, made in a traditional way as a circle. He implied that the concepts it depicts are also traditional.

Since he described the original paintings as conventional representations of a temple, I asked whether the Huichol also depicted peyote visions, that is, whether paintings could be used to show personal experience as well as a traditional design. He replied that if a person has a peyote vision, he or she can make a yarn painting as a reminder of what they saw. They can keep it for when they get old. As they go on in life, they can keep the painting and add others to it. However, they must keep it well guarded.

Eligio Carrillo confirmed a number of the points made by Chavelo about the relationship between sacred and commercial yarn paintings. He agreed that sacred yarn paintings are made as prayers or offerings; however, it is acceptable to make copies in order to support oneself.

> ELIGIO: For this reason [as a religious offering], we use the nierika. For this reason, we make it. But we don't make it to sell. Those which we [sell are] copies. [The originals] are the basis [the foundation], which, like those we make here, they are carried to that place [that is, taken on pilgrimages].

Eligio and Chavelo appear to contradict each other, since Chavelo maintains that sacred paintings should not leave a temple, while Eligio describes taking them on pilgrimages and leaving them as offerings. I believe that this is because they are describing different uses of yarn paintings. Chavelo is describing a painting as something equivalent to the god disk, which sits on the altar and represents the temple itself. To Chavelo, even the sacred paintings that are taken on pilgrimages are copies of the original god disk.

According to Eligio, the yarn paintings themselves represent powers, whether they are sacred offerings or commercial paintings. This is because the same powers and their origins are depicted in both kinds of paintings.

> ELIGIO: But they are powers, how a person should make them. What is it that they contain. What is it that we search for. Which is the power. Which are the [cardinal] places of the gods. Everything. Everything. Well drawn out, we have

here. But we draw it out of this [the nierika, or yarn painting], where we learn. Because it is the mirror. For this reason, we can explain, a person can explain it himself. That is what this contains.

HOPE: The yarn painting is like a mirror of the gods. And you bring it forth from that?

ELIGIO: Yes, exactly. It is representing it, now, that which it contains. What is it that he is seeing here, the shaman. Translating it with which part, with which colors, all that.

I went on to ask Eligio whether yarn paintings in themselves had a form of power. He said that they might, but that their power depended on the power of the person who made them.

HOPE: This is a question that many people have asked me, whether there is power in the painting itself. For example, if I buy a painting—I am a buyer and I buy a painting—does that painting have the power of a shaman also?

ELIGIO: Yes, because it carries all the power that there is. That's how it is. For this reason, many times, many people don't know what it contains. Well then, since I am explaining all the powers that you want to know about, you will know which are the powers. That which it contains, in my opinion, it has to carry some of the power of a shaman.

HOPE: Then if I touch that painting, I can feel the powers that it contains, which the shaman put in that painting.

ELIGIO: That is what I was saying, with faith. If you do it with faith, yes. Yes, you can do that. Everything can be done with faith. That's how it is.

Eligio made a further distinction between original power—power that a person earns for himself or herself through shamanic training—and derived power, which can be gifted from a mara'akame or an artist to another person when the artist teaches another person his or her designs. While derived power may still have some force, it is not equal to original power. Only people who undertake their own training can acquire their own designs and the power that goes with them.

HOPE: And if a person is not a shaman and makes a yarn painting, does it have the same power?

ELIGIO: It's less then. For example, if you [Hope] make one, it is less. It is less. Because it doesn't have the original power . . . That is how things are in this world. It's like, now, [my apprentice], I passed my power to him. Well, now he is doing the designs that I did, but it is secondhand power, it isn't worth anything, or it is worth less. They are very pretty, but it is from the mind of another person.

. . . For example, if you do this [that is, copy an artist's design], "Well, I am going to make the same thing." You make it up. It is made up from your mind. I can do the same, but it is not made up from what you did. That's how it is. Those are the powers here. What has value is the one who is making it up, because he has it [his heart] open to make and unmake. That's how it is.

HOPE: Then he has to follow the path of a shaman also in order to have different ones [that is, his own yarn-painting designs]?

ELIGIO: Yes, well, that one means . . . but that he might change, that he changes the way he works and everything. It is also very difficult, to change.

HOPE: Why does he need to change how he works?

ELIGIO: Because it is my style.

HOPE: Why [change]?

ELIGIO: So he can do his own style—the way he works, where he gets his designs. He must change his designs and the colors. Because not all us artists work the same. He has his work, he has his difference. That's how the power is here.

A yarn painting can have the power to open the mind of a person who looks at it. "Opening the mind" means that a painting can give a person shamanic vision as well as more kupuri, or life energy. However, Eligio repeated several times that this could only happen if the person had faith and believed in the gods and their powers.

This information emerged in a conversation during which I posed a question asked of me by Charles D. Laughlin, who was studying Tibetan Buddhist practices. Tibetans believe mandalas have power in themselves and can affect a person who looks at them. Laughlin wanted to know whether the Huichol shared this belief. I repeated his question to Eligio. Unfortunately, my lack of knowledge about Tibetan mandalas meant I could not formulate very sophisticated questions. I also used the Spanish word "*afectar*" to translate the English verb "affect," meaning simply "to influence." Eligio understood "afectar" to mean "have a negative influence on." Therefore, he pointed out several times that the influence of yarn paintings on the mind was positive, not negative. He typically uses the word "*concentrar*" to mean that a person has become more focused or aware and has developed shamanic abilities with the help of the gods.

HOPE: Someone asked me this. I don't know whether you can answer. He wants to know whether, by seeing a yarn painting, it makes you . . . gives you [shamanic] vision. Do the colors affect the mind of the person who sees them and give him vision?

ELIGIO: Yes, of course. . . .

HOPE: How does that happen?

ELIGIO: As long as you have faith or belief in it. One can learn, you can learn what you . . . If you feel that you want to know about the things of the gods, it can concentrate you [meaning "to focus or increase shamanic ability"]. And yes, you can see. These are things . . . they are images that are recorded [in the mind]. And to any person, they can be given as recordings.

HOPE: It is as though the yarn painting can open the mind?

ELIGIO: Yes, exactly. It can open the mind. Of anyone. As long as you have faith.

HOPE: Does it affect the body also?

ELIGIO: No, that part no. It does not affect it. [Note here that Eligio is interpreting the Spanish word "afectar" to mean "having a negative influence on," such as damaging the body. I intended it to mean influencing the body generally.] . . . On the contrary, it will open the mind for you. It opens the mind more. Yes, these are things [powers] of the gods, then.

HOPE: It would be better if he were here to ask this. I don't know exactly how . . . what kinds of questions this gentleman wants to know about. He studies the art of the Tibetan people. And there are . . . [people] like monks, who are celibate. And they make paintings of sand with colors, also, and then they meditate on the paintings. And they say that it gives them more power.

ELIGIO: More power.

HOPE: More vision, through their meditation on the colors. He knows more about it. This gentleman is interested in the effect on the mind, of these things.

ELIGIO: Yes, as you say it, it is probably the same thing, that thing too. It opens the mind. On the contrary, it doesn't harm it. Rather, it opens it. More knowledge or understanding [of the things of the gods].

HOPE: And do different colors have different effects? On the mind?

ELIGIO: No, at the very moment, they come together. Then they go to work. That is to say, the colors [do]. Then they work together. That is the power that they have.

HOPE: Do they have an effect on the life energy or personal soul power?

ELIGIO: [again interpreting "have an effect" as negative] No, not on that. On the contrary, one receives more life energy.

HOPE: It gives you more life energy?

ELIGIO: Yes, more.

My interviews indicate that some yarn paintings have more shamanic power than others. The sacred paintings, made and kept in temples, have important sacred meaning and power. The copies made for commercial use have less power and fewer restrictions on their use.

The interview with Eligio indicates that an artist can transfer his own power into a physical painting, but only if the artist has power himself. Designs that are taught to or copied by others will not have the same force as original designs.

It is interesting to compare the Huichol view with that of the Navajo. According to Parezo (1991, 63–98), Navajo sand painters believed that power resides in an exact duplication of the image of a holy person. Changing the image removes most of the danger. In contrast, Huichol artists believe that sacred power lies more in the process of making the painting.

14

shamanic art, global market

When I began visiting Lupe in the late 1980s, the market for Huichol art was still quite limited. When I flew into Puerto Vallarta, I found one newly opened fine-art gallery specializing in Huichol art. A folk-art gallery had a few good pieces of Huichol weaving, embroidery, and beaded jaguar heads. Some tourist souvenir stands sold tired and dusty-looking items such as painted or beaded snakes and deerskin quivers with Huichol bows and arrows. In Tepic, the few stores that specialized in Huichol art had stacks of yarn paintings piled in the corners and a variety of Huichol souvenir items on their counters, such as god's eyes, little brown dolls in Huichol costumes, pillows with embroidered Huichol designs, and backstrap-woven bags with "Nayarit" written on them. The owners spoke little or no English. The shops looked as though few tourists ventured into them. They sold mainly to intrepid connoisseurs who ventured into Tepic in search of genuine Huichol art and to local Mexicans looking for souvenirs of Nayarit.

Since my first trips, I have witnessed an explosive growth in the market and in the diversity of Huichol products for sale. In this section, I will look at changes in the market over the last twenty years and at how recent trends may play out in the future. I explore the market for yarn paintings, the buyers, and the market structure. I asked the artists how they modify their paintings for the market and how they respond to interest in their sacred worldview.

The largest market for Huichol art is still in Puerto Vallarta, the tourist center closest to the Huichol Sierra. Puerto Vallarta itself has grown enormously over the last twenty years, changing from a quiet fishing village with a few hotels and bungalows into a major city full of hotels, time-share developments, and shopping malls. By 1993, there were at least nine galleries, all selling significant amounts of Huichol art. By 2005, there were at least twenty galleries selling

relatively high-end art, such as good-quality yarn paintings, and dozens more galleries carrying mass-produced Huichol beadwork.

There are also stores specializing in Huichol art in Tepic and in Guadalajara, particularly at the Basilica of Zapopan, which has added a Huichol museum to its shop. Huichol art is now distributed to more distant tourist centers, such as Cancún, Taxco, and San Miguel de Allende. In Mexico City, Huichol work must compete with folk arts and crafts from all over Mexico; museums and stores such as FONART sell some yarn paintings, but it is not a specialty.

Transportation routes influence where the Huichol sell their work. Artists from Nayarit and San Andrés find it convenient to sell their work in Puerto Vallarta. There is a slow bus that winds through the mountains from San Andrés to Ruíz on the coast. There used to be regularly scheduled air flights from San Andrés to Tepic, but the plane, an ancient DC-3, crashed in the mountains. Air charters in smaller planes are still available, and artists who use them can leave their communities in the Sierra and arrive in Puerto Vallarta in a matter of hours. Some artists even operate as middlemen on these trips, buying work from other artists in the Sierra and reselling it to dealers. Artists from Santa Catarina and San Sebastián have to make a much longer trip to go to Tepic or Puerto Vallarta. They tend to travel down the east side of the Sierra and sell their work in Guadalajara and Mexico City.

Some artists manage to sell directly to the public, including non-Spanish-speaking tourists. In Mexico City, a market called the Ciudadela fosters sales of native crafts by providing living quarters for indigenous artists. A group of Huichols, mostly from Santa Catarina, operates out of this market and also sells at the upscale Bazar Sábado in San Ángel, a Mexico City neighborhood. One artist from the Ciudadela became a major reseller of yarn paintings that he purchased in Guadalajara and Tepic.

Elsewhere, Huichol artists try to sell directly to the public if they can. The Nayarit government now allows Huichol artists to sell in the main plaza of Tepic. It tries to control the process by rotating the booths among different families and community groups so that no one group can monopolize the opportunity. This gives the Huichol a chance to make some direct sales, but their customers are limited. Comparatively few foreign tourists venture into Tepic, which is a rather dingy market and industrial town. Most shoppers are local Mexicans looking for inexpensive trinkets and beadwork jewelry, which forces prices down. Few yarn painters sell in this location.

It can be difficult for artists to sell directly to tourists. For a short time in the mid-1990s, indigenous people could sell crafts directly to tourists on the street in Puerto Vallarta. This caused problems for the galleries, since the Huichol were selling at the wholesale price, the same price they charged the galleries. Tourists were beginning to complain about the galleries' markups. I was told that the police discouraged direct sales by scooping the Huichol artists up from the sidewalk, driving them out of town, and leaving them there.

By 2005, two Huichol families had opened galleries in Puerto Vallarta: the Bautista family and the Castro family. Both families were experienced business-people. They have been selling in the Puerto Vallarta market for more than fifteen years, but used to sell to middlemen. Their galleries are interesting, since they represent a new effort by Huichol to compete directly with other upscale art galleries rather than to sell at a stall in a street market.

I visited both galleries in 2005. The Castro family's gallery had a better location, on Basilio Badillo, a street with more traffic and high-end galleries. It appeared cleaner and more polished and was therefore probably more attractive to tourists. When I visited, the store was staffed by a mestizo man who said he was paid on commission. Fluent in English, he was an aggressive salesman, which may be an asset in selling art in a tourist location. In contrast, most Huichol tend to be quite low-key in selling, often saying little and not pressuring customers. Few can speak enough English to communicate well with buyers. Nevertheless, when I returned two years later, the gallery was no longer there.

The Bautistas' gallery—called Gallery Niuweme—is operated by Iginio Bautista Bautista, a young Huichol bead artist from San Andrés who has travelled in the United States. This gallery featured work by Iginio's more famous relative, Francisco Bautista. In 2005, the gallery's location was somewhat out of the main tourist district; the walls were dark and water-stained; and I noticed that the gallery was catering to a Huichol clientele, selling supplies such as sandals, cera de Campeche, and hanks of beads. By 2007, the gallery had moved to a more central location; it was now painted white and appeared more prosperous.

The dealers in Huichol art have diverse backgrounds and motivations. They include the following:

» Private dealers who purchase for resale in other countries. These buyers tend to be foreign expatriates, such as Americans or Europeans who live in Mexico or travel there frequently. They purchase art in Mexico and take it back to their own countries to sell. They combine a love of Mexican art and culture with high

esteem for the Huichol, and often are motivated by personal as well as financial reasons. Few rely exclusively on the sale of Huichol art in order to make a living. These buyers often have longstanding relationships with Huichol families, friends, and artists. They have considerable knowledge and artistic taste. They know who the best artists are and seek them out, making trips into the interior if the artists do not come to them. Private dealers try to buy the highest-quality Huichol art before it reaches the galleries in Mexico, and they usually succeed.

» Gallery owners in Mexico. The Mexican galleries are more diverse. Some gallery owners are similar to the expatriate private dealers in their connoisseurship and the quality of the paintings they are interested in. They have longstanding patrón relationships with particular artists. Some gallery owners regard Huichol art as one among many Mexican craft commodities, similar to Talavera pottery or Guerrero masks. These gallery owners move with buyers' trends, selling whichever crafts and artists are currently popular. Most galleries are owned by businesspeople who are Mexican nationals. A few galleries are owned by expatriates or employ expatriates who can speak tourists' languages. Some galleries are outlets for governmental agencies, such as the Nayarit or Jalisco state governments, or FONART, the Mexican craft-development agency. The governmental outlets are usually staffed by clerks who know little about the Huichol or their art. The goods are supplied by a central buying agency, and sometimes the central buyers know more about the Huichol than the gallery workers do. The governmental outlets tend to sell the cheapest Huichol art, usually made in volume by "folk art" artists; they also sell cheap Huichol-inspired souvenirs, such as pencils with god's eyes attached, beaded key rings, or pillows and napkins with coarse cross-stitch embroidery in Huichol designs. Some of the souvenirs may be made by Huichol; others are made by mestizos. In the past, governmental agencies attempted to foster yarn painting through projects such as the INI-sponsored school in Tepic during the 1960s or an instructional program in the Sierra during the 1970s. Now these agencies concentrate more on financing and marketing Huichol crafts rather than on teaching the Huichol what to make.

» Time-share stores. Time-share is a system whereby buyers purchase the right to use a property for a specified time each year. Like many tourist resorts, Puerto Vallarta is a hotbed of time-share sales, combined with a booming real estate market. Time-share companies try to lure tourists into listening to a real-estate sales pitch by offering discounts on tourist merchandise or outings. In Puerto Vallarta, several galleries, including a large "museum" on the Malecon,

are actually time-share companies offering discounted Huichol art. The time-share companies drive down the price of Huichol art because they sell it as a loss leader—a practice that ultimately reduces prices for both Huichol artists and other galleries.

» Retail stores and galleries outside Mexico. Most of these purchase from wholesalers in Mexico that are either Mexican galleries or private dealers. A few gallery owners travel to Mexico to do their own buying directly from the Huichol.

The United States is probably the largest market for yarn paintings outside Mexico, particularly in the Southwest and California. Yarn paintings are also sold in Canada, Japan, Germany, Austria, and other European countries. There are scholars from most of these countries working with the Huichol, and these scholars may help facilitate exhibitions and interest. Quite a few artists now go on tours outside Mexico to museums and galleries, and local exhibitions have become relatively common.

There is a pyramid of sales and revenues, depending on the quality of the art and how well known the artist is. Top artists receive the highest prices by selling directly to buyers from foreign countries. Often, much or all of their production is commissioned in advance. Artists in the middle range sell to wholesale dealers for resale in foreign countries or to the better galleries in Mexico. Artists at the bottom level receive the lowest prices by selling to governmental outlets and lower-paying galleries in Mexico, or by selling directly to tourists on the street.

To facilitate an understanding of the paintings and their markets, I have divided the market into categories. My categories were originally defined by René d'Harnoncourt in the 1930s for the marketing of Indian arts and crafts during the New Deal (Schrader 1983, 142–145); they were later adapted by Parezo (1991, 164–70) in her study of Navajo sand painting. These categories are useful because they set Huichol art into a historical framework that can be generalized to other Native arts and crafts, and more broadly to ethnic and tourist arts as a whole.

D'Harnoncourt segmented the market for Native arts and crafts into three groups: fine art, gift and home decoration, and tourist souvenirs. The fine-art market was the high end: objects that were rare or of high aesthetic value, made by highly skilled artists. The main buyers were collectors and museums. The gift and home-decoration market consisted of well-made, useful objects that

were constructed of good-quality materials and designed to last. The tourist-souvenir market was the low end: inexpensive, mass-produced objects usually bought by tourists for their emotional associations, such as souvenirs or mementos of a trip.

Each category required its own marketing strategy. For example, fine-art objects could be displayed in a gallery setting, on pedestals, with little ethnographic detail. They commanded high prices that fewer buyers were able to pay. Thus, they served mainly to create demand among the general public and to show what indigenous artists were capable of.

Tourist souvenirs could be sold at low prices to a mass market. They were not to be mixed with better-quality objects in displays, because they would pull down prices and encourage buyers to think of all Native arts as cheap, poorly made, and disposable. The midlevel had the greatest potential for market expansion, which would generate good revenue for the artists while supplying consumers with products they would be proud to own.

I have adapted D'Harnoncourt's categories to reflect the design of yarn paintings. I have used price as a rough indicator of value only, quoting all prices in U.S. dollars in order to make them comparable. In reality, there is a considerable range of prices, since paintings are sold in both U.S. dollars and Mexican pesos and at both wholesale and retail prices.

Fine-art yarn paintings are those made by top artists, who have become famous in their own right. These artists may have had personal gallery exhibitions and toured other countries. Their paintings are usually of very high quality, both in design and workmanship. They exhibit unique and recognizable styles as well as superb color use. Their styles are often copied by their own apprentices and other artists. This category includes very large, elaborate paintings, such as those made for museums or institutions. The paintings in this category can range from 24" x 24" (60 x 60 cm) to several yards (meters) in length. The prices range from about $500 to $10,000 or more.

Souvenir yarn paintings are small, less than 12" x 12" (30 x 30 cm). Some are as small as 4" x 4" (10 x 10 cm). The paintings are often unsigned, or if they are signed, the artist is not well known. An experienced artist might be able to produce one or two paintings of this type a day. Prices range from about $5 to $50. Parezo described Navajo sand paintings that are made with stencils and produced at a rate of sixty a day; there is nothing comparable to this for yarn paintings. Even the simplest yarn paintings use freehand designs, and the com-

paratively time-consuming method of pressing the yarn ensures that the artists cannot make more than a few a day.

The gift and home-decoration paintings are larger, ranging from about 12" x 12" (30 x 30 cm) to 24" x 24" (60 x 60 cm), and the designs are more elaborate than those used for souvenir paintings. Paintings take up to a week to make, depending on yarn thickness and the amount of detail they include. The artist usually signs the painting, and the dealers usually know something about the artists. Some artists are quite well known among dealers, and buyers may request paintings by a particular artist. Other artists are shadowy figures whom dealers know little more about than their names or communities of origin. Paintings in the midrange usually sell from about $50 to $1,000.

Recent Trends

Several trends have affected the market for Huichol art since the 1990s. The Tepehuane, another indigenous group, has begun to sell yarn paintings. Huichol beadwork has experienced explosive growth in popularity. There have been abortive efforts to start artist cooperatives. There has been a resurgence of interest in yarn painting among younger Huichol artists, some of whom are testing other media for paintings. Finally, e-commerce is now having a major influence on the price and availability of Huichol art.

Tepehuane Art

In 1994, the Tepehuane began making yarn paintings. The Tepehuane speak a Uto-Aztecan language closely related to Pima and Papago. They live north of the Huichol, in northern Nayarit and Durango. They have a different culture from the Huichol, but share some customs, such as shamanic ceremonies and curing. They use *macuche* (wild tobacco) in their ceremonies rather than peyote, and do not go on peyote pilgrimages. They do not use yarn paintings as offerings in their traditional culture.

In 1994, Gabriel Bautista Cervantes, a young Tepehuane man whose family had moved to Tepic, observed the success that the Huichol were having as yarn painters. He made several paintings and offered them for sale to the shops run by the Nayarit government. I met him there and photographed his first paintings, which depicted Tepehuane subjects. His color use was very different from that of the Huichol, although the technique and materials were the same.

By 1996, Gabriel and his twelve brothers and sisters were making yarn paint-

ings, and his mother and father sold them. By 2002, some of the spouses of the twelve siblings were also making paintings. By 2005, the women in the family were still making yarn paintings, but some of the young men had turned to higher-paying waged jobs.

The family sold within Mexico and wholesaled to dealers internationally. They were considerably more skilled at commerce than many Huichol artists and learned how to package and ship through international couriers such as DHL. They carried a range of products at different price points, everything from tiny inexpensive paintings to huge murals. They yarn-painted bas-relief plaques with suns or sun-moon eclipses and constantly evolved new products and tested them to see whether they would sell. By 2007, the family had a network of international buyers and were exporting paintings to Guatemala, Japan, and Europe. They were shifting their business model to making paintings to order rather than on speculation, then hoping to sell it.

The color use and subject matter of Tepehuane paintings have changed over time. Gabriel's first paintings used earth tones such as greens and browns, highlighted by oranges—which is not a color combination commonly used by

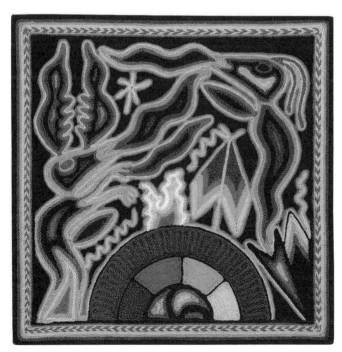

Fig. 14.1. Bautista Cervantes family, yarn painting, 2000. 12" x 12" (30 x 30 cm). This group of Tepehuane began to make yarn paintings in the 1990s. Photo credit: Adrienne Herron.

Huichol. By 1996, some Tepehuane paintings were direct copies of those by Huichol artists such as José Benítez Sánchez. Other paintings had Tepehuane subjects. By 2005, the Tepehuane were turning out repetitive paintings with variations on the eclipse theme, such as suns and moons with human faces. They mixed astrological elements with a repertoire of Tepehuane symbols, such as deer, hummingbirds, prayer arrows, or sacred tobacco, and with depictions of ceremonies or curing. They turned out so many paintings that there was a great deal of repetition. Most were small paintings made for the souvenir market or the low end of the gift market. However, I have seen some large paintings that could be considered fine art and that use original subject matter based in Tepehuane culture.

The Tepehuane have a different color sense than the Huichol. Their colors seem more "acid" and harder edged than the Huichol's. Huichol colors seem softer and more blended. The Tepehuane told me that they prefer to use only fuerte colors rather than the mix of fuerte and bajito colors preferred by the Huichol. Their mass-produced work relies heavily on bright, primary red, blue, and yellow.

The Tepehuane art is genuinely indigenous, and interesting in its own right. For this reason, I have followed it since the beginning and will continue to document it. It is a case of an art adopted from another culture that is now becoming integrated into the culture of this particular family. For example, several young Tepehuane women asserted to me that yarn painting was an art form of both the Tepehuane and the Huichol, but that only the Huichol made beadwork. (The Tepehuane have had no interest in beads.) To my knowledge, this one family in Tepic is still the only group of Tepehuanes who make yarn paintings. It will be interesting to see whether, over time, the art spreads to other Tepehuane, such as those still living in northern Nayarit and Durango.

One concern is the effect of Tepehuane yarn paintings on the market for Huichol art. The Tepehuane have generally priced their work lower than that of the average Huichol artist, and much less than what the best Huichol artists command. Generally, their art is priced at the high end of the souvenir and folk-art market. Some unscrupulous dealers have capitalized on the popularity of Huichol art by selling Tepehuane art as Huichol. At one time, a good deal of the so-called Huichol art sold on the Internet had been made by the Tepehuane, and it is still quite common to see this confusion on eBay.

I questioned the sale of Tepehuane art as Huichol in a gallery in the United States. The owner told me that the gallery had bought Tepehuane paintings at a

gift show from a wholesaler who claimed that the Tepehuane were extensively intermarried with the Huichol and that therefore there was little difference between the two tribes. This was not true, since the only Tepehuane who made yarn paintings were from one family in Tepic, and that family has not intermarried with the Huichol at all. Buyers in the United States who have purchased Tepehuane art represented as Huichol may have recourse under the Indian Arts and Crafts Act of 1990, which requires art to be truthfully labelled by the tribal affiliation of the producers (Indian Arts and Crafts Association 1999, 116).

Tepehuane paintings can usually be distinguished from Huichol paintings by the writing on the back or by the drawing style and color use. The Tepehuane often (though not always) write "*cultura tepehuane*" or "*arte tepehuane*" on the back of their paintings. Moreover the family's name is Bautista Cervantes.[1] (There are Huichol with the surname Bautista, but not Bautista Cervantes). Any art signed with either of these is almost certainly Tepehuane, not Huichol.

The Tepehuane produce a large volume of paintings. They may be selling almost as many yarn paintings as the Huichol themselves, particularly smaller paintings (12" x 12" [30 x 30 cm] or smaller). This is because many Huichol artists do not do yarn painting full time and may produce only a limited number of paintings a year. In addition, Huichol paintings are often larger and of better quality. And finally, many Huichol now do beadwork rather than yarn painting, for reasons explored below. Hence, the Tepehuane have become significant suppliers of the market for yarn painting.

Beadwork

During the 1990s, there was an explosion of interest in Huichol beadwork, especially beads applied with wax to sculptural shapes. When I first went to Mexico, I saw only a few kinds of beaded items, such as small gourd bowls and carved wooden snakes. Both of these grew out of objects used as religious offerings. More spectacular were carved wooden jaguar heads covered with beads. One dealer told me that the idea of beading jaguar heads had been invented by a dealer in the early 1980s. He bought jaguar heads in Guerrero and asked the Huichol to bead them.

Facing page

Fig. 14.2. A Huichol artist using a needle to apply beads to a wooden eclipse plaque while waiting for customers in the plaza of Tepic, 2005. Photo credit: Hope MacLean.

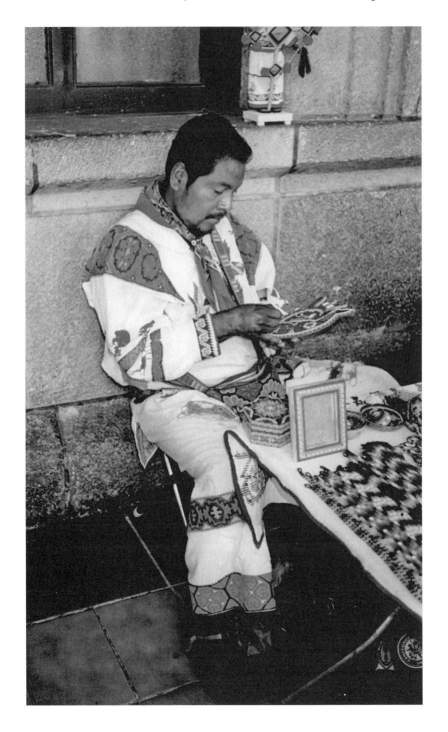

In the 1990s, beads of all kinds became popular in the North American market, and film stars such as Goldie Hawn were photographed wearing beaded running shoes. Huichol beadwork was pulled along by this market trend, and became enormously popular. There was competitive pressure on dealers to find new and original items that no one else had. Dealers began giving the Huichol exotic items to bead, such as fanciful wooden masks carved in Guerrero, reproductions of pre-Columbian pottery, gigantic wooden jaguar statues, masks a yard (meter) long, and the real skulls of bulls, antelope, and deer. Dealers brought in wooden and papier-mâché animal forms from all over the world, including such non-Mexican animals as giraffes and elephants. Small beaded animals made on an assembly line filled the stores. Some stores even sold beaded dime-store knickknacks, such as beaded ceramic clown figures. Interior designers hired Huichol artists to bead the living room furniture of wealthy clients. Perhaps one of the oddest bead projects was a set of beaded carved penises that a homosexual client requested from a dealer for use as Christmas presents.

The Huichol seem to have no spiritual qualms about beading almost any item a dealer suggests. They cheerfully bead any surface given to them. Perhaps they do not see the underlying object as important unless it is something with religious meaning in Huichol culture, such as snakes or bowls. While beadwork designs such as those of corn, deer, or the nierika do have symbolic meaning, the symbols do not confer sacred status on commercial objects.

A spin-off from the baroque competition in beadwork has been an increased range of yarn-painted items. Artists and dealers experimented by using yarn painting on items that had been successfully marketed with beads. For example, yarn-painted bowls are somewhat common, as is the occasional yarn-painted mask or Huichol drum. I have seen yarn painting successfully used on papier-mâché deer sculptures, carved wooden jaguar heads, and eclipse (sun-moon) plaques. However, this generally seems to happen more often at the high end of the market, where the products are unique, one-of-a-kind objects sold in galleries. I have seen few Huichol-made, mass-produced, yarn-painted items comparable to the assembly-line beaded animals.[2] Nor have I seen yarn painting used on the wide and eccentric assortment of items given to the Huichol to bead.

The booming market for beads has attracted a different group of Huichol artists than yarn painting has. Teenage boys have become some of the fastest and most daring beadworkers. Since the market rewards bravado in design, it

stimulates these young men to constant innovation. It is also common to see women doing beadwork, and even children as young as seven or eight. In contrast, it is rare for women or teenage boys to do yarn painting, and I have never seen children do yarn painting.

Recruiting Younger Yarn Painters

A third development is a considerable increase in the number of young yarn painters. In 1993–1994, I found few young yarn painters. Most painters at the time were men who had started yarn painting during the 1960s and 1970s and who had already been painting for up to thirty years. While some older artists had trained family members and apprentices, few young artists were doing yarn painting. Instead, most younger Huichol were doing beadwork, which was experiencing an explosive growth in popularity. Beadwork was faster to make, more profitable, easier to learn, and highly salable. As a result, I speculated that unless yarn painting became more attractive economically, it might become a dwindling specialty.

The situation changed during the 1990s when a group of younger artists emerged in Tepic, especially in Zitacua. The artist José Benítez Sánchez was appointed governor of the colonia, and he employed a number of family members and apprentices to help him complete paintings. The apprenticeships led to the formation of a group of new yarn painters who are centered in Zitacua and who tend to paint in the style of José Benítez. Since Benítez's style is popular and salable, it is advantageous for other artists to copy him. Some of these younger artists directly copy Benítez's color combinations. Most draw figures in his style, such as a pointed human face. Some copy his very intricate, intertwined figures, while others are using more widely spaced figures.

The economics of living in a city puts pressure on the Huichol to produce art. The urban Huichol have many expenses, such as rent, water, electricity, gas for cooking, school fees, bus fares, and purchased food; these expenses may be considerably less for Huichol living in the country, especially those who can still grow their own food and collect firewood. One of the few ways that urban Huichol can earn enough cash is by making art. This pressure increases the volume of art produced in cities and may increase the number of artists working on yarn painting. Thus, by encouraging the Huichol to settle in Zitacua, the government may also have stimulated the production of art.

Cooperatives

I have been told about attempts to set up cooperatives to market Huichol art over the years. In 1993–1994, the Nayarit government worked with artists in Tepic to set up a cooperative based in the Museo de Cuatro Pueblos. The state was involved in constructing the new tourist-hotel district of Nuevo Vallarta, and was planning to market Huichol art in the hotels. When I returned several years later, I asked about the cooperative. I was told that it had collapsed amid accusations of misappropriation of funds. I heard tales of another cooperative, based in the Sierra, which folded amid similar accusations. As a result, the Huichol remain relentless free enterprisers, personally selling their art to their own lists of clients and producing whatever art they think the market will buy.

Cooperatives have both advantages and disadvantages. At best, cooperatives may help artists receive a fair price for their work. For example, Sna Jolobil, a cooperative organized by an American, has allowed Maya women to control production and maintain high prices for the finest and most time-consuming weaving and embroidery (Eber and Rosenbaum 1993, 166–167; Morris 1987). Among the Inuit of Canada, cooperatives controlled the output of lithographed prints and maintained high prices for the limited output of numbered editions. In contrast, the market for Inuit soapstone carving was less controlled. Inuit could sell to any buyers they could find, and so prices fluctuated more (Myers 1984). On the other hand, cooperatives are vulnerable to the personal failings and political agendas of participants and may act as barriers to innovation. The difficulty of controlling corruption seems to have limited the value of cooperatives among the Huichol.

The Effect of the Internet

I am somewhat dismayed by the effect the Internet is having on the sale of Huichol art. I have informally tracked e-commerce in Huichol art since the mid-1990s, when it began. My conclusion is that the Internet is significantly depressing the prices of Huichol art, has probably driven many dealers out of business, and may be harming the ability of the Huichol to make a living from their art.

It has taken a few years to achieve these results. For example, when I did my fieldwork in 1993–1994, the retail price of a good-quality 24" x 24" (60 x 60 cm) yarn painting was about $600–$800 in a Mexican gallery and about $1,000–$1,200 in a good gallery in the United States. When dealers first began to sell on

the Internet, around 1996–1998, the price structure was maintained. The first Internet sellers tended to be relatively sophisticated independent dealers or good galleries in the United States.

Then some dealers in Mexico began to sell at the Mexican retail price, which was about half the U.S. retail price. Since the dealers were living in cities such as Tepic or Puerto Vallarta, they did not have to pay travel costs to find or transport the art, and since they operated on the Internet, they did not have to pay the cost of maintaining a gallery; as a result, they could afford to discount prices significantly. These Mexican dealers began to flood the market with poorer-quality yarn paintings and Tepehuane art. For a while, much of what was claimed to be Huichol on the Internet was actually Tepehuane. After a few years, some dealers began to identify the Tepehuane work correctly, perhaps in response to the U.S. legislation requiring the accurate identification of tribal origins. By about 2000, the retail price of a 24" x 24" (60 x 60 cm) painting sold from Mexico on the Internet had dropped to about $400.

I began to see fewer and fewer high-end dealers offering good Huichol art on the Internet. When I interviewed gallery owners in the American Southwest between 2000 and 2002, they told me that their buyers were complaining that the prices charged in U.S. stores were higher than those on the Internet. Customers wanted the stores to sell for less, but were still buying.

Then came eBay. In the last few years, the price of Huichol art has fallen dramatically on eBay. In 2005–2006, the price was about $300–$400 for a reasonably good 24" x 24" (60 x 60 cm) painting; in 2008, prices were falling so much that paintings offered for $125 were not selling. Many of the paintings on eBay are of low to medium quality, but sometimes very good paintings from excellent artists appear and are sold at fire-sale prices. I have seen paintings sold for much less than the artist charges as a wholesale price to a dealer. (The saddest thing on eBay is to watch very high prices paid for art that is clearly not Huichol at all; I once saw a painting of Navajo women that was falsely attributed to Ramón Medina Silva create a ferocious bidding frenzy and sell for considerably more than a genuine Huichol painting.)

One consequence of this may be to drive the U.S. galleries away from Huichol art. When I returned to the same southwestern galleries in 2007, most no longer carried Huichol art. Dealers said it was no longer profitable for them. In the 1990s, Huichol art was new and exciting, and so it commanded high prices; now it is no longer seen as exclusive, and so collectors and high-end buyers have moved on.

I fear that the long-term result will be to severely depress the Huichol econ-
omy. When retail prices are very low and many stores no longer want to carry
Huichol art, Huichol artists are relegated to the few remaining outlets. Many
Huichol began to rely on the sale of art for their livelihoods during the boom
market of the 1990s and early 2000s. Now those same artists are competing for
the few remaining buyers. Increased poverty among the Huichol may be the re-
sult, especially among the new generation of young urban Huichol who rely on
making art for their livings.

There may still be some room at the top for the best yarn painters. Their work
is seldom seen on the Internet, except on the websites of a few good galleries.
When they appear on eBay, it seems to be by accident, and often the sellers do
not seem aware of who the artists are or what their work is worth. For example,
I once saw a small but fine painting by Santos Daniel Carrillo Jiménez sell for $10
on eBay; the same painting might command $150–$200 in a good gallery.

Can the Huichol counter this trend by using the Internet themselves? So far,
I have seen little evidence of this alternative. I have seen several websites that
are attributed to Huichol artists, but that appear to be maintained by American
supporters; the artists do not seem to do much business directly on these sites.
Nor have I met any Huichol artists in Mexico who are able to use the Internet. I
tried to introduce Santos Daniel, a well-educated artist, to the Internet, but he
has not been able to follow it up. Eligio Carrillo has a daughter who is studying
accounting at the postsecondary level, including how to use a computer; she
may eventually be able to help her family conduct e-commerce.

There are formidable barriers to be overcome before the Huichol can use the
Internet. Right now there are few, if any, computer-literate Huichol with the fi-
nancial backing to access the Internet. Public Internet access is widely available
in Mexico in small storefronts that sell time-use by the minute, but the cost is
comparatively high for those earning Mexican wages. Carrying out e-commerce
requires having access to electricity, a personal computer, a telephone line, an
Internet service provider, and someone to design a website. Many Huichol are
still illiterate or semiliterate; many still do not have access to electricity, run-
ning water, or a land-based telephone line. The cost of buying and maintaining
a computer would be completely impossible for people who may struggle to
earn enough each day to buy tortillas and beans for their families. I do not fore-
see any quick solution to the effect of e-commerce on Huichol artists.

15

the influence of
the market

One of my first interests was to find out what we can learn from yarn paintings about Huichol shamanism and visionary experience. Some authors have maintained that yarn paintings are simply commercial products, turned out in volume by artists distant from the culture. The artists may use symbols drawn from Huichol culture, but lack any deeper personal or philosophical understanding of shamanism. The artists' aesthetic choices may be driven purely by commercial factors.

Therefore, I explored how the art is influenced by the marketplace. Cross-cultural influence can go both ways. Western buyers may influence what sort of paintings the painters make, and the Huichol may try to modify what they do in order to communicate certain ideas to their buyers.

Buyers' choices can affect what sort of paintings artists make. The principal buyers affecting the marketing of yarn paintings are retail and wholesale dealers who interact directly with the Huichol. While tourists and the general public are the end consumers, their influence is mainly passed on through intermediaries, since relatively few Huichol sell directly to the public.

Nevertheless, when I watched artists and dealers interacting, few dealers told the artists directly what to make. Instead, artists made what they wanted to and brought their paintings to dealers for sale. Dealers purchased the paintings according to their own criteria of salability. For example, one dealer told me that paintings of goddesses sold well to her female clients. The dealers usually did not explain much to the artists about the reasons for their choices.

One Mexican dealer was more active than others in asking artists to use particular themes and materials. Several artists told me that they had begun using certain materials or painting innovative themes at his request. He asked Santos Daniel Carrillo Jiménez to make a painting based on the nierika symbols used in

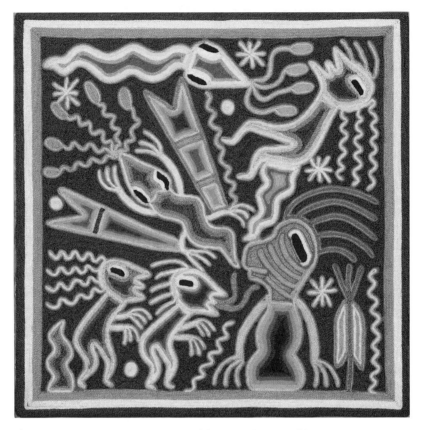

Fig. 15.1. Unknown artist, yarn painting of the spiritual power of shamans, 2005. 12" x 12" (30 x 30 cm). The image is painted in the style of José Benítez Sánchez. Photo credit: Adrienne Herron.

face painting, and suggested to Modesto Rivera Lemus that he make a painting about the solar eclipse.

Most artists I spoke to had at least a general idea of what types of paintings sold well, who the buyers are, and where they might get the best prices. A few artists knew that there was an international art market. However, most artists did not really seem to understand the business of art well, even though they may have toured other countries.

One sign of the artists' unfamiliarity with market concepts was their lack of understanding of the difference between wholesale and retail prices. For example, Lupe's family travelled a good deal in the United States, selling their work

directly to the public. They became accustomed to receiving North American retail prices. Since the wholesale dealers in Mexico seem to pay, at best, about a quarter to a third of the North American retail price—a fairly standard markup in the arts-and-crafts industry—this family's expectations had become grossly inflated.[1] When they were unable to find anyone in Mexico who would pay them the prices they were used to, they felt cheated and became unwilling to sell their work. I heard similar complaints from other Huichol artists, who felt put upon because dealers mark up their paintings or take a commission rather than paying the full retail price to the artists. On the other hand, I met one artist who is knowledgeable enough to adjust his prices according to fluctuations of the Mexican peso against the U.S. dollar.

Huichol artists are businesspeople who must make a living for themselves and their families. Stark poverty and harsh working conditions are the norm for most of their compatriots. Thus, yarn painters exercise common sense when trying to learn how to satisfy their market.

One way they satisfy buyers is by painting popular designs or subjects. Fabian González Ríos described to me the designs that sell best for him. He said his most popular subjects were religious themes, such as depictions of the peyote pilgrimage and of fiestas such as the Bull Ceremony or the Drum Ceremony; in addition, paintings of a woman giving birth sell especially well in shops in Tepic. The last design is the mythological theme introduced by Guadalupe de la Cruz Ríos.

The yarn painters also try to accommodate demands for the older types of yarn painting, which use fewer figures with less detail, as well as the more recent types, which use more detail. Eligio Carrillo said that these preferences affected the types of designs he made and their intricacy.

> ELIGIO: Some of my friends want the paintings complicated. Because the paintings are for sale, after all [that is, he makes the paintings so that they will please buyers]. Some want them with lots of designs. Others don't; they want the paintings to have just one design, but a big one.

Eligio adjusted his painting style accordingly. He illustrated this point by showing how he could eliminate the ring of figures around the outside and then enlarge the central figures (see, for example, fig. 9.4). A large but simple design appeals to some buyers. Others want a more complex design so that they can learn more about the details of the Huichol beliefs illustrated in the painting. Accordingly, he tries to meet both needs with different types of paintings.

ELIGIO: When I do it with a lot of designs, [they say,] "I don't understand it. What does it mean?" For that reason, many times I do it [simply, like this]. When other people ask me, "Make me just one large design. Just with the necessary parts, the most important," that's how I do it. But so that it is a little bit more spread out, like this, and so it looks good also. Not very complicated. [On the other hand,] many people want it complicated. Because they want to understand [the meaning of the painting]. I don't know how they know this [namely, that the painting has meaning].
HOPE: Do they want many designs because they want to ask and learn what does this mean? What does that mean?
ELIGIO: Yes.

I asked Eligio what his own aesthetic criteria were—that is, which type of painting he preferred. Although he liked both types, he preferred paintings that illustrated more, rather than less, of the powers of the gods.

HOPE: And you yourself, what do you like?
ELIGIO: Well, to me both kinds look good. Well, for example, I say to you . . . I am taking away this, then this gets larger [*indicates removing the ring of peyote spirits, the ring of green faces around the outside*]. It is the same. Well, the only thing is that I am going to take away this, this power that I told you about, or the power that it contains. That the tiny gods, then, these ones are representing, when that shaman is translating. That's [how we see] where they carry the gods, which are words, or which gather together in this place, right. And even if we take away this, in every way it is the same.
HOPE: Then a person sees more of where the powers come from when there are more designs?
ELIGIO: Yes, exactly.

The artists also try to respond to the desires of their buyers in the colors they use. Santos Daniel Carrillo Jiménez echoed Eligio's comments on how he chooses to use simple or complex color combinations. Santos felt that the choice was up to the client. Some buyers like color combinations that are simple, as in the old style of making yarn paintings, and some like complex color combinations.

Artists' Views on Future Trends in Yarn Painting

I asked the artists how yarn paintings might change in the future. I hoped that this question might bring out what the artists' own aesthetic goals were. How-

ever, the artists answered very specifically, interpreting it as a question of what the market might demand of them.

Most yarn painters had lived through considerable change in the techniques of doing paintings. They had seen the transition from thicker to thinner yarns. They thought there was a good likelihood that the materials might change again. However, they stressed that though materials and techniques of manufacture might change, the concepts underlying the paintings should not. The concepts should remain the same because the paintings depict ideas that are central to Huichol culture, as Fabian González explained:

> FABIAN: And in the future, what are they going to want? They're going to want it [the yarn] even thinner, but I've never seen any [yarn] thinner. They aren't going to be able to get it.
> HOPE: They'll want just thread, like embroidery thread?
> FABIAN: I don't see it [that is, there is no yarn like that available].
> HOPE: What do you think? How are the yarn paintings going to change in the future? Do you think they are going to change more?
> FABIAN: I think so. They are going to change more.
> HOPE: Have you any idea how they are going to change, in what direction?
> FABIAN: I think, in style. Well, the designs aren't going to change. I think the designs are going to be the same, but the yarn will change. The yarn always changes.
> HOPE: The materials?
> FABIAN: This, the designs, isn't going to change, because how can we change the customs, the beliefs? I can't change them; I can't put other styles, other designs. If I put other designs, I won't know the story behind them, the significance, right? If I make it like this, from what I know, what I understand, my beliefs and religion, the things that I am making will go on being made.

Fabian's emphasis that the designs cannot change reveals an underlying aesthetic concept. The artists generally felt that yarn paintings should reflect the beliefs and practices of the Huichol, such as the correct activities in ceremonies, the appropriate offerings for a pilgrimage, or the story details of a myth or legend. The artist cannot and should not change these aspects. While the materials were open to change, the stories were not.

To Fabian, it was important that the artist understand the stories and the significance of the paintings and that he be able to explain them. If the paintings were somehow changed in design, they would no longer be about what he knew.

Mariano Valadez echoed Fabian's insistence that the stories and the beliefs should not change. He said that if a change in design occurs, it is because the artist has learned something new or understood a new aspect of the tradition. The tradition itself does not change.

> HOPE: And you haven't changed your methods, going from the thick yarn to the thin?
>
> MARIANO: No, it is the same. Or rather, it changes only because the yarn gets thinner. But you don't really notice, because only the material is changing. The methods are the same because whether it is the work or the imagination, those are the same. But at times, when a style is changed, or some picture, it is because at times, a person has another explanation—it changes—but it is still the Huichol religion. That doesn't change.

Vicente Carrillo felt the need for a less time-consuming, more easily manufactured product than either yarn paintings or beads, since different methods might be more profitable for the artists. He expected that change would come soon, but he was not sure how or in which direction. He said that beadwork was becoming more popular than yarn painting. He speculated that in the future, the artists might not work with yarn or beads at all. Perhaps they would do easel painting or something simpler. He observed that marketplaces such as Puerto Vallarta are almost saturated with Huichol art, but that the buyers are limited to foreigners.

Vicente demonstrated awareness of the relatively time-consuming Huichol work, its low profitability for the artists, the dependence on foreign buyers, and the possibility of market saturation. His idea that the Huichol might turn to easel painting is interesting. Brody (1976) documented a similar transition from indigenous art forms to easel paintings in the Native American arts of the Southwest.

Since my conversation with Vicente in 1994, I have seen several experiments in easel painting. In 2002, I saw some paintings in a gallery in Tucson that looked as though they had been painted with acrylics; they were very simple landscapes with sky, trees, and ground, and each had a large appliqué of Huichol beadwork glued in the center. The effect was an uneasy melding of the two media, which use very different conventions. In 2005, a dealer showed me several superb watercolors by a new Huichol artist, José Carrillo. The dealer said he was a schoolteacher in his thirties from Guadalupe Ocotán, and from the sophistication of his drawing style, I suspect that he may have had Western art training.

It is worth noting that the artists are not talking about how they might innovate spontaneously to meet their own artistic needs. They seem to be quite content with the status quo. Rather, they talked about how the demand for certain materials might change, or how particular buyer interests might shift, and they would have to adapt accordingly. In fact, Fabian González and Mariano Valadez indicated that there is an inherent conservatism in yarn paintings. As long as the painters try to depict Huichol beliefs and customs faithfully, the designs are unlikely to change radically.

Huichol Artists Reflect on Buyers' Motivations

The modifications that yarn painters make in order to suit the market include changes of detail and complexity, colors and yarns, and subject matter. In making these changes, yarn painters seem to be guided by direct preferences expressed by the buyers. But regarding the deeper question of why Westerners buy their art and what buyers want from it, the artists profess some mystification.

Many yarn paintings have some sort of explanation written on the back. At first, I wondered whether the artists wrote the texts because they had a particular desire to reach out to Westerners and explain Huichol culture and religion. However, the texts are so problematic that one wonders for whose benefit they are written.

There is abundant evidence that Western buyers prefer an explanation when they purchase indigenous arts, and that a religious meaning is most attractive to them. Parezo (1991, 183–184) discovered that vendors of Navajo sand paintings quickly learned that tourists were more likely to buy the paintings if they had some sort of legend written on the back. Chatwin (1987, 257–261) described the complex negotiations of a dealer in Australian aboriginal art who insisted that she could not sell a painting without a mythological story attached, while the aboriginal artist and his ritual "policeman" tried to refrain from leaking any really sacred knowledge.

The attempt to increase salability may be one reason why the Huichol paintings have text, but one wonders what is really being communicated. The text is usually written in Spanish, which is unlikely to help much in selling the painting to non-Spanish-speaking tourists. Moreover, the texts are often very difficult to read. Typically, they are written in phonetic Mexican Spanish with many idiosyncratic spellings. Some texts are written in Huichol, which would be readable only by other Huichol. Some texts have writing that is almost completely

illegible. Pens skip, ink is too faint, ink from thick markers runs together, and there is seldom an effort to correct illegibility.

It is quite possible that the Huichol do not realize how difficult their texts are to read and understand. Many Huichol artists are illiterate, and so they dictate their texts to a well-meaning helper, who may be only somewhat literate. The artists may have no idea whether the writer is doing a good job. Semiliterate writers often do not spell well, form letters well, or follow the rules of grammar and composition (they may, for example, fail to use punctuation).

Furthermore, the writers often assume a knowledge of Huichol religion, culture, and mythology that most buyers are unlikely to have. For example, a painting titled *The Birth of the Sun God* refers to a mountain in the desert north of San Luis Potosí, to a long Huichol myth, and to the pilgrimage to Wirikuta. Without this background knowledge, a buyer would be unlikely to understand the references.

One wonders how important it is to the artists to convey the text, and for whose benefit they communicate. Grady (2004) addressed ekphrasis, or the use of text to explain the visual, in yarn paintings, concluding that the artists' descriptions are often more confusing than illuminating. She asked whether the artists deliberately try to obscure meaning—for example, by writing two different explanations on the same painting or by writing confusing or illegible descriptions. She noted that in her experience, some Huichol refuse to answer questions at all.

The problem, to me, seems to lie in literacy. I find that most artists will give long, comprehensive explanations of their yarn paintings when asked to describe them orally. The same artists may write confusing, illegible descriptions on a painting—if they can write at all. The artists are also limited by the space available on the back of paintings, even on 24" x 24" (60 x 60 cm) paintings. Some very small paintings, such as those that are 4" x 4" (10 x 10 cm), may have lengthy explanations but little room to write them. It is also quite difficult to write on the board; few pens will mark clearly, and pencil barely shows. I suspect that the problem of having two different descriptions for similar paintings may be due to a careless recorder—perhaps a clerk in a store who was copying and not paying much attention.[2]

The opposite problem occurs when the same description is applied to different paintings. When I sampled a large number of paintings in 1993–1994, I found that one artist—José Benítez Sánchez—engaged in this practice. Perhaps he considered them all variations on a single myth or theme, or perhaps he was not interested in giving more refined explanations; that year, he was turning

out large numbers of paintings to pay some debts. Certainly, he had demonstrated the ability to give very long, cosmological descriptions when asked.

When I started my research, I speculated that Huichol artists might be writing the texts because they wanted to teach Western buyers about their culture. Therefore, I asked the artists what they would like Westerners to learn from their art, what messages they wanted to convey about Huichol culture, and why they thought Westerners bought their art. These questions were difficult for the artists to answer. They seemed not to have thought very much about such questions. They had difficulty speculating about either their own thoughts about buyers, or about what the buyers might be thinking. Most did not understand the question about what they might be trying to teach Westerners, and it was clear that they had no particular program of ideas they were trying to communicate to Western buyers. They—and I—did much better on questions that were more specific and concrete, such as what kind of designs sold best or which materials buyers asked for.

Language is one barrier, as Vicente Carrillo explained. When I asked him why he thought Westerners buy yarn paintings, he replied that he didn't know why people buy them. He just offered his art to North Americans, and they helped him financially by buying it. He said that it was good for the Huichol that they do so, and he was grateful to the buyers for their interest. He would be interested to find out what the buyers think, but he has never asked.

HOPE: Why not?
Vicente: Because they speak English.
HOPE: No one has come who speaks Spanish?
Vicente: No one has explained to me.

Mariano Valadez was married to an American and has lived in the United States. More than some other artists, he understood my questions about what Westerners might be looking for in Huichol art and how the artists could meet the buyers' desires. However, even Mariano did not waste much time speculating about why Huichol culture was of interest to Westerners. He echoed the gratitude expressed by other artists for Westerners buying their art. It helped the Huichol financially and allowed them to continue practicing their culture.

MARIANO: On one hand, I would like to thank the people who come to buy [art], because they are supporting the Huichol Center by giving it financial resources to buy medicine, food, so that this Huichol Center keeps going. And I think that it is they who are helping the people, all those who buy art in the center.

On the other hand also, we have things that they [the buyers] can see here, whereas in the mountains, it is very difficult to see them. So they can see them here, and also . . . it isn't good for the [Western] people to travel there, because there are no stores, there are no services in the mountains.

Mariano felt that what Westerners could learn about Huichol religion and culture was limited. While yarn paintings could give some idea of the religion, people could understand the religion only by living it. Few Westerners were able to make that commitment. Thus, the art served as a window on the Huichol beliefs, but not as any deeper form of teaching.

> HOPE: And what do you think the Huichol religion can teach to the people of the North? Do you have any ideas about that?
> Mariano: What can it teach them?
> HOPE: The Huichol, to the North Americans.
> MARIANO: Well, only through the art, what the religion is about, but portrayed in pictures, or in masks or bowls . . . only through these types of offerings . . . But in reality, a person cannot understand the life of the Huichol. They can only know it from outside, as though they were observing a custom. But I think the Huichol cannot teach anything else, about how they live, because the person would have to travel and see how they live, all the explanation. But that life is very difficult, the life of the Indians. But in the culture, through the work, the [Huichol] are teaching everything, so much that in the designs of the yarn paintings, they say a great deal. That is all that they can offer.

Chavelo González expressed most succinctly, and probably most accurately, why Westerners might buy yarn paintings. He thought it was because they like the stories.

> HOPE: Why do you think the North Americans like the Huichol yarn paintings?
> CHAVELO: I look at it this way. The North Americans like the designs, not just that a yarn painting is very pretty. Some North Americans, even if a yarn painting is badly made, they may buy it. But because of its meaning, its story. The story is what gives it value. Because you might see a yarn painting that has very pretty colors, pretty designs, well combined. But if it doesn't have meaning, well, maybe someone may buy it or maybe not. But what is important is the meaning, the story, the design. That is what is important. Some North Americans see that. There are some who like the story of a design—they may buy it. That's what the difference is.
> HOPE: That they are buying it because it is part of the sacred lore?

CHAVELO: Yes, some may buy it just because it is pretty, a decoration, and there are others who buy yarn paintings because they like the story, the meaning.

Responding to this interest in meaning, some artists professed an openness to teaching other people about their culture. Fabian González said that he enjoyed explaining Huichol traditions to Westerners through his art. He liked to explain Huichol customs and ceremonies. He liked the fact that people from other countries want to learn about Huichol beliefs. If anyone asked about them, he was pleased to explain. I then asked whether some Huichol did not like to teach about the customs. He agreed that there are some such people, but said that he is not one. Nothing ever happened to him as a result.

Fabian's reference to possible harm that might befall him because of teaching Westerners about Huichol beliefs is significant. By this, he referred to punishment from the deities, who may send sickness or death to him or his family. Some Huichol fear divine sanction. For example, the anthropologist Barbara Myerhoff (1968, 8) noted that Ramón Medina had asked and received permission from Tatewari, the fire god, to reveal Huichol sacred stories to her, and he told her that he was therefore not afraid of supernatural sanctions.

There may be a reluctance to speak openly even to other Huichol about occult matters, as Eligio Carrillo explained:

HOPE: Why do you think there are some people who want to keep the religion hidden, and others who are willing to talk about this?
ELIGIO: Well, they are closed people. Old-time Huichol like we were once. And they don't even want to teach their own family. Those people don't want to teach their wife, nor their brother, no one, nor their children. They just receive [information from the gods] for themselves, and they want to be here learning it. No more. When that person dies, then no one knows. That's how many are. But many others are not. Among we Huichol, that's how it is. Many others, no, they talk to everyone. They are friends of everyone. The person who is no more than himself alone, that person is not a friend. That person doesn't have friends, not with anyone.
HOPE: Thinking only of himself?
ELIGIO: He himself. No more. And it is as though he had a mirror in front of his face. Every face like this [holding his palm up in front of his face]. He doesn't see other people. He is covered by his own mirror, turned toward himself. He doesn't talk to you—he is doing nothing more than looking at himself talking to himself. That's how it is.

HOPE: I am looking at the person talking with his mirror in front?

ELIGIO: Talking to his own mirror.

HOPE: And he doesn't see the people—he only sees his own face.

ELIGIO: That's how it is.

HOPE: And to you, it is better to speak to everyone, to teach, so that all this will survive?

ELIGIO: Yes, I have talked to many people. Many people know me. And I talk to them this way. Many people like it. They gather around, they meet together, listening. They like it. They say, "Well, many people don't like to talk about this, and you do." And yes, I do. Maybe because the others don't know, for that reason they don't want to talk. But I know some things, and I speak about it. But no one taught me, neither my father, nor my mother, nor my grandfather, no one. No one. No one. I learned all by myself.

HOPE: From the gods?

ELIGIO: From Tatewari, the fire god. He, yes, he has concentrated me.

This discussion with Eligio reflects the difficulty that even the Huichol themselves experience in relation to the question of openness; and while Eligio opts for openness, other Huichol may not.

In 2001, one artist told me that a backlash was developing in the community of San Andrés. The new Huichol governors had decreed that the artists should no longer explain the meaning of yarn paintings to foreigners and had ordered all members of the community to leave the cities and return to the Sierra. The artist told me that he disagreed with the governors, that he had been explaining the meanings of his paintings to buyers for thirty years, and that he intended to continue. In addition, he felt that this was a passing phase and that other governors might have different ideas. For example, in the early 1990s, some governors of San Andrés confiscated cameras from visitors and refused to return them, but this practice ended with a new set of governors.

Huichol communities are independent of one another, and the Huichol tend to be independent-minded people. The governors of San Andrés have no jurisdiction over Huichol living elsewhere in the Sierra or in cities and do not speak for them. Some artists commented on this situation to me with amusement or skepticism. To me, it seems to reflect the tension between openness and secrecy, which swings back and forth over time and between different individuals and communities.

Caution about revealing occult knowledge meets an opposite principle surrounding yarn paintings. The Huichol believe that a competent artist should be

willing and able to explain what a painting means to anyone who asks. Chavelo González explained:

> HOPE: You know many North Americans who come here and who want to learn something, and often they don't know what they want to learn, and they are looking for something. Have you tried to teach them anything through your yarn paintings?
>
> CHAVELO: Yes, when they ask questions, a person should tell them what it is. What this means. What is the meaning of that. I can tell them. But also, the person should try to ask.
>
> HOPE: If the person doesn't ask?
>
> CHAVELO: If they don't ask . . . if a person makes a guess, if they try to say what it means, it's possible they will offend or not know what the other person had in their mind. It is better to ask.
>
> HOPE: To know better the stories of the Huichol?
>
> CHAVELO: Yes.

The Huichol idea that only the original artist can say what a painting means is very different from the Western tradition of art criticism. Contemporary Western critics feel free to assign meaning to an artist's work. Indeed, some artists refuse to explain what their art means, saying that it is up to the beholder to decide. The idea is that visual art speaks for itself and that anyone is free to read his or her personal interpretation into it. The Huichol artists do not share this notion.

Yarn paintings evolved through an iterative process, a kind of dialogue between artists and buyers. It is not just a case of Western buyers seeing a traditional art and deciding to buy it. Sometimes, dealers suggest ideas for paintings, which the artists pick up and use. Most of the time, it is the artists who propose concepts to the market through their works. The paintings that are sold today are outcomes of this process.

16

ancient aesthetics,
modern images

What conclusions can we draw from this study of commercial yarn paintings? What do yarn paintings tell us about why the Huichol make art, and what ideas guide their artistic choices? Here I will try to go below the surface details of technique and draw out some principles underlying the Huichol philosophy of art.

There is no question that financial motivations play a part in the making of yarn paintings. The artists make yarn paintings to sell as a way to support their families; most artists have few other ways of making a living. Many older artists have little or no formal schooling, and their fallback source of cash income is dangerous work in the fields or manual labor for low wages. The importance of economic motivations is also shown by the fact that many artists are abandoning yarn painting for arts such as beadwork, which they consider more profitable and increasingly popular. The artists who are presently making yarn paintings seem mainly to be those who have a genuine preference for this particular art form.

It is also clear that the purposes and functions of commercial yarn paintings are different from those of sacred offerings. Sacred paintings are made with ceremony and fasting and are created with the intention of offering them to the gods. Commercial paintings are made in everyday circumstances and are designed to attract buyers. Sacred paintings are smaller, simpler, and often round, and they may have only a few key images, such as one or two deer, a sun or nierika, a snake, or a scorpion. The commercial paintings can be larger, are usually square or rectangular, and incorporate more-complex designs and storytelling themes, such as myths and ceremonies.

There has been a debate in the literature about whether yarn paintings are purely commercial products bearing little relation to Huichol shamanism. While commercial paintings are not the same as the sacred offerings, they do retain a significant amount of shamanic content. Commercial paintings are a repository of a great deal of information about Huichol shamanism. I have re-

corded dozens of variant versions of myths, many of which do not appear in the anthropological literature. They document ceremonies, including the required offerings. They describe the Huichol deities, along with their appropriate clothes, face paintings, animals, and attributes. The colors used can have important spiritual meaning. They can be records of visionary experience. Therefore, I feel it is a mistake to dismiss them as purely commercial products with no greater meaning.

The question of whether yarn paintings are "authentic" is equally vexed. Grady (1998) devotes her doctoral dissertation to discussing the difficulties surrounding the concept of authenticity in Huichol art. I find the term almost impossible to pin down, because of the underlying assumptions that the Western art market brings to bear on indigenous arts and crafts. Yarn paintings are authentic in the sense that they are made by Huichol artisans (not offshore workers) and are usually accurate renditions of concepts in Huichol culture, including shamanism. I have drawn a clear distinction between paintings that are used for ceremonial purposes and those that are not—another grey area in some of the writing on authenticity.

Is the commercialization of a once-sacred art necessarily destructive of the culture and its religion? Although some may deplore commercialization, on general principles, as a form of debasement, I do not see it that way. One might equally ask whether Catholic spirituality is debased or destroyed by the sale of souvenir icons, crosses, or pictures of the Virgin or the pope. Evidently, Catholicism continues to be practiced devoutly, and the sale of artifacts and souvenirs supports churches and shrines. The commercial industry, in effect, supports the religion and may actually increase devotion in its practitioners. Similarly, the sale of Huichol yarn paintings may give the artists monetary rewards and demonstrate external respect for Huichol culture and religion. The artists repeatedly said that they valued the opportunity to focus on their traditions, and the sale of art provides funds that I often saw them use to finance ceremonies and pilgrimages.

Do commercial motivations mean that yarn paintings have lost whatever other aesthetic meaning they once had? As Anderson (1990, 234) asked, does an ethnic art necessarily discard the sophisticated aesthetic system of the traditional culture when it becomes commercialized? I would suggest that in the case of the yarn paintings, this depressing scenario has not happened. The reason lies in the fortunate coinciding of the aesthetic values of Western buyers and Huichol sellers.

Both the Huichol and Westerners have reached a tacit agreement that yarn paintings should be about traditional Huichol religion and culture. The Western preference grows out of a long-standing preference for the exotic in indigenous arts—a preference that Graburn (1978) poked fun at in his title "'I Like Things to Look More Different Than That Stuff Did.'" Western buyers particularly like ethnic art that deals with religious themes or has a myth attached to it. It is even better if an object has been used in a ritual—a desire that Mexican sellers of Indian masks are quick to capitalize on. Why Western art buyers feel this need to touch and own religious artifacts from other cultures is a fascinating anthropological study in itself, and several authors have made a start at explaining it (Graburn 1978; Greenhalgh 1978).

The important point here is that the Western preference coincides with the religious and visionary themes that Huichol yarn painters prefer to use. The artists like this arrangement for several reasons. First, they have not had to invent new subject matter; they find their ideas within their own traditions. They can paint what they already know. As a result, the artists express gratitude that the making of yarn paintings allows them to spend their time thinking about their own traditions while still making a living. In the analysis of yarn-painting subjects, I noted that yarn paintings are almost exclusively religious in content. The one exception seems to have been a brief foray into designs such as Walt Disney characters or Che Guevara's likeness. This exception indicates that the artists might produce paintings with nonreligious themes again if the market demanded it of them, just as many artists are now turning to the more profitable beadwork.

Fortunately, the market has not pushed the artists in the direction of reproducing commercial art from Western culture; instead, dealers urge the artists to make designs from Huichol traditions. This encouragement has enabled the artists to work within the context of Huichol aesthetic values and has led to a flowering of Huichol art in yarn paintings. I would suggest that far from being a degenerate art, yarn paintings continue to manifest outstanding creativity within the Huichol artistic and philosophical tradition.

notes

CHAPTER 1

1. In English, the term "yarn painting" is commonly used, although some use "string painting." Mexicans use several terms, depending on which aspects of the art they want to emphasize. The terms *cuadra* (Sp.: picture), *cuadra de estambre* (Sp.: wool painting), *tabla* (Sp.: board), or *tabla de cera* (Sp.: waxed board) all emphasize the materials. *Tabla votiva* (Sp.: votive or offering board) emphasizes the religious purpose. Huichol commonly use the term *nierika*.

2. There has been some discussion about whether *kieri* refers to *Datura*, sometimes called jimsonweed, or to other species of *Solandra*. Both types of plants are hallucinogenic and are related. Some Huichol seem to have called *kieri* beneficial, and others have called it evil (Schaefer 1990, 145). Peter Furst (1989) clarified this discussion after interviewing Guadalupe de la Cruz Ríos. She told him that the evil plant in her painting is *Datura inoxia*, properly called *kieri-xra* in Huichol.

3. Susan Eger married Mariano Valadez, and has written under the names Susan or Susana and the surnames Eger, Eger Valadez, or Valadez. I have standardized her name as Susana Eger Valadez. The couple have since separated.

4. Since about 2000, the Huichol have been buying cell phones, which make wireless communication possible in rural communities where there have never been telephone lines and where many do not have electricity. The mountainous terrain and dispersed settlements of the Huichol would make it prohibitively expensive to provide landlines.

5. I have often used first names instead of surnames to refer to the artists; for example, I refer to "Lupe" rather than "Señora de la Cruz Ríos." This reflects current Huichol practice, which tends to emphasize calling people by first name. The Huichol did not adopt last names until the end of the nineteenth century, when Spanish census takers insisted that they do so (Lumholtz 1902, 2:98–99). I refer to myself the same way.

6. Fagan (1998, 65) cites a San shaman in southwest Africa who drew people's attention to things they could not see during a trance dance, such as a spirit eland that was standing in the semidarkness beyond the fire. His vision was strikingly similar to my own. The eland is a type of antelope, a member of the deer family.

CHAPTER 2

1. I have seen Internet sites claiming that the Huichol and their culture are dying quickly. Perhaps the authors say this to raise money or to convince people to buy crafts that may not be available in the future. It is an urban myth that ignores the reality of a rapidly growing population.

2. The spelling "Zitacua" is used on the government sign at the entrance to the colony.

CHAPTER 3

1. Schaefer (2002, 305) gives the spelling of *hix+apa* and defines it as "land of the living, placed in the middle between the underworld . . . and the upper world." Lupe pronounced the word differently and seemed to use the term more generally to mean the center point in a sacred map. She may also have been referring to *xrapa*, a giant fig tree (Lumholtz 1900, 171).

2. Eligio Carrillo commented to me that the wooden saint of San Andrés is a special saint adopted by that community and not by Huichol generally, and that Semana Santa is the fiesta held for that saint. He said that his family never had anything to do with that *santo* (even though they came from San Andrés during the Mexican Revolution) and that the main purpose they knew of for it was that some people prayed to it for healing. His perspective provides an interesting contrast with modern accounts of elaborate Semana Santa ceremonies in San Andrés. Such practices may not have been the case ninety years ago, when Eligio's family left San Andrés.

3. I suspect that the translation of "Takutsi Nakawe" as "Grandmother Growth" is poetic license on the part of Lumholtz, the first person to write the term in English. Some of my consultants translate *kutsi* as "elder sister" rather than "grandmother," which would make Takutsi Nakawe's status as "Our Elder Sister Nakawe," comparable to Tamatsi Kauyumari, or "Our Elder Brother Deer."

4. When the Mexican government was arranging protection for Huichol sacred sites in the early 1990s, there was some discussion among Huichol elders about whether the protected site for Tatei Rapawiyeme should be located in Lake Chapala or at a site farther south in the state of Colima (Leopoldo López, Instituto Nacional Indigenista, personal communication).

5. The suffix "-*ero*" suggests a word borrowed from Spanish. Liffman (2002, 24) also suggests *kawitero* is a "loan word," not a term native to Huichol.

CHAPTER 4

1. Berrin (1978, 152–153) illustrates four yarn paintings that were collected by Lumholtz in the 1890s and Zingg in the 1930s.

2. Perhaps Knab's term "wewia" is related to the word *wewiakate*, a word that Chavelo González translated as *"dioses"* (gods).

3. See Chapter 5 for a discussion of rock carvings.

CHAPTER 5

1. There is a collection of yarn paintings in the National Museum of Anthropology in Mexico City, but there is little record of their provenance or meaning (Jesús Jáuregui, personal communication). The labels on the boxes state that they were collected in Mesquitic in the 1950s. They were probably collected by Alfonso Soto Soria, but there is no record whether they are sacred paintings or were made specifically for him.

2. The Ortiz Monasterio family was involved in an odd project to fly deer from a zoo in Mexico City to the Sierra to replace overhunted deer stocks. Not surprisingly, the deer died and the project was unsustainable. Shortly after, they won a contest offered by an airline. The prize was a trip to New York City, and so they flew several families from Santa Catarina to New York for a weekend.

3. The Navajo use a very similar coiled serpent in a sand painting made for the Beautyway ceremony (Sandner 1979, 107).

CHAPTER 6

1. It seems to me that Lupe's pinpointing of her birth date to the end of the Mexican Revolution is the most accurate benchmark, because it is one date that Huichol are likely to remember. Lupe's passport had a birth date of 8 June 1922, but this date may have been assigned later by an official. It does not accord with her remembered date or her statement that she was a year older than Ramón Medina. Most Huichol of Lupe's generation were illiterate and did not have birth certificates, so it is common to hear very general estimates of their ages.

2. There is some confusion in the literature about the relative ages of Ramón and Lupe. Myerhoff (1974, 30) said Lupe was three or four years *younger* than Ramón, giving Ramón's age as about forty in 1965. However, if Lupe was born in 1918, she would have been about forty-seven in 1965 and Ramón might have been in his midforties. Ramón told Furst (personal communication) that Lupe was quite a bit *older* than he was. Therefore, Furst (2003, 19) thought that Lupe was about ninety when she died, and gave the year of her death as 1998; this would have made Lupe's birth year about 1908. (In fact, Lupe died on 9 May 1999, not 1998, according to her family and her gravestone. She was about eighty-one years old.)

3. Kamffer (1957) briefly refers to yarn paintings, but he does not discuss them in any depth.

4. Myerhoff listed Kuka as a participant in the 1966 pilgrimage and mentioned her

by name in her thesis (1968, 141) and by pseudonym in her book (1974, 119–121). I recognized José Ríos in Furst's film of the 1968 pilgrimage.

5. The paintings are reproduced in Furst and Myerhoff (1966). Two of the three are reproduced in Furst (1968–1969) and reprinted in Furst and Nahmad (1972). One is in MacLean (2001b, 72).

6. Lupe gave me quite a different interpretation of this painting. She said that it represents the shaman's path to enlightenment. The star represents the attainment of vision at the end of years of pilgrimage. The flowers on either side are temptations that the shaman must resist.

7. The artists' inclination to make copies creates problems for some dealers at the upper end of the market. Western buyers want original art, which is unique and one of a kind, rather than copies, especially if they are paying a high price. One gallery owner solved this problem by telling the Huichol that they should offer him only original designs and that if they subsequently made copies, he did not want to see them. Galleries at the lower end of the market do not seem particularly concerned about copying.

8. Furst (1978, 27) states that Ramón "sometimes straddled with less than equanimity the two contradictory worlds" and that he "occasionally acted out . . . in alcoholic conviviality."

9. I have taken the date of publication from Fikes (1985, 373). These magazines were reprinted in 1980, though with black-and-white rather than color illustrations; my references are to the 1980 edition.

10. The exhibition began in San Francisco, where it ran from 4 November 1978 to 4 March 1979, then travelled to Chicago's Field Museum (1 May 1979 to 3 September 1979) and New York's American Museum of Natural History (7 November 1979 to 10 February 1980) (Berrin and Dreyfus n.d.).

CHAPTER 7

1. In addition to published works on Huichol art, I have relied on the following collections, particularly for paintings of the 1960s and 1970s: the San Diego Museum of Man, the UCLA Fowler Museum, the Ruth Gruhn–Alan Bryan collection, and the Knox collection (Knox and Maud 1980).

2. In 1993–1994, Benítez seemed to discover a color combination that sold particularly well. He was flooding the market with paintings made from a combination of red, cobalt blue, sage green, and orange. These paintings usually had simple designs, and many were based on a circular shape with repeating symbols.

3. Lang told me that the "masterwork" paintings have the code MW written on them.

4. All the datable paintings by Benítez that I have seen use the older style in the 1970s (Negrín, 1977, 1979; Berrin 1978; one painting in a private collection dates from the early 1970s).

5. According to a tipped-in errata note, the paintings in this book are mislabelled. The painting I refer to is on page 48 (Negrín 1986).

CHAPTER 8

1. The fretwork (Greek key) and stair-step motifs are ancient. They are painted on the clothing of shaft-tomb ceramic figures up to two thousand years old from the Huichol's own region (Kan et al. 1989, 15, 83). The fretwork is woven in bags from Puebloan or even earlier Basketmaker sites in the American Southwest (Amsden 1934, plate 35), which suggests a pan-Uto-Aztecan distribution for the motif.

CHAPTER 9

1. Some women still have time to embroider their own clothing. Others are under pressure to sell their embroidery and weaving as fast as they can make it. Increasingly, women in the Sierra make their dresses with colorful cotton broadcloth, either plain or printed. The passion for color, particularly red, is seen in clothes made of vibrant prints, such as those featuring Christmas poinsettias or Thanksgiving corn and pumpkins.

CHAPTER 10

1. The radio program may have been on the Canadian Broadcasting Corporation sometime between 1995 and 2000.

2. Eligio said that when a shaman lights his fire during a ceremony, it becomes the shaman's temple. He often uses the terms "sacred temple" and "ceremonial fire" synonymously. It is customary to hold ceremonies outdoors on the family patio with participants in a circle around the fire.

3. Eligio uses the Spanish word "*aigre*" for "air." This may be local Mexican or rural dialect; however, he often seems to use "aigre" specifically to refer to winds as spiritual entities, or to "magical air" as a spiritual power, rather than simply to the air (Sp.: *aire*) that surrounds us. Kearney 1972, 48–49, describes a similar use of "aigre" to refer to spiritually charged winds among the Zapotec.

4. The flowers I saw had many stamens and few petals. They closely resemble photographs of *Pseudobombax palmeri* (also known as the *cuajilote* or the shaving brush tree; see photographs at www.desertmuseumdigitallibrary.org). Bauml (1994, 95–96) reports that a consultant in San Andrés told him that the flowers of this tree are used on an altar or in the xiriki.

CHAPTER 11

1. For an illustration of this painting, see Furst (1968–1969, 20) or Furst and Nahmad (1972, n.p.). The paintings reproduced in the Furst and Nahmad volume are in a twenty-page color insert; the painting I refer to is on the eighth page of this insert.

CHAPTER 12

1. The Huichol word written as "iyari" is often pronounced "iyarli" (like the English name Charlie), which makes it sound even more like the Nahua *"yolli."*

2. Most Huichol are familiar with electricity, since they visit the city, where even most low-income houses now have access to electricity. They are also familiar with portable tape recorders, which are quite popular, and with cars, although few can afford to own one. In our discussion, Eligio introduced the analogy of electricity and tape recorders. I introduced the idea of a car's steering wheel and motor.

3. There are some striking similarities between Huichol aesthetic concepts and Aztec concepts, as described by Anderson (1990, 140–156). Nevertheless, the Huichol do not seem to share some of the Aztecs' grim and pessimistic ideas, such as the belief that nothing matters except art, or that life is ephemeral and meaningless. My perception is that the Huichol have a more cheerful outlook on life.

CHAPTER 14

1. Gabriel Bautista signed his first paintings as "Gabriel Bautista C."

2. The Tepehuane mass-produce yarn-painted items such as eclipse plaques, but few Huichol do.

CHAPTER 15

1. A retail price markup of at least double or triple the wholesale price is standard in the gift industry; for example, an item that wholesales for $1 will retail for $2–$3. Art galleries often take a commission of 50 percent of the retail price.

2. The painting illustrated in Grady's (2004, 76) article was by Cresencio Pérez Robles. He often sells through the government store, DIF, in Nayarit, where the clerks have limited knowledge about the Huichol. It is possible that a clerk miscopied and wrote two different explanations on identical paintings.

glossary

A number of different systems have been developed to transcribe the Huichol language. The first consistent system was developed for the Summer Institute of Linguistics by John B. McIntosh and Joseph E. Grimes (1954), and published as a Huichol-Spanish dictionary. Since the 1980s, the Huichol themselves have been working on a transcription system for use in their schools, in cooperation with linguists at the University of Guadalajara (Consejo Supremo Huichol 1990). I have followed the Huichol orthography wherever possible, assuming that it contains the most accurate rendering of Huichol sounds.

According to Grimes (1964, 13), there are three main dialects of Huichol: an eastern dialect spoken in Santa Catarina and San Sebastián; a central dialect spoken in San Andrés; and a western dialect. The dialects are distinguished by a few consistently occurring sound shifts. The principal difference in the sound system is a shift from the English sound *sh* (written with the Mexican *x*) to *r* to *rr* (a hard rolled *r*). A second shift is from *r* to *l* to *rl* (pronounced as in the English name Charlie). Huichol orthography adopts the convention of writing this sound with an *r*, even though many speakers pronounce it as an *l* or *rl*. So, for example, the term "nierika" (Hui.: face, mirror) can be written and pronounced as "nielika," and "hikuri" (Hui.: peyote) can be rendered as "hikuli." These variations are commonly seen in the literature.

One sound, which Grimes (1964, 13) calls a high back vowel, is found in Huichol but not in English; this sound may be pronounced as halfway between an *i* and a *u*. In Huichol orthography, it is written with the plus (+) sign. I have chosen an alternate method, using *ü*, which makes it easier for English-speaking readers to understand.

Huichol

Aariwama, Aariwameta: a rain goddess whose sacred site is a cave near San Andrés (also Tatei Nüariwame [or Nüaariwama], Nealiwame [or Na'aliwaeme])

Auromanaka: a sacred site in the north, located at Cerro Gordo in Durango

haka: a bamboo-like cane, used for making prayer arrows (Lat.: *Arundo donax*)

hawime itari: term used by Zingg for yarn painting or a sacred, round board

Hewi: people who preceded the Huichol in the Sierra

hikuri/hikuli: the peyote cactus (Lat.: *Lophophora williamsii*)

Hi xrapa: the center of the Huichol world

itari/itali: a decorated board serving as a "bed" for the gods; a yarn painting; an altar, a blanket, or a mat that the mara'akame places on the ground during a ceremony

iyari: heart, soul, memory

kakauyari: gods who are ancestors of the Huichol; perhaps also, deified human ancestors

kawitero (plural: kawiterutsixi): wise elder

Kieri/Kieli: deity known as Tree of the Wind; a dangerous but powerful ally of shamans

kieri: a hallucinogenic plant identified generally as a species of *Solandra*; may include several species

kieri-xra: an evil form of kieri, identified as *Datura inoxia*

kupuri: life force, energy

mara'akame (plural: mara'akate): a shaman, ceremonial leader, healer, and singer

matsuwa: bracelet, wrist guard

muwieri: a shaman's plume; a carved stick with feathers attached to one end; also, deer's antlers

nawa: corn beer

nierika (plural: nierikate): yarn painting; also means shamanic vision and that which is seen by using vision; related concepts include face (of a person or god), eye, mirror, any painting or depiction of deities, and face-painting designs

Otata: deity of the North

Paritsika: the scorpion god, whose sacred site is in Wirikuta

Reunar: a volcano in Wirikuta; site of the birth of the sun as well as a pilgrimage destination

Takutsi Nakawe: translated as "Grandmother Growth" by Lumholtz; possibly "Our Elder Sister Nakawe"; the goddess of creation and fertility

takwatsi: a rectangular basket used to store religious tools, such as shaman's plumes

Tamatsi Kauyumari: "Our Elder Brother Deer"; the deer god

Ta Selieta: the deity of the South

Tatei Haramara: the Pacific Ocean and a sacred site at San Blas, Nayarit

Tateikie: the House of Our Mother; the community of San Andrés

Tatei Matinieri: a spring in the desert of Wirikuta

Tatei Niwetsika: Our Mother of Maize; the corn goddess

Tatei Nüariwama: Our Mother of Lightning and Storms

Tatei Rapawiyeme: a sacred site in the south, associated with Lake Chapala

tatei teima: "our Mothers," a collective term for goddesses

Tatei Werika Uimari: Our Young Mother Eagle Girl, a sky goddess who holds the earth in her claws

Tatei Utuanaka: the goddess of earth and fertility

Tatei Yurianaka: Our Mother, the fertile earth

Tau, Tayau: Our Father the Sun; the sun god

Tatewari: Our Grandfather Fire; the fire god

Teekata: a sacred site near Santa Catarina; its caves considered to be the home of the gods

tepari/tepali: a god disk; a disk of solidified volcanic ash (tuff) or occasionally of wood or clay, placed on an altar, embedded in the wall of a xiriki, or put in floor of a tuki

tsikürü/sikuli: a god's eye or thread cross; a form of nierika

Tuapurie: the community of Santa Catarina

tuki: a temple; a large building where the Huichol hold ceremonies

Tüki: a deer spirit who gives off powder in the form of small multicolored deer

Tutsipa: Tuxpan de Bolaños

uxa/urra (plural: urrari): a plant with a yellow root (*Berberis trifoliolata* [Moric.] Fedde var. *glauca* I. M. Johnson) used to make face painting; colored lights seen by shamans on people's faces; the spiritual power carried by the pollen of a peyote flower and transferred from peyote to a person

ürü: a prayer arrow; a notched painted stick, often with miniature objects attached to represent prayers to deities

ürükate: crystals that incarnate the souls of deceased ancestors of the Huichol people; arrows with crystals attached

uweni: an elaborate armchair with a backrest; made of wood splints, it is often used by shamans in ceremony

Watakame: the Worker; a mythological character who is the ancestor of the modern Huichol

Wautüa: the community of San Sebastián; the eastern division of the Huichol

Wirikuta: a desert north of San Luis Potosí where the Huichol make pilgrimages to collect peyote. Huichol often refer to this area in Spanish as "Real de Catorce" and write it as "Real 14."

Wixarika/Wirrarika: the Huichol's name for themelves; the western division of the Huichol

Xatsitsarie: Guadalupe Ocotán

xiriki/ririki: god house; a place used to hold religious goods and offerings. A separate building in the family compound on most ranchos, it usually has an altar or a raised platform on which are placed important artifacts, such as stone disks, or tepari.

xrapa: a giant fig tree; perhaps also the world tree

xukuli/rukuri: a gourd-shell votive bowl
Yokawima: Mother of the Deer
Zitacua: the Huichol colony in Tepic

Spanish Terms as Used by the Huichol

bajito: soft, low, descending, coming down; used in relation to colors
Cambio de las Varas: a ceremony to change the civil governors in the Sierra
cantador: a singing shaman
cargo: position of responsibility or community obligation, especially in indigenous religious ceremonies or civil government
cera de Campeche: an orange beeswax considered the best adhesive for yarn paintings
colonia: settlement, urban neighborhood
copal: dried tree resin burned as incense
comunidad: a legal category of protected land held in common by an indigenous group, similar to a reservation in the United States
cuadrille: white cotton cloth with regular spaces between warp and weft threads, which can be used as a guide for cross-stitch embroidery. Cuadrille is commercially manufactured and sold in fabric stores in Mexico. The Huichol use it to make clothing and bags.
cuadro, cuadra: picture, yarn painting
cuadra de estambre: yarn painting
dibujo: design; the main element of a yarn painting
ejido: a legal category of protected land held in common by members
elote: corn on the cob
fiesta: celebration; used by the Huichol to describe ceremonies
Fiesta de Pachitas: the Ash Wednesday ceremony that begins Lent
Fondo Nacional para el Fomento de las Artesanías (FONART): the Mexican government agency for marketing Native crafts
fondo: background; blocks of solid color behind the main designs of a yarn painting
fuerte: strong, bright; used in relation to colors
HUICOT: an acronym of Huichol, Cora, and Tepehuane; designated a plan to develop services in the Huichol Sierra during the 1970s
Instituto National Indigenista (INI): National Indian Institute; a governmental body that formulates policy and provides services to indigenous peoples
manta: cotton cloth used for making clothing; includes unbleached, loosely woven cloth, recycled flour sacking, better-quality bleached broadcloth, and cuadrille

mestizo: a mixed-race (European and Native) Mexican; used also to refer to Spanish-derived Mexican culture

metate: stone table used for grinding corn

peyote: a hallucinogenic cactus (*Lophophora williamsii*)

polvo: powder; used by Eligio Carrillo to translate "pollen"

primo: cousin; used generally for many kinds of relatives

rancho: an isolated farm or homestead

rellenar el fondo: to fill in the background of a yarn painting with yarn

santo: saint; a wooden statue of Christ on the cross used in Huichol ceremonies

Semana Santa: Easter Week ceremony

subedito: rising, going up, becoming more fuerte; used in relation to colors

tabla: board; yarn painting

tabla de cera: waxed board; yarn painting

tabla votiva: votive board; yarn painting

Union de Comunidades Indígenas Huicholes-Jalisco (UCIH): Union of Huichol Indian Communities of Jalisco

bibliography

Amsden, Charles Avery. 1934 [1982]. *Navaho Weaving: Its Technic and History*. Santa Ana, Calif.: Fine Arts Press / Southwest Museum. Reprint, Glorieta, N.M.: Rio Grande.

Anderson, Richard L. 1990. *Calliope's Sisters: A Comparative Study of Philosophies of Art*. Englewood Cliffs, N.J.: Prentice-Hall.

Andrews, Ted. 1991. *How to See and Read the Aura*. St. Paul, Minn.: Llewellyn.

Anguiano, Marina. 1992. *Nayarit: Costa y Altiplanicie en el Momento del Contacto*. Mexico City: Universidad Nacional Autónoma de México.

Bandelier, Adolf F. 1971. *The Delight Makers*. New York: Harcourt Brace Jovanovich.

Barron-Cohen, S., 1996. "Is there a Normal Phase of Synaesthesia in Development?" *Psyche: An Interdisciplinary Journal of Research on Consciousness* 2, no. 27. http://psyche .csse.monash.edu.au/v.2/psyche-2-27-barron_cohen.html.

Bateson, Mary Catherine. 1984. *With a Daughter's Eye*. New York: Pocket Books.

Bauml, James A. 1994. "Ethnobotany of the Huichol People of Mexico." PhD diss., Claremont Graduate School.

Bauml, James A., Gilbert Voss, and Peter Collings. 1990. "'Uxa Identified." *Journal of Ethnobiology* 10, no. 1 (Summer): 99–101.

Benítez, Fernando. N.d. Introduction to *El Arte Simbolico y Decorativo de los Huicholes*, by Carl Lumholtz, 7–8. Mexico City: Instituto Nacional Indigenista.

———. 1968. *Los Indios de México*. Vol. 2. Mexico City: Ediciones Era.

———. 1970. *Los Indios de México*. Vol. 3. Mexico City: Ediciones Era.

———. 1975. *In the Magic Land of Peyote*. Translated by John Upton. Austin: Univ. of Texas Press.

Bernstein, Susan. 1989. Preface to *Mirrors of the Gods*, edited by Susan Bernstein, vi. San Diego: San Diego Museum of Man.

Berrin, Kathleen, ed. 1978. *Art of the Huichol Indians*. San Francisco: Fine Arts Museums of San Francisco.

Berrin, Kathleen, and Renee Dreyfus. N.d. [c. 1978]. *The Art of Being Huichol*. San Francisco: The Fine Arts Museums of San Francisco. Mimeographed pamphlet.

Blodgett, Jean. 1978. *The Coming and Going of the Shaman*. Winnipeg: Winnipeg Art Gallery.

Brennan, Barbara Ann. 1987. *Hands of Light*. Toronto: Bantam.

Brody, J. J. 1976 "The Creative Consumer: Survival, Revival, and Invention in Southwest Indian Arts." In *Ethnic and Tourist Arts: Cultural Expressions from the Fourth World*,

edited by Nelson Graburn, 70–84. Berkeley and Los Angeles: Univ. of California Press.

Brown, Jennifer S. H., and Robert Brightman. 1988. *"The Orders of the Dreamed": George Nelson on Cree and Northern Ojibwa Religion and Myth.* Winnipeg: Univ. of Manitoba Press.

Chatwin, Bruce. 1987. *The Songlines.* New York: Viking Penguin.

Consejo Supremo Huichol. 1990. *Ne rxapa matüari mieme ti terüwame ti utüwame wirxari-kaki (Mi Libro Huichol. Jalisco-Nayarit, Primer grado).* 2nd ed. Toluca, México: Secretaría de Educación Pública.

Cordy-Collins, Alana. 1989. "The Origins of Huichol Art." In *Mirrors of the Gods*, edited by Susan Bernstein, 41–50. San Diego: San Diego Museum of Man.

Cowen, Tyler. 2005. *Markets and Cultural Values: Liberty vs. Power in the Lives of Mexican Amate Painters.* Ann Arbor: Univ. of Michigan Press.

Davis, Wade. 1998. *The Clouded Leopard.* Vancouver: Douglas and McIntyre.

Delpar, Helen. 2000. "Mexican Culture, 1920–1945." In *The Oxford History of Mexico*, edited by Michael C. Meyer and William H. Beazley, 543–572. Oxford: Oxford Univ. Press.

DeMille, Richard, ed. 1980. *The Don Juan Papers: Further Castaneda Controversies.* Santa Barbara, Calif.: Ross-Erikson.

Díaz Romo, Patricia. 1993. "La Plaga química." *Ojarasca*, no. 24, 43–44.

Dubin, Lois Sherr. 1999. *North American Indian Jewelry and Adornment.* New York: Abrams.

Durán, Diego. 1964 [1581]. *The History of the Indies of New Spain.* Translated by Doris Heyden and Fernando Horcasitas. New York: Orion.

———. 1971 [1574–1576, 1579]. *Book of the Gods and Rites and the Ancient Calendar.* Translated and edited by Fernando Horcasitas and Doris Heyden. Norman: Univ. of Oklahoma Press.

Eber, Christine, and Brenda Rosenbaum. 1993. "That We May Serve Beneath Your Hands and Feet: Woman Weavers in Highland Chiapas, Mexico." In *Crafts in the World Market*, edited by June Nash, 155–179. Albany: State Univ. of New York.

Eger, Susan. 1978. "Huichol Women's Art." With the assistance of Peter R. Collings. In Berrin, *Art of the Huichol Indians*, 35–53.

Eger Valadez, Susana. 1986a. "Dreams and Visions from the Gods: An Interview with Ulu Temay, Huichol Shaman." *Shaman's Drum*, no. 6, 18–23.

———. 1986b. "Mirrors of the Gods: The Huichol Shaman's Path of Completion." *Shaman's Drum*, no. 6, 29–39.

Eger Valadez, Susana, and Mariano Valadez. 1992. *Huichol Indian Sacred Rituals.* Oakland, Calif.: Dharma Enterprises.

Estrada, Alvaro. 1981. *Maria Sabina: Her Life and Chants.* Translated by Henry Munn. Santa Barbara, Calif.: Ross-Erikson.

Fabila, Alfonso. 1959. *Los Huicholes*. Mexico City: Instituto Nacional Indigenista.

Fagan, Brian. 1998. *From Black Land to Fifth Sun: The Science of Sacred Sites*. Reading, Mass.: Addison-Wesley / Helix.

Farella, John R. 1984. *The Main Stalk: A Synthesis of Navajo Philosophy*. Tucson: Univ. of Arizona Press.

Faris, James C. 1990. *The Nightway: A History and a History of Documentation of a Navajo Ceremonial*. Albuquerque: Univ. of New Mexico Press.

Fikes, Jay Courtney. 1985. "Huichol Indian Identity and Adaptation." PhD diss., University of Michigan.

———. 1993. *Carlos Castaneda: Academic Opportunism and the Psychedelic Sixties*. Victoria, B.C.: Millenia Press.

Foster, Michael S., and Phil C. Weigand, eds. 1985. *The Archaeology of West and Northwest Mesoamerica*. Boulder, Colo.: Westview.

Furst, Jill Leslie, and Peter T. Furst. 1980. *Pre-Columbian Art of Mexico*. New York: Abbeville.

Furst, Peter T. 1966. "Shaft Tombs, Shell Trumpets and Shamanism: A Culture-Historical Approach to Problems in West Mexican Archaeology." PhD diss., University of Southern California.

———. 1967. "Huichol Conceptions of the Soul." *Folklore Americas* 27:39–106.

———. 1968–1969. "Myth in Art: A Huichol Depicts His Reality." *Los Angeles County Museum of Natural History Quarterly* 7, no. 3: 16–25.

———. 1969. *To Find Our Life: The Peyote Hunt of the Huichols of Mexico*. Latin American Center, University of California at Los Angeles. Film.

———. 1972. "To Find Our Life: Peyote among the Huichol Indians of Mexico." In *Flesh of the Gods*, edited by Peter T. Furst, 136–184. New York: Praeger.

———. 1974. "The Roots and Continuities of Shamanism." *Artscanada* nos. 184–187, 33–60.

———. 1975. Introduction to *In the Magic Land of Peyote*, by Fernando Benítez. Austin: Univ. of Texas Press.

———. 1978. "The Art of Being Huichol." In Berrin, *Art of the Huichol Indians*, 18–34.

———. 1989. "The Life and Death of the Crazy Kiéri: Natural and Cultural History of a Huichol Myth." *Journal of Latin American Lore* 15, no. 2: 155–177.

———. 1996. "Myth as History, History as Myth: A New Look at Some Old Problems in Huichol Origins." In *People of the Peyote*, edited by Stacy B. Schaefer and Peter T. Furst, 26–60. Albuquerque: Univ. of New Mexico Press.

———. 2003. *Visions of a Huichol Shaman*. Philadelphia: University of Pennsylvania Museum of Archaeology and Anthropology.

———. 2006. *Rock Crystals and Peyote Dreams: Explorations in the Huichol Universe*. Salt Lake City: Univ. of Utah Press.

Furst, Peter T., and Barbara Myerhoff. 1966. "Myth as History: The Jimson Weed Cycle of the Huichols of Mexico." *Antropológica* 17 (June): 3–39.

Furst, Peter T., and Salomón Nahmad Sittón. 1972. *Mitos y Arte Huicholes*. Mexico City: Secretaria de Educación Pública.

Gebhart-Sayer, Angelika. 1985. "The Geometric Designs of the Shipibo-Conibo in Ritual Context." *Journal of Latin American Lore* 11, no. 2: 143–175.

Giammattei, Victor Michael, and Nanci Greer Reichert. 1975. *Art of a Vanished Race: The Mimbres Classic Black-on-White*. Woodland, Calif.: Dillon-Tyler.

Goulet, Jean-Guy. 1998. *Ways of Knowing: Experience, Knowledge, and Power among the Dene Tha*. Vancouver: Univ. of British Columbia Press / Univ. of Nebraska Press.

Graburn, Nelson, ed. 1976. *Ethnic and Tourist Arts*. Berkeley and Los Angeles: Univ. of California Press.

———. 1978 "'I Like Things to Look More Different Than That Stuff Did': An Experiment in Cross-Cultural Art Appreciation." In *Art in Society*, edited by Michael Greenhalgh and Vincent Megaw, 51–70. London: Duckworth.

Grady, C. Jill. 1998. "Huichol Authenticity." PhD diss., Univ. of Washington.

———. 2004. "Huichol Yarn Painting Texts: Postcolonial Ekphrasis, Ethnic Art, and Exhibits." *Museum Anthropology* 27, nos. 1–2: 73–86.

Grady, C. Jill, and Susana Eger Valadez. 2001. "They'll Take Manhattan." *Native Peoples* 14, no. 4: 32–36.

Greenhalgh, Michael. 1978. "European Interest in the Non-European: The Sixteenth Century and Pre-Columbian Art and Architecture." In *Art in Society*, edited by Michael Greenhalgh and Vincent Megaw, 88–103. London: Duckworth.

Grimes, Joseph E. 1964. *Huichol Syntax*. London: Mouton.

Grimes, Joseph E., and Barbara F. Grimes. 1962. "Semantic Distinctions in Huichol (Uto-Aztecan) Kinship." *American Anthropologist* 64:104–112.

Grimes, Joseph E., and Thomas B. Hinton. 1969. "The Huichol and Cora." In *Handbook of Middle American Indians*, edited by E. Z. Vogt and R. Wauchope, 8:792–813. Austin: Univ. of Texas Press.

Grindal, Bruce T. 1983. "Into the Heart of Sisala Experience: Witnessing Death Divination." *Journal of Anthropological Research* 39, no. 1: 60–80.

Halifax, Joan. 1982. *Shaman: The Wounded Healer*. London: Thames and Hudson.

Harner, Michael. 1973. "Common Themes in South American Indian Yagé Experiences." In *Hallucinogens and Shamanism*, edited by Michael Harner, 155–175. New York: Oxford Univ. Press.

———. 1980. *The Way of the Shaman*. San Francisco: Harper and Row.

Hill, Jane H. 1992. "The Flower World of Old Uto-Aztecan." *Journal of Anthropological Research* 48, no. 2: 117–144.

———. 2001. "Proto-Uto-Aztecan: A Community of Cultivators in Central Mexico?" *American Anthropologist* 103, no. 4: 913–934.

Howard, Kathleen L., and Diana F. Pardue. 1996. *Inventing the Southwest: The Fred Harvey Company and Native American Art.* Flagstaff, Ariz.: Northland.

Hrdlička, Aleš. 1903. "The Region of the Ancient 'Chichimecs,' with Notes on the Tepecanos and the Ruin of La Quemada, Mexico." *American Anthropologist* 5, no. 3:385–440.

———. 1907. "Huichol." In *Handbook of American Indians North of Mexico,* 30:575–577. Washington, DC: Bureau of American Ethnology, Smithsonian Institution.

Indian Arts and Crafts Association, Council for Indigenous Arts and Culture. 1999. *Collecting Authentic Indian Arts and Crafts: Traditional Work of the Southwest.* Summertown, Tenn.: Book Publishing.

Itten, Johannes. 1973. *The Art of Colour.* Translated by Ernst van Haagen. New York: Van Nostrand Reinhold.

Jáuregui, Jesús. 1993. "Un siglo de tradición mariachera entre los huicholes: La familia Ríos." In *Música y danzas del gran Nayar,* edited by Jesús Jáuregui, 311–335. México, DF: Centro de Estudios Mexicanos y Centroamericanos / Instituto Nacional Indigenista.

Kamffer, Raúl. 1957. "Plumed Arrows of the Huicholes of Western Mexico." *Américas* 9, no. 6 (June): 12–16.

Kan, Michael, Clement Meighan, and H. B. Nicholson. 1989. *Sculpture of Ancient West Mexico.* Rev. ed. Albuquerque: Univ. of New Mexico Press.

Kaplan, Flora S. 1993. "Mexican Museums in the Creation of a National Image in World Tourism." In *Crafts in the World Market,* edited by June Nash, 103–125. Albany: State Univ. of New York.

Kaufmann, Carole N. 1976. "Functional Aspects of Haida Argillite Carvings." In Graburn, *Ethnic and Tourist Arts,* 56–84.

Kearney, M. 1972. *The Winds of Ixtepeji.* New York: Holt, Rinehart and Winston.

Kensinger, Kenneth M. 1973. "Banisteriopsis Usage among the Peruvian Cashinahua." In *Hallucinogens and Shamanism,* edited by Michael Harner, 9–14. New York: Oxford Univ. Press.

Kent, Kate Peck. 1976. "Pueblo and Navajo Weaving Traditions and the Western World." In Graburn, *Ethnic and Tourist Arts,* 85–101.

Kindl, Olivia Selena. 1997. "La Jícara Huichola: Un Microcosmos Mesoamericano." Licenciada thesis, Escuela Nacional de Antropología e Historia (INAH/SEP), Mexico City.

———. 2003. *La Jícara Huichola: Un Microcosmos Mesoamericano.* Mexico City: Instituto Nacional de Antropología e Historia / University of Guadalajara.

———. 2005. "Pasos del Caminante Silencioso." *Artes de México*, no. 75, 56–59.

Kiva Arts. 1992. Catalogue. Cottonwood, Ariz.: Kiva Arts.

Klein, Cecilia. 1982. "Woven Heaven, Tangled Earth: A Weaver's Paradigm of the Mesoamerican Cosmos." In *Ethnoastronomy and Archaeoastronomy in the American Tropics*, edited by Anthony F. Aveni and Gary Urton, 1–35. New York: Annals of the New York Academy of Sciences.

Knab, Tim. 1977. "Notes Concerning the Use of Solandra among the Huichols." *Economic Botany* 31:80–86

———. 2004. *Mad Jesús*. Albuquerque: Univ. of New Mexico Press.

Knox, Bryant, and Ralph N. Maud. 1980. *The Huichol of Mexico, Sept. 8–Oct. 3, 1980*. Burnaby, B.C.: Simon Fraser Gallery. Mimeograph, in the National Library and Archives of Canada, Ottawa.

Krakauer, Jon. 2003. *Under the Banner of Heaven*. New York: Doubleday.

Leadbeater, C. W. 1927 [1987]. *The Chakras*. Wheaton, Ill.: Theosophical Publishing House / Quest Books.

Liffman, Paul M. 2002. "Huichol Territoriality: Land Claims and Cultural Representation in Western Mexico." PhD diss., University of Chicago.

Lommel, Andreas. 1967. *Shamanism*. New York: McGraw-Hill.

López Austin, Alfredo. 1988. *The Human Body and Ideology*. Vol. 1. Translated by Thelma Ortiz de Montellano and Bernard Ortiz de Montellano. Salt Lake City: Univ. of Utah Press.

López Austin, Alfredo, and Leonardo López Luján. 2001. *Mexico's Indigenous Past*. Translated by Bernard Ortiz de Montellano. Norman: Univ. of Oklahoma Press.

Lumholtz, Carl. 1891. "Report on Explorations in Northern Mexico." *Bulletin of the American Geographical Society* 23, no. 2: 386–402.

———. 1900. *Symbolism of the Huichol Indians*. New York: American Museum of Natural History.

———. 1902. *Unknown Mexico*. 2 vols. New York: Charles Scribner's Sons.

———. 1904. *Decorative Art of the Huichol Indians*. New York: American Museum of Natural History.

Luna, L. E. 1990. "The Ayahuasca Visions of Pablo Amaringo." *Shaman's Drum*, no. 20 (Summer), 30–43.

Lyon, G. F. 1826. *Journal of a Residence and Tour in the Republic of Mexico in the Year 1826*. Vol. 2. London: John Murray.

MacDonald, George F., John L. Cove, Charles D. Laughlin, Jr., and John McManus. 1989. "Mirrors, Portals, and Multiple Realities." *Zygon* 24, no. 1: 39–64.

MacLean, Hope. 1995. "Huichol Indian Yarn Painting and Shamanism: An Aesthetic Analysis." PhD diss., University of Alberta.

————. 2000. "The 'Deified' Heart: Huichol Indian Soul-Concepts and Shamanic Art." *Anthropologica* 42:75–90.

————. 2001a. "The Origins of Huichol Indian Yarn Painting." *American Indian Art Magazine* 26, no. 3 (Summer): 42–53.

————. 2001b. "The Origins of Huichol Indian Yarn Painting, Part II: Styles, Themes and Artists." *American Indian Art Magazine* 26, no. 4 (Fall): 68–77, 98–99.

————. 2001c. "Sacred Colors and Shamanic Vision among the Huichol Indians of Mexico." *Journal of Anthropological Research* 57:305–323.

————. 2003 "Huichol Yarn Paintings, Shamanic Art, and the Global Marketplace." *Studies in Religion* 32, no. 3: 311–335.

————. 2004. Review of *Visions of a Huichol Shaman*, by Peter T. Furst. *Journal of Anthropological Research* 60:273–275.

————. 2005a. Review of *Huichol Mythology*, by Robert M. Zingg. *Journal of Anthropological Research* 61, no. 2: 225–226.

————. 2005b. *Yarn Paintings of the Huichol*. Wakefield, Quebec: Singing Deer Press.

————. 2010. "The Origins of Huichol Yarn Paintings." In *Huichol Art and Culture: Balancing the World*, edited by Melissa S. Powell and C. Jill Grady, 64–77. Santa Fe: Museum of New Mexico Press.

Malotki, Ekkehart, and Ken Gary. 2001. *Hopi Stories of Witchcraft, Shamanism, and Magic.* Lincoln: Univ. of Nebraska Press.

Manzanilla González, Alfonso, ed. N.d. [1976]. *Report on Plan HUICOT.* Mimeograph, in author's collection.

Mata Torres, Ramón. N.d. *Peregrinación del Peyote*. Guadalajara: La Casa de las Artesanías del Gobierno de Jalisco.

————. 1980. *El Arte de los Huicholes*. Guadalajara.

McIntosh, Juan B., and José Grimes. 1954. *Niuqui'iquisicayari: Vocabulario Huichol-Castellano, Castellano-Huichol.* Mexico City: Instituto Linguistico de Verano.

Medina Silva, Ramón. 1996. "A Huichol Soul Travels to the Land of the Dead." In *People of the Peyote*, edited by Stacy B. Schaefer and Peter T. Furst, 389–402. Albuquerque: Univ. of New Mexico Press.

Moore, Reavis. 1993. *Native Artists of North America.* Santa Fe: Muir.

Morris, Walter F., Jr. 1987. *Living Maya*. New York: Abrams.

Muller, Kal. 1978. "Huichol Art and Acculturation." In Berrin, *Art of the Huichol Indians*, 84–100.

Museo Nacional de Artes e Industrias Populares. 1954. *Los Huicholes.* Mexico City: Museo Nacional de Artes e Industrias Populares.

Myerhoff, Barbara. 1968. "The Deer-Maize-Peyote Complex among the Huichol Indians of Mexico." PhD diss., University of California, Los Angeles.

————. 1974. *Peyote Hunt*. Ithaca, N.Y.: Cornell Univ. Press.

Myers, Marybelle. 1984. "Inuit Arts and Crafts Co-operatives in the Canadian Arctic." *Canadian Ethnic Studies* 16, no. 3: 132–152.

Nahmad Sittón, Salomón. 1972. "Artesanías Coras y Huicholes." In *Mitos y Arte Huicholes*, edited by Peter T. Furst and Salamón Nahmad Sittón, 126–167. Mexico City: Secretaria de Educación Pública.

Negrín, Juan. 1975. *The Huichol Creation of the World*. Sacramento: E. B. Crocker Art Gallery.

————. 1977. *El arte contemporáneo de los huicholes*. Guadalajara: Universidad de Guadalajara –INAH.

————. 1979. "The Huichol Indians: A Pre-Columbian Culture in Mexico Today." *UNESCO Courier* (Feb.): 17–27.

————. 1985. *Acercamiento Histórico y Subjectivo al Huichol*. Guadalajara: Universidad de Guadalajara.

————. 1986. *Nierica: Arte contemporáneo huichol*. Mexico City: Museo de Arte Moderno.

————. 2005. "Corazón, memoria y visiones." *Artes de México*, no. 75, 38–54.

Opler, Morris. 1941 [1965]. *An Apache Life-Way*. Reprint, New York: Cooper Square.

Ortiz Monasterio, Pablo, José Antonio Nava, and Ramón Mata Torres. 1992. *Corazón de Venado*. Mexico City: Casa de las Imágenes.

Painter, Muriel Thayer. 1986. *With Good Heart: Yaqui Beliefs and Ceremonies in Pascua Village*. Edited by Edward H. Spicer and Wilma Kaemlein. Tucson: Univ. of Arizona Press.

Parezo, Nancy J. 1991. *Navajo Sandpainting: From Religious Act to Commercial Art*. Albuquerque: Univ. of New Mexico Press. Originally published in 1983 by the Univ. of Arizona Press (Tucson).

Perrin, Michel. 1996. "The Urukáme, a Crystallization of the Soul: Death and Memory." Translated by Karin Simoneau. In *People of the Peyote*, edited by Stacy B. Schaefer and Peter T. Furst, 403–428. Albuquerque: Univ. of New Mexico Press.

Prem Das [Paul C. Adams]. 1978. "Initiation by a Huichol Shaman." In Berrin, *Art of the Huichol Indians*, 129–141.

————. 1979. "Huichol Nieríkaya: Journey to the Realm of the Gods." In *Shamanic Voices*, edited by Joan Halifax, 1. New York: Dutton.

Reichard, Gladys A. 1936 [1971]. *Navajo Shepherd and Weaver*. New York: Augustin. Reprint, Glorieta, N.M.: Rio Grande.

————. 1944. *Prayer: The Compulsive Word*. Monographs of the American Ethnological Society 7. Seattle: Univ. of Washington Press.

————. 1950 [1963]. *Navaho Religion*. 2nd ed. New York: Bollingen Foundation.

Ridington, Robin. 1988. *Trail to Heaven*. Vancouver, B.C.: Douglas and McIntyre.

Rojas, Beatriz, ed. 1992. *Los Huicholes: Documentos Históricos*. Mexico City: SEP, CIESAS, INI.

———. 1993. *Los Huicholes en la Historia.* Mexico City: Centro de Estudios Mexicanos y CentroAmericanos, Instituto Nacional Indigenista.

Sandner, Donald. 1979. *Navaho Symbols of Healing.* New York: Harcourt Brace Jovanovich.

Sayer, Chloe. 1985. *Mexican Costume.* London: Colonnade Books / British Museum Publications.

Schaefer, Stacy B. 1978. *Las Aguilas Que Cantan: The Eagles That Sing.* Exhibition catalogue. Santa Cruz: Univ. of California, Santa Cruz.

———. 1989. "The Loom and Time in the Huichol World." *Journal of Latin American Lore* 15, no. 2: 179–194.

———. 1990. "Becoming a Weaver: The Woman's Path in Huichol Culture." PhD diss., University of California, Los Angeles.

———. 2002. *To Think with a Good Heart: Wixárika Women, Weavers, and Shamans.* Salt Lake City: Univ. of Utah Press.

Schaefer, Stacy B., and Peter T. Furst, eds. 1996. *People of the Peyote: Huichol Indian History, Religion, and Survival.* Albuquerque: Univ. of New Mexico Press.

Schrader, Robert Fay. 1983. *The Indian Arts and Crafts Board.* Albuquerque: Univ. of New Mexico Press.

Smith, Valene L., and Maryann Brent, eds. 2001. *Hosts and Guests Revisited: Tourism Issues of the Twenty-First Century.* Elmsford, N.Y.: Cognizant Communications.

Soto Soria, Alfonso. 1955. "Los Huicholes." *Artes de México,* no. 7, 3–18.

———. 1969. "Los Huicholes y su mundo magico." *Artes de México,* no. 124, 52–67.

Southwest Indian Foundation. 1996. Catalogue. Gallup, N.M.: Southwest Indian Foundation.

Spicer, Edward. 1980. *The Yaquis: A Cultural History.* Tucson: Univ. of Arizona Press.

Stromberg, Gobi. 1976. "The Amate Bark-Paper Painting of Xalitla." In Graburn, *Ethnic and Tourist Arts,* 149–162.

Tanner, Clara Lee. 1973 [1957]. *Southwest Indian Painting.* 2nd ed. Tucson: Univ. of Arizona Press.

Turner, Edith. 1994. "A Visible Spirit Form in Zambia." In *Being Changed by Cross-Cultural Encounters: The Anthropology of Extraordinary Experience,* edited by David E. Young and Jean-Guy Goulet, 71–95. Peterborough, Ont.: Broadview.

———. 1996. *The Hands Feel It: Healing and Spirit Presence among a Northern Alaskan People.* DeKalb, Ill.: Northern Illinois Univ. Press.

Underhill, Ruth M. 1938. *Singing for Power: The Song Magic of the Papago Indians of Southern Arizona.* Berkeley and Los Angeles: Univ. of California Press.

———. 1939 [1969]. *Social Organization of the Papago Indians.* New York: Columbia Univ. Contributions in Anthropology 30. Reprint, New York: AMS Press.

———. 1979. *Papago Woman.* New York: Holt, Rinehart and Winston.

Valdovinos, Margarita, and Johannes Neurath. 2007. "Instrumentos de los dioses: Piezas selectas de la colección Preuss." *Artes de México*, no. 85: 50–63.

Vogt, Evon Z. 1969. *Zinacantan*. Cambridge, Mass.: Harvard Univ. Press.

Weigand, Phil C. 1972. *Co-operative Labor Groups in Subsistence Activities among the Huichol Indians of the Gubernancia of San Sebastián Teponahuastlan, Municipio of Mezquitic, Jalisco, Mexico*. Mesoamerican Studies 7. Carbondale: Southern Illinois Univ. Museum.

———. 1975. "Possible References to La Quemada in Huichol Mythology." *Ethnohistory* 22, no. 1 (Winter): 15–20.

———. 1981. "Differential Acculturation among the Huichol Indians." In *Themes of Indigenous Acculturation in Northwest Mexico*, edited by Thomas B. Hinton and Phil C. Weigand, 9–21. Tucson: Univ. of Arizona Press.

Wheat, Margaret M. 1967. *Survival Arts of the Primitive Paiutes*. Reno: Univ. of Nevada Press.

Williams, Adrianna. 1994. *Covarrubias*. Edited by Doris Ober. Austin: Univ. of Texas Press.

Young, David E., and Jean-Guy Goulet, eds. 1994. *Being Changed by Cross-Cultural Encounters: The Anthropology of Extraordinary Experience*. Peterborough, Ont.: Broadview.

Young, David E., Grant C. Ingram, and Lise Swartz. 1989. *Cry of the Eagle: Encounters with a Cree Healer*. Toronto: Univ. of Toronto Press.

Zingg, Robert M. 1938 [1977]. *The Huichols: Primitive Artists*. New York: Stechert. Reprint, Millwood, N.Y.: Kraus.

———. 2004. *Huichol Mythology*. Edited by Jay C. Fikes, Phil C. Weigand, and Acelia García de Weigand. Tucson: Univ. of Arizona Press.

index

Page numbers in *italics* indicate illustrations.

Aariwama, Aariwameta. *See* Tatei Nüariwama

abstract art, 117, 130, 161

acrylic. *See* yarns

aesthetics, 8; of Aztecs, 213, 258n3; fuerte-bajito system of, 156–158; of Huichol, 145–146, 213, 250–252, 258n3

Africa, African people: visionary experiences among, 11, 253n 6

Aitsarie: imagery in yarn paintings, *70, 71*; sacred site of, 71

altars, 33, 41

altered states of consciousness, 165, 169, 191

Amaringo, Pablo, 165

Amatlán de Jora, Mexico, 22

American Museum of Natural History (New York), 111

animals: imagery in yarn paintings, 127

Anasazi culture, 80

Arapaho people: myths of, 49

Artes de México: publishing on Huichol art, 108

art dealers: characteristics of, 223–224; cooperation in research, 7; influences on artists, 237–239; Internet sales of, 234–236; marketing Tepehuane art as Huichol, 229–230; promotion of yarn paintings by, 191

art galleries: description and locations of, 221–224; and Huichols, run by, 222–223

artists: on buyers, 243–249; as businesspeople, 238–239; cooperatives of, 227, 234; documentation of, 122; and e-commerce, 236; market influences on, 237–240; photos of, at work, *16, 136, 231*; recruitment of youth, 233; secrecy and explanation of meaning by, 247–249; as shamans, 199, 217–220; souls of, and art production, 206–213; on trends in yarn paintings, 240–243; variation in abilities of, 190; and vision as inspiration,

191–200. *See also* shamans; souls; women; yarn paintings

Atenco River. *See* Chapalagana River

Australia, Aboriginal people of, 243

authenticity, 251

ayahuasca (*Banisteriopsis caapi*): visions due to, 165–166, 191

Aztec culture: colors and directions, 181; designs used by, 146; offerings made by, 37, 49; soul concepts of, 201–204; visionary experience among, 15, 47

Basilica of Zapopan, 91–92, 100; Huichol museum in, 222

Bautista Bautista, Iginio, 223

Bautista Cervantes family, 227–230, *228. See also* Tepehuane people

Bautista Cervantes, Gabriel, 227, 258n1(chap. 14)

Bazar Sábado: market for Huichol arts, 222

beads, beadwork, 37, 78; color use in, 146–151; and offerings, used in, 37–38; sale of, 104, 124; 230, 231, 232–233; and yarn paintings, used in, 141

beeswax. *See* wax

Benítez, Fernando: criticism of yarn paintings, 194–195; and Ramón Medina Silva, research with, 101

Benítez Flores, Eliseo, 119

Benítez Sánchez, José (Yucauye Kukame): color use by, 161, 256n2; life history of, 102, 113, 117–121; publication on, 4, 110–111; style of, 238, 256n4; and texts on art, 244–245; training of apprentices in Zitacua by, 233; on uxa, 52; yarn paintings of, 143–144

birds: imagery in yarn paintings, 89, 127, *128*

birth: imagery in yarn paintings, 98, *99*, 127, *128*, 239

blood. *See* sacrifice

JHL